ART HISTORY

PORTABLE EDITION　　　　THIRD EDITION

A View of the World
Part One: Asian, African, and Islamic Art
and Art of the Americas

MARILYN STOKSTAD

Judith Harris Murphy Distinguished Professor of Art History Emerita
The University of Kansas

CONTRIBUTORS

David A. Binkley, Claudia Brown, Patricia J. Darish,

Robert D. Mowry, and D. Fairchild Ruggles

PEARSON

Prentice
Hall

Upper Saddle River, NJ 07458

Editor-in-Chief: Sarah Touborg
Sponsoring Editor: Helen Ronan
Editorial Assistant: Christina DeCesare
Editor in Chief, Development: Rochelle Diogenes
Development Editors: Jeannine Ciliotta, Margaret Manos,
 Teresa Nemeth, and Carol Peters
Media Editor: Alison Lorber
Director of Marketing: Brandy Dawson
Executive Marketing Manager: Marissa Feliberty
AVP, Director of Production and Manufacturing: Barbara Kittle
Senior Managing Editor: Lisa Iarkowski
Production Editor: Barbara Taylor-Laino
Production Assistant: Marlene Gassler
Senior Operations Specialist: Brian K. Mackey
Operations Specialist: Cathleen Peterson
Creative Design Director: Leslie Osher
Art Director: Amy Rosen
Interior and Cover Design: Anne DeMarinis
Layout Artist: Gail Cocker-Bogusz
Line Art and Map Program Management: Gail Cocker-Bogusz,
 Maria Piper

Line Art Studio: Peter Bull Art Studio
Cartographer: DK Education, a division of Dorling Kindersley, Ltd.
Pearson Imaging Center: Corin Skidds, Greg Harrison, Robert
 Uibelhoer, Ron Walko, Shayle Keating, and Dennis Sheehan
Site Supervisor, Pearson Imaging Center: Joe Conti
Photo Research: Laurie Platt Winfrey, Fay Torres-Yap, Mary Teresa
 Giancoli, and Christian Peña, Carousel Research, Inc.
Director, Image Resource Center: Melinda Patelli
Manager, Rights and Permissions: Zina Arabia
Manager, Visual Research: Beth Brenzel
Manager, Cover Visual Research and Permissions: Karen Sanatar
Image Permission Coordinator: Debbie Latronica
Manager, Cover Research and Permissions: Gladys Soto
Copy Editor: Stephen Hopkins
Proofreaders: Faye Gemmellaro, Margaret Pinette, Nancy Stevenson,
 and Victoria Waters
Composition: Prepare, Inc.
Portable Edition Composition: Black Dot
Cover Printer: Phoenix Color Corporation
Printer/Binder: R. R. Donnelley

Maps designed and produced by DK Education, a division of Dorling Kindersley, Limited, 80 Strand London WC2R 0RL.
DK and the DK logo are registered trademarks of Dorling Kindersley Limited.

Credits and acknowledgements borrowed from other sources and reproduced, with permission, in this textbook appear on the
appropriate page within text or on the credit pages in the back of this book.

Cover Photo:
 Seated Buddha, Cave 20, Yungang, Datong, Shanzi. Northern Wei dynasty. c. 460 CE. Stone, height 45′ (13.7 m).
 Photo: © Cultural Relics Publishing House.

Pearson Education LTD.
Pearson Education Australia PTY, Limited
Pearson Education Singapore, Pte. Ltd
Pearson Education North Asia Ltd

Pearson Education, Canada, Ltd
Pearson Educación de Mexico, S.A. de C.V
Pearson Education—Japan
Pearson Education Malaysia, Pte. Ltd

10 9 8 7 6 5 4 3 2 1

ISBN 0-13-605406-4
ISBN 978-0-13-605406-1

CONTENTS

11

JAPANESE ART BEFORE 1392 372

12

ART OF THE AMERICAS BEFORE 1300 394

13

ART OF ANCIENT AFRICA 420

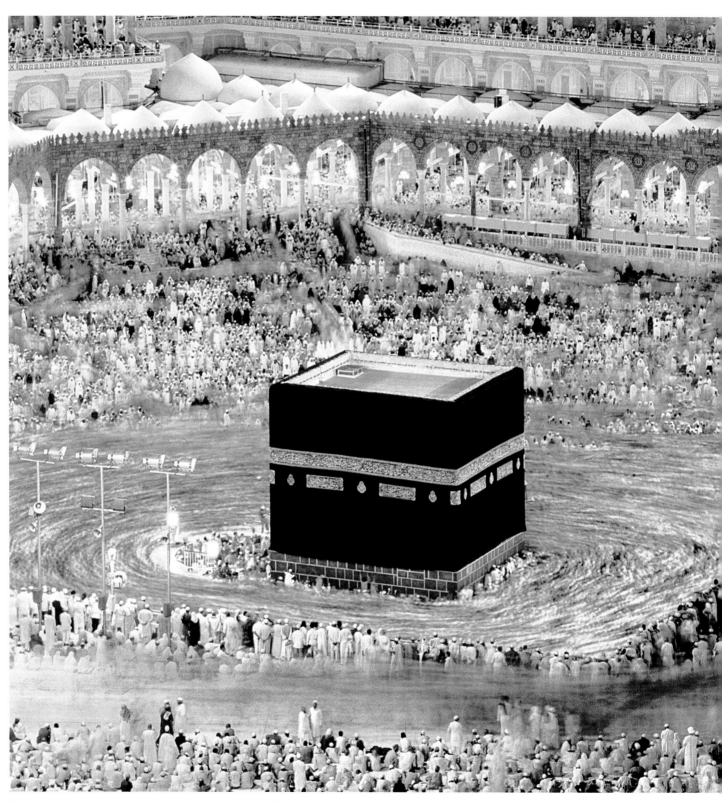

8–1 | **THE KAABA, MECCA** The Kaaba represents the center of the Islamic world. Its cubical form is draped with a black textile that is embroidered with a few Qur'anic verses in gold.

ISLAMIC ART

8 In the desert outside of Mecca in 610 CE, an Arab merchant named al-Amin sought solitude in a cave. On that night, which Muslims call "The Night of Destiny," an angel appeared to al-Amin and commanded him to recite revelations from God (Allah). In that moment, al-Amin became Muhammad ("Messenger of God"). His revelations form the foundation of the religion called Islam ("submission to God's will"), whose adherents are Muslims ("those who have submitted to God"). For the rest of his life, Muhammad recited revelations in cadenced verses to his followers who committed them to memory. After his death, they transcribed the verses and organized them in chapters called *surahs*, thus compiling the holy book of Islam: the Qur'an ("Recitation").

The first person to accept Muhammad as God's Prophet was his wife, Khadija, followed soon thereafter by other family members. But many powerful Meccans were hostile to the message of the young visionary, and he and his companions were forced to flee in 622. Settling in an oasis town, later renamed Medina ("City"), Muhammad built a house that became a gathering place for the converted and thus the first Islamic mosque.

In 630, Muhammad returned to Mecca with an army of ten thousand, routed his enemies, and established the city

as the spiritual capital of Islam. After his triumph, he went to the Kaaba (FIG. 8–1), a cubical shrine said to have been built for God by the biblical patriarch Abraham and long the focus of pilgrimage and polytheistic worship. He emptied the shrine, repudiating its accumulated pagan idols, while preserving the enigmatic cubical structure itself and dedicating it to God.

The Kaaba is the symbolic center of the Islamic world, the place to which all Muslim prayer is directed and the ultimate destination of Islam's obligatory pilgrimage, the Hajj. Each year, huge numbers of Muslims from all over the world travel to Mecca to circumambulate the Kaaba during the month of pilgrimage. The exchange of ideas that occurs during the intermingling of these diverse groups of pilgrims has been a primary source of Islamic art's cultural eclecticism.

CHAPTER-AT-A-GLANCE

- **ISLAM AND EARLY ISLAMIC SOCIETY**
- **ART DURING THE EARLY CALIPHATES** | Architecture | Calligraphy | Ceramics and Textiles
- **LATER ISLAMIC ART** | Architecture | Portable Arts | Manuscripts and Painting
- **THE OTTOMAN EMPIRE** | Architecture | Illuminated Manuscripts and *Tugras*
- **THE MODERN ERA**
- **IN PERSPECTIVE**

ISLAM AND EARLY ISLAMIC SOCIETY

Seemingly out of nowhere, Islam arose in seventh-century Arabia, a land of desert oases with no cities of great size, sparsely inhabited by tribal nomads. Yet, under the leadership of its founder, the Prophet Muhammad (c. 570–632 CE), and his successors, Islam spread rapidly throughout northern Africa, southern and eastern Europe, and much of Asia, gaining territory and converts with astonishing speed. Because Islam encompassed geographical areas with a variety of long-established cultural traditions, and because it admitted diverse peoples among its converts, it absorbed and combined many different techniques and ideas about art and architecture. The result was a remarkable eclecticism and artistic sophistication.

Muslims date their history as beginning with the hijira ("emigration"), the flight of the Prophet Muhammad in 622 from Mecca to Medina. In less than a decade Muhammad had succeeded in uniting the warring clans of Arabia under the banner of Islam. Following his death in 632, four of his closest associates in turn assumed the title of caliph ("successor").

Muhammad's act of emptying the Kaaba of its pagan idols confirmed the fundamental concept of **aniconism** (avoidance of figural imagery) in Islamic art. Following his example, the Muslim faith discourages the representation of figures, particularly in religious contexts. Instead, Islamic artists elaborated a rich vocabulary of nonfigural ornament, including complex geometric designs and scrolling vines sometimes known as **arabesques**. Islamic art revels in surface decoration, in manipulating line, color, and especially pattern, often highlighting the interplay of pure abstraction, organic form, and script.

According to tradition, the Qur'an assumed its final form during the time of the third caliph, Uthman (ruled 644–56). As the language of the Qur'an, the Arabic language and script have been a powerful unifying force within Islam. From the eighth through the eleventh centuries, Arabic was the universal language among scholars in the Islamic world and in some Christian lands as well. Inscriptions frequently ornament works of art, sometimes written clearly to provide a readable message, but in other cases written as complex patterns simply to delight the eye.

The accession of Ali as the fourth caliph (ruled 656–61) provoked a power struggle that led to his assassination and resulted in enduring divisions within Islam. Followers of Ali, known as Shi'ites (referring to the party or *shi'a* of Ali), regard him alone as the Prophet's rightful successor. Sunni Muslims, in contrast, recognize all of the first four caliphs as "rightly guided." Ali was succeeded by his rival Muawiya (ruled 661–80), a close relative of Uthman and the founder of the Umayyad dynasty (661–750).

Islam expanded dramatically. In just two decades, seemingly unstoppable Muslim armies conquered the Sasanian Persian Empire, Egypt, and the Byzantine provinces of Syria and Palestine. By the early eighth century, under the Umayyads, they had reached India, conquered northern

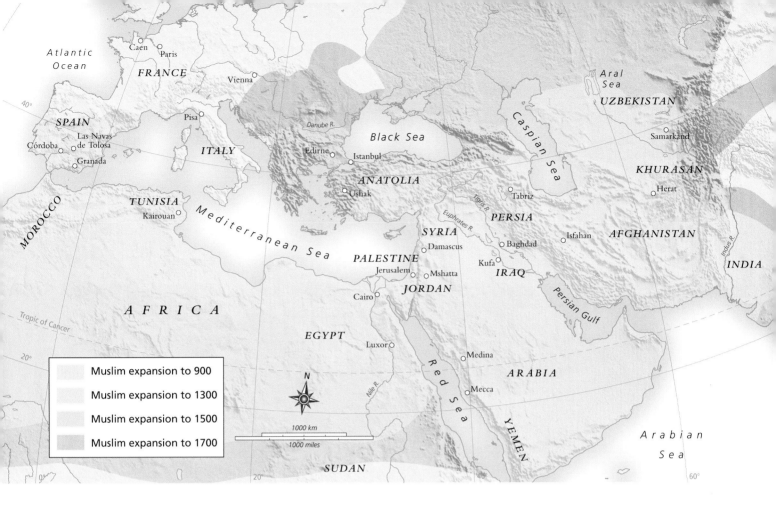

MAP 8–1 | **THE ISLAMIC WORLD**

Within 200 years after 622 CE, the Islamic world expanded from Mecca to India in the east, and to Morocco
and Spain in the west.

Africa and Spain, and penetrated France to within 100 miles
of Paris before being turned back (MAP 8–1). In these newly
conquered lands, the treatment of Christians and Jews who
did not convert to Islam was not consistent, but in general, as
"People of the Book"—followers of a monotheistic religion
based on a revealed scripture—they enjoyed a protected sta-
tus. However, they were also subject to a special tax and
restrictions on dress and employment.

Muslims participate in congregational worship at a
mosque (*masjid*, "place of prostration"). The Prophet Muham-
mad himself lived simply and instructed his followers in prayer
at a mud-brick house, now known as the Mosque of the
Prophet, where he resided in Medina. This was a square enclo-
sure that framed a large courtyard. Facing the courtyard along
the east wall were small rooms where Muhammad and his
family lived. Along the south wall, a thatched portico sup-
ported by palm-tree trunks sheltered both the faithful as they
prayed and Muhammad as he spoke from a low platform. This
simple arrangement inspired the design of later mosques.

Lacking an architectural focus such as an altar, nave, or dome,
the space of this prototypical mosque reflected the founding
spirit of Islam in which the faithful pray directly to God with-
out the intermediary of a priesthood.

ART DURING THE EARLY CALIPHATES

The caliphs of the Umayyad dynasty (661–750), which ruled
from Damascus in Syria, built mosques and palaces through-
out the Islamic Empire. These buildings projected the author-
ity of the new rulers and reflected the growing acceptance of
Islam. In 750 the caliphs of the Abbasid dynasty replaced the
Umayyads in a coup d'etat, ruling until 1258 in the grand
manner of the ancient Persian emperors. Their capital was
Baghdad in Iraq, and their art patronage reflected Persian and
Turkic traditions. Their long and cosmopolitan reign saw
achievements in medicine, mathematics, the natural sciences,
philosophy, literature, music, and art. They were generally

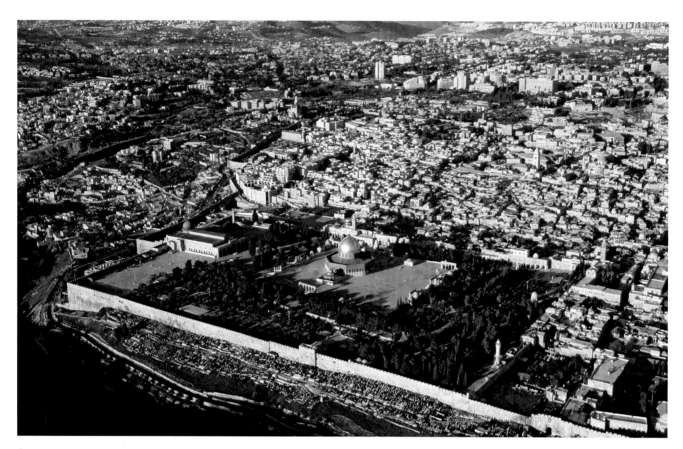

8–2 | **AERIAL VIEW OF HARAM AL-SHARIF, JERUSALEM**

The Dome of the Rock occupies a place of visual height and prominence in Jerusalem and, when first built,
strikingly emphasized the arrival of Islam and its community of adherents in that ancient city.

tolerant of the ethnically diverse populations in the territories they subjugated, and they admired the past achievements of Roman civilization and the living traditions of Byzantium, Persia, India, and China, freely borrowing artistic techniques and styles from all of them.

Architecture

While Mecca and Medina remained the holiest Muslim cities, under the Umayyad caliphs the political center moved away from the Arabian peninsula to the Syrian city of Damascus. Here, inspired by the Roman and Byzantine architecture of the eastern Mediterranean, the Muslims became enthusiastic builders of shrines, mosques, and palaces. The simple congregational mosque with hypostyle columns eventually gave way to new types, such as cruciform and centrally planned mosques. Although tombs were officially discouraged in Islam, they proliferated from the eleventh century onward, in part due to funerary practices imported from the Turkic northeast, and in part due to the rise of Shi'ism with its emphasis on genealogy and particularly ancestry through Muhammad's daughter, Fatima. The Umayyads launched the practice of building both urban palaces and rural estates; under later dynasties such as the Abbasids, the Spanish Umayyads, and

their successors, these were huge, sprawling complexes with an urban infrastructure of mosques, bathhouses, reception rooms, kitchens, barracks, gardens, and road networks.

THE DOME OF THE ROCK. The Dome of the Rock is the first great monument of Islamic art. Built in Jerusalem, it is the third most holy site in Islam. In the center of the city rises the Haram al-Sharif ("Noble Sanctuary") (FIG. 8–2), a rocky outcrop from which Muslims believe Muhammad ascended to the presence of God on the "Night Journey" described in the Qur'an. Jews and Christians variously associate the same site with Solomon's Temple, the site of the creation of Adam, and the place where the patriarch Abraham prepared to sacrifice his son Isaac at the command of God. In 691–2, the Umayyads had completed the construction of a shrine over the rock (FIGS. 8–3, 8–4) using Syrian artisans trained in the Byzantine tradition. By appropriating a site holy to the Jewish and Christian faiths, the Dome of the Rock is the first architectural manifestation of Islam's view of itself as completing the prophecies of those faiths and superseding them.

Structurally, the Dome of the Rock imitates the centrally planned form of Early Christian and Byzantine **martyria**. However, unlike its models, with their plain exteriors, it is

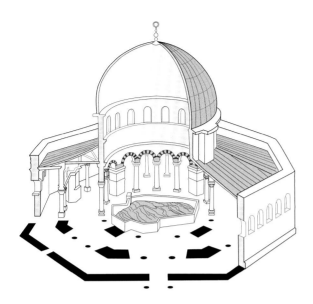

8–3 | CUTAWAY DRAWING OF THE DOME OF THE ROCK

arcades of alternating **piers** and **columns**, covers the central space containing the rock (FIG. 8–3). These arcades create concentric **aisles** (**ambulatories**) that permit devout visitors to circumambulate the rock. Inscriptions from the Qur'an interspersed with passages from other texts, including information about the building itself, form a **frieze** around the inner wall. As the pilgrim walks around the central space to read the inscriptions in brilliant gold mosaic on turquoise green ground, the building communicates both as a text and as a dazzling visual display. These passages of text are especially notable because they are the oldest surviving written Qur'an verses and the first use of monumental Qur'anic inscriptions in architecture. Below the frieze are walls covered with pale marble, the veining of which creates abstract symmetrical patterns, and columns with shafts of gray marble and gilded capitals. Above the calligraphic frieze is another mosaic frieze depicting thick, symmetrical vine scrolls and trees in turquoise, blue, and green, embellished with imitation jewels, over a gold ground. The mosaics are variously thought to represent the gardens of Paradise and trophies of Muslim victories offered to God. The decorative program is extraordinarily rich, but remarkably enough, the focus of the building is neither art nor architecture but the plain rock within it.

crowned with a golden dome that dominates the Jerusalem skyline, and it is decorated with opulent marble veneer and **mosaics** inside its exterior tiles. The dome, surmounting an octagonal **drum** pierced with windows and supported by

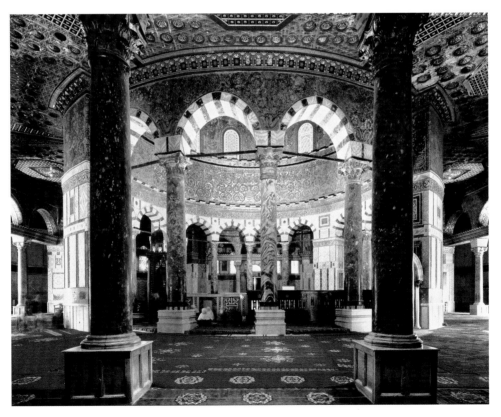

8–4 | DOME OF THE ROCK, JERUSALEM
691–2. Interior.

The arches of the inner and outer face of the central arcade are encrusted with golden mosaics.
The carpets and ceiling are modern but probably reflect the original patron's intention.

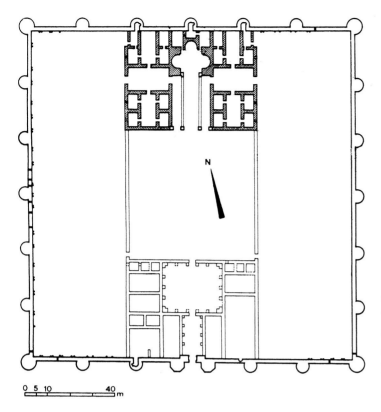

8–5 | **PLAN OF THE PALACE AT MSHATTA, JORDAN**
743–4.

MSHATTA PALACE. The Umayyad caliphs built profusely decorated palatial hunting retreats on the edge of the desert where local chieftains could be entertained and impressed. One such palace was built at Mshatta, near present-day Amman, Jordan (probably in 743–4). Although the east and west sides of Mshatta seem never to have been completed, this square, stone-walled complex is nevertheless impressively monumental (FIG. 8–5). It measured 472 feet on each side, and its outer walls and gates were guarded by towers and bastions reminiscent of a Roman fort. Inside, around a large central court, were a mosque, a domed audience hall, and private apartments.

Unique among surviving palaces, Mshatta was decorated with a frieze that extended in a band about 16 feet high across the base of its façade. This frieze was divided by a zigzag molding into triangular compartments, each punctuated by a large **rosette** carved in high relief (FIG. 8–6). The compartments were filled with intricate carvings in low relief that included interlacing scrolls inhabited by birds and other animals, urns, and candlesticks. Beneath one of the rosettes, two facing lions drink at an urn from which grows the Tree of Life, an ancient Persian motif. However, where the frieze runs across the outer wall of the mosque, to the right of the entrance, animal and bird imagery is conspicuously absent, in close observance of the strictures against icons.

THE GREAT MOSQUE OF KAIROUAN. Mosques provide a place for regular public worship. The characteristic elements of the **hypostyle** (multicolumned) mosque developed during the Umayyad period (see "Mosque Plans," right). The Great Mosque of Kairouan, Tunisia (FIG. 8–7), built in the ninth century, reflects the early form of the mosque but is elaborated with new additions. Its large rectangular plan is divided between a courtyard and a flat-roofed hypostyle prayer hall oriented toward Mecca. The system of repeated bays and aisles can easily be extended as the congregation grows in size—one of the hallmarks of the hypostyle plan. New is the huge tower (the **minaret**, from which the faithful are called to prayer) that rises from one end of the courtyard and that stands as a powerful sign of Islam's presence in the city.

The **qibla** wall, marked by a centrally positioned **mihrab** niche, is the wall of the prayer hall that is closest to Mecca. In the Great Mosque of Kairouan, the *qibla* wall is given heightened importance by a raised roof, a dome over the *mihrab*, and an aisle that marks the axis that extends from the *mihrab* to the minaret. The *mihrab* belongs to the tradition of niches that signify a holy place—the shrine for the Torah scrolls in a synagogue, the frame for the sculpture of a god or ancestor in Roman architecture, the apse in a church.

The **maqsura**, an enclosure in front of the *mihrab* for the

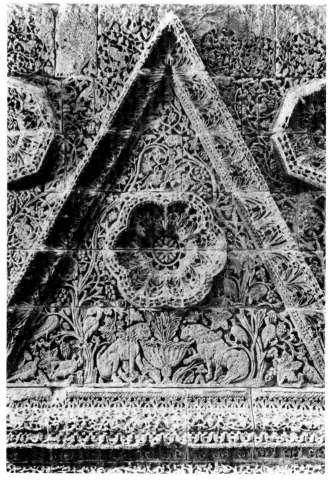

8–6 | **FRIEZE, DETAIL OF FAÇADE OF THE PALACE AT MSHATTA**
Stone. Staatliche Museen zu Berlin, Preussischer Kulturbesitz, Museum für Islamische Kunst.

Elements of Architecture
MOSQUE PLANS

Following the model of the Mosque of the Prophet in Medina, the earliest mosques were columnar **hypostyle halls**. The Great Mosque of Cordoba (SEE FIG. 8-8) was approached through an open courtyard, its interior divided by rows of columns leading, at the far end, to the *mihrab* niche of a *qibla* wall indicating the direction of Mecca.

A second type, the **four-*iwan* mosque**, such as the Masjid-i Jami at Isfahan, was developed in Iran. The *iwans*—huge barrel-vaulted halls with wide-open, arched entrances—faced each other across a central courtyard; the inner façade of this courtyard was thus given cross-axial emphasis, height, and greater monumentality (SEE FIG. 8-14).

Centrally planned mosques, such as the Sultan Selim Mosque at Edirne (SEE FIG. 8-27), were strongly influenced by Byzantine church plans, such as the Hagia Sophia (SEE FIG. 7-26) and are typical of the Ottoman architecture of Turkey. The interiors are dominated by a large domed space uninterrupted by structural supports. Worship is directed, as in other mosques, toward a *qibla* wall and *mihrab* opposite the entrance.

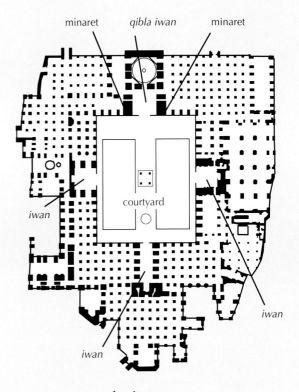

four-iwan mosque
Congregational Mosque, Isfahan

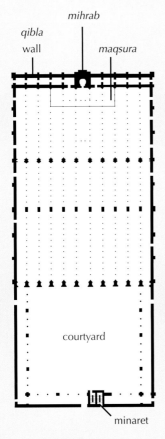

hypostyle mosque
Great Mosque, Cordoba,
after extension by
al-Hakam II

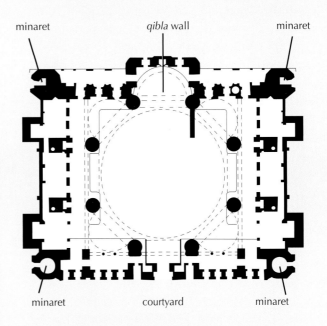

central-plan mosque
Sultan Selim Mosque, Edirne
(Plans are not to scale)

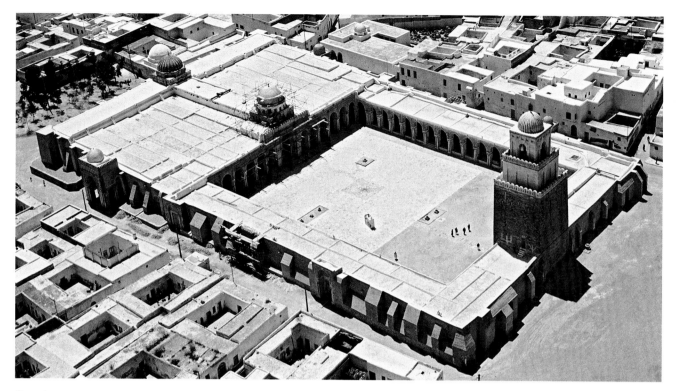

8–7 | **THE GREAT MOSQUE, KAIROUAN, TUNISIA**
836–75.

ruler and other dignitaries, became a feature of the principal congregational mosque after an assassination attempt on one of the Umayyad rulers. The **minbar**, or pulpit, stands by the *mihrab* as the place for the prayer leader and as a symbol of authority (for a fourteenth-century example of a *mihrab* and a *minbar*, SEE FIG. 8–16).

THE GREAT MOSQUE OF CORDOBA. When the Abbasids overthrew the Umayyads in 750, a survivor of the Umayyad dynasty, Abd al-Rahman I (ruled 756–88), fled across North Africa into southern Spain (known as *al-Andalus* in Arabic) where, with the support of Muslim settlers, he established himself as the provincial ruler, or *emir*. While the caliphs of the Abbasid dynasty ruled the eastern Islamic world from Baghdad for five centuries, the Umayyad dynasty ruled in Spain from their capital in Cordoba (756–1031). The Umayyads were noted patrons of the arts, and one of the finest surviving examples of Umayyad architecture is the Great Mosque of Cordoba (see "Mosque Plans," page 289).

In 785, the Umayyad conquerors began building the Cordoba mosque on the site of a Christian church built by the Visigoths, the pre-Islamic rulers of Spain. The choice of site was both practical—for the Muslims had already been borrowing space within the church—and symbolic, an appropriation of place (similar to the Dome of the Rock) that affirmed their presence. Later rulers expanded the building three times, and today the walls enclose an area of about 620 by 460 feet, about a third of which is the court-

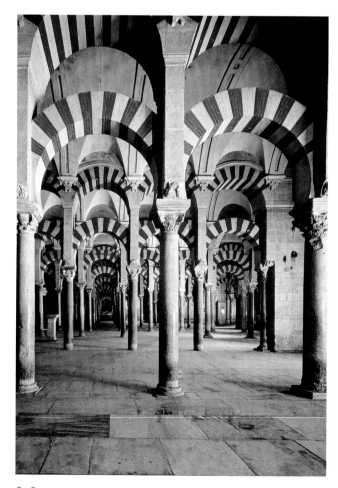

8–8 | **PRAYER HALL, GREAT MOSQUE, CORDOBA, SPAIN.**
Begun 785–86.

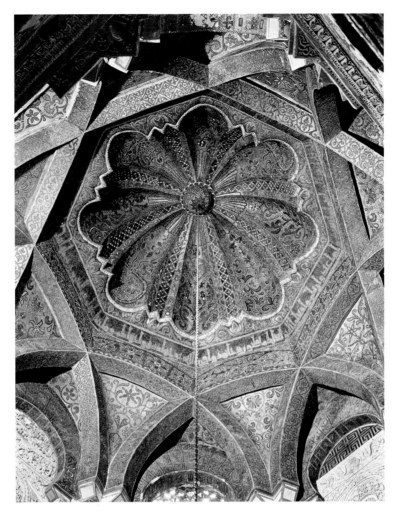

8–9 | **DOME IN FRONT OF THE** *MIHRAB,* **GREAT MOSQUE**
965.

yard. This patio was planted with fruit trees beginning in the early eighth century; today orange trees seasonally fill the space with color and scent. Inside, the proliferation of pattern in the repeated columns and double flying arches is colorful and dramatic. The marble columns and capitals in the hypostyle prayer hall were recycled from the Christian church that had formerly occupied the site, as well as from classical buildings in the region, which had been a wealthy Roman province. FIG. 8–8 shows the mosque's interior with columns of slightly varying heights. Two tiers of arches, one over the other, surmount these columns; the upper tier springs from rectangular posts that rise from the columns. This double-tiered design effectively increases the height of the interior space and provides excellent air circulation as well as a sense of monumentality and awe. The distinctively shaped **horseshoe arches**—a form known from Roman times and favored by the Visigoths—came to be closely associated with Islamic architecture in the West (see "Arches and Muqarnas," page 292). Another distinctive feature of these arches, also adopted from Roman and Byzantine precedents, is the alternation of white stone and red brick **voussoirs** forming the curved arch.

In the final century of Umayyad rule, Cordoba emerged as a major commercial and intellectual hub and a flourishing center for the arts, surpassing Christian European cities economically and also in science, literature, and philosophy. As a sign of this new prestige and power, Abd al-Rahman III (ruled 912–61) boldly reclaimed the title of caliph in 929. He and his son al-Hakam II (ruled 961–76) made the Great Mosque a focus of patronage, commissioning costly and luxurious renovations such as a new *mihrab* with three bays in front of it. The melon-shaped, ribbed dome over the central bay seems to float upon a web of criss-crossing arches (FIG. 8–9). The complexity of the design, which differs from the geometric configuration of the domes to either side, reflects the Islamic interest in mathematics and geometry, not purely as abstract concepts but as sources for artistic inspiration. Lushly patterned mosaics with inscriptions, geometric motifs, and stylized vegetation clothe both this dome and the *mihrab* below in brilliant color and gold. These were installed by a Byzantine master who was sent by the emperor in Constantinople, bearing boxes of the small glazed ceramic and glass pieces (**tesserae**). Such artistic exchange is emblematic of the interconnectedness of the medieval Mediterranean— through trade, diplomacy, and competition.

Elements of Architecture
ARCHES AND MUQARNAS

I slamic builders explored structure in innovative ways. They explored the variations and possibilities of the horseshoe arch (SEE FIG. 8–8) (which had a very limited use before the advent of Islam) and the pointed arch (SEE FIG. 8–14). There are many variations of each, some of which disguise their structural function beneath complex decoration.

Unique to Islam, *muqarnas* are small nichelike component that is usually stacked and used in multiples as interlocking, successive, non-load-bearing, vaulting units. Over time they became increasingly intricate (and non-structural) so that they dazzled the eye and confused the rational mind (SEE FIG. 8–18). They are frequently used to fill the hoods of *mihrabs* and portals and, on a larger scale, to vault domes, softening or even masking the transition from the vertical plane to the horizontal.

horseshoe arch **pointed arch**

muqarnas

Calligraphy

Muslim society holds **calligraphy** (the art of fine hand lettering) in high esteem. Since the Qur'an is believed to reveal the word of God, its words must be written accurately, with devotion and embellishment. Writing was not limited to books and documents but was displayed on the walls of buildings, on metalwork, textiles, and ceramics. Since pictorial imagery developed relatively late in Islamic art (and there was no figural imagery at all in the religious context), inscription became the principal vehicle for visual communication. The written word thus played two roles: It could convey verbal information about a building or object, describing its beauty or naming its patron, while also delighting the eye in an entirely aesthetic sense. Arabic script is written from right to left, and each letter usually takes one of three forms depending on its position in a word. With its rhythmic interplay between verticals and horizontals, the system lends itself to many variations. Formal **Kufic** script (after Kufa, a city in Iraq) is blocky and angular, with strong upright strokes and long horizontals. It may have developed first for carved or woven inscriptions where clarity and practicality of execution were important.

Most early Qur'ans had large Kufic letters and only three to five lines per page, which had a horizontal orientation. The visual clarity was necessary because one book was often shared by multiple readers simultaneously. A page from a ninth-century Syrian Qur'an exemplifies the style common from the eighth to the tenth century (FIG. 8–10). Red diacritical marks (pronunciation guides) accent the dark brown ink; the *surah* ("chapter") title is embedded in the burnished ornament at the bottom of the sheet. Instead of page numbers, the brilliant gold of the framed words and the knoblike projection in the left-hand margin are a distinctive means of marking chapter breaks.

Calligraphers enjoyed the highest status of all artists in Islamic society. Included in their numbers were a few princes and women. Apprentice scribes had to learn secret formulas for inks and paints; become skilled in the proper ways to sit, breathe, and manipulate their tools; and develop their individual specialties. They also had to absorb the complex literary traditions and number symbolism that had developed in Islamic culture. Their training was long and arduous, but unlike other craft practitioners who were generally anonymous in the early centuries of Islam, outstanding calligraphers received public recognition.

By the tenth century, more than twenty cursive scripts had come into use. They were standardized by Ibn Muqla (d. 940), an Abbasid official who fixed the proportions of the letters in each and devised a method for teaching the calligraphy that is still in use today. The Qur'an was usually written on **parchment** (treated animal skin) and **vellum** (calfskin or a fine parchment). Paper was first manufactured in Central Asia during the mid-eighth century, having been

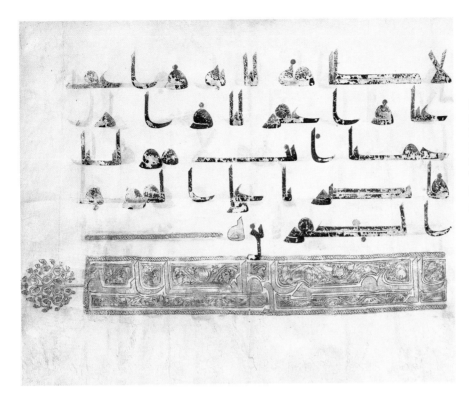

8–10 | PAGE FROM THE QUR'AN
(Surah II: 286 and title Surah III) in
Kufic script, from Syria, 9th century.
Black ink pigments, and gold on vellum,
8⅜ × 11⅛″ (21.8 × 29.2 cm).
The Metropolitan Museum of Art,
New York.

Rogers Fund, 1937 (37.99.2)

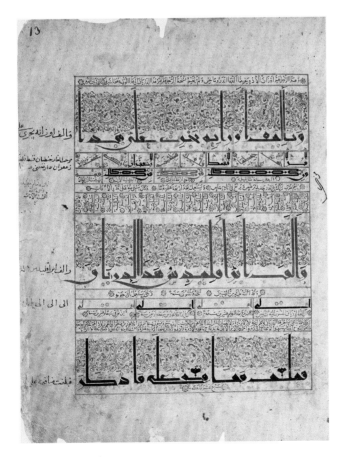

8–11 | ARABIC MANUSCRIPT PAGE
Attributed to Galinus. Iraq. 1199.
Headings are in ornamental Kufic
script with a background of scrolling
vines, while the text—a medical trea-
tise—is written horizontally and verti-
cally in Naskhi script.
Bibliothèque Nationale, Paris.

introduced earlier by Buddhist monks. Muslims learned
how to make high-quality, rag-based paper, eventually
establishing their own paper mills. By about 1000, paper
had largely replaced the more costly parchment, encourag-
ing the proliferation of increasingly elaborate and decora-
tive cursive scripts, which generally superseded Kufic by
the thirteenth century. Of the major styles, one extraordi-
narily beautiful form, known as *naskhi,* was said to have
been revealed and taught to scribes in a vision. Even those
who cannot read Arabic can enjoy the flowing beauty of its
lines, which are often interlaced with swirling vine scrolls
(FIG. 8–11).

On objects made of ceramics, ivory, and metal, as well as textiles, calligraphy was prominently displayed. It was the only decoration on a type of white pottery made in the ninth and tenth centuries in and around the region of Khurasan (also known as Nishapur, in present-day northeastern Iran) and Samarkand (in present-day Uzbekistan). Now known as Samarkand ware, these elegant pieces are characterized by the use of a clear lead glaze applied over a black inscription on a white slip-painted ground. In FIG. 8–12 the script's horizontals and verticals have been elongated to fill the bowl's rim. The inscription translates: "Knowledge: the beginning of it is bitter to taste, but the end is sweeter than honey," an apt choice for tableware and appealing to an educated patron. Inscriptions on Samarkand ware provide a storehouse of such popular sayings.

A Kufic inscription appears on a tenth-century piece of silk from Khurasan (FIG. 8–13): "Glory and happiness to the Commander Abu Mansur Bukhtakin. May God prolong his prosperity." Such good wishes were common in Islamic art, appearing as generic blessings on ordinary goods sold in the marketplace or, as here, personalized for the patron. Texts can sometimes help determine where and when a work was made, but they can also be frustratingly uninformative when little is known about the patron, and they are not always

tiles, with the way similar subjects appear in other mediums, and with other Kufic inscriptions—sometimes reveal more than the inscription alone.

This silk must have been brought from the Near East to France by knights at the time of the First Crusade. Known as the Shroud of Saint Josse, the silk was preserved in the Church of Saint-Josse-sur-Mer, near Caen in Normandy. Textiles were an actively traded commodity in the medieval Mediterranean region and formed a significant portion of dowries and inheritances. Because of this, textiles were an important means of disseminating artistic styles and techniques. This fragment shows two elephants with rich ornamental coverings facing each other on a dark red ground, each with a mythical griffin between its feet. A caravan of two-humped Bactrian camels linked with rope moves up the left side, part of the elaborately patterned borders. The inscription at the bottom is upside-down, suggesting that the missing portion of the textile was a fragment from a larger and more complex composition. The weavers used a complicated loom to produce repeated patterns. The technique and design derive from the sumptuous pattern-woven silks of Sasanian Iran (Persia). The Persian weavers had, in turn, adapted Chinese silk technology to the Sasanian taste for paired heraldic beasts and other Near Eastern imagery. This tradition, with modifications—the depiction of animals, for example, became less naturalistic—continued after the Islamic conquest of Iran.

LATER ISLAMIC ART

The Abbasid caliphate began a slow disintegration in the ninth century, and thereafter power in the Islamic world became fragmented among more or less independent regional rulers. During the eleventh century, the Saljuqs, a Turkic people, swept from north of the Caspian Sea into Khurasan and took Baghdad in 1055, becoming the virtual rulers of the Abbasid Empire. The Saljuqs united most of Iran and Iraq, establishing a dynasty that endured from 1037/38 to 1194. A branch of the dynasty, the Saljuqs of Rum, ruled much of Anatolia (Turkey) from the late eleventh to the beginning of the fourteenth century. The Islamic world suffered a dramatic rift in the early thirteenth century when the nomadic Mongols—non-Muslims led by Genghiz Khan (ruled 1206–27) and his successors—attacked northern China, Central Asia, and ultimately Iran. The Mongols captured Baghdad in 1258 and encountered weak resistance until they reached Egypt. There, the young Mamluk dynasty (1250–1517), founded by descendants of slave soldiers (*mamluk* means "slave"), firmly defeated the Mongols. In Spain, the borders of Islamic territory were gradually pushed back by Christian forces and Muslim rule ended altogether in 1492.

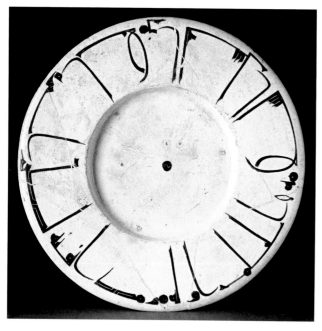

8–12 | BOWL WITH KUFIC BORDER
Samarkand, Uzbekistan. 9th–10th century. Earthenware with slip, pigment, and lead glaze, diameter 14½" (37 cm).
Musée du Louvre, Paris.

The white ground of this piece imitated prized Chinese porcelains made of fine white kaolin clay. Both Samarkand and Khurasan were connected to the Silk Road, the great caravan route to China (Chapter 10), and were influenced by Chinese culture.

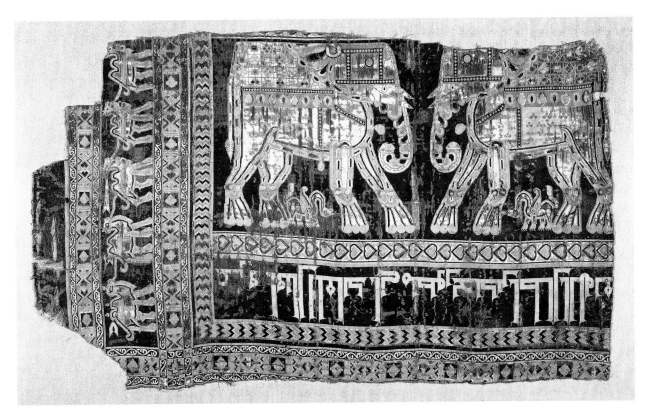

8–13 | TEXTILE WITH ELEPHANTS AND CAMELS
Known today as the Shroud of Saint Josse, from Khurasan or Central Asia. Before 961. Dyed silk, largest fragment 20½ × 37″ (94 × 52 cm). Musée du Louvre, Paris.

Silk textiles were both sought-after luxury items and a medium of economic exchange. Government-controlled factories, known as *tiraz*, produced cloth for the court as well as for official gifts and payments. A number of fine Islamic fabrics have been preserved in the treasuries of medieval European churches, where they were used for priests' ceremonial robes, altar cloths, and to wrap the relics of Christian saints.

Although the religion of Islam remained a dominant and unifying force throughout these developments, the history of later Islamic society and culture reflects largely regional phenomena. Only a few works have been selected here and in Chapter 23 to characterize the art of Islam, and they by no means provide a comprehensive history of Islamic art.

Architecture

The Saljuq Dynasty and its successors built on a grand scale, expanding their patronage from mosques and palaces to include new functional buildings, such as tombs, **madrasas** (colleges for religious and legal studies), public fountains, urban hostels, and remote caravanserais (inns) for traveling merchants in order to encourage long-distance trade. They developed a new mosque plan organized around a central courtyard framed by four large *iwans* (large vaulted halls with rectangular plans and monumental arched openings); this four-*iwan* plan was already being used for schools and palaces.

Furthermore, they amplified the social role of architecture so that multiple building types were combined in large and diverse complexes, supported by perpetual endowments that funded not only the building, but its administration and maintenance. Increasingly, these complexes included the patron's own tomb, thus giving visual prominence to the act of individual patronage and the expression of personal identity.

THE GREAT MOSQUE OF ISFAHAN. The Masjid-i Jami ("Congregational mosque") of Isfahan (the Saljuq capital in Iran) was modified in this period from its original form as a simple hypostyle mosque to a more complex plan. Specifically, two great brick domes were added in the late eleventh century, one of them marking the *mihrab*, and in the twelfth century the mosque was reconfigured as a four-*iwan* plan. The massive *qibla iwan* on the southwest side is a twelfth-century structure to which a vault filled with **muqarnas** (stacked niches) was added in the fourteenth-century (see "Arches and Muqarnas," page 292). Its twin minarets and the façade of brilliant blue, glazed tile that wraps around the entire

A MAMLUK GLASS OIL LAMP

Made of ordinary sand and ash, glass is the most ethereal of materials. The Egyptians produced the first glassware during the second millennium BCE, yet the tools and techniques for making it have changed little since then. During the thirteenth and fourteenth centuries CE, glassmakers in Syria, Egypt, and Italy derived a new elegant thinness through blowing and molding techniques. Mamluk glassmakers especially excelled in the application of enameled surface decoration in gold and various colors.

This mosque lamp was suspended from chains attached to its handles, although it could also stand on its high footed base. Exquisite glass was also used for beakers and vases, but lamps, lit from within by oil and wick, must have glowed with special richness. A mosque required hundreds of lamps, and there were hundreds of mosques—glassmaking was a booming industry in Egypt and Syria.

Blue, red, and white enamel and gilding cover the surface of the lamp in vertical bands that include swirling vegetal designs and cursive inscriptions interrupted by roundels containing iconic emblems. The inscription on the vessel's flared neck is a Qur'anic quotation (Surah 24:35) commonly found on mosque lamps: "God is the light of the heavens and the earth. His light is as a niche wherein is a lamp, the lamp in a glass, the glass as a glittering star." The emblem, called a blazon, identifies the patron—on this cup, it is the sign of Sayf al-Din Shaykhu al-'Umari, who built a mosque and a Sufi lodge in Cairo. The blazon resembles European heraldry. It was a "symbolic/emblematic language of power [that] passed to Western Europe beginning in the early twelfth century as the result of the Crusades, where it evolved into the genealogical system we know as heraldry" (Redford "A Grammar of Rūm Seljuk Ornament," *Mésogeois* 25–26 [2005]: 288). These emblems, which appear in Islamic glass, metalwork, and architecture, reflect an increasing interest in figural imagery that coincided with the increased production of illustrated books.

MAMLUK GLASS OIL LAMP
Syria or Egypt. c. 1355. Glass, polychrome enamel, and gold, height 12" (30.5 cm). Corning Museum of Glass, Corning, New York.
(52.1.86)

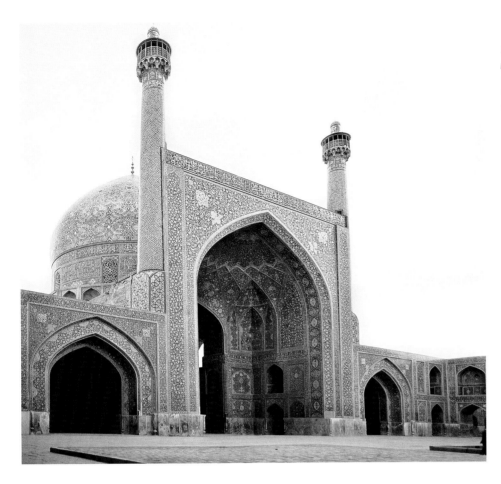

8–14 | **COURTYARD,
MASJID-I JAMI, ISFAHAN** Iran
11th–18th century.
14th-century *iwan* vault,
17th-century minarets.

courtyard belong to the seventeenth century (FIG. 8–14). The many changes made to this mosque reflect its ongoing importance to the community it served.

A TILE MIHRAB. A fourteenth-century tile *mihrab*, originally from a *madrasa* in Isfahan but now in the Metropolitan Museum of Art in New York, is one of the finest examples of early architectural ceramic decoration in Islamic art (FIG. 8–15). More than 11 feet tall, it was made by painstakingly cutting each individual piece of tile, including the pieces making up the letters on the curving surface of the niche. The color scheme—white against turquoise and cobalt blue with accents of dark yellow and green—was typical of this type of decoration, as were the harmonious, dense, contrasting patterns of organic and geometric forms. The cursive inscription of the outer frame quotes Surah 9, verses 18–20, from the Qur'an, reminding the faithful of their duties. It is rendered in elegant white lettering on a blue ground, while the Kufic inscription bordering the pointed arch reverses these colors for a pleasing contrast.

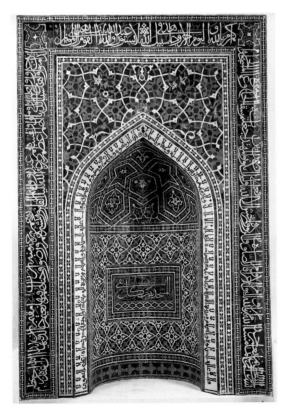

8–15 | **TILE MOSAIC** *MIHRAB*
Madrasa Imami, Isfahan, Iran. Founded 1354. Glazed and cut tiles,
11′3″ × 7′6″ (3.43 × 2.29 m). The Metropolitan Museum of Art, New York.
Harris Brisbane Dick Fund (39.20)

This *mihrab* has three inscriptions: the outer inscription, in cursive, contains Qur'anic verses (Surah 9) that describe the duties of believers and the Five Pillars of Islam. Framing the niche's pointed arch, a Kufic inscription contains sayings of the Prophet. In the center, a panel with a line in Kufic and another in cursive states: "The mosque is the house of every pious person."

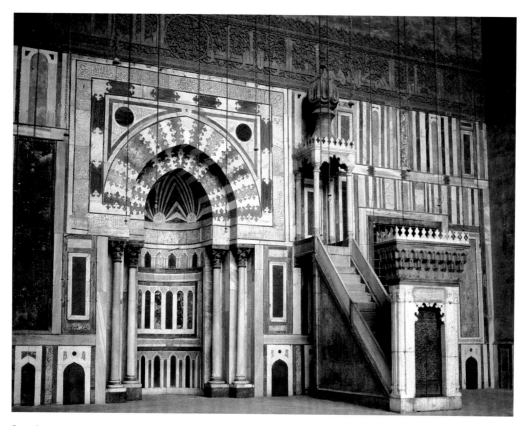

8–16 | *QIBLA* **WALL WITH** *MIHRAB* **AND** *MINBAR*, **SULTAN HASAN** *MADRASA*-**MAUSOLEUM-MOSQUE COMPLEX**
Main *iwan* (vaulted chamber) in the mosque, Cairo, Egypt. 1356–63.

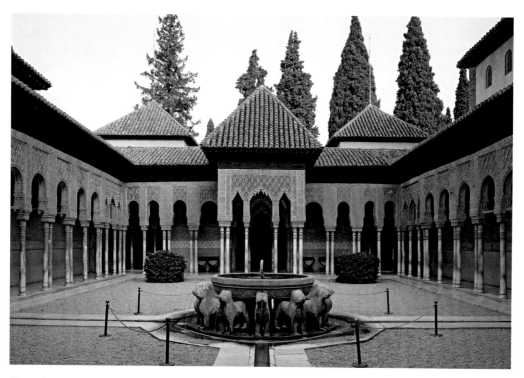

8–17 | **COURT OF THE LIONS, ALHAMBRA, GRANADA, SPAIN.**
1354–91.

An ample water supply had long made Granada a city of gardens. This fountain fills the courtyard with the sound of its life-giving abundance, while channel-lined walkways form the four-part *chahar bagh*. Channeling water has a practical role in the irrigation of the garden, and here it is raised to the level of an art form.

THE *MADRASA*-MAUSOLEUM-MOSQUE IN CAIRO. Beginning in the eleventh century, Muslim rulers and wealthy individuals endowed hundreds of charitable complexes, including many *madrasas*. These were public displays of piety as well as personal wealth and status. The combined *madrasa*-mausoleum-mosque complex established in mid–fourteenth-century Cairo by the Mamluk Sultan Hasan (FIG. 8–16) is such an example. With a four-*iwan* plan, each *iwan* served as a classroom for a different branch of study, the students housed in a multistoried cluster of tiny rooms around each one. Standing just beyond the *qibla iwan*, the patron's monumental domed tomb attached his identity ostentatiously to the architectural complex. The sumptuous *qibla iwan* served as the prayer hall for the complex. Its walls are ornamented with colorful marble paneling, typical of Mamluk patronage, that culminates in a doubly recessed *mihrab* framed by slightly pointed arches on columns. The marble blocks of the arches are ingeniously joined in interlocking pieces of alternating colors called **joggled** *voussoirs*. The paneling is surmounted by a wide band of Kufic inscription in stucco set against a background of scrolling vines. Next to the *mihrab* stands an elaborate thronelike *minbar*. The Sultan Hasan complex is excessive in its vast scale and opulent decoration, but money was not an object: The project was financed by the estates of victims of the bubonic plague that had raged in Cairo in 1348–50.

THE ALHAMBRA. Muslim architects also created luxurious palaces set in gardens. The Alhambra in Granada, in southeastern Spain, is an outstanding example of beautiful and refined Islamic palace architecture. Built on the hilltop site of a pre-Islamic fortress, this palace complex was the seat of the Nasrids (1232–1492), the last Spanish Muslim (Moorish) dynasty, Islamic territory having shrunk from most of the Iberian Peninsula to the region around Granada. To the conquering Christians at the end of the fifteenth century, the Alhambra represented the epitome of luxury. Thereafter, they preserved the Alhambra as much to commemorate the defeat of Islam as for its beauty. Literally a small town extending for about half a mile along the crest of a high hill overlooking Granada, it included government buildings, royal residences, gates, mosques, baths, servants' quarters, barracks, stables, a mint, workshops, and gardens. Most of what one sees at the site today was built in the fourteenth century or in later centuries by Christian patrons.

The Alhambra was a sophisticated citadel whose buildings offered dramatic views to the settled valley and snow-capped mountains around it, while enclosing gardens within its courtyards. One of these is the Court of the Lions which stood at the heart of the so-called Palace of the Lions, the private retreat of Sultan Muhammad V (ruled 1354–59 and 1362–91). The Court of the Lions is divided evenly into four parts by cross-axial walkways that meet at a central marble fountain held aloft on the backs of twelve stone lions (FIG. 8–17). An Islamic garden divided thus into quadrants is called a *chahar bagh*. The

Art and Its Context
THE FIVE PILLARS OF ISLAM

Islam emphasizes a direct, personal relationship with God. The Pillars of Islam, sometimes symbolized by an open hand with the five fingers extended, enumerate the duties required of Muslims by their faith.

- The first pillar (*shahadah*) is to proclaim that there is only one God and that Muhammad is his messenger. While monotheism is common to Judaism, Christianity, and Islam, and Muslims worship the god of Abraham, and also acknowledge Hebrew and Christian prophets such as Musa (Moses) and Isa (Jesus), Muslims deem the Christian Trinity polytheistic and assert that God was not born and did not give birth.
- The second pillar requires prayer (*salat*) to be performed by turning to face the Kaaba in Mecca five times daily: at dawn, noon, late afternoon, sunset, and nightfall. Prayer can occur almost anywhere, although the prayer on Fridays takes place in the congregational mosque. Because ritual ablutions are required for purity, mosque courtyards usually have fountains.
- The third pillar is the voluntary payment of annual tax or alms (*zakah*), equivalent to one-fortieth of one's assets. *Zakah* is used for charities such as feeding the poor, housing travelers, and paying the dowries of orphan girls. Among Shi'ites, an additional tithe is required to support the Shi'ite community specifically.
- The fourth pillar is the dawn-to-dusk fast (*sawm*) during the month of Ramadan, the month when Muhammad received the revelations set down in the Qur'an. The fast of Ramadan is a communally shared sacrifice that imparts purification, self-control, and kinship with others. The end of Ramadan is celebrated with the feast day 'Id al-Fitr (Festival of the Breaking of the Fast).
- For those physically and financially able to do so, the fifth pillar is the pilgrimage to Mecca (*hajj*), which ideally occurs at least once in the life of each Muslim. Among the extensive pilgrimage rites are donning simple garments to remove distinctions of class and culture; collective circumambulations of the Kaaba; kissing the Black Stone inside the Kaaba (probably a meteorite that fell in pre-Islamic times); and the sacrificing of an animal, usually a sheep, in memory of Abraham's readiness to sacrifice his son at God's command. The end of the *hajj* is celebrated by the festival 'Id al-Adha (Festival of Sacrifice).

The directness and simplicity of Islam have made the Muslim religion readily adaptable to numerous varied cultural contexts throughout history. The Five Pillars instill not only faith and a sense of belonging, but also a commitment to Islam in the form of actual practice.

courtyard is encircled by an arcade of stucco arches supported on single columns or clusters of two and three. Second-floor **miradors**—windows that frame specifically intentioned views—look over the courtyard, which was planted with aromatic citrus and flowers. From these windows, protected by latticework screens, it is quite likely that the women of the court, who did not appear in public, would watch the activities of the men below. At one end of the Palace of the Lions, a particularly magnificent *mirador* looks out onto a large, lower garden and the plain below. From here, the sultan literally oversaw the fertile valley that was his kingdom.

On the south side of the Court of the Lions, the lofty Hall of the Abencerrajes was designed as a winter reception hall and music room. In addition to having excellent acoustics, its ceiling exhibits dazzling geometrical complexity and exquisitely carved stucco (**FIG. 8–18**). The star-shaped vault is formed by a honeycomb of clustered *muqarnas* arches that alternate with corner **squinches** that are filled with more *muqarnas*. The square room thus rises to an eight-pointed star, pierced by eighteen windows, that culminates in a burst of *muqarnas* floating high overhead, perceived and yet ultimately unknowable, like the heavens themselves.

Portable Arts

Islamic society was cosmopolitan, with pilgrimage, trade, and a well-defined road network fostering the circulation of marketable goods. In addition to the import and export of basic foodstuffs and goods, luxury arts brought particular pleasure and status to their owners and were visible signs of cultural refinement. These art objects were eagerly exchanged and collected from one end of the Islamic world to the other, and they were sought by European patrons as well.

METAL. Islamic metalworkers inherited the techniques of their Roman, Byzantine, and Sasanian predecessors, applying this heritage to new forms, such as incense burners and water pitchers in the shape of birds and animals. An example of this delight in fanciful metalwork is an unusually large and stylized griffin, perhaps originally used as a fountain (**FIG. 8–19**). Now in Pisa, Italy, it is probably Fatimid work from Egypt, and it may have arrived as booty from Pisan victories over the Egyptian fleet in 1087. The Pisans displayed it atop their cathedral from about 1100 to 1828. Made of cast bronze, it is decorated with incised representations of feathers, scales, and silk trappings. The decoration on the mighty creature's thighs includes animals in medallions; the bands across its chest and back are embellished with Kufic lettering and scale and circle patterns.

The Islamic world was administered by educated functionaries who often commissioned personalized containers for their pens, ink, and blotting sand. One such container, an inlaid brass box, belonged to the grand vizier, or chief minister, of Khurasan in the early thirteenth century (**FIG. 8–20**). The artist cast, engraved, embossed, and inlaid the box with consummate

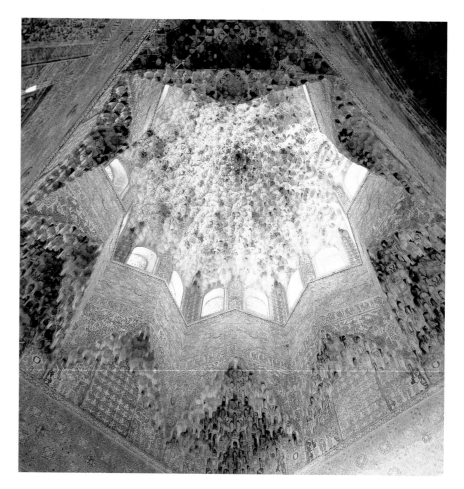

8–18 | **MUQARNAS DOME, HALL OF THE ABENCERRAJES, PALACE OF THE LIONS, ALHAMBRA**
Built between 1354–91.

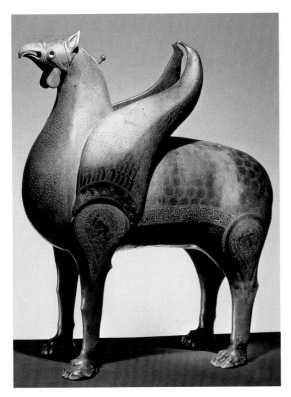

8–19 | GRIFFIN
Islamic Mediterranean, probably Fatimid, Egypt. 11th century. Bronze, height 42⅛″ (107 cm). Museo dell' Opera del Duomo, Pisa.

skill. Scrolls, interlacing designs, and human and animal figures enliven its calligraphic inscriptions. A silver shortage in the mid-twelfth century prompted the development of inlaid brasswork like this that used the more precious metal sparingly. Humbler brassware was also available to those of lesser rank than the vizier.

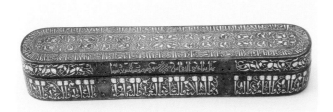

8–20 | PEN BOX
By Shazi, from Iran or Afghanistan. 1210–11. Brass with inlaid silver, copper, and black organic material; height 2″, length 12⅜″, width 2½″ (5 × 31.4 × 6.4 cm). Freer Gallery of Art, Smithsonian Institution, Washington, D.C.
(F1936.7)

The inscriptions on this box include some twenty honorific phrases extolling its owner, al-Mulk. The *naskhi* script on the lid calls him the "luminous star of Islam." The largest inscription, written in animated *naskhi* (an animated script is one with human or animal forms in it), asked twenty-four blessings for him from God. Shazi, the designer of the box, signed and dated it in animated Kufic on the side of the lid, making it one of the earliest signed works in Islamic art. The owner enjoyed his box for only ten years; he was killed by Mongol invaders in 1221.

CERAMICS. In the ninth century, potters developed a technique to produce a lustrous metallic surface on their ceramics. They may have learned the technique from Islamic glassmakers who had produced luster-painted vessels a century earlier. First the potters applied a paint laced with silver, copper, or gold oxides to the surface of already fired and glazed tiles or vessels. In a second firing with relatively low heat and less oxygen, these oxides burned away to produce a reflective shine. The finished **lusterware** resembled precious metal. At first the potters covered the entire surface with luster, but soon they began to use luster to paint dense, elaborate patterns using geometric design, foliage, and animals in golden brown, red, purple, and green. Lusterware tiles, dated 862–3, decorated the *mihrab* of the Great Mosque at Kairouan.

The most spectacular lusterware pieces are the double-shell fritware, in which an inner solid body is hidden beneath a densely decorated and perforated outer shell. A jar in the Metropolitan Museum of Art known as **THE MACY JUG** (after a previous owner) exemplifies this style (**FIG. 8–21**). The black

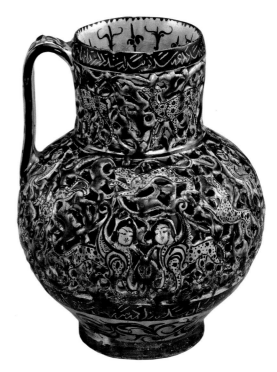

8–21 | THE MACY JUG
Iran. 1215–16. Composite body glazed, painted fritware and incised (glaze partially stained with cobalt), with pierced outer shell, 6⅝ × 7¾″ (16.8 × 19.7 cm). The Metropolitan Museum of Art, New York.
Fletcher Fund, 1932 (32.52.1)

Fritware was used to make beads in ancient Egypt and may have been rediscovered there by Islamic potters searching for a substitute for Chinese porcelain. Its components were one part white clay, ten parts quartz, and one part quartz fused with soda, which produced a brittle white ware when fired. The colors on this double-walled ewer and others like it were produced by applying mineral glazes over black painted detailing. The deep blue comes from cobalt and the turquoise from copper. Luster, a thin, transparent glaze with a metallic sheen, was applied over the colored glazes.

underglaze-painted decoration represents animals and pairs of harpies and sphinxes set into an elaborate "water-weed" pattern. The outer shell is covered with a turquoise glaze, enhanced by a deep cobalt-blue glaze on parts of the floral decoration and finally a luster overglaze that gives the entire surface a metallic sheen. An inscription includes the date AH 612 (1215–16 CE).

TEXTILES. The tradition of silk weaving that passed from Sasanian Persia to Islamic artisans in the early Islamic period (SEE FIG. 8–13) was kept alive in Muslim Spain. Spanish designs reflect a new aesthetic, with an emphasis beginning in the thirteenth century on forms that had much in common with architectural ornament. An eight-pointed star forms the center of a magnificent silk and gold banner (FIG. 8–22). The calligraphic panels continue down the sides and a second panel crosses the top. Eight lobes with gold crescents and white

8–22 | BANNER OF LAS NAVAS DE TOLOSA
Detail of center panel, from southern Spain. 1212–50. Silk tapestry-weave with gilt parchment, 10'9 ⅞" × 7'2 ⅜" (3.3 × 2.2 m). Museo de Telas Medievales, Monasterio de Santa María la Real de Las Huelgas, Burgos, Spain.

This banner was a trophy taken by the Christian king Ferdinand III, who gave it to Las Huelgas, the Cistercian convent outside Burgos, the capital city of Old Castile and the burial place of the royal family. This illustration shows only a detail of the center section of the textile. The calligraphic panels continue down the sides, and a second panel crosses the top.

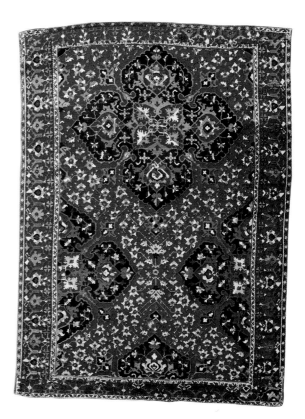

8–23 | MEDALLION RUG, VARIANT STAR USHAK STYLE
Anatolia (present-day Turkey). 16th century. Wool, 10'3" × 7'6 ¼" (313.7 × 229.2 cm). The St. Louis Art Museum. Gift of James F. Ballard.

inscribed parchment medallions form the lower edge of the banner. In part, the text reads: "You shall believe in God and His Messenger. . . . He will forgive you your sins and admit you to gardens underneath which rivers flow, and to dwelling places goodly in Gardens of Eden; that is the mighty triumph."

The Qur'an describes paradise as a shady garden with four rivers, and many works of Islamic art evoke both paradisiac and garden associations. In particular, Persian and Turkish carpets were often embellished with elegant designs of flowers and shrubs inhabited by birds. Laid out on the floor of an open-air hall and perhaps set with bowls of ripe fruit and other delicacies, such carpets brought the beauty of nature indoors. Written accounts indicate that elaborate patterns appeared on Persian carpets as early as the seventh century. In one fabled royal carpet, garden paths were rendered in real gold, leaves were modeled with emeralds, and highlights on flowers, fruits, and birds were created from pearls and jewels.

A carpet from Ushak in western Anatolia (Turkey), created in the first half of the sixteenth century, retains its vibrant colors (FIG. 8–23). Large, deeply serrated quatrefoil medallions establish the underlying star pattern but arabesques flow in every direction. This "infinite arabesque," as it is called (the pattern repeats infinitely in all directions), is characteristic of Ushak carpets. Carpets were usually at least three times as long as they were wide; the asymmetry of this carpet may indicate that it was cut and shortened.

Technique
CARPET MAKING

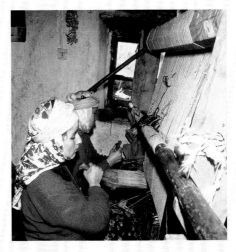

Because textiles are made of organic materials that are destroyed through use, very few carpets from before the sixteenth century have survived. There are two basic types of carpets: flat-weaves and pile, or knotted, carpets. Both can be made on either vertical or horizontal looms.

The best-known flat-weaves today are kilims, which are typically woven in wool with bold, geometric patterns and sometimes with brocaded details. Kilim weaving is done with a **tapestry** technique called slit tapestry (see diagram a).

Knotted carpets are an ancient invention. The oldest known example, excavated in Siberia and dating to the fourth or fifth century BCE, has designs evocative of Achaemenid art, suggesting that the technique may have originated in Central Asia. In knotted carpets, the pile—the plush, thickly tufted surface—is made by tying colored strands of yarn, usually wool but occasionally silk for deluxe carpets, onto the vertical elements (the **warp**) of a yarn grid (see diagram b or c). These knotted loops are later trimmed and sheared to form the plush pile surface of the carpet. The **weft** strand (crosswise threads) are shot horizontally, usually twice, after each row of knots is tied, to hold the knots in place and to form the horizontal element common to all woven structures. The weft is usually an undyed yarn and is hidden by the colored knots of the warp. Two common knot tying techniques are the asymmetrical knot, used in many carpets from Iran, Egypt, and Central Asia (formerly termed the Sehna knot), and the symmetrical knot (formerly called the Gördes knot) more commonly used in Anatolian Turkish carpet weaving. The greater the number of knots, the shorter the pile. The finest carpets can have as many as 2,400 knots per square inch, each one tied separately by hand.

Although royal workshops produced luxurious carpets (SEE FIG. 8–23), most knotted rugs have traditionally been made in tents and homes. Either women or men, depending on local custom, wove carpets. The photograph in this box shows two women, sisters in Çanakkale province in Turkey, weaving a large carpet in a typical Turkish pattern. The woman in the foreground pushes a row of knots tightly against the row below it with a wood comb called a beater. The other woman pulls a dark red weft yarn against the warp threads before tying a knot. Working between September and May, these women may weave five carpets, tying up to 5,000 knots a day. A Çanakkale rug will usually have only 40–50 knots per square inch. Generally, an older woman works with a young girl, who learns the art of carpet weaving at the loom and eventually passes it on to the next generation.

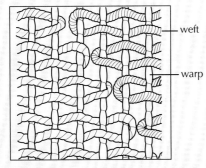

a. Kilim weaving pattern used in flat-weaving

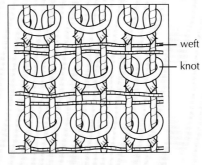

b. Symmetrical knot, used extensively in Iran

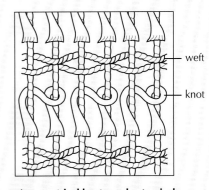

c. Asymmetrical knot, used extensively in Turkey

Rugs have long been used for Muslim prayer, which involves repeatedly kneeling and touching the forehead to the floor before God. While individuals often had their own small prayer rugs, with representations of niches to orient the faithful in prayer, many mosques were furnished with wool-pile rugs received as pious donations (see, for example, the rugs on the floor of the Sultan Selim Mosque in FIG. 8–28). In Islamic houses, people sat and slept on cushions and thick mats laid directly on the floor, so that cushions took the place of the fixed furnishings of Western domestic environments.

From the late Middle Ages to today, carpets and textiles are one of the predominant Islamic arts, and the Islamic art form best known in the West. Historically, rugs from Iran, Turkey, and elsewhere were highly prized among Westerners, who often displayed them on tables rather than floors.

Manuscripts and Painting

The art of book production flourished from the first century of Islam. Islam's emphasis on the study of the Qur'an promoted a high level of literacy among both women and men,

and calligraphers were the first artisans to emerge from anonymity and achieve individual distinction and recognition for their skill. Books on a wide range of secular as well as religious subjects were available, although hand-copied books—even on paper—always remained fairly costly. Libraries, often associated with *madrasas*, were endowed by members of the educated elite. Books made for royal patrons had luxurious bindings and highly embellished pages, the result of workshop collaboration between noted calligraphers and illustrators. New scripts were developed for new literary forms.

The manuscript illustrators of Mamluk Egypt (1250–1517) executed intricate nonfigural geometric designs for the Qur'ans they produced. Geometric and botanical ornamentation contributed to unprecedented sumptuousness and complexity. As in architectural decoration, the exuberant ornament was underlaid by strict geometric organization. In an impressive frontispiece originally paired with its mirror image on the facing left page, the design radiates from a sixteen-pointed starburst, filling the central square (FIG. 8–24). The surrounding ovals and medallions are filled with interlacing foliage and stylized flowers that provide a backdrop for the holy scripture. The page's resemblance to court carpets was not coincidental. Designers worked in more than one medium, leaving the execution of their efforts to specialized artisans. In addition to religious works, scribes copied and recopied famous secular texts—scientific treatises, manuals of all kinds, stories, and especially poetry. Painters supplied illustrations for these books and also created individual small-scale paintings—**miniatures**—that were collected by the wealthy and placed in albums.

THE HERAT SCHOOL. One of the great royal centers of miniature painting was at Herat in western Afghanistan. A school of painting and calligraphy was founded there in the early fifteenth century under the highly cultured patronage of the Timurid dynasty (1370–1507). In the second half of the fifteenth century, the leader of the Herat school was Kamal al-Din Bihzad (c. 1450–1514). When the Safavids supplanted the Timurids in 1506–7 and established their capital at Tabriz in northwestern Iran, Bihzad moved to Tabriz and briefly resumed his career there. Bihzad's paintings, done around 1494 to illustrate the *Khamsa* (Five Poems), written by Nizami, demonstrate his ability to render human activity convincingly. He set his scenes within complex, stagelike architectural spaces that are stylized according to Timurid conventions, creating a visual balance between activity and architecture. In **THE CALIPH HARUN AL-RASHID VISITS THE TURKISH BATH** (FIG. 8–25), the bathhouse, its tiled entrance leading to a high-ceiling dressing room with brick walls, provides the structuring element. Attendants wash long, blue towels and hang them to dry on overhead clotheslines. A worker reaches for one of the towels with a long pole, and a client prepares to wrap himself discreetly in a towel before removing his outer garments. The blue door on the left leads to a room where a barber grooms the caliph while attendants bring water for his bath. The asym-

metrical composition depends on a balanced placement of colors and architectural ornaments within each section.

An illustrated copy of the *Khamsa* (FIG. 8–26) from Herat in slightly earlier period contains a romantic scene in a landscape setting. The painting shows the gold-crowned princess Shirin at the moment when she sees a portrait of Khusrau hanging in a tree and falls in love with him. She is shown at the moment of discovery, holding the portrait before her, as one of her dismayed attendants grabs her cloak as if to hold her back from destiny. The background consists of an ochre-colored arid landscape that rises to two ranges of hills from which emerge two trees. Almost hidden in the upper left, a man observes the scene. This is Shapur, the painter of Khusrau's portrait and his friend, but at the same time the inclusion of this figure makes witty reference to the painter of the manuscript page. In contrast to the plain background, in the foreground, a rock-bordered stream—its silvery surface now tarnished to gray—winds its way through a meadow of flowers and a tree. Overhead, a cloud painted in a Chinese style seems to reflect the agitation in her heart. By the beginning of the seventeenth century, this manuscript was in the hands of the Mughal rulers of India, evidence of the enduring appreciation for Timurid painting and of the cultural exchanges that took place as both artists and art moved to new courts and collections.

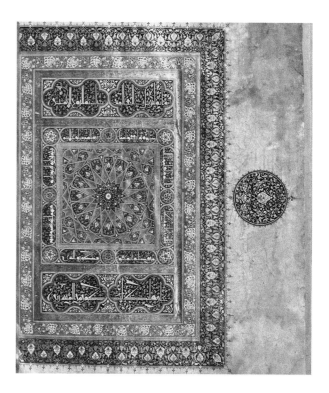

8–24 QUR'AN FRONTISPIECE (RIGHT HALF OF TWO-PAGE SPREAD) Cairo, Egypt. c. 1368. Ink, pigments, and gold on paper, 24 × 18" (61 × 45.7 cm). National Library, Cairo. Ms. 7.

The Qur'an to which this page belonged was donated in 1369 by Sultan Shaban to the *madrasa* established by his mother. A close collaboration between illuminator and scribe can be seen here and throughout the manuscript.

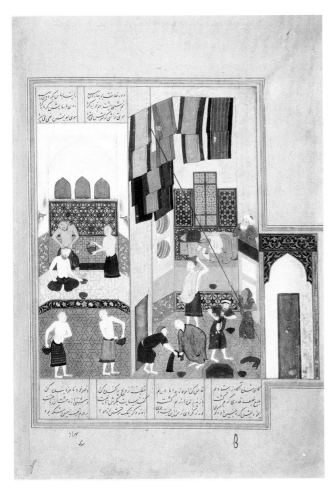

8–25 | Kamal al-Din Bihzad **THE CALIPH HARUN AL-RASHID VISITS THE TURKISH BATH**
From a copy of the 12th-century *Khamsa (Five Poems)* of Nizami. Herat, Afghanistan. c. 1494. Ink and pigments on paper, approx. 7 × 6″ (17.8 × 15.3 cm). The British Library, London.
Oriental and India Office Collections (Ms. Or. 6810, fol. 27v)

Despite early warnings against it as a place for the dangerous indulgence of the pleasures of the flesh, the bathhouse (*hammam*), adapted from Roman and Hellenistic predecessors, became an important social center in much of the Islamic world. The remains of an eighth-century *hammam* still stand in Jordan, and a twelfth-century *hammam* is still in use in Damascus. *Hammams* had a small entrance to keep in the heat, which was supplied by steam ducts running under the floors. The main room had pipes in the wall with steam vents. Unlike the Romans, who bathed and swam in pools of water, Muslims preferred to splash themselves from basins, and the floors were slanted for drainage. A *hammam* was frequently located near a mosque, part of the commercial complex provided by the patron to generate income for the mosque's upkeep.

THE OTTOMAN EMPIRE

With the breakdown of Saljuq power in Anatolia at the end of the thirteenth century, another group of Muslim Turks seized power in the early fourteenth century in the northwestern part of that region, having migrated there from their homeland in Central Asia. Known as the Ottomans, after an early leader named Osman, they pushed their territorial boundaries westward and, in spite of setbacks inflicted by the Mongols, ulti-

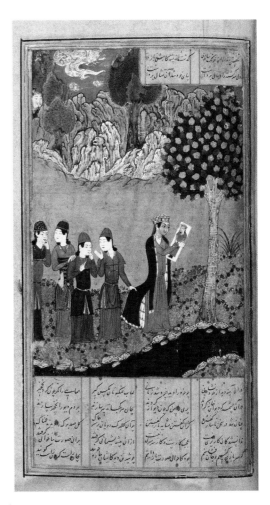

8–26 | **THE PORTRAIT OF KHUSRAU SHOWN TO SHIRIN**
From a copy of the 12th-century *Khamsa (Five Poems)* of Nizami. Herat, Afghanistan, 1442. Ink, pigments, and gold on paper. The British Library, London.

mately created an empire that extended over Anatolia, western Iran, Iraq, Syria, Palestine, western Arabia (including Mecca and Medina), northern Africa (excepting Morocco), and part of eastern Europe. In 1453, they captured Constantinople, ultimately renaming it Istanbul, and brought the Byzantine Empire to an end. The Ottoman Empire lasted until 1918.

Architecture

Upon conquering Istanbul, the rulers of the Ottoman Empire converted the great Byzantine church of Hagia Sophia into a mosque, framing it with two graceful Turkish-style minarets in the fifteenth century and two more in the sixteenth century (SEE FIG. 7–25). In conformance with Islamic aniconism, the church's mosaics were destroyed or whitewashed. Huge calligraphic disks with the names of God, Muhammad, and the early caliphs were added to the interior in the mid-nineteenth century (SEE FIG. 7–27). At present, Hagia Sophia is neither a church nor a mosque but a state museum.

THE ARCHITECT SINAN. Ottoman architects had already developed the domed, **centrally planned mosque** (see

"Mosque Plans," page 289), but this great Byzantine structure of Hagia Sophia inspired them to strive for a more ambitious scale. For the architect Sinan (c. 1489–1588) the development of a monumental centrally planned mosque was a personal quest. Sinan began his career in the army and served as engineer in the Ottoman campaign at Belgrade, Vienna, and Baghdad. He rose through the ranks to become, in 1528, chief architect for Suleyman "the Magnificent," the tenth Ottoman sultan (ruled 1520–66). Suleyman's reign marked the height of Ottoman power, and the sultan sponsored a building program on a scale not seen since the days of the Roman Empire. Serving Suleyman and his successor, Sinan is credited with more than 300 imperial commissions, including palaces, *madrasas* and Qur'an schools, tombs, public kitchens and hospitals, caravanserais, treasure houses, baths, bridges, viaducts, and 124 large and small mosques.

Sinan's crowning accomplishment, completed about 1579, when he was over 80, was a mosque he designed in the provincial capital of Edirne for Suleyman's son Selim II (ruled 1566–74) (FIG. 8–27). The gigantic hemispheric dome that tops this structure is more than 102 feet in diameter, larger than the dome of Hagia Sophia, as Sinan proudly pointed out. The dome crowns a building of extraordinary architectural coherence. The transition from square base to the central dome is accomplished by corner half-domes that enhance the spatial plasticity and openness of the vast interior of the prayer hall (FIG. 8–28). The eight massive piers that bear the dome's weight are visible both within and without—on the exterior they resolve in pointed towers that encircle the main dome—revealing the structural logic of the building and clarifying its form. In the arches that support the dome and span from one pier to the next—and indeed at every level—light pours from windows into the interior, a space at once soaring and serene.

In addition to the mosque, the complex housed a *madrasa* and other educational buildings, a cemetery, a hospital, and charity kitchens, as well as the income-producing covered market and baths. Framed by the vertical lines of four minarets and raised on a platform at the city's edge, the Selimiye mosque dominates the skyline.

The interior was clearly influenced by Hagia Sophia—an open expanse under a vast dome floating on a ring of light—but it lacks Hagia Sophia's longitudinal pull from entrance to sanctuary. The Selimiye mosque is truly centrally planned structure and a small fountain covered by a platform (visible in the lower right OF FIG. 8–28) emphasizes this centralization.

Illuminated Manuscripts and *Tugras*

A combination of abstract setting with realism in figures and details characterizes Ottoman painting. Ottoman painters adopted the style of the Herat school (as influenced by Timurid conventions) for their miniatures, enhancing its decorative aspects with an intensity of religious feeling. At the Ottoman court of Sultan Suleyman in Istanbul, the imperial workshops produced even more remarkable illuminated manuscripts.

Following a practice begun by the Saljuqs and Mamluks, the Ottomans put calligraphy to political use, developing the design of imperial ciphers—*tugras*—into a specialized art form. Ottoman *tugras* combined the ruler's name and title with the motto "Eternally Victorious" into a monogram denoting the authority of the sultan and of those select officials who were also granted an emblem. *Tugras* appeared on seals, coins, and buildings, as well as on official documents called *firmans*, imperial edicts supplementing Muslim law. Suleyman issued hundreds of edicts, and a high court official supervised specialist calligraphers and illuminators who produced the documents with fancy *tugras* (FIG. 8–29).

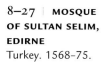

8–27 | MOSQUE OF SULTAN SELIM, EDIRNE
Turkey. 1568–75.

The minarets that pierce the sky around the prayer hall of this mosque, their sleek, fluted walls and needle-nosed spires soaring to more than 295 feet, are only 12½ feet in diameter at the base, an impressive feat of engineering. Only royal mosques were permitted multiple minarets, and having more than two was unusual.

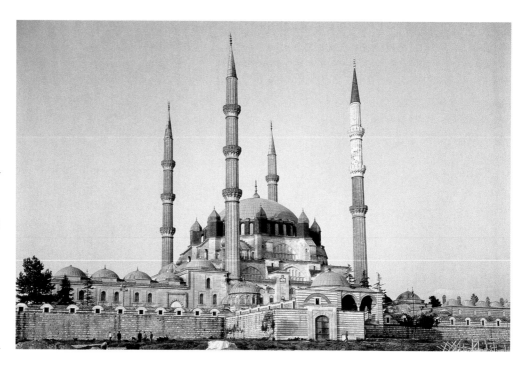

8–28 | INTERIOR, MOSQUE OF SULTAN SELIM

Tugras were drawn in black or blue with three long, vertical strokes (*tuğ* means "horsetail") to the right of two concentric horizontal teardrops. Decorative foliage patterns fill the space. Fill decoration became more naturalistic by the 1550s and in later centuries spilled outside the emblems' boundary lines. The rare, oversized *tugra* in FIG. 8-29 has a sweeping, fluid line drawn with perfect control according to set proportions. The color scheme of the delicate floral inter-lace enclosed in the body of the *tugra* may have been inspired by Chinese blue-and-white ceramics; similar designs appear on Ottoman ceramics and textiles.

THE MODERN ERA

For many years the largest and most powerful political entity in the Islamic World, the Ottoman Empire lasted until the end of World War I. It was not until 1918 that modern Turkey was founded in Anatolia, the former heart of the empire. The twentieth century saw the dissolution of the great Islamic empires and the formation of smaller nation-states in their place. The question of identity and its expression in art changed significantly as Muslim artists and architects sought training abroad and participated in an international movement that swept away many of the visible signs that formerly expressed their cultural character and difference. The abstract work of the architect Zaha Hadid (SEE FIG. 32–80), who was born in Baghdad and studied and practiced in London, is exemplary of the new internationalism. But earlier, when architects in Islamic countries were debating whether modernity promised opportunities for new expression or simply another form of Western domination, the Egyptian Hasan Fathy (1900–89) asked whether abstraction could serve the cause of social justice. He revived traditional, inexpensive, and locally obtainable materials such as mud brick and forms such as wind scoops (an inexpensive means of catching breezes to cool a building's interior) to build affordable housing for the poor. For architects around the world, Fathy's New Gourna Village (designed 1945–47) in Luxor, Egypt, was a model of environmental sustainability realized in pure geometric forms that resonated with references to Egypt's architectural past (FIG. 8–30). In their simplicity, his watercolor paintings are as beautiful as his buildings.

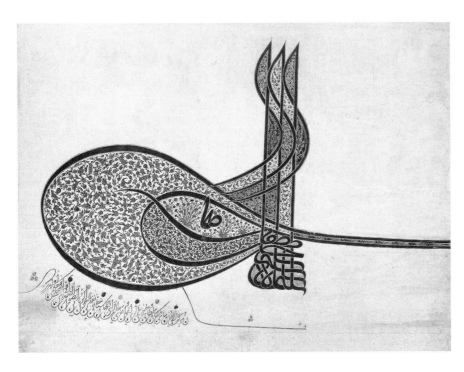

8–29 | ILLUMINATED *TUGRA* OF SULTAN SULEYMAN
Istanbul, Turkey. c. 1555–60. Ink, paint, and gold on paper, removed from a *firman* and trimmed to 20½ × 25⅜" (52 × 64.5 cm). The Metropolitan Museum of Art, New York.
Rogers Fund, 1938 (38.149.1).

The *tugra* shown here is from a document endowing an institution in Jerusalem that had been established by Suleyman's wife, Hurrem.

8–30 | **HASAN FATHY MOSQUE AT NEW GOURNA**
Luxor, Egypt, 1945–47. Gouache on paper, 22½ × 17⅞″ (52.8 × 45.2 cm).
Collection: Aga Khan Award for Architecture, Geneva, Switzerland.

One of many buildings designed for the Egyptian Department of Antiquities for a village relocation project. Seven thousand people were removed from their village near pharaonic tombs and resettled on agricultural land near the Nile. Fathy's emphasis on both the traditional values of the community and the individualism of its residents was remarkably different from the abstract and highly conformist character of other modern housing projects of the period.

IN PERSPECTIVE

In Islamic art, a proscription against figural imagery in religious contexts gave rise instead to the development of a rich vocabulary of ornament and pattern using abstract geometrical figures and botanically inspired design. Motifs readily circulated in the Islamic world via portable objects in the hands of pilgrims and traveling merchants. Textiles and carpets especially were widely traded both within the Islamic world and between it and its neighbors. The resulting eclecticism of motif and technique is an enduring characteristic of Islamic art.

As with geometric and floral ornament, writing played a central role in Islamic art. Since the lessons of the Qur'an were not to be presented pictorially, instead the actual words of the Qur'an were incorporated in the decoration of buildings and objects to instruct and inspire the viewer. As a result, calligraphy

emerged as the most highly valued form of art, maintaining its prestige even after manuscript painting grew in importance under court patronage from the thirteenth century onward.

Architecture also played an important role in Islam and reveals the flexibility and innovation of Islamic culture. The mosque began as a simple space for congregational gathering and prayer but grew in complexity. The individual mosque, whether hypostyle, domical, or four-*iwan*, was eventually combined with other functional types (such as schools, tombs, and public fountains), culminating with the vast complexes of the Ottoman era. The Islamic world's awareness of history is especially evident in its architecture, as for instance in the Mosque of Selim II—an homage to the Hagia Sophia—or as seen in Hasan Fathy's self-conscious evocation of vernacular Egyptian architecture.

DOME OF ROCK
BEGUN 691–2

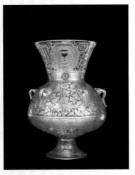

PRAYER HALL, GREAT MOSQUE
CÓRDOBA,
BEGUN 785–86

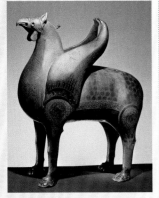

GRIFFIN 11TH CENTURY

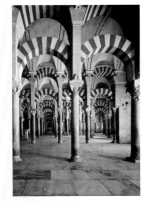

**MAMLUK HANGING
GLASS OIL LAMP**
C. 1355

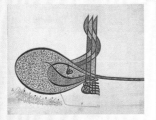

**ILLUMINATED TUGRA
OF SULTAN SULEYMAN**
C. 1555–60

600

800

1000

1200

1400

2000

ISLAMIC ART

◄ **Founding of Islam** 622 CE
◄ **Early Caliphs** 663–61 CE
◄ **Umayyad Dynasty** c. 661–750 CE

◄ **Abbasid Dynasty** c. 750–1258 CE
◄ **Spanish Umayyad Dynasty**
c. 756–1031 CE

◄ **Fatimid Dynasty**
c. 909–1171 CE

◄ **Saljuqs Dynasty**
c. 1037–1194 CE
◄ **Saljuqs of Rum Dynasty**
late 11th–early 14th century CE

◄ **Spanish Nasrid Dynasty**
c. 1232–1492 CE
◄ **Egyptian Mamluk Dynasty**
c. 1250–1517 CE
◄ **Ottoman Empire**
c. 1290–1918 CE
◄ **Turkic Timurid Dynasty**
c. 1370–1507 CE

◄ **Fall of Constantinople
to Ottoman Turks**
1453 CE

◄ **Modern Turkey Founded**
1918 CE

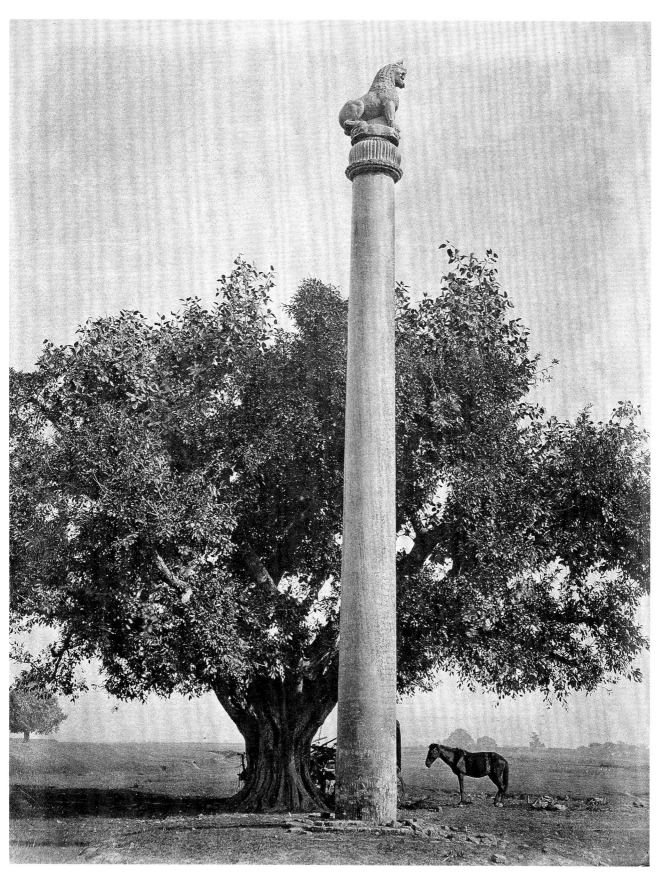

9–1 **ASHOKAN PILLAR** Lauriya Nandangarh, Maurya period. 246 BCE.

CHAPTER NINE

ART OF SOUTH AND SOUTHEAST ASIA BEFORE 1200

9

According to legend, the ruler Ashoka was stunned by grief and remorse as he looked across the battlefield. In the custom of his dynasty, he had gone to war, expanding his empire until he had conquered many of the peoples of the Indian subcontinent. Now, in 265 BCE, after the final battle in his conquest of the northern states, he was suddenly—unexpectedly—shocked by the horror of the suffering he had caused. In the traditional account, it is said that only one form on the battlefield moved, the stooped figure of a Buddhist monk slowly making his way through the carnage. Watching this spectral figure, Ashoka abruptly turned the moment of triumph into one of renunciation. Decrying vio-

lence and warfare, he vowed to become a *chakravartin* ("world-conquering ruler"), not through the force of arms but through spreading the teachings of the Buddha and establishing Buddhism as the major religion of his realm.

Although there is no proof that Ashoka himself converted to Buddhism, he erected and dedicated monuments to the Buddha throughout his empire—shrines, monasteries, sculpture, and the columns known as **ASHOKAN PILLARS** (**FIG. 9–1**). With missionary ardor, he dispatched delegates throughout the Indian subcontinent and to countries as distant as Syria, Egypt, and Greece. In his impassioned propagation of Buddhism, Ashoka stimulated an intensely rich period of art.

THE INDIAN SUBCONTINENT

The South Asian subcontinent, or Indian subcontinent, as it is commonly called, is a peninsular region that includes the present-day countries of India, southeastern Afghanistan, Pakistan, Nepal, Bhutan, Bangladesh, and Sri Lanka (MAP 9–1). From the beginning, these areas have been home to societies whose cultures are closely linked and which have maintained remarkable continuity over time. (South Asia is distinct from Southeast Asia, which includes Brunei, Burma [Myanmar], Cambodia [Kampuchea], East Timor, Indonesia, Laos, Malaysia, the Philippines, Singapore, Thailand, and Vietnam.) Present-day India is approximately one-third the size of the United States. A low mountain range, the Vindhya Hills, acts as a kind of natural division that demarcates North India from South India, which are of approximately equal size. On the northern border rises the protective barrier of the Himalayas, the world's tallest mountains. To the northwest are other mountains through whose passes came invasions and immigrations that profoundly affected the civilization of the subcontinent. Over these passes, too, wound the major trade routes that linked the Indian subcontinent by land to the rest of Asia and to Europe. Surrounded on the remaining sides by oceans, the subcontinent has also been connected to the world since ancient times by maritime trade, and during much of the period under discussion here it formed part of a coastal trading network that extended from eastern Africa to China.

Differences in language, climate, and terrain within India have fostered distinct regional and cultural characteristics and artistic traditions. However, despite such regional diversity, several overarching traits tend to unite Indian art. Most evi-

dent is a distinctive sense of beauty, with voluptuous forms and a profusion of ornament, texture, and color. Visual abundance is considered auspicious, and it reflects a belief in the generosity and favor of the gods. Another characteristic is the pervasive symbolism that enriches all Indian arts with intellectual and emotional layers. Third, and perhaps most important, is an emphasis on capturing the vibrant quality of a world seen as infused with the dynamics of the divine. Gods and humans, ideas and abstractions, are given tactile, sensuous forms, radiant with inner spirit.

INDUS VALLEY CIVILIZATION

The earliest civilization of South Asia was nurtured in the lower reaches of the Indus River, in present-day Pakistan and in northwestern India. Known as the Indus Valley or Harappan civilization (after Harappa, the first-discovered site), it flourished from approximately 2600 to 1900 BCE, or during roughly the same time as the Old Kingdom period of Egypt, the Minoan civilization of the Aegean, and the dynasties of Ur and Babylon in Mesopotamia. Indeed, it is considered, along with Egypt and Mesopotamia, to be one of the world's earliest urban river-valley civilizations.

It was the chance discovery in the late nineteenth century of some small seals, such as those in FIGURE 9–2, that provided the first clue that an ancient civilization had existed in this region. The seals appeared to be related to, but not the same as, seals known from ancient Mesopotamia (SEE FIG. 2–12). Excavations begun in the 1920s and continuing into the present subsequently uncovered a number of major urban areas at points along the lower Indus River, including Harappa, Mohenjo-Daro, and Chanhu-Daro.

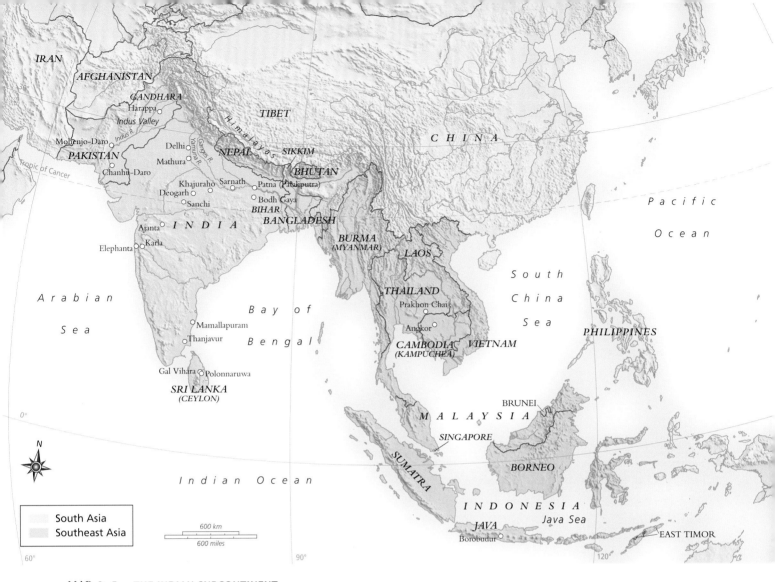

MAP 9–1 THE INDIAN SUBCONTINENT

The Vindhya Hills are a natural feature dividing North and South India.

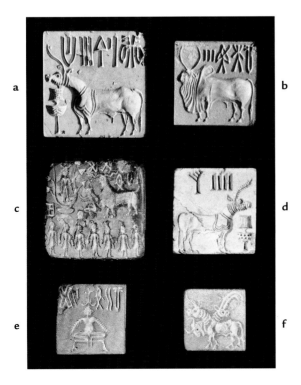

MOHENJO-DARO. The ancient cities of the Indus Valley resemble each other in design and construction, suggesting a coherent culture. At Mohenjo-Daro, the best preserved of the sites, archaeologists discovered an elevated **citadel** area, presumably containing important government structures, surrounded

9–2 SEAL IMPRESSIONS
a., d. horned animal; b. buffalo; c. sacrificial rite to a goddess (?); e. yogi; f. three-headed animal. Indus Valley civilization, c. 2500–1500 BCE. Seals: steatite, each approx. 1¼ × 1¼″ (3.2 × 3.2 cm).

The more than 2,000 small seals and impressions that have been found offer an intriguing window on the Indus Valley civilization. Usually carved from steatite stone, the seals were coated with alkali and then fired to produce a lustrous, white surface. A perforated knob on the back of each may have been for suspending them. The most popular subjects are animals, most commonly a one-horned bovine standing before an altarlike object (a, d). Animals on Indus Valley seals are often portrayed with remarkable naturalism, their taut, well-modeled surfaces implying their underlying skeletons. The function of the seals remains enigmatic, and the script that is so prominent in the impressions has yet to be deciphered.

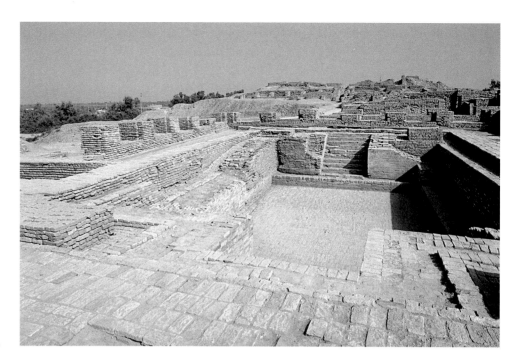

9–3 LARGE WATER TANK
Possibly a public or ritual bathing area, Mohenjo-Daro. Indus Valley civilization, Harappan. c. 2600–1900 BCE.

by a wall about 50 feet high. Among the buildings is a remarkable water tank, a large water-tight pool that may have been a public bath but could also have had a ritual use (FIG. 9–3). Stretching out below this elevated area was the city, arranged in a gridlike plan with wide avenues and narrow side streets. Its houses, often two stories high, were generally built around a central courtyard. Like other Indus Valley cities, Mohenjo-Daro was constructed of fired brick, in contrast to the less durable sun-dried brick used in other cultures of the time. The city included a network of covered drainage systems that channeled away waste and rainwater. Clearly the technical and engineering skills of this civilization were highly advanced. At its peak, about 2500 to 2000 BCE, Mohenjo-Daro was approximately 6 to 7 square miles in size and had a population of about 20,000 to 50,000.

INDUS VALLEY SEALS. Although little is known about the Indus Valley civilization, motifs on the seals as well as the few artworks that have been discovered strongly suggest continuities with later South Asian cultures. The seal in FIGURE 9–2E, for example, depicts a man in the meditative posture associated in Indian culture with a yogi, one who seeks mental and physical purification and self-control, usually for spiritual purposes. In FIGURE 9–2C, the persons with elaborate headgear in a row or procession observe a figure standing in a tree—possibly a goddess—and a kneeling worshiper. This scene may offer some insight into the religious or ritual customs of Indus Valley people, whose deities may have been ancient prototypes of later Indian gods and goddesses.

Numerous **terra cotta** figurines and a few stone and bronze statuettes have been found in the Indus Valley. They reveal a confident maturity of artistic conception and technique. Two main styles appear: One is similar to Mesopotamian art in its motifs

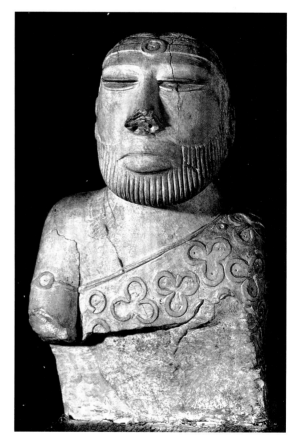

9–4 TORSO OF A "PRIEST-KING"
Mohenjo-Daro. Indus Valley civilization, c. 2000–1900 BCE. Steatite, height 6⅞" (17.5 cm). National Museum of Pakistan, Karachi.

and rather abstract rendering, while the other foreshadows the later Indian artistic tradition in its sensuous naturalism.

"PRIEST-KING" FROM MOHENJO-DARO. The torso of a man, sometimes called the "priest-king," may represent a leader or

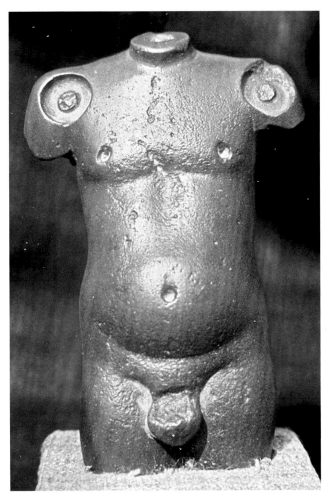

9–5 TORSO
Harappa. Indus Valley civilization, c. 2000 BCE. Red sandstone, height 3¾″ (9.5 cm). National Museum, New Delhi.

an ancestor figure (FIG. 9–4). Although the striated beard and the smooth, planar surfaces of the face resemble the treatment of the head found in Mesopotamian art, distinctive physical traits emerge, including a low forehead, a broad nose, thick lips, and long slit eyes. The man's garment is patterned with a **trefoil** (three-lobed) motif. The depressions of the trefoil pattern were originally filled with red paint, and the eyes were inlaid with colored shell or stone. A narrow band with a circular ornament encircles the upper arm and the head. It falls in back into two long strands and may be an indication of rank. Certainly, with its formal pose and simplified, geometric form, the statue conveys a commanding human presence.

NUDE TORSO FROM HARAPPA. Although its date is disputed by some, a nude male torso found at Harappa is an example of a contrasting naturalistic style (FIG. 9–5) of ancient Indus origins. Less than 4 inches tall, it is one of the most extraordinary portrayals of the human form to survive from any early civilization. In contrast to the more athletic male ideal developed in ancient Greece, this sculpture emphasizes the soft

texture of the human body and the subtle nuances of muscular form. The abdomen is relaxed in the manner of a yogi able to control his breath. With these characteristics the Harappa torso forecasts the essential aesthetic attributes of later Indian sculpture.

The reasons for the demise of this flourishing civilization are not yet understood. All we know is that between 2000 and 1750—possibly because of climate changes, a series of natural disasters, and invasions—the cities of the Indus Valley civilization declined, and predominantly rural societies evolved.

THE VEDIC PERIOD

About 2000 BCE nomadic shepherds, the Aryans, entered India from central Asia and the Russian steppes. Gradually they supplanted the indigenous populations and introduced the horse and chariot, the Sanskrit language, a hierarchical social order, and religious practices that centered on the propitiation of gods through fire sacrifice. Their sacred writings known as the Vedas gave the period its name. The earliest Veda consists of hymns to various Aryan gods including the divine king Indra. The importance of the fire sacrifice, overseen by a powerful priesthood, the Brahmins, and religiously sanctioned social classes persisted through the Vedic period. At some point, the class structure became hereditary and immutable, with lasting consequences for Indian society. The Vedic period witnessed the formation of three of the four major enduring religions of India—Hinduism, Buddhism, and Jainism.

During the latter part of this period, from about 800 BCE, the Upanishads were composed. These metaphysical texts examine the meanings of the earlier, more cryptic Vedic hymns. They focus on the relationship between the individual soul, or *atman,* and the universal soul, or Brahman, as well as on other concepts central to subsequent Indian philosophy. One is the assertion that the material world is illusory and that only Brahman is real and eternal. Another holds that our existence is cyclical and that beings are caught in *samsara,* a relentless cycle of birth, life, death, and rebirth. Believers aspire to attain liberation from *samsara* and to unite individual *atman* with the eternal, universal Brahman.

The latter portion of the Vedic period also saw the flowering of India's epic literature, written in the melodious and complex Sanskrit language. By around 400 BCE, the eighteen-volume *Mahabharata,* the longest epic in world literature, and the *Ramayana,* the most popular and enduring religious epic in India and Southeast Asia, were taking shape. These texts, the cornerstones of Indian literature, relate histories of gods and humans that bring the philosophical ideas of the Vedas to a more accessible and popular level.

In this stimulating religious, philosophical, and literary climate numerous religious communities arose. The most

influential teachers of these times were Shakyamuni Buddha and Mahavira. The Buddha, or "enlightened one," lived and taught in India around 500 BCE; his teachings form the basis of the Buddhist religion (see "Buddhism," page 317). Mahavira (c. 599–527 BCE), regarded as the last of twenty-four highly purified superbeings called pathfinders *(tirthankaras),* was the founder of the Jain religion. Both Shakyamuni Buddha and Mahavira espoused some basic Upanishadic tenets, such as the cyclical nature of existence and the need for liberation from the material world. However, they rejected the authority of the Vedas, and with it the legitimacy of the fire sacrifice and the hereditary class structure of Vedic society, with its powerful, exclusive priesthood. In contrast, Buddhism and Jainism were open to all, regardless of social position.

Buddhism became a vigorous force in South Asia and provided the impetus for much of the major art created between the third century BCE and the fifth century CE. The Vedic tradition, meanwhile, continued to evolve, emerging later as Hinduism, a loose term that encompasses the many religious forms that resulted from the mingling of Vedic culture with indigenous beliefs (see "Hinduism," page 318).

THE MAURYA PERIOD

After about 700 BCE, cities again began to appear on the subcontinent, especially in the north, where numerous kingdoms arose. For most of its subsequent history, India was a shifting mosaic of regional dynastic kingdoms. From time to time, however, a particularly powerful dynasty formed an empire. The first of these was the Maurya dynasty (c. 322–185 BCE), which extended its rule over all but the southernmost portion of the subcontinent.

YAKSHI FROM DIDARGANJ. The art of the Maurya period reflects an age of heroes. At this time emerged the ideal of upholding *dharma,* the divinely ordained moral law believed to keep the universe from falling into chaos. This heroic ideal seems fully embodied in a life-size statue found at Didarganj, near the Maurya capital of Pataliputra (FIG. 9–6). The statue, dated by most scholars to the Mauryan period, probably represents a *yakshi,* a spirit associated with the productive forces of nature. With its large breasts and pelvis, the figure embodies the association of female beauty with procreative abundance, bounty, and auspiciousness—qualities that in turn reflect the generosity of the gods and the workings of *dharma* in the world.

Sculpted from fine-grained sandstone, the statue conveys the *yakshi*'s authority through the frontal rigor of her pose, the massive volumes of her form, and the strong, linear patterning of her ornaments and dress. Alleviating and counter-

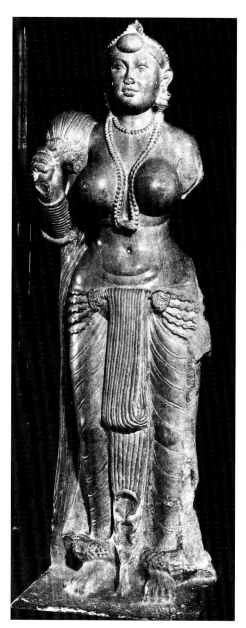

9–6 YAKSHI HOLDING A FLY-WHISK
Didarganj, Patna, Bihar, India. Probably Maurya period, c. 250 BCE. Polished sandstone, height 5'4¼" (1.63 m). Patna Museum, Patna.

Discovered near the ancient Maurya capital of Pataliputra, this sculpture has become one of the most famous works of Indian art. Holding a fly-whisk in her raised right hand, the *yakshi* wears only a long shawl and a skirtlike cloth. The cloth rests low on her hips, held in place by a girdle. Subtly sculpted parallel creases indicate that it is gathered closely about her legs. The ends, drawn back up over the girdle, cascade down to her feet in a broad, central loop of flowing folds ending in a zigzag of hems. Draped low over her back, the shawl passes through the crook of her arm and then flows to the ground. (The missing left side of the shawl probably mirrored this motion.) The *yakshi*'s jewelry is prominent. A double strand of pearls hangs between her breasts, its shape echoing and emphasizing the voluptuous curves of her body. Another strand of pearls encircles her neck. She wears a simple tiara, plug earrings, and rows of bangles. The nubbled tubes about her ankles probably represent anklets made of beaten gold. Her hair is bound in a large bun in back, and a small bun sits on her forehead. This hairstyle appears again in Indian sculpture of the later Kushan period (c. second century CE).

Myth and Religion
BUDDHISM

The Buddhist religion developed from the teachings of Shakyamuni Buddha, who lived from about 563 to 483 BCE in the present-day regions of Nepal and central India. At his birth, it is believed, seers foretold that the infant prince, named Siddhartha Gautama, would become either a *chakravartin*—a "world-conquering ruler"—or a *buddha*—a "fully enlightened being." Hoping for a ruler like himself, Siddhartha's father tried to surround his son with pleasure and shield him from pain. Yet the prince was eventually exposed to the sufferings of old age, sickness, and death—the inevitable fate of all mortal beings. Deeply troubled by the human condition, Siddhartha at age 29 left the palace, his family, and his inheritance to live as an ascetic in the wilderness. After six years of meditation, he attained complete enlightenment near Bodh Gaya, India.

Following his enlightenment, the Buddha ("Enlightened One") gave his first teaching in the Deer Park at Sarnath. Here he expounded the Four Noble Truths that are the foundation of Buddhism: (1) life is suffering; (2) this suffering has a cause, which is ignorance; (3) this ignorance can be overcome and extinguished; (4) the way to overcome this ignorance is by following the eightfold path of right view, right resolve, right speech, right action, right livelihood, right effort, right mindfulness, and right concentration. After the Buddha's death at the age of 80, his many disciples developed his teachings and established the world's oldest monastic institutions.

A *buddha* is not a god but rather one who sees the ultimate nature of the world and is therefore no longer subject to *samsara*, the cycle of birth, death, and rebirth that otherwise holds us in its grip, whether we are born into the world of the gods, humans, animals, demons, tortured spirits, or hell beings.

The early form of Buddhism, known as Theravada or Hinayana, stresses self-cultivation for the purpose of attaining *nirvana*, which is the extinction of *samsara* for oneself. Theravada Buddhism has continued mainly in southern India, Sri Lanka, and Southeast Asia. Within 500 years of the Buddha's death, another form of Buddhism, known as Mahayana, became popular mainly in northern India; it eventually flourished in China, Korea, Japan, and in Tibet (as Vajrayana). Compassion for all beings is the foundation of Mahayana Buddhism, whose goal is not *nirvana* for oneself but buddhahood (enlightenment) for every being throughout the universe. Mahayana Buddhism recognizes *buddhas* other than Shakyamuni from the past, present, and future. One such is Maitreya, the next *buddha* to appear on earth. Another is Amitabha Buddha, the Buddha of Infinite Light and Infinite Life (that is, incorporating all space and time), who dwells in a paradise known as the Western Pure Land. Amitabha Buddha became particularly popular in East Asia. Mahayana Buddhism also developed the category of *bodhisattvas* ("those whose essence is wisdom"), saintly beings who are on the brink of achieving buddhahood but have vowed to help others achieve buddhahood before crossing over themselves. In art, *bodhisattvas* and *buddhas* are most clearly distinguished by their clothing and adornments: *bodhisattvas* wear the princely garb of India, while *buddhas* wear monks' robes.

balancing this hierarchical formality are her soft, youthful face, the precise definition of prominent features such as the stomach muscles, and the polished sheen of her exposed flesh. This lustrous polish is a special feature of Mauryan sculpture.

THE RISE OF BUDDHISM. In addition to depictions of popular deities like the *yakshis* and their male counterparts, *yakshas,* the Maurya period is also known for art associated with the rise of Buddhism, which became the official state religion under the Emperor Ashoka (ruled c. 273–232 BCE), the grandson of the dynasty's founder, and considered one of India's greatest rulers. Among the monuments he erected to Buddhism throughout his empire were monolithic **pillars** set up primarily at sites related to events in the Buddha's life.

Pillars had been used as flag-bearing standards in India since earliest times. The creators of the Ashokan pillars seem to have adapted this already ancient form to the symbolism of Indian creation myths and the new religion of Buddhism. The fully developed Ashokan pillar—a slightly tapered sandstone **shaft** that usually rested on a stone foundation slab sunk more than 10 feet into the ground—rose to a height of around 50 feet (SEE FIG. 9–1). On it were carved inscriptions relating to rules of *dharma* that Vedic kings were enjoined to uphold, but that many later Buddhists interpreted as also referring to Buddhist teachings or exhorting the Buddhist community to unity. At the top, carved from a separate block of sandstone, an elaborate **capital** bore animal sculpture. Both shaft and capital were given the characteristic Maurya polish. Scholars believe that the pillars symbolized the *axis mundi*, or "axis of the world," joining earth with the cosmos. It represented the vital link between the human and celestial realms, and through it the cosmic order was impressed onto the terrestrial.

Myth and Religion
HINDUISM

Hinduism is not one religion but many related beliefs and innumerable sects. It results from the mingling of Vedic beliefs (first appearing around 1500 BCE) with indigenous, local beliefs and practices. All three major Hindu sects draw upon the texts of the Vedas, which are believed to be sacred revelations set down about 1200–800 BCE. The gods lie outside the finite world, but they can appear in visible form to believers. Each Hindu sect takes its particular deity as supreme. By worshiping gods with rituals, meditation, and intense love, individuals may be reborn into increasingly higher positions until they escape the cycle of life, death, and rebirth, which is called *samsara*. The most popular deities are Vishnu, Shiva, and the Great Goddess, Devi. Deities are revealed and depicted in multiple aspects.

Vishnu: Vishnu is a benevolent god who works for the order and well-being of the world. He is often represented lying in a trance or asleep on the Cosmic Waters, where he dreams the world into existence. His symbols are the wheel and a conch shell. A huge figure, he usually has four arms and wears a crown and lavish jewelry. He rides a man-bird, Garuda. Vishnu appears in ten different incarnations, including Rama and Krishna, who have their own cults. Rama embodies virtue, and, assisted by the monkey king, he fights the demon Ravana. As Krishna, Vishnu is a supremely beautiful, blue-skinned youth who lives with the cowherds, loves the maiden Radha, and battles the demon Kansa.

Shiva: Shiva, Lord of Existence, embodies the entire universe; he is both creative and destructive, light and dark, male and female. His symbol is the *lingam*, an upright phallus, which is represented as a low pillar. As an expression of his power and creative energy, he is often represented as Lord of the Dance,

dancing the Cosmic Dance, the endless cycle of death and rebirth, destruction and creation (see "Shiva Nataraja of the Chola Dynasty," page 331). He dances within a ring of fire, his four hands holding fire, a drum, and gesturing to the worshipers. Shiva's animal is the bull. His consort is Parvati; their sons are the elephant-headed Ganesha, God of Prosperity, and the six-faced Karttikeya, God of War.

Devi: Devi, the Great Goddess, controls material riches and fertility. She has forms indicative of beauty, wealth, and auspiciousness, but also forms of wrath, pestilence, and power. As the embodiment of cosmic energy, she provides the vital force to all the male gods. Her symbol is an abstract depiction of female genitals, often associated with the *lingam* of Shiva. When armed and riding a lion (as the goddess Durga), she personifies righteous fury. As the goddess Lakshmi, she is the goddess of wealth and beauty. She is often represented by the basic geometric forms—squares, circles, triangles.

Brahma: Brahma, the creator, once had his own cult. Brahma embodies spiritual wisdom. His four heads symbolize the four cosmic cycles, four earthly directions, and four classes of society: priests (brahmins), warriors, merchants, and laborers.

There are countless other deities, but central to Hindu practice are *puja* (forms of worship) and *darshan* (beholding a deity), generally performed to obtain a deity's favor and in the hope that this favor will lead to liberation from *samsara*. Because desire for the fruits of our actions traps us, the ideal is to consider all earthly endeavors as sacrificial offerings to a god. Pleased with our devotion, he or she may grant us an eternal state of pure being, pure consciousness, and pure bliss.

LION CAPITAL FROM SARNATH. The capital in FIGURE 9–7 originally crowned the pillar erected at Sarnath in northeast India, the site of the Buddha's first sermon. The lowest portion represents the down-turned petals of a lotus blossom. Because the lotus flower emerges from murky waters without any mud sticking to its petals, it symbolizes the presence of divine purity in the imperfect world. Above the lotus is an *abacus* (the slab forming the top of a capital) embellished with **low-relief** carvings of wheels, called *chakras*, alternating with four different animals: lion, horse, bull, and elephant. The animals may symbolize the four great rivers of the world, which are mentioned in Indian creation myths. Standing on this abacus are four back-to-back lions. Facing the four cardinal directions, the lions may be emblematic of the universal

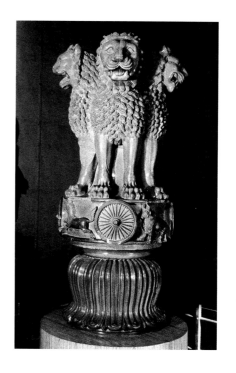

9–7 LION CAPITAL
Ashokan pillar at Sarnath, Uttar Pradesh, India.
Maurya period, c. 250 BCE. Polished sandstone, height 7′
(2.13 m). Archaeological Museum, Sarnath.

nature of Buddhism. Their roar might be compared with the speech of the Buddha that spreads far and wide. The lions may also refer to the Buddha himself, who is known as "the lion of the Shakya clan" (the clan into which the Buddha was born as prince). The lions originally supported a great copper wheel, now lost. A universal Buddhist symbol, the wheel refers to Buddhist teaching, for with his sermon at Sarnath the Buddha "set the wheel of the law [*dharma*] in motion."

Their formal, heraldic pose imbues the lions with something of the monumental quality evident in the statue of the *yakshi* of the same period. We also find the same strong patterning of realistic elements: Veins and tendons stand out on the legs; the claws are large and powerful; the mane is richly textured; and the jaws have a loose and fluttering edge.

THE PERIOD OF THE SHUNGAS AND EARLY ANDHRAS

With the demise of the Maurya Empire, India returned to local rule by regional dynasties. Between the second century BCE and the early first century CE, the most important of these dynasties were the Shunga (185–72 BCE) in central India and the early Andhra (73 BCE–50 CE) in South India. During this period, some of the most magnificent early Buddhist structures were created.

Stupas

Religious monuments enclosing relic chambers, called **Stupas** are fundamental to Buddhism (see "Stupas and Temples," page 320). A stupa may be small and plain or large and elaborate. Its form may vary from region to region, but its symbolic meaning remains virtually the same, and its plan is a carefully calculated *mandala,* or diagram of the cosmos as it is envisioned in Buddhism. Stupas are open to all for private worship.

Sequencing Events
KEY HISTORIC PERIODS OF INDIAN ART TO 950 CE

c. 322–185 BCE	Maurya Period
185 BCE–50 CE	Periods of the Shungas and Early Andhras
c. 30 BCE–433 CE	Kushan and Later Andhra Periods
c. 320–486 CE	Gupta Period

The first stupas were constructed to house the Buddha's remains after his cremation. According to tradition, the relics were divided into eight portions and placed in eight **reliquaries.** Each reliquary was then encased in its own burial mound, called a stupa. Since the early stupas held actual remains of the Buddha, they were venerated as his body and, by extension, his enlightenment and attainment of *nirvana*—liberation from rebirth. The method of veneration was, and still is, to circumambulate, or walk around, the stupa in a clockwise direction. In the mid-third century BCE, King Ashoka opened the original eight stupas and divided their relics among many more stupas, probably including the one at Sanchi.

THE GREAT STUPA AT SANCHI. Probably no early Buddhist structure is more famous than the Great Stupa at Sanchi in central India (FIG. 9–8). Originally built by King Ashoka in the Maurya period, the Great Stupa was part of a large monastery complex crowning a hill. During the mid-second century BCE, the stupa was enlarged to its present size, and the surrounding stone railing was constructed. About 100 years later, elaborately carved stone gateways were added to the railing.

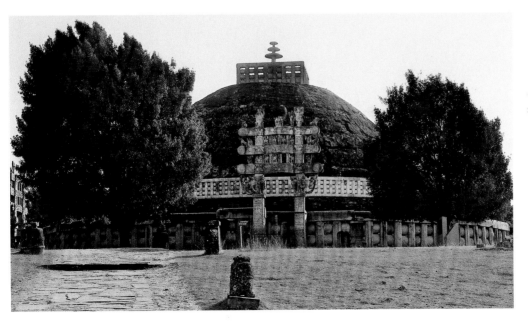

9–8 **GREAT STUPA, SANCHI**
Madhya Pradesh, India. Founded 3rd century BCE, enlarged c. 150–50 BCE.

Elements of Architecture
STUPAS AND TEMPLES

Buddhist architecture in South Asia consists mainly of stupas and temples, often at monastic complexes containing *viharas* (monks' cells and common areas). These monuments may be either structural—built up from the ground—or rock-cut—hewn out of a mountainside. Stupas derive from burial mounds and contain relics beneath a solid, dome-shaped core. A major stupa is surrounded by a railing that creates a sacred path for ritual circumambulation at ground level. This railing is punctuated by gateways called *toranas,* aligned with the cardinal points; access is through the eastern *torana.* The stupa sits on a round or square terrace; stairs lead to an upper circumambulatory path around the platform's edge. On top of the stupa's dome a railing defines a square, from the center of which rises a mast supporting tiers of disk-shaped "umbrellas."

Hindu architecture in South Asia consists mainly of temples, either structural or rock-cut, executed in a number of styles and dedicated to a vast range of deities. The two general Hindu temple types are the northern and southern styles—corresponding to North India and South India, respectively. Within these broad categories is great stylistic diversity, though all are raised on plinths and dominated by their superstructures, towers called **shikharas** in the North and **vimanas** in the South. *Shikharas* are crowned by **amalakas,** vimanas by large **capstones.** Inside, a series of **mandapas** (halls) leads to an inner sanctuary, the **garbhagriha,** which contains a sacred image. An *axis mundi* runs vertically up from the Cosmic Waters below the earth, through the *garbhagriha*'s image, and out through the top of the tower.

Jain architecture consists mainly of structural and rock-cut monasteries and temples that have much in common with their Buddhist and Hindu counterparts. Buddhist, Hindu, and Jain temples may share a site.

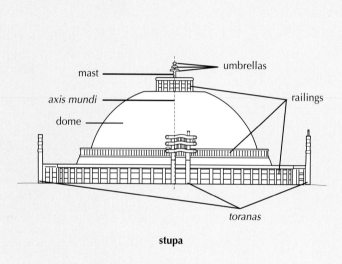

stupa

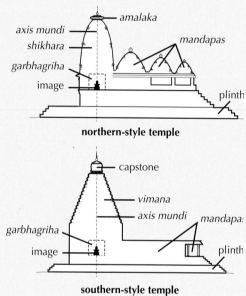

northern-style temple

southern-style temple

The Great Stupa at Sanchi is a representative of the early central Indian type. Its solid, hemispherical **dome** was built up from rubble and dirt, faced with **dressed stone,** then covered with a shining white plaster made from lime and powdered seashells. The dome—echoing the arc of the sky—sits on a raised base. Around the perimeter is a walkway enclosed by a railing and approached by a pair of staircases. As is often true in religious architecture, the railing provides a physical and symbolic boundary between an inner, sacred area and the outer, profane world. On top of the dome, another stone railing, square in shape, defines the abode of the gods atop the cosmic mountain. It encloses the top of a mast bearing three stone disks, or "umbrellas," of decreasing size. These disks have been interpreted in various ways. They correspond to the "Three Jewels of Buddhism," the Buddha, the Law, and the Monastic Order, and they may also refer to the Buddhist concept of the three realms of existence—desire, form, and formlessness. The mast itself is an *axis mundi,* connecting the Cosmic Waters below the earth with the celestial realm above it and anchoring everything in its proper place.

A 10-foot-tall stone railing rings the entire stupa, enclosing another, wider, circumambulatory path at ground level. Carved with octagonal uprights and lens-shaped crossbars, it probably simulates the wooden railings of the time.

This design pervaded early Indian art, appearing in relief sculpture and as architectural ornament. Four stone gateways, or *toranas*, punctuate the railing (FIG. 9–9). Set at the four cardinal directions, the *toranas* symbolize the Buddhist cosmos. According to an inscription, they were sculpted by ivory carvers from the nearby town of Vidisha. The only elements of the Great Stupa at Sanchi to be ornamented with sculpture, the *toranas* rise to a height of 35 feet. Their square posts are carved with symbols and scenes drawn mostly from the Buddha's life and the *jataka* tales, stories of the Buddha's past lives. Vines, lotuses, geese, and mythical animals decorate the sides, while guardians sculpted on the lowest panel of each inner side protect the entrance. The capitals above the posts consist of four back-to-back elephants on the north and east gates, dwarfs on the west gate, and lions on the south gate. The capitals in turn support a three-tiered superstructure in which posts and crossbars are elaborately carved with still more symbols and scenes and studded with freestanding sculptures depicting such subjects as *yakshis* and *yakshas*, riders on real and mythical animals, and the Buddhist wheel. As in all known early Buddhist art, the Buddha himself is not shown in human form. Instead, he is represented by symbols such as his footprints, an empty "enlightenment" seat, or a stupa.

Forming a bracket between each capital and the lowest crossbar is a sculpture of a *yakshi* (FIG. 9–10). These *yakshis* are some of the finest female figures in Indian art, and they make an instructive comparison with the *yakshi* of the Maurya period (SEE FIG. 9–6). The earlier figure was distinguished by a formal, somewhat rigid pose, an emphasis on realistic details, and a clear distinction between clothed and nude parts of the body. In contrast, the Sanchi *yakshi* leans daringly into space with casual abandon, supported by one leg as the other charmingly crosses behind. Her thin, diaphanous garment is noticeable only by its hems, and so she appears almost nude, which emphasizes her form. The band pulling gently at her abdomen accentuates the suppleness of her flesh. The swelling, arching curves of her body evoke this deity's procreative and bountiful essence. As the personification of the waters, she is the source of life. Here she symbolizes the sap of the tree, which flowers at her touch.

The profusion of designs, symbols, scenes, and figures carved on all sides of the gateways to the Great Stupa not only relates the history and lore of Buddhism, but also represents the teeming life of the world and the gods.

Buddhist Rock-Cut Halls

From ancient times, caves have been considered hallowed places in India, for they were frequently the abode of holy ones and ascetics. Around the second century BCE, Buddhist monks began to hew caves for their own use out of the stone plateaus in the region of south-central India known as the Deccan. The exteriors and interiors were carved from top to

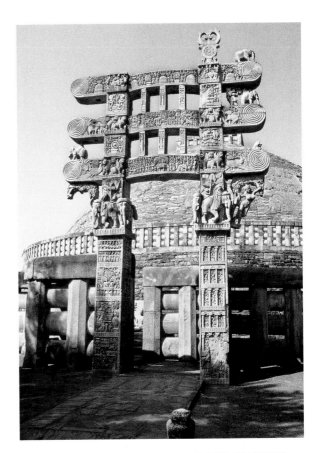

9–9 EAST *TORANA* OF THE GREAT STUPA AT SANCHI
Early Andhra period, mid-1st century BCE. Stone, height 35′ (10.66 m).

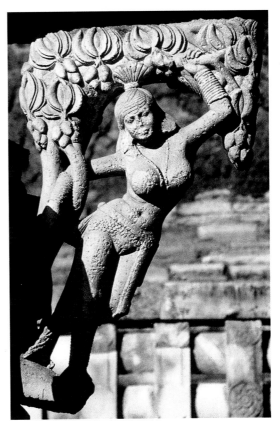

9–10 *YAKSHI* BRACKET FIGURE
East *torana* of the Great Stupa at Sanchi. Stone, height approx. 60″ (152.4 cm).

bottom like great pieces of sculpture, with all details completely finished in stone. To enter one of these remarkable halls is to feel transported to an otherworldly, sacred space. The energy of the living rock, the mysterious atmosphere created by the dark recess, the echo that magnifies the smallest sound—all combine to promote a state of heightened awareness.

THE CHAITYA HALL AT KARLA. The monastic community made two types of rock-cut halls. One was the *vihara,* used for the monks' living quarters, and the other was the *chaitya,* meaning "sanctuary," which usually enshrined a stupa. A *chaitya* hall at Karla, dating from the first century BCE to the first century CE, is the largest and most fully developed example of these early Buddhist works (FIGS. 9–11, 9–12). At the entrance, columns once supported a balcony, in front of which a pair of Ashokan-type pillars stood. The walls of the vestibule are carved in relief with rows of small balcony railings and arched windows, simulating the façade of a great multistoried palace. At the base of the side walls, enormous statues of elephants seem to be supporting the entire structure on their backs. Dominating the upper portion of the main façade is a large horseshoe-shaped opening called a sun window or *chaitya* window, which provides the hall's main source of light. The window was originally fitted with a carved wood screen, some of which remains, that filtered the light streaming inside.

Three entrances pierce the main façade. Flanking the entrances are sculpted panels of *mithuna* couples, amorous male and female figures that evoke the harmony and fertility of life. The interior hall, 123 feet long, has a 46-foot-high ceiling carved in the form of a **barrel vault** ornamented with arching wooden ribs. Both the interior and exterior of the hall were once brightly painted. A wide central aisle and two narrower side aisles lead to the stupa in the **apse** at the far end.

The closely spaced columns that separate the side aisles from the main aisle are unlike any known in the West, and they are important examples in the long and complex evolution of the many Indian styles. The base resembles a large pot set on a stepped pyramid of planks. From this potlike form rises a massive octagonal shaft. Crowning the shaft, a bell-shaped lotus capital supports an inverted pyramid of planks, which serves in turn as a platform for sculpture. The statues depict pairs of kneeling elephants, each bearing a *mithuna* couple. These figures, the only sculpture within this austere hall, represent the nobility coming to pay homage at the temple. The pillars around the apse are plain, and the stupa is simple. A railing motif ornaments the base; the dome was once topped with wooden "umbrella" disks, only one of which remains. As with nearly everything in the cave, the stupa is carved from the living rock. Although much less ornate than the stupa at Sanchi, its symbolism is the same.

THE KUSHAN AND LATER ANDHRA PERIODS

Around the first century CE, the regions of present-day Afghanistan, Pakistan, and North India came under the control of the Kushans, a nomadic people forced out of northwest China by the Han. Exact dates are uncertain, but they ruled from the first to the third century CE. The beginning of the long reign of their most illustrious king, Kanishka, is variously dated from 78 to 143 CE. Kanishka's patronage supported the building of many stupas and Buddhist monasteries.

Buddhism during this period underwent a profound evolution that resulted in the form known as Mahayana, or Great Vehicle (see "Buddhism," page 317). This vital new

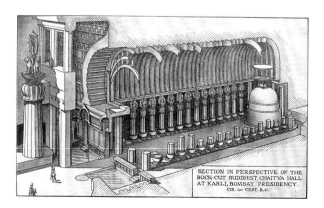

9–11 SECTION OF THE *CHAITYA* HALL AT KARLA
Maharashtra, India. 1st century BCE to 1st century CE.

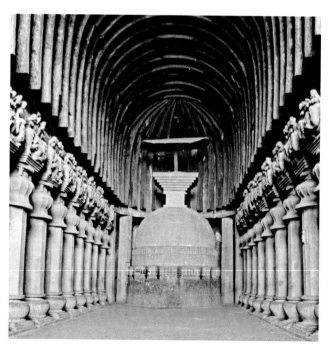

9–12 *CHAITYA* HALL AT KARLA

movement, which was to sweep most of northern India and eastern Asia, probably inspired the first depictions of the Buddha himself in art. (Previously, as in the Great Stupa at Sanchi, the Buddha had been indicated solely by symbols.) The two earliest schools of representation arose in the Gandhara region in the northwest (present-day Pakistan and Afghanistan) and in the famous religious center of Mathura in central India. Both of these areas were ruled by the Kushans. Slightly later, a third school, known as the Amaravati school after its most famous site, developed to the south under the Andhra dynasty, which ruled much of southern and central India from the second century BCE through the second century CE.

While all three schools cultivated distinct styles, they shared a basic visual language, or iconography, in which the Buddha is readily recognized by certain characteristics. He wears a monk's robe, a long length of cloth draped over the left shoulder and around the body. The Buddha is said to have had thirty-two major distinguishing marks, called *lakshana*, some of which are reflected in the iconography (see "Buddhist Symbols," page 381). These include a golden-colored body, long arms that reached to his knees, the impression of a wheel *(chakra)* on the palms of his hands and the soles of his feet, and the *urna*—a tuft of white hair between his eyebrows. Because he had been a prince in his youth and had worn the customary heavy earrings, his earlobes are usually shown elongated. The top of his head is said to have had a protuberance called an *ushnisha,* which in images often resembles a bun or topknot and symbolizes his enlightenment.

The Gandhara School

Gandharan art combines elements of Hellenistic, Persian, and native styles. A typical image from the Gandhara school portrays the Buddha as a superhuman figure, more powerful and heroic than an ordinary human (FIG. 9–13). This over–life-size Buddha dates to the fully developed stage of the Gandhara style around the third century CE. It is carved from schist, a fine-grained dark stone. The Buddha's body, revealed through the folds of the garment, is broad and massive, with heavy shoulders and limbs and a well-defined torso. His left knee bends gently, suggesting a slightly relaxed posture.

The treatment of the robe is especially characteristic of the Gandhara manner. Tight, riblike folds alternate with delicate creases, setting up a clear, rhythmic pattern of heavy and shallow lines. On the upper part of the figure, the folds break asymmetrically along the left arm; on the lower part, they drape in a symmetric U shape. The strong tension of the folds suggests life and power within the image. This complex fold pattern resembles the treatment of togas on certain Roman statues (SEE FIG. 6–12), and it exerted a strong influence on portrayals of the Buddha in Central and East Asia. The Gandhara region's relations with the Hellenistic world may have

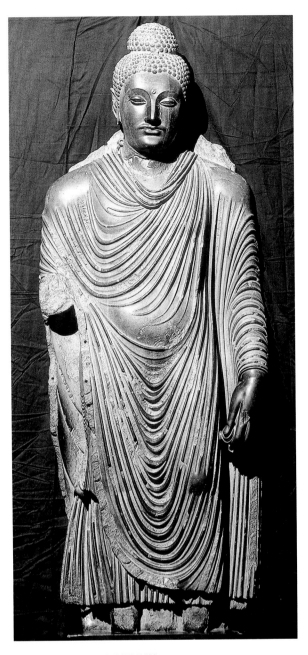

9–13 STANDING BUDDHA
Gandhara, Pakistan. Kushan period, c. 2nd–3rd century CE. Schist, height 7′6″ (2.28 m). Lahore Museum, Lahore.

led to this strongly Western style in its art. Pockets of Hellenistic culture had thrived in neighboring Bactria (present-day northern Afghanistan and southern Uzbekistan) since the fourth century BCE, when the Greeks under Alexander the Great reached the borders of India. Also, Gandhara's position near the East-West trade routes appears to have stimulated contact with Roman culture in the Near East during the early centuries of the first millennium CE.

The Mathura School

The second major school of Buddhist art in the Kushan period—that found at Mathura—was not allied with the Hellenistic-Roman tradition. Instead, the Mathura style

evolved from representations of *yakshas,* the indigenous male nature deities. Images produced at Mathura during the early days of the school may be the first representations of the Buddha to appear in art.

The **stele** in FIGURE 9–14 is one of the finest of the early Mathura images. The sculptors worked in a distinctive local sandstone flecked with cream-colored spots. Carved in **high relief,** it depicts a seated Buddha with two attendants. The Buddha sits in a yogic posture on a pedestal supported by lions. His right hand is raised in a symbolic gesture meaning "have no fear." Images of the Buddha rely on a repertoire of such gestures, called *mudras,* to communicate certain ideas, such as teaching, meditation, or the attaining of enlightenment (see "*Mudras,*" page 325). The Buddha's *urna,* his *ushnisha,* and the impressions of *chakras* on his palms and soles are all clearly visible in this figure. Behind his head is a large, circular halo; the scallop points of its border represent radiating light. Behind the halo are branches of the pipal tree, the tree under which the Buddha was seated when he achieved enlightenment. Two celestial beings hover above.

As in the Gandhara school, the Mathura work gives a powerful impression of the Buddha. Yet this Buddha's riveting outward gaze and alert posture impart a more intense, concentrated energy. The robe is pulled tightly over the body, allowing the fleshy form to be seen as almost nude. Where the pleats of the robe appear, such as over the left arm and fanning out between the legs, they are depicted abstractly through compact parallel

9–15 SIDDHARTHA IN THE PALACE
Detail of a relief from Nagarjunakonda, Andhra Pradesh, India. Later Andhra period, c. 3rd century CE. Limestone. National Museum, New Delhi.

In his *Buddhacharita,* a long poem about the life of the Buddha, the great Indian poet Ashvagosha (c. 100 CE) describes Prince Siddhartha's life in the palace: "The monarch [Siddhartha's father], reflecting that the prince must see nothing untoward that might agitate his mind, assigned him a dwelling in the upper storeys of the palace and did not allow him access to the ground. Then in the pavilions, white as the clouds of autumn, with apartments suited to each season and resembling heavenly mansions come down to earth, he passed the time with the noble music of singing-women." Later, during an outing, a series of unexpected encounters confronts Siddhartha with the nature of mortality. Deeply shaken, he cannot bring himself to respond to the perfumed entreaties of the women who greet him on his return: "For what rational being would stand or sit or lie at ease, still less laugh, when he knows of old age, disease and death?" In this relief, the prince, though surrounded by women in the pleasure garden, seems already to bear the sober demeanor of these thoughts, which were profoundly to affect not only his life, but the world. (Translated by E. H. Johnston).

formations of ridges with an **incised** line in the center of each ridge. This characteristic Mathura tendency to abstraction also appears in the face, whose features take on geometric shapes, as in the rounded forms of the widely opened eyes. Nevertheless, the torso with its subtle and soft modeling is strongly naturalistic.

The Amaravati School

Events from the Buddha's life were popular subjects in the reliefs decorating stupas and Buddhist temples. One example from Nagarjunakonda, a site of the Amaravati school in the south, depicts a scene from the Buddha's life when he was Prince Siddhartha, before his renunciation of his princely status and his subsequent quest for enlightenment (FIG. 9–15). Carved in low relief, the panel reveals a scene of pleasure around a pool of water. Gathered around Siddhartha, the largest figure and the only male, are some of the palace women. One holds his foot, entreating him to come into the water; another sits with legs drawn up on the nearby rock; others lean over his shoulder or fix their hair; one comes into the scene with a box of jewels on her head. The panel is

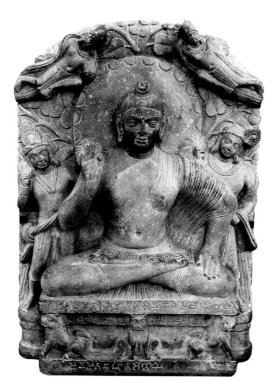

9–14 BUDDHA AND ATTENDANTS
Katra Keshavdev, Mathura, Madhya Pradesh, India. Kushan period, c. late 1st–early 2nd century CE. Red sandstone, height 27¼″ (69.2 cm). Government Museum, Mathura.

Myth and Religion
MUDRAS

Mudras (the Sanskrit word for "signs") are ancient symbolic hand gestures that are regarded as physical expressions of different states of being. In Buddhist art, they function iconographically. *Mudras* also are used during meditation to release these energies. The following are the most common *mudras* in Asian art.

Dharmachakra Mudra

The gesture of teaching, setting the *chakra* (wheel) of the *dharma* (law, or doctrine) in motion. Hands are at chest level.

Dhyana Mudra

A gesture of meditation and balance, symbolizing the path toward enlightenment. Hands are in the lap, the lower representing *maya*, the physical world of illusion, the upper representing *nirvana*, enlightenment and release from the world.

Vitarka Mudra

This variant of *dharmachakra mudra* stands for intellectual debate. The right and/or left hand is held at shoulder level with thumb and forefinger touching.

Abhaya Mudra

The gesture of reassurance, blessing, and protection, this *mudra* means "have no fear." The right hand is at shoulder level, palm outward.

Bhumisparsha Mudra

This gesture calls upon the earth to witness Shakyamuni Buddha's enlightenment at Bodh Gaya. A seated figure's right hand reaches toward the ground, palm inward.

Varada Mudra

The gesture of charity, symbolizing the fulfillment of all wishes. Alone, this *mudra* is made with the right hand; but when combined with *abhaya mudra* in standing *buddha* figures (as is most common), the left hand is also shown in *varada mudra*.

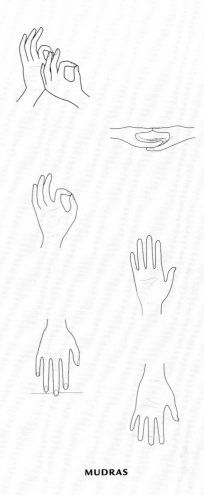

MUDRAS

framed by decorated columns, crouching lions, and amorous *mithuna* couples. (One of these couples is visible at the right of the illustration.) The scene is skillfully orchestrated to revolve around the prince as the main focus of all eyes. Typical of the southern school, the figures are slighter than those of the Gandhara and Mathura schools. They are sinuous and mobile, even while at rest. The rhythmic nuances of the limbs and varied postures not only create interest in the activity of each individual but also engender a light and joyous effect.

During the first to third century CE, each of the three major schools of Buddhist art developed its own distinct idiom for expressing the complex imagery of Buddhism and depicting the image of the Buddha. The Gandhara and Ama-

ravati schools declined over the ensuing centuries, mainly due to the demise of the dynasties that had supported them. However, the schools of central India, including the school of Mathura, continued to develop, and from them came the next major development in Indian Buddhist art.

THE GUPTA PERIOD

The Guptas, who founded a dynasty in the eastern region of central India known as Magadha, expanded their territories during the fourth century to form an empire that encompassed northern and much of southern India. Although Gupta power prevailed for only about 166 years (c. 320–486 CE)

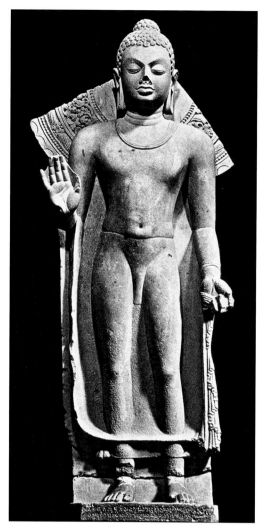

9-16 STANDING BUDDHA
Sarnath, Uttar Pradesh, India. Gupta period, 474 CE. Chunar sandstone, height 6′ 4″ (1.93 m). Archaeological Museum, Sarnath.

before the dynasty's collapse around 500 CE, the influence of Gupta culture was felt for centuries.

The Gupta period is renowned for the flourishing artistic and literary culture that brought forth some of India's most widely admired sculpture and painting. During this time, Buddhism reached its greatest influence in India, although Hinduism, supported by the Gupta monarchs, began to rise in popularity.

Buddhist Sculpture

Two schools of Gupta Buddhist sculpture reached their artistic peak during the second and third quarters of the fifth century and dominated in northern India: the Mathura, one of the major schools of the earlier Kushan period, and the school at Sarnath.

The standing Buddha in FIGURE 9-16 embodies the fully developed Sarnath Gupta style. Carved from fine-grained sandstone, the figure stands in a mildly relaxed pose, the body

clearly visible through a clinging robe. This plain robe, portrayed with none of the creases and folds so prominent in the Kushan period images, is distinctive of the Sarnath school. Its effect is to concentrate attention on the perfected form of the body, which emerges in high relief. The body is graceful and slight, with broad shoulders and a well-proportioned torso. Only a few lines of the garment at the neck, waist, and hems interrupt the purity of its subtly shaped surfaces; the face, smooth and ovoid, has the same refined elegance. The downcast eyes suggest otherworldly introspection, yet the gentle, open posture maintains a human link. Behind the head are the remains of a large, circular halo. Carved in concentric circles of pearls and foliage, the halo would have contrasted dramatically with the plain surfaces of the figure.

The Sarnath Gupta style reveals the Buddha in perfection and equilibrium. He is not represented as a superhuman presence but as a being whose spiritual purity is evidenced by, and fused with, his physical purity, one whose nature blends the fully enlightened with the fully human.

Painting

The Gupta aesthetic also found expression in painting. Some of the finest surviving works are murals from the Buddhist rock-cut halls of Ajanta, in the western Deccan region of

9-17 BODHISATTVA
Detail of a wall painting in Cave I, Ajanta, Maharashtra, India. Gupta period, c. 475 CE.

9–18 VISHNU TEMPLE AT DEOGARH
Uttar Pradesh, India. Post-Gupta period, c. 530 CE.

India (FIG. 9–17). Under a local dynasty, many caves were carved around 475 CE, including Cave I, a large *vihara* hall with monks' chambers around the sides and a Buddha shrine chamber in the back. The walls of the central court were covered with murals painted in mineral pigments on a prepared plaster surface. Some of these paintings depict episodes from the Buddha's past lives. Flanking the entrance to the shrine are two large **bodhisattvas,** one of which is seen in FIGURE 9–17.

Bodhisattvas are enlightened beings who postpone *nirvana* and buddhahood to help others achieve enlightenment. They are distinguished from *buddhas* in art by their princely garments. The *bodhisattva* here is lavishly adorned with delicate ornaments. He wears a complicated crown with many tiny pearl festoons, large earrings, long necklaces of twisted pearl strands, armbands, and bracelets. A striped cloth covers his lower body. The graceful bending posture and serene gaze impart a sympathetic attitude. His spiritual power is suggested by his large size in comparison with the surrounding figures.

The naturalistic style balances outline and softly graded color tones. Outline drawing, always a major ingredient of Indian painting, clearly defines shapes; tonal gradations impart the illusion of three-dimensional form, with lighter tones used for protruding parts such as the nose, brows, shoulders, and chest muscles. Together with the details of the jewels, these highlighted areas resonate against the subdued tonality of the figure and the somber, flower-strewn background seen in FIGURE 9–17. Sophisticated, realistic detail is balanced, in typical Gupta fashion, by the languorous human form. In no other known examples of Indian painting do *bodhisattvas* appear so graciously divine yet, at the same time, so palpably human. This particular synthesis, evident also in the Sarnath statue, is the special Gupta artistic achievement.

THE POST-GUPTA PERIOD

Although the Gupta dynasty came to an end around 500 CE, its influence—in both religion and the arts—lingered until the mid-tenth century. Although Buddhism had flourished in India during the fifth century, Hinduism, sponsored by Gupta monarchs, began its ascent toward eventual domination of Indian religious life. Hindu temples and sculpture of the Hindu gods, though known earlier, increasingly appeared during the Gupta period and post-Gupta periods.

The Early Northern Temple

The Hindu temple developed many different forms throughout India, but it can be classified broadly into two types: northern and southern. The northern type is chiefly distinguished by a superstructure called a *shikhara* (see "Stupas and Temples," page 320). The *shikhara* rises as a solid mass above the flat stone ceiling and windowless walls of the sanctum, or *garbhagriha,* which houses an image of the temple's deity. As it rises, it curves inward in a mathematically determined ratio. (In mathematical terms, the *shikhara* is a paraboloid.) Crowning the top is a circular, cushionlike element called an *amalaka,* a fruit. From the *amalaka,* a **finial** (a knoblike decoration at the top point of a spire) takes the eye to a point where the earthly world is thought to join the cosmic world. An imaginary *axis mundi* penetrates the entire temple, running from the point of the finial, through the exact center of the *amalaka* and *shikhara,* down through the center of the *garbhagriha* and its image, finally passing through the base of the temple and into the earth below. In this way the temple becomes a conduit between the celestial realms and the earth. This theme, familiar from Ashokan pillars and Buddhist stupas, is carried out with elaborate exactitude in Hindu temples, and it is one of the most important elements underlying their form and function (see "Meaning and Ritual in Hindu Temples and Images," page 328).

TEMPLE OF VISHNU AT DEOGARH. One of the earliest northern-style temples is the temple of Vishnu at Deogarh in central India, which dates from around 530 CE (FIG. 9–18). Much of the *shikhara* has crumbled away, so we cannot determine its original shape with precision. Nevertheless, it was clearly a massive, solid structure built of large cut stones. It would have given the impression of a mountain, which is one of several metaphoric meanings of a Hindu temple. This early temple has only one chamber, the *garbhagriha,* which corresponds to the center of a sacred diagram called a *mandala* on which the entire temple site is patterned. As the deity's residence, the *garbhagriha* is likened to a sacred cavern within the "cosmic mountain" of the temple.

The entrance to a Hindu temple is elaborate and meaningful. The doorway at Deogarh is well preserved and an

Art and Its Context
MEANING AND RITUAL IN HINDU TEMPLES AND IMAGES

The Hindu temple is one of the most complex and meaningful architectural forms in Asian art. Age-old symbols and ritual functions are embedded not only in a structure's many parts, but also in the process of construction itself. Patron, priest, and architect worked as a team to ensure the sanctity of the structure from start to finish. No artist or artisan was more highly revered in ancient Indian society than the architect, who could oversee the construction of an abode in which a deity would dwell.

For a god to take up residence, however, everything had to be done properly in exacting detail. By the end of the first millennium, the necessary procedures had been recorded in texts called the *Silpa Shastra*. First, an auspicious site was chosen; a site near water was especially favored, for water makes the earth fruitful. Next, the ground was prepared in an elaborate process that took several years: Spirits already inhabiting the site were invited to leave; the ground was planted and harvested through two seasons; then cows—sacred beasts since the Indus Valley civilization—were pastured there to lend their potency to the site. When construction began, each phase was accompanied by ritual to ensure its purity and sanctity.

All Hindu temples are built on a mystical plan known as a *mandala,* a schematic design of a sacred realm or space—specifically, the *mandala* of the Cosmic Man (Vastupurusha *mandala*), the primordial progenitor of the human species. His body, fallen on earth, is imagined as superimposed on the *mandala* design; together, they form the base on which the temple rises. The Vastupurusha *mandala* always takes the form of a square subdivided into a number of equal squares (usually sixty-four) surrounding a central square. The central square represents Brahman, the primordial, unmanifest Formless One. This square corresponds to the temple's sanctum, the windowless *garbhagriha,* or "womb chamber." The nature of Brahman is clear, pure light; that we perceive the *garbhagriha* as dark is considered a testament to our deluded nature. The surrounding squares belong to lesser deities, while the outermost compartments hold protector gods. These compartments are usually represented by the enclosing wall of a temple compound.

The *garbhagriha* houses the temple's main image—most commonly a stone, bronze, or wood statue of Vishnu, Shiva, or Devi. In the case of Shiva, the image is often symbolic rather than anthropomorphic. To ensure perfection, the proportions of the image follow a set canon, and rituals surround its making. When the image is completed, a priest recites *mantras,* or mystic syllables, that bring the deity into the image. The belief that a deity is literally present is not taken lightly. Even in India today, any image "under worship"—whether it be in a temple or a field, an ancient work or a modern piece—will be respected and not taken from the people who worship it.

A Hindu temple is a place for individual devotion, not congregational worship. It is the place where a devotee can make offerings to one or more deities and be in the presence of the god who is embodied in the image in the *garbhagriha*. Worship generally consists of prayers and offerings such as food and flowers or water and oil for the image, but it can also be much more elaborate, including dancing and ritual sacrifices.

excellent example (FIG. 9–19). Because the entrance takes a worshiper from the mundane world into the sacred, stepping over a threshold is considered a purifying act. Two river goddesses, one on each upper corner of the lintel, symbolize the purifying waters flowing down over the entrance. These imaginary waters also provide symbolic nourishment for the vines and flowers decorating some of the vertical jambs. The innermost vines sprout from the navel of a dwarf, one of the popular motifs in Indian art. *Mithuna* couples and small replicas of the temple line other jambs. At the bottom, male and female guardians flank the doorway. Above the door, in the center, is a small image of the god Vishnu, to whom the temple is dedicated.

Large panels sculpted in relief with images of Vishnu appear as "windows" on the temple's exterior. These elaborately framed panels do not function literally to let light *into* the temple; they function symbolically to let the light of the deity *out* of the temple to be seen by those outside. The pan-

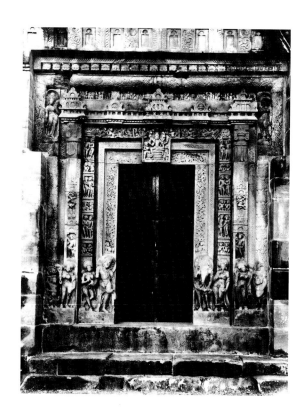

9–19 **DOORWAY OF THE VISHNU TEMPLE AT DEOGARH**

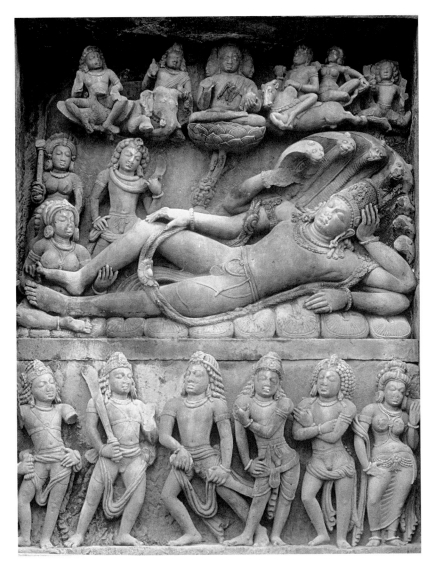

9–20 **VISHNU NARAYANA ON THE COSMIC WATERS**
Relief panel in the Vishnu Temple at Deogarh. c. 530 CE. Stone.

els thus symbolize the third phase of Vishnu's threefold emanation from Brahman, the Formless One, into our physical world. (See "Hinduism," page 318.)

One panel depicts Vishnu lying on the Cosmic Waters at the beginning of creation (FIG. 9–20). This vision represents the second stage of the deity's emanation. Vishnu sleeps on the serpent of infinity, Ananta, whose body coils endlessly into space. Stirred by his female aspect (*shakti*, or female energy), personified here by the goddess Lakshmi, seen holding his foot, Vishnu dreams the universe into existence. From his navel springs a lotus (shown in this relief behind Vishnu), and the unfolding of space-time begins. The first being to be created is Brahma (not to be confused with Brahman), who appears here as the central, four-headed figure in the row of gods portrayed above the reclining Vishnu. Brahma turns himself into the universe of space and time by thinking, "May I become Many."

The sculptor has depicted Vishnu as a large, resplendent figure with four arms. His size and his many arms connote his omnipotence. He is lightly garbed but richly ornamented. The ideal of the Gupta style persists in the smooth, perfected shape of the body and in the lavishly detailed jewelry, including Vishnu's characteristic cylindrical crown. The four rightmost figures in the frieze below personify Vishnu's powers. They stand ready to fight the appearance of evil, represented at the left of the frieze by two demons who threaten to kill Brahma and jeopardize all creation.

The birth of the universe and the appearance of evil are thus portrayed here in three clearly organized registers. Typical of Indian religious and artistic expression, these momentous events are set before our eyes not in terms of abstract symbols, but as a drama acted out by gods in superhuman form. The birth of the universe is imagined as a lotus unfolding from the navel of Vishnu.

Monumental Narrative Reliefs

The Hindu god Shiva was known in Vedic times as Rudra, "the howler." He was "the wild red hunter" who protected beasts and inhabited the forests. Shiva, which means "benign," exhibits a wide range of aspects or forms, both gentle and wild: He is the Great Yogi who dwells for vast periods of time

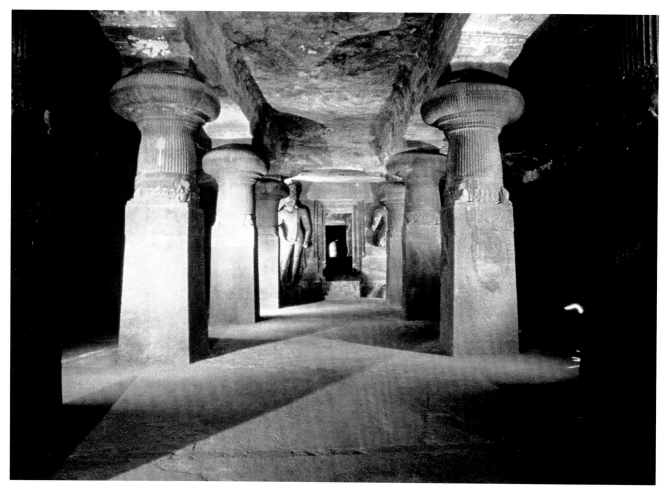

9–21 CAVE-TEMPLE OF SHIVA AT ELEPHANTA
Maharashtra, India. Post-Gupta period, mid-6th century CE. View along the east-west axis to the *lingam* shrine.

in meditation in the Himalayas; he is also the husband par excellence who makes love to the goddess Parvati for eons at a time; he is the Slayer of Demons; and he is the Cosmic Dancer who dances the destruction and re-creation of the world.

TEMPLE OF SHIVA AT ELEPHANTA. Many of these forms of Shiva appear in the monumental relief panels adorning the Cave temple of Shiva carved in the mid-sixth century on the island of Elephanta off the coast of Bombay in western India. The cave-temple is complex in layout and conception, perhaps to reflect the nature of Shiva. While most temples have one entrance, this temple offers three—one facing north, one east, and one west. The interior, impressive in its size and grandeur, is designed along two main axes, one running north-south, the other east-west. The three entrances provide the only source of light, and the resulting cross- and back-lighting effects add to the sense of the cave as a place of mysterious, almost confusing complexity.

Along the east-west axis, large pillars cut from the living rock appear to support the low ceiling and its beams, although, as with all architectural elements in a cave-temple,

they are not structural (FIG. 9–21). The pillars form orderly rows, but the rows are hard to discern within the framework of the cave shape, which is neither square nor longitudinal, but formed of overlapping *mandalas* that create a symmetric yet irregular space. The pillars are an important aesthetic component of the cave. Each has an unadorned, square base rising to nearly half its total height. Above is a circular column, which has a curved contour and a billowing "cushion" capital. Both column and capital are delicately fluted, adding a surprising refinement to these otherwise sturdy forms. The focus of the east-west axis is a square *lingam* **shrine,** shown here at the center of the illustration. Each of its four entrances is flanked by a pair of colossal standing guardian figures. In the center of the shrine is the *lingam,* the phallic symbol of Shiva. The *lingam* represents the presence of Shiva as the unmanifest Formless One, or Brahman. It symbolizes both his erotic nature and his aspect as the Great Yogi who controls his seed. The *lingam* is synonymous with Shiva and is seen in nearly every Shiva temple and shrine.

The focus of the north-south axis, in contrast, is a relief on the south wall depicting Shiva in his second stage of the

THE OBJECT SPEAKS

SHIVA NATARAJA OF THE CHOLA DYNASTY

Perhaps no sculpture is more representative of Hinduism than the statues of Shiva Nataraja, or Dancing Shiva, a form perfected by sculptors under the royal patronage of the South Indian Chola dynasty in the late tenth to eleventh century. (For the architecture and painting of the period, see figs. 9–26 and 9–27.) The dance of Shiva is a dance of cosmic proportions, signifying the universe's cycle of death and rebirth; it is also a dance for each individual, signifying the liberation of the believer through Shiva's compassion. In the iconography of the Nataraja, perfected over the centuries, this sculpture shows Shiva with four arms dancing on the prostrate body of Apasmaru, a dwarf figure who symbolizes "becoming" and whom Shiva controls. Shiva's extended left hand holds a ball of fire; a circle of fire rings the god as well. The fire is emblematic of the destruction of *samsara* and the physical universe as well as the destruction of *maya* and our ego-centered perceptions. Shiva's back right hand holds a drum; its beat represents the irrevocable rhythms of creation and destruction, birth and death. His front right arm gestures the "have no fear" *mudra* (see "Mudras," page 325). The front left arm, gracefully stretched across his body with the hand pointing to his raised foot, signifies the promise of liberation.

The artist has rendered the complex pose with great clarity. The central axis, which aligns the nose, navel, and insole of the weight-bearing foot, maintains the figure's equilibrium while the remaining limbs asymmetrically extend far to each side. Shiva wears a short loincloth, a ribbon tied above his waist, and delicately tooled ornaments. The scant clothing reveals his perfected form with its broad shoulders tapering to a supple waist. The jewelry is restrained and the detail does not detract from the beauty of the body.

The deity does not appear self-absorbed and introspective as he did in the Eternal Shiva relief at Elephanta (see

fig. 9–22). He turns to face the viewer, appearing lordly and aloof yet fully aware of his benevolent role as he generously displays himself for the devotee. Like the Sarnath Gupta Buddha (see fig. 9–16), the Chola Shiva Nataraja presents a characteristically Indian synthesis of the godly and the human, this time expressing the *bhakti* belief in the importance of an intimate relationship with a lordly god through whose compassion one is saved. The earlier Hindu emphasis on ritual and the depiction of the heroic feats of the gods is subsumed into the all-encompassing, humanizing factor of grace.

The fervent religious devotion of the *bhakti* movement was fueled by the sublime writings of a series of poet-saints who lived in the south of India. One of them, Appar, who lived from the late sixth to mid-seventh century CE, wrote this vision of the Shiva Nataraja. The ash the poem refers to is one of many symbols associated with the deity. In penance for having lopped off one of the five heads of Brahma, the first created being, Shiva smeared his body with ashes and went about as a beggar.

> If you could see
> the arch of his brow,
> the budding smile
> on lips red as the kovvai fruit,
> cool matted hair,
> the milk-white ash on coral skin,
> and the sweet golden foot
> raised up in dance,
> then even human birth on this wide earth
> would become a thing worth having.

(Translated by Indira Vishvanathan Peterson)

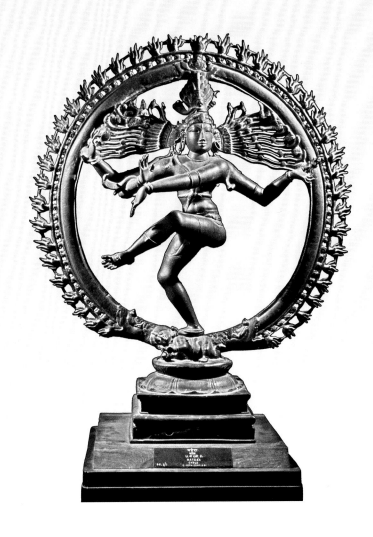

SHIVA NATARAJA
Thanjavur, Tamil Nadu. Chola dynasty, 12th century CE. Bronze, 32″ (81.25 cm). National Museum of India, New Delhi.

threefold emanation. A huge bust of the deity represents his Sadashiva, or Eternal Shiva, aspect (FIG. 9–22). Three heads are shown resting upon the broad shoulders of the upper body, but five heads are implied: the fourth in back and the fifth, never depicted, on top. The heads summarize Shiva's fivefold nature as creator (back), protector (left), destroyer (right), obscurer (front), and releaser (top). The head in the front depicts Shiva deep in introspection. The massiveness of the broad head, the large eyes barely delineated, and the mouth with its heavy lower lip suggest the god's serious depths. Lordly and majestic, he easily supports his huge crown, intricately carved with designs and jewels, and the matted, piled-up hair of a yogi. On his left shoulder, his protector nature is depicted as female, with curled hair and a pearl-festooned crown. On his right shoulder, his wrathful, destroyer nature wears a fierce expression, and snakes encircle his neck.

Like the relief panels at the temple to Vishnu in Deogarh (SEE FIG. 9–20), the reliefs at Elephanta are early examples of the Hindu monumental narrative tradition. Measuring 11 feet in height, they are set in recessed niches, one on either side of each of the three entrances and three on the south wall. The panels portray the range of Shiva's powers and some of his different aspects, presented in the context of narratives that help devotees understand his nature. Taken as a whole, the reliefs represent the manifestation of Shiva in our world. Indian artists often convey the many aspects or essential nature of a deity through multiple heads or arms—which they do with such convincing naturalism that we readily accept the additions. Here, for example, the artist has united three heads onto a single body so skillfully that we still relate to the statue as an essentially human presence.

The third great Hindu deity is Devi, a designation covering many deities who embody the feminine. In general, Devi represents the power of *shakti,* a divine energy understood as feminine. *Shakti* is needed to overcome the demons of our afflictions, such as ignorance and pride. Among the most widely worshiped goddesses are Lakshmi, goddess of wealth and beauty, and Durga, the warrior goddess.

DURGA RELIEF AT MAMALLAPURAM. Durga is the essence of the conquering powers of the gods. A large relief at Mamallapuram, near Madras, in southeastern India, depicts Durga in her popular form as the slayer of Mahishasura, the buffalo demon (FIG. 9–23). Triumphantly riding her lion, a symbol of her *shakti,* the eight-armed Durga battles the demon. His huge figure with its human body and buffalo head is shown lunging to the right, fleeing her onslaught as his warriors fall to the ground. Accompanied by energetic, dwarfish warriors, victorious Durga, though small, sits erect and alert, flashing her weapons. The moods of victory and defeat are clearly distinguished between the left and right sides of the panel. The

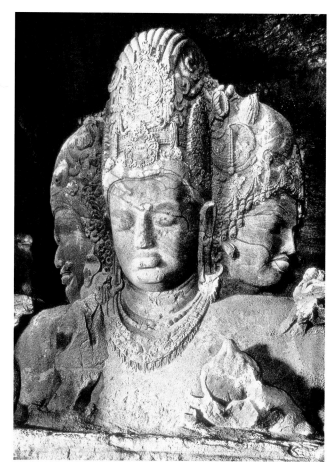

9–22 ETERNAL SHIVA
Rock-cut relief in the Cave-Temple of Shiva at Elephanta.
Mid-6th century CE. Height approx. 11′ (3.4 m).

9–23 DURGA MAHISHASURA-MARDINI (DURGA AS SLAYER OF THE BUFFALO DEMON)
Rock-cut relief, Mamallapuram, Tamil Nadu, India.
Pallava period, c. mid-7th century CE. Granite, height approx. 9′ (2.7 m).

artist clarifies the drama by focusing our attention on the two principal actors. Surrounding figures play secondary roles that support the main action, adding visual interest and variety.

Stylistically, this and other panels at Mamallapuram represent a high point of the Indian monumental relief tradition. Here, as elsewhere, the reliefs portray stories of the gods and goddesses, whose heroic deeds unfold before our eyes. Executed under the dynasty of the Pallavas, which flourished in southern India from the seventh to ninth century CE, this panel illustrates the gentle, simplified figure style characteristic of Pallava sculpture. Figures tend to be slim and elegant with little ornament, and the rhythms of line and form have a graceful, unifying, and humanizing charm.

The Early Southern Temple

The coastal city of Mamallapuram was also a major temple site under the Pallavas. Along the shore are many large granite boulders and cliffs, and from these the Pallava stonecutters carved reliefs, halls, and temples. Among the most interesting Pallava creations is a group of temples known as the Five Rathas, which preserve a sequence of early architectural styles. As with other rock-cut temples, the Five Rathas were probably carved in the style of contemporary wood or brick structures that have long since disappeared.

DHARMARAJA RATHA AT MAMALLAPURAM. One of this group, the Dharmaraja Ratha, epitomizes the early southern-style temple (FIG. 9–24). Though strikingly different in appearance from the northern style, it uses the same symbolism to link the heavens and earth and it, too, is based on a *mandala*. The temple, square in plan, remains unfinished, and the *garbhagriha* usually found inside was never hollowed out. On the lower portion, only the columns and niches have been carved. The use of a single deity in each niche forecasts the main trend in temple sculpture in the centuries ahead: The tradition of narrative reliefs declined and the stories they told became concentrated in statues of individual deities, which conjure up entire mythological episodes through characteristic poses and a few symbolic objects.

Southern and northern temples are most clearly distinguished by their superstructures. The Dharmaraja Ratha does not culminate in the paraboloid of the northern *shikhara* but in a pyramidal tower called a **vimana**. Each story of the *vimana* is articulated by a **cornice** and carries a row of miniature shrines. Both shrines and cornices are decorated with a window motif from which faces peer. The shrines not only demarcate each story, but also provide loftiness for this palace for a god. Crowning the *vimana* is a dome-shaped octagonal **capstone** quite different from the *amalaka* of the northern style.

During the centuries that followed, both northern- and southern-style temples developed into complex, monumental forms, but their basic structure and symbolism remained the same as those we have seen in these simple, early examples at Deogarh and Mamallapuram.

THE TENTH THROUGH THE FOURTEENTH CENTURIES

During the tenth through the fourteenth centuries, many small kingdoms and dynasties flourished, giving rise to a number of regional styles. Some were relatively long-lived, such as the Pallavas and Cholas in the south and the Palas in the northeast. Though Buddhism remained strong in a few areas—notably under the Palas—it generally declined, while the Hindu gods Vishnu, Shiva, and the Goddess (mainly Durga) grew increasingly popular. Local kings rivaled each other in the building of temples to their favored deity, and many complicated and subtle variations of the Hindu temple emerged with astounding rapidity in different regions. By around 1000 CE the Hindu temple had reached unparalleled heights of grandeur and engineering.

The Monumental Northern Temple

The Kandariya Mahadeva, a temple dedicated to Shiva at Khajuraho, in central India, was probably built by a ruler of the Chandella dynasty in the late tenth or early eleventh

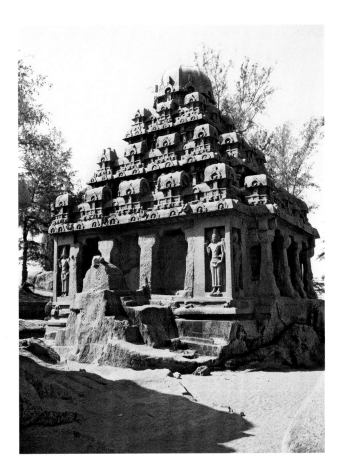

9–24 DHARMARAJA RATHA, MAMALLAPURAM
Tamil Nadu, India. Pallava period, c. mid-7th century CE.

century (FIG. 9–25). Khajuraho was the capital and main temple site for the Chandellas, who constructed more than eighty temples there, about twenty-five of which are well preserved. The Kandariya Mahadeva temple is in the northern style, with a *shikhara* rising over its *garbhagriha*. Larger, more extensively ornamented, and expanded through the addition of halls on the front and porches to the sides and back, the temple seems at first glance to have little in common with its precursor at Deogarh (SEE FIG. 9–18). Actually, however, the basic elements and their symbolism remain unchanged.

As at Deogarh, the temple rests on a stone terrace that sets off a sacred space from the mundane world. A steep flight of stairs at the front (to the right in the illustration) leads to a series of three halls (distinguished on the outside by three pyramidal roofs) preceding the *garbhagriha*. Called **mandapas,** the halls symbolize the deity's threefold emanation. They serve as spaces for ritual, such as dances performed for the deity, and for the presentation of offerings. The temple is built of stone blocks using only **post-and-lintel construction.** Because vault and arch techniques are not used, the interior spaces are not large.

The exterior has a strong sculptural presence, its massiveness suggesting a "cosmic mountain" composed of ornately carved stone. The *shikhara* rises more than 100 feet over the *garbhagriha* and is crowned by a small *amalaka*. The *shikhara* is bolstered by the many smaller *shikhara* motifs bundled around it. This decorative scheme adds a complex richness to the sur-

face, but it also obscures the shape of the main *shikhara*, which is slender, with a swift and impetuous upward movement. The roofs of the *mandapas* contribute to the impression of rapid ascent by growing progressively taller as they near the *shikhara*.

Despite its apparent complexity, the temple has a clear structure and unified composition. The towers of the superstructure are separated from the lower portion by strong horizontal **moldings** and by the open spaces over the *mandapas* and porches. The moldings and rows of sculpture adorning the lower part of the temple create a horizontal emphasis that stabilizes the vertical thrust of the superstructure. Three rows of sculpture—some 600 figures—are integrated into the exterior walls. Approximately 3 feet tall and carved in high relief, the sculptures depict gods and goddesses, some in erotic postures. They are thought to express Shiva's divine bliss, the manifestation of his presence within, and the transformation of one into many.

In addition to its horizontal emphasis, the lower portion of the temple is characterized by a verticality that is created by protruding and receding elements. Their visual impact is similar to that of engaged columns and buttresses, and they account for much of the rich texture of the exterior. The porches, two on each side and one in the back, contribute to the complexity by outwardly expanding the ground plan, yet their curved bases also reinforce the sweeping vertical movements that unify the entire structure.

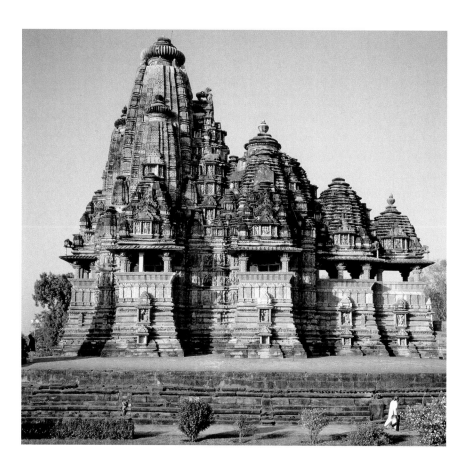

9–25 **KANDARIYA MAHADEVA TEMPLE, KHAJURAHO**
Madhya Pradesh, India. Chandella dynasty, c. 1000 CE.

9–26 **RAJARAJESHVARA TEMPLE TO SHIVA, THANJAVUR**
Tamil Nadu, India. Chola dynasty, 1003–10 CE.

The Monumental Southern Temple

The Cholas, who succeeded the Pallavas in the mid-ninth century, founded a dynasty that governed most of the far south well into the late thirteenth century. The Chola dynasty reached its peak during the reign of Rajaraja I (ruled 985–1014 CE). As an expression of gratitude for his many victories in battle, Rajaraja built the Rajarajeshvara Temple to Shiva in his capital, Thanjavur (present-day Tanjore). Known alternatively as the Brihadeshvara, this temple is the supreme achievement of the southern style of Hindu architecture (FIG. 9–26). It stands within a huge, walled compound near the banks of the Kaveri River. Though smaller shrines dot the compound, the Rajarajeshvara dominates the area.

Clarity of design, a formal balance of parts, and refined decor contribute to the Rajarajeshvara's majesty. Rising to an astonishing height of 216 feet, this temple was probably the tallest structure in India in its time. Like the Kandariya Mahadeva temple at Khajuraho, the Rajarajeshvara has a longitudinal axis and greatly expanded dimensions, especially with regard to its superstructure. Typical of the southern style, the *mandapa* halls at the front of the Rajarajeshvara have flat roofs, as opposed to the pyramidal roofs of the northern style.

The base of the *vimana*, which houses the *garbhagriha*, rises for two stories, with each story emphatically articulated by a large cornice. The exterior walls are ornamented with niches, each of which holds a single statue, usually depicting a form of Shiva. The clear, regular, and wide spacing of the niches imparts a calm balance and formality to the lower portion of the temple, in marked contrast to the irregular, concave-convex rhythms of the northern style.

The *vimana* of the Rajarajeshvara is a four-sided, hollow pyramid that rises for thirteen stories. Each story is decorated with miniature shrines, window motifs, and robust dwarf figures who seem to be holding up the next story. Because these sculptural elements are not large in the overall scale of the *vimana*, they appear well integrated into the surface and do not obscure the thrusting shape. This is quite different from the effect of the small *shikhara* motifs on the *shikhara* of the Kandariya Mahadeva temple (SEE FIG. 9–25). Notice also that in the earlier southern style as embodied in the Dharmaraja Ratha (SEE FIG. 9–24), the shrines on the *vimana* were much larger in proportion to the whole and thus each appeared to be nearly as prominent as the *vimana*'s overall shape.

Because the Rajarajeshvara *vimana* is not obscured by its decorative motifs, it forcefully ascends skyward. At the top is an octagonal dome-shaped capstone similar to the one that crowned the earlier southern-style temple. This huge capstone is exactly the same size as the *garbhagriha* housed thirteen stories directly below. It thus evokes the shrine a final

time before the eye ascends to the point separating the worldly from the cosmic sphere above.

The Bhakti Movement in Art

Throughout this period, two major religious movements were developing that affected Hindu practice and its art: the tantric, or esoteric, and the *bhakti,* or devotional. Although both movements evolved throughout India, the influence of tantric sects appeared during this period primarily in the art of the north (see Chapter 23 for a discussion of their continued development), while the *bhakti* movements found artistic expression mostly in the south.

The *bhakti* devotional movement was based on ideas expressed in ancient texts, especially the *Bhagavad Gita. Bhakti* revolves around the ideal relationship between humans and deities. According to *bhakti,* it is the gods who create *maya,* or illusion, in which we are all trapped. They also reveal truth to those who truly love them and whose minds are open to them. Rather than focusing on ritual and the performance of *dharma* according to the Vedas, *bhakti* stresses an intimate, personal, and loving relation with god, and the complete devotion and surrender to god. Inspired and influenced by *bhakti,* southern artists produced some of India's greatest works, as revealed in the few remaining paintings and in the famous bronze works of sculpture (see "Shiva Nataraja of the Chola Dynasty" on page 331).

WALL PAINTING AT RAJARAJESHVARA TEMPLE. Rajaraja's building of the Rajarajeshvara was in part a reflection of the fervent movement of Shiva *bhakti* that had reached its peak by that time. The corridors of the circumambulatory passages around its *garbhagriha* were originally adorned with wall paintings. Overpainted later, they were only recently rediscovered. One painting apparently depicts the ruler Rajaraja himself, not as a warrior or majestic king on his throne, but as a simple mendicant humbly standing behind his religious teacher (FIG. 9–27). With his white beard and dark skin, the aged teacher contrasts with the youthful, bronze-skinned king. The position of the two suggests that the king treats the saintly teacher, who in the devotee's or *bhakta's* view is equated with god, with intimacy and respect. Both figures allude to their devotion to Shiva by holding a small flower as an offering, and both emulate Shiva in their appearance by wearing their hair in the "ascetic locks" of Shiva in his Great Yogi aspect.

The portrayal does not represent individuals so much as a contrast of types: the old and the youthful, the teacher and the devotee, the saint and the king—the highest religious and worldly models, respectively—united as followers of Shiva. Line is the essence of the painting. With strength and grace, the even, skillfully executed line defines the boldly simple forms and features. With less shading and fewer details, these figures are flattened, more linear versions of those in the Gupta paintings at Ajanta (SEE FIG. 9–17). A cool, sedate calm

9–27 RAJARAJA I AND HIS TEACHER
Detail of a wall painting in the Rajarajeshvara Temple to Shiva. Chola dynasty, c. 1010 CE.

infuses the monumental figures, but the power of line also invigorates them with a sense of strength and inner life.

The *bhakti* movement spread during the ensuing centuries into North India. However, during this period a new religious culture penetrated the subcontinent: Turkic, Persian, and Afghan invaders had been crossing the northwest passes into India since the tenth century, bringing with them Islam and its artistic tradition. New religious forms eventually evolved from Islam's long and complex interaction with the peoples of the subcontinent, and so too arose uniquely Indian forms of Islamic art, adding yet another dimension to India's artistic heritage.

ART OF SOUTHEAST ASIA

Trade and cultural exchange, notably by the sea routes linking China and India, brought Buddhism, Hinduism, and other aspects of India's civilization to the various regions of Southeast Asia and the Asian archipelago. Although Theravada Buddhism (see "Buddhism," page 317) had the most lasting impact in the region, other trends in Buddhism, including

9–28 BUDDHA MAITREYA
Buriram Province, Thailand, 8th century. Copper alloy with
inlaid black glass eyes, 38″ (96.5 cm). Asia Society, New York.
Mr. and Mrs. John D. Rockefeller 3rd Collection, 1979.063

Mahayana and esoteric (tantric) traditions, also played a role.
Elements of Hinduism, including its epic literature, were also
adopted in the region.

THAILAND—PRAKHON CHAI STYLE. Even the earliest major
flowering of Buddhist art in eighth- and ninth-century
Southeast Asia was characterized by distinctly local interpre-
tations of the inheritance from India. For example, a strik-
ingly beautiful style of Buddhist sculpture in Thailand, one
with distinct iconographic elements, has been identified
based on the 1964 discovery of a hoard of images in an
underground burial chamber in the vicinity of Prakhon
Chai, Buriram Province, near the modern border with
Cambodia. Distinguished by exquisite craftsmanship and a
charming naturalism, enhanced by inlaid materials for the
eyes, a standing figure of the Buddha Maitreya (FIG. 9–28)
exemplifies the lithe and youthful proportions typical of the
Prakhon Chai style. The iconography departs from the
princely interpretation of the Buddha, presenting instead
ascetic elements—abbreviated clothing and a loose arrange-
ment of long hair. The esoteric (tantric) associations of these

9–29 BUDDHA SHAKYAMUNI
Mon Dvaravati period, Thailand. 9th century. Sandstone.
Norton Simon Museum, Los Angeles.

features are further emphasized by the multiple forearms, an
element which was highly developed in Hindu sculpture and
which came to be common in esoteric Buddhist art.

THAILAND—DVARAVATI STYLE. The Dvaravati kingdom, of
Mon people, flourished in central Thailand from at least the
sixth to the eleventh century. This kingdom embraced Ther-
avada Buddhism and produced some of the earliest Buddhist
images in Southeast Asia, based on pre-Gupta period Indian
models. During the later centuries, Dvaravati sculptors
restated elements of the Gupta style (SEE FIG. 9–16), and
introduced Mon characteristics into classical forms inherited
from India (FIG. 9–29).

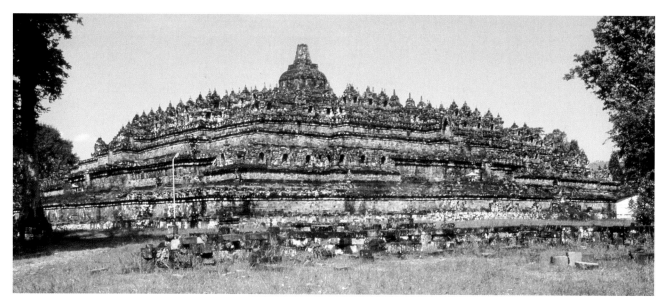

9–30　**BOROBUDUR**
Central Java, Indonesia. c. 800 CE.

9–31　**PLAN OF BOROBUDUR**

9–32　**COURTLY ATTENDANTS**
Detail of a narrative relief sculpture, Borobudur.

JAVA—BOROBUDUR.　The most monumental of Buddhist sites in Southeast Asia is Borobudur (FIGS. 9–30, 9–31) in central Java, an island of Indonesia. Built about 800 CE and rising more than 100 feet from ground level, this stepped pyramid of volcanic-stone blocks is surmounted by a large stupa, itself ringed by seventy-two smaller openwork stupas. Probably commissioned to celebrate the Buddhist merit of the Shailendra rulers, the monument expresses a complex range of Mahayana symbolism, incorporating earthly and cosmic realms. Jataka tales and other Buddhist themes are elaborately narrated in the reliefs of the lower galleries (FIG. 9–32), and more than 500 sculptures of transcendental Buddhas on the balustrades and upper terraces complete the monument, conceived as a *mandala* in three dimensions (SEE FIG. 9–32).

CAMBODIA—ANGKOR VAT.　In Cambodia (Kampuchea), Khmer kings ruled at Angkor more than four hundred years from the ninth to the thirteenth century. Among the state

temples, Buddhist as well as Hindu, they built Angkor Vat (FIG. 9–33), the crowning achievement of Khmer architecture. Angkor had already been the site of royal capitals of the Khmer, who had for centuries vested temporal as well as spiritual authority in their kings, long before King Suryavarman II (ruled 1113–1150) began to build the royal complex known today as Angkor Vat. Dedicated to the worship of Vishnu, the vast array of structures is both a temple and a symbolic cosmic mountain. The complex incorporates a stepped pyramid with five towers set within four enclosures of increasing perimeter. Suryavarman's predecessors had associated themselves with Hindu and Buddhist deities at Angkor by building sacred structures. His construction pairs him with Vishnu to affirm his royal status as well as his ultimate destiny of union with the Hindu god. Low-relief sculptures illustrate scenes from the *Ramayana,* the *Mahabharata,* and other Hindu texts, and also depict Suryavarman II with his armies (FIG. 9–34).

SRI LANKA. Often considered a link to Southeast Asia, the island of Sri Lanka is so close to India's southeastern coast that Ashoka's son is said to have brought Buddhism there within his father's lifetime. Sri Lanka played a major role in the strengthening of Theravada traditions, especially by pre-

Sequencing Works of Art

c. 800 CE	Borobudur, Central Java, Indonesia
1003–10 CE	Rajarajeshvara Temple to Shiva, Thanjavur, India
11th–12th century CE	Parinirvana of the Buddha, Gal Vihara, Sri Lanka
12th century CE	Angkor Vat, Angkor, Cambodia

serving scriptures and relics, and it became a focal point for the Theravada Buddhist world. Sri Lankan sculptors further refined Indian styles and iconography in colossal Buddhist sculptures. The rock-cut Parinirvana of the Buddha at Gal Vihara (FIG. 9–35) is one of three colossal Buddhas at the site. This serene and dignified image restates one of the early themes of Buddhist art, that of the Buddha's final transcendence, with a sophistication of modeling and proportion that updates and localizes the classical Buddhist tradition.

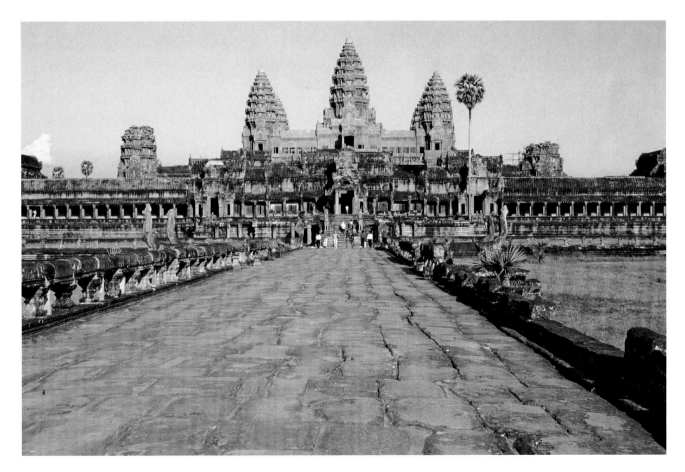

9–33 ANGKOR VAT
Angkor, Cambodia. 12th century.

9–34 BATTLE SCENE
Detail of relief sculpture, Angkor Vat.

IN PERSPECTIVE

The earliest civilization of South Asia arose in the Indus River valley. Like contemporaneous early civilizations in the Aegean, Mesopotamia, and Egypt, this civilization is remarkable for its sophisticated town planning, advanced architectural monuments, and means of record keeping, using seals and a written language. Its distinctive pictorial and sculptural representation established a strong precedent for later Indian art, both in its sensitivity to modeling of the human form and in its symbolic representation of supernatural motifs.

The subsequent rise of Buddhism in India gave Asia a rich pictorial and sculptural tradition. The narratives of the Buddha's life and his previous incarnations provided a major theme for art throughout East Asia and Southeast Asia. The anthropomorphic image of the Buddha himself, which first appeared in the Indian subcontinent during the early centuries of the Common Era, gave expressive form for the veneration of an earthly teacher and served as the basis for the celestial Buddhas envisioned by Mahayana Buddhists everywhere.

The rise of Hinduism surpassed the Buddhist tradition in South Asia. Hindu monuments explored a divine geometry in multitiered roofs and sequenced entrances. Sculptures of Hindu deities combined heroic, superhuman physical attributes with humane grace. Exquisite in proportion and supple in their dancelike poses, these painted and sculpted Hindu divinities set a style that remains classical today.

Southeast Asian art generally expressed the ideals of Theravada Buddhism. Strong traces of a concept of divine kingship were also made manifest by ambitious ruler-patrons, especially in Cambodia and Indonesia, and their influence may still be seen in later centuries. Within that tradition, elements of the sculptural styles originating in India were developed into Southeast Asian works of sublime beauty.

**9–35 PARINIRVANA
OF THE BUDDHA**
Gal Vihara, near Polonnaruwa,
Sri Lanka, 11th–12th century.
Stone.

SEAL IMPRESSIONS
c. 2500–1500 BCE

YAKSHI HOLDING A FLY-WHISK
c. 250 BCE

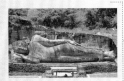

GREAT STUPA, SANCHI
c. 150–50 BCE

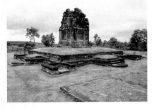

VISHNU TEMPLE AT DEOGARH
c. 530 CE

**PARINIRVANA OF
THE BUDDHA**
11ᵀᴴ–12ᵀᴴ CENTURY CE

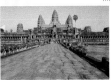

ANGKOR VAT
12ᵀᴴ CENTURY CE

3000
BCE

1500

400

200

200
CE

400

600

800

1000

1200

ART OF SOUTH AND SOUTHEAST ASIA BEFORE 1200

◀ **Indus Valley Civilization**
c. 2600–1900 BCE

◀ **Vedic Period** c. 1750–322 BCE

◀ **Shakyamuni Buddha** c. 563–483 BCE

◀ **Maurya** c. 322–185 BCE

◀ **Shunga** 185 BCE–50 CE
◀ **Early Andhra** 185 BCE–50 CE
◀ **Kushan** 1st century–3rd century CE
◀ **Later Andhra** c. 30 BCE–433 CE

◀ **Gupta** c. 320–480 CE

◀ **Dvaravati Kingdom**
6th century–11th century CE

◀ **Khmer Rule at Angkor**
9th century–13th century CE

◀ **Chola Dynasty**
Mid-9th century–late 13th century CE

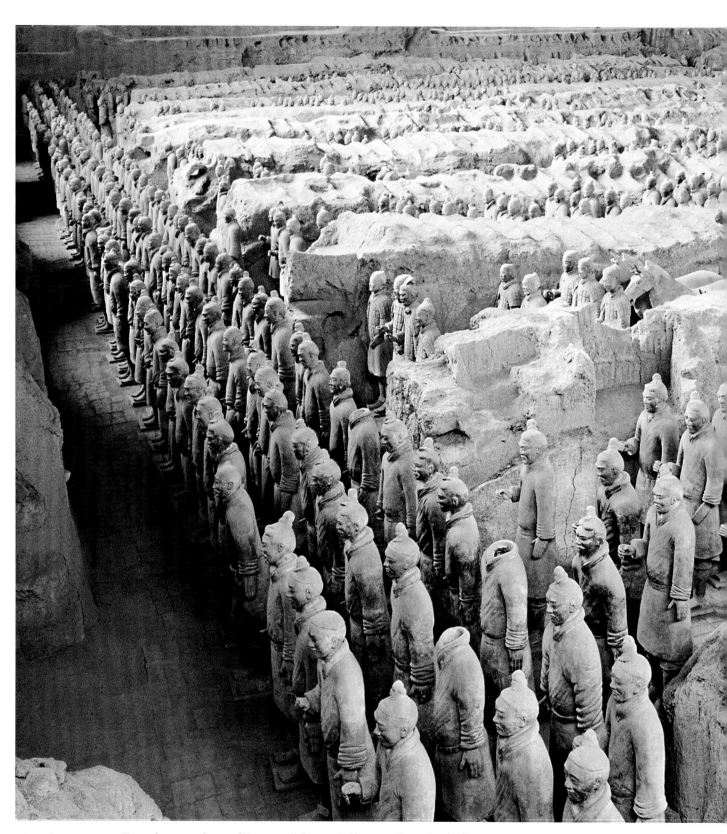

10-1 **SOLDIERS** From the mausoleum of Emperor Shihuangdi, Lintong, Shaanxi. Qin dynasty, c. 210 BCE. Earthenware, life-size.

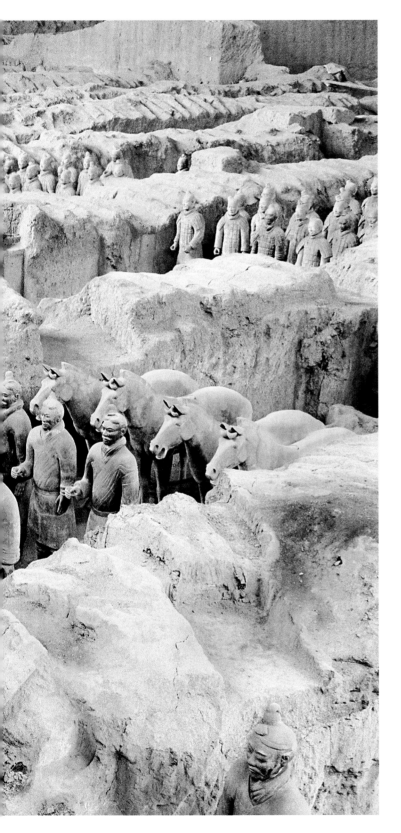

CHINESE AND KOREAN ART BEFORE 1279

10 As long as anyone could remember, the huge mound in China's Shaanxi province in northern China had been part of the landscape. No one dreamed that an astonishing treasure lay beneath the surface until one day in 1974 when peasants digging a well accidentally brought to light the first hint of the riches. When archaeologists began to excavate the mound, they were stunned by what they found: a vast underground army of more than 7,000 life-size terra-cotta soldiers and horses standing in military formation, facing east, ready for battle (FIG. 10–1). Originally painted in vivid colors, they emerged from the earth a ghostly gray. For more than 2,000 years, while the tumultuous history of China unfolded overhead, they had guarded the tomb of Emperor Shihuangdi, the ruthless ruler who first united the states of China into an empire, the Qin dynasty.

In 1990, a road-building crew in central China accidentally uncovered an even richer vault, containing perhaps tens of thousands of terra-cotta figures. Although excavations there are barely under way, the artifacts so far uncovered are exceptional both in artistic quality and in what they tell us about life—and death—during the Han dynasty, which is about 100 years later than the Qin dynasty.

China has had a long-standing traditional interest in and respect for antiquity, but archaeology is a relatively young discipline there. Only since the 1920s have scholars methodically dug into the layers of history that lie buried at thousands of sites across the country. Yet in that short period so much has been unearthed that ancient Chinese history has been rewritten many times.

THE MIDDLE KINGDOM

Among the cultures of the world, China is distinguished by its long, uninterrupted development, now traced back some 8,000 years. From Qin, pronounced "chin," comes our name for the country that the Chinese call the Middle Kingdom, the country in the center of the world. Present-day China occupies a large landmass in the center of Asia, covering an area slightly larger than the continental United States. Within its borders lives one-fifth of the human race.

The historical and cultural heart of China—sometimes called Inner China—is the land watered by its three great rivers, the Yellow, the Yangzi, and the Xi (MAP 10–1). The Qinling Mountains divide Inner China into north and south, regions with strikingly different climates, cultures, and historical fates. In the south, the Yangzi River flows through lush green hills to the fertile plains of the delta. Along the southern coastline, rich with natural harbors, arose China's port cities, the focus of a vast maritime trading network. The Yellow River, nicknamed "China's Sorrow" because of its disastrous floods, winds through the north. The north country is a dry land of steppe and desert, hot in the summer and lashed by cold winds in the winter. Over its vast and vulnerable frontier have come the nomadic invaders that are a recurring theme in Chinese history, but caravans and emissaries from Central Asia, India, Persia, and, eventually, Europe also crossed this border.

NEOLITHIC CULTURES

Early archaeological evidence had led scholars to believe that agriculture, the cornerstone technology of the Neolithic period, made its way to China from the ancient Near East. More recent findings, however, suggest that agriculture based on rice and millet arose independently in East Asia before 5000 BCE and that knowledge of Near Eastern grains followed some 2,000 years later. One of the clearest archaeological signs of Neolithic culture in China is evidence of the vigorous emergence of towns and cities. At Jiangzhai, near modern Xi'an, for example, the foundations of more than 100 dwellings have been discovered surrounding the remains of a community center, a cemetery, and a kiln. Dated to about 4000 BCE, the ruins point to the existence of a highly developed early society. Elsewhere in China, the foundations of the earliest known palace have been uncovered and dated to about 2000 BCE.

Painted Pottery Cultures

In China, as in other places, distinctive forms of Neolithic pottery identify different cultures. One of the most interesting objects thus far recovered is a shallow red bowl with a turned-out rim (FIG. 10–2). Found in the village of Banpo near the Yellow River, it was crafted sometime between 5000 and 4000 BCE. The bowl is an artifact of the Yangshao culture, one of the most important of the so-called Painted Pottery cultures of Neolithic China. Although the potter's wheel had not yet been developed, the bowl is perfectly round and its surfaces are highly polished, bearing witness to a distinctly advanced technology. The decorations are especially intriguing. The marks on the rim may be evidence of the beginnings of writing in China, which was fully developed by the time the first definitive examples appear during the second millennium BCE, in the later Bronze Age.

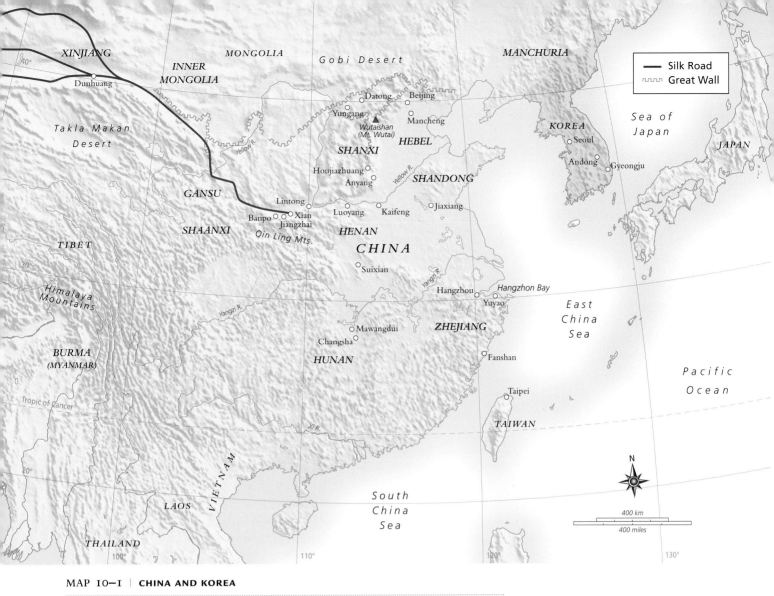

MAP 10–1 | **CHINA AND KOREA**

The heart of China is crossed by three great rivers—the Yellow, Yangzi, and Xi—and is divided into northern and southern regions by the Qinling Mountains.

10–2 | **BOWL**
Banpo, near Xi'an, Shaanxi. Neolithic period, Yangshao culture, 5000–4000 BCE. Painted pottery, height 7″ (17.8 cm). Banpo Museum.

Inside the bowl, a pair of stylized fish suggests that fishing was an important activity for the villagers. The image between the two fish represents a human face with four more fish, one on each side. Although there is no certain interpretation of the image, it may be a depiction of an ancestral figure who could assure an abundant catch, for the worship of ancestors and nature spirits was a fundamental element of later Chinese beliefs.

Liangzhu Culture

Banpo lies near the great bend in the Yellow River, in the area traditionally regarded as the cradle of Chinese civilization, but archaeological finds have revealed that Neolithic cultures arose over a far broader area. Recent excavations in sites more than 800 miles away, near the Hangzhou Bay, in the southeastern coastal region, have turned up half-human, half-animal images more than 5,000 years old (FIG. 10–3). Large, round eyes, a flat nose, and a rectangular mouth protrude

10–3 | **IMAGE OF A DEITY**
Detail from a *cong* (SEE FIG. 10-4 for schematic of a complete *cong*) recovered from Tomb 12, Fanshan, Yuyao, Zhejiang. Neolithic period, Liangzhu culture, before 3000 BCE. Jade, 3½ × 6⅞″ (8.8 × 17.5 cm). Zhejiang Provincial Museum, Hangzhou.

slightly from the background pattern of wirelike lines. Above the forehead, a second, smaller face grimaces from under a huge headdress. The image is one of eight that were carved in **low relief** on the outside of a large jade **cong**, an object resembling a cylindrical tube encased in a rectangular block **(FIG. 10–4)**. This *cong* must have been an object of importance, for it was found near the head of a person buried in a large tomb at the top of a mound that served as an altar. Hundreds of jade objects have been recovered from this mound, which measures about 66 feet square and rises in three levels.

10–4 | **SCHEMATIC DRAWING OF A CONG**

The *cong* is one of the most prevalent and mysterious of early Chinese jade shapes. Originating in the Neolithic era, it continued to play a prominent role in burials through the Shang and Zhou dynasties. Many scholars believe that the *cong* was connected with the practice of contacting the spirit world. They suggest that the circle symbolized heaven; the square, earth; and the hollow, the axis connecting these two realms. The animals found carved on many *cong* may have portrayed the priest's helpers or alter egos.

The intricacy of the carving shows the technical sophistication of this jade-working culture, named the Liangzhu, which seems to have emerged around 3300 BCE. Jade, a stone cherished by the Chinese throughout their history, is extremely hard and is difficult to carve. Liangzhu artists must have used sand as an abrasive to slowly grind the stone down, but we can only wonder at how they produced such fine work.

The meaning of the masklike image is open to interpretation. Its combination of human and animal features seems to show how the ancient Chinese imagined supernatural beings, either deities or dead ancestors. Similar masks later formed the primary decorative motif of Bronze Age ritual objects. Still later, Chinese historians began referring to the ancient mask motif as **taotie**, but the motif's original meaning had already been lost. The jade carving here seems to be a forerunner of this most central and mysterious image. This would suggest that, despite origins miles apart, various separate Neolithic cultures merged to form a single civilization in China.

BRONZE AGE CHINA

China entered its Bronze Age in the second millennium BCE. As with agriculture, scholars at first theorized that the technology had been imported from the Near East. Archaeological evidence now makes clear, however, that bronze casting using the **piece-mold casting** technique arose independently in China, where it attained an unparalleled level of excellence (see "Piece-Mold Casting," page 347).

Shang Dynasty

Traditional Chinese histories tell of three Bronze Age dynasties: the Xia, the Shang, and the Zhou. Modern scholars had tended to dismiss the Xia and Shang as legendary, but twentieth-century archaeological discoveries fully established the historical existence of the Shang (c. 1700–1100 BCE) and point strongly to the historical existence of the Xia as well.

Shang kings ruled from a succession of capitals in the Yellow River Valley, where archaeologists have found walled cities, palaces, and vast royal tombs. Their state was surrounded by numerous other states—some rivals, others clients—and their culture spread widely. Society seems to have been highly stratified, with a ruling group that had the bronze technology needed to make weapons. They maintained their authority in part by claiming power as intermediaries between the supernatural and human realms. The chief Shang deity, Shangdi, may have been a sort of "Great Ancestor." Nature and fertility spirits were also honored, and regular sacrifices were believed necessary to keep the spirits of dead ancestors alive so that they might help the living.

Shang priests communicated with the supernatural world through **oracle** bones. An animal bone or piece of tortoiseshell was inscribed with a question and heated until it cracked, then the crack was interpreted as an answer. Oracle

Technique
PIECE-MOLD CASTING

The early **piece-mold** technique for bronze casting is different from the **lost-wax** process developed in the ancient Mediterranean and Near East. Although we do not know the exact steps ancient Chinese artists followed, we can deduce the general procedure for casting a simple vessel.

First, a model of the bronze-to-be was made of clay and dried. Then, to create a mold, damp clay was pressed onto the model; after the clay mold dried, it was cut away in pieces, which were keyed for later reassembly and then fired. The original model itself was shaved down to serve as the core for the mold. After this, the pieces of the mold were reassembled around the core and held in place by bronze spacers, which locked the core in position and ensured an even casting space around the core. The reassembled mold was then covered with another layer of clay, and a sprue, or pouring duct, was cut into the clay to receive the molten metal. A *riser duct* may also have been cut to allow the hot gases to escape. Molten bronze was then poured into the mold. When the metal cooled, the mold was broken apart to reveal a bronze copy of the original clay model. Finely cast relief decoration could be worked into the model or carved into the sectional molds, or both. Finally, the vessel could be burnished—a long process that involved scouring the surface with increasingly fine abrasives.

bones, many of which have been recovered and deciphered, contain the earliest known form of Chinese writing, a script fully recognizable as the ancestor of the system still in use today (see "Chinese Characters," page 348).

RITUAL BRONZES. Shang tombs reveal a warrior culture of great splendor and violence. Many humans and animals were sacrificed to accompany the deceased. In one tomb, for example, chariots were found with the skeletons of their horses and drivers; in another, dozens of human skeletons lined the approaches to the central burial chamber. The tombs contain hundreds of jade, ivory, and lacquer objects, gold and silver ornaments, and bronze vessels. The enormous scale of Shang burials illustrates the great wealth of the civilization and the power of a ruling class able to consign such great quantities of treasure to the earth, as well as this culture's reverence for the dead.

Bronze vessels are the most admired and studied of Shang artifacts. Like oracle bones and jade objects, they were connected with ritual practices, serving as containers for offerings of food and wine. A basic repertoire of about thirty shapes evolved. Some shapes clearly derive from earlier pottery forms, others seem to reproduce wooden containers, while still others are purely sculptural and take the form of fantastic composite animals.

The illustrated bronze **FANG DING**, a square vessel with four legs, is one of hundreds of vessels recovered from the royal tombs near the last of the Shang capitals, Yin, present-day Anyang (**FIG. 10–5**). Weighing more than 240 pounds, it is one of the largest Shang bronzes ever recovered. In typical Shang style, its surface is decorated with a complex array of images based on animal forms. The *taotie*, usually so prominent, does not appear. Instead, a large deer's head adorns the center of each side, and images of deer are repeated on each of the four legs. The rest of the surface is filled with images resembling birds, dragons, and other fantastic creatures. Such images seem to be related to the hunting life of the Shang, but their deeper significance is unknown. Sometimes strange, sometimes fearsome, Shang creatures seem always to have a sense of mystery, evoking the Shang attitude toward the supernatural world.

10–5 FANG DING
Tomb 1004, Houjiazhuang, Anyang, Henan. Shang dynasty, Anyang period, c. 12th century BCE. Bronze, height 24½" (62.2 cm). Academia Sinica, Taipei, Taiwan.

Art and Its Context
CHINESE CHARACTERS

Each word in Chinese is represented by its own unique symbol, called a character. Some characters originated as **pictographs**, images that mean what they depict. Writing reforms over the centuries have often disguised the resemblance, but if we place modern characters next to their oracle-bone ancestors, the picture comes back into focus:

	water	horse	moon	child	tree	mountain
Ancient						
Modern						

Other characters are **ideographs**, pictures that represent abstract concepts or ideas:

sun + moon = bright

日　月　明

woman + child = good

女　子　好

Most characters were formed by combining a radical, which gives the field of meaning, with a phonetic, which originally hinted at pronunciation. For example, words that have to do with water have the character for "water" 水 abbreviated to three strokes 氵 as their radical.

Thus "to bathe," 沐 pronounced *mu*, consists of the water radical and the phonetic 木, which by itself means "tree" and is also pronounced *mu*. Here are other "water" characters. Notice that the connection to water is not always literal.

river	sea	weep	pure, clear	extinguish, destroy
河	海	泣	清	滅

These phonetic borrowings took place centuries ago. Many words have shifted in pronunciation, and for this and other reasons there is no way to tell how a character is pronounced or what it means just by looking at it. While at first this may seem like a disadvantage, in the case of Chinese it is actually a strength. Spoken Chinese has many dialects. Some are so far apart in sound as to be virtually different languages. But while speakers of different dialects cannot understand each other, they can still communicate through writing, for no matter how they say a word, they write it with the same character. Writing has thus played an important role in maintaining the unity of Chinese civilization through the centuries.

Zhou Dynasty

Around 1100 BCE, the Shang were conquered by the Zhou from western China. During the Zhou dynasty (1100–221 BCE) a feudal society developed, with nobles related to the king ruling over numerous small states. (Zhou nobility are customarily ranked in English by such titles as duke and marquis.) The supreme deity became known as Tian, or Heaven, and the king ruled as the Son of Heaven. Later Chinese ruling dynasties continued to follow the belief that imperial rule emanated from a mandate from Heaven.

The first 300 years of this longest Chinese dynasty were generally stable and peaceful. In 771 BCE, however, the Zhou suffered defeat at the hands of a nomadic tribe in the west. Although they quickly established a new capital to the east, their authority had been crippled, and the later Eastern Zhou period was a troubled one. States grew increasingly independent, giving the Zhou kings merely nominal allegiance. Smaller states were swallowed up by their larger neighbors. During the time historians call the Spring and Autumn period (722–481 BCE), ten or twelve states, later reduced to seven, emerged as powers. During the ensuing Warring States period (481–221 BCE), intrigue, treachery, and increasingly ruthless warfare became routine.

Against this background of constant social turmoil, China's great philosophers arose—such thinkers as Confucius, Laozi, and Mozi. Traditional histories speak of China's "one hundred schools" of philosophy, indicating a shift of focus from the supernatural to the human world. Nevertheless, elaborate burials on an even larger scale than before reflected the continuation of traditional beliefs.

BRONZE BELLS. Ritual bronze objects continued to play an important role during the Zhou dynasty, and new forms developed. One of the most spectacular recent discoveries is a carillon of sixty-five bronze bells arranged in a formation 25 feet long (FIG. 10–6), found in the tomb of Marquis Yi of the state of Zeng. Each bell is precisely calibrated to sound two tones—one when struck at the center, another when struck nearer the rim. The bells are arranged in scale patterns in a variety of registers, and several musicians would have moved around the carillon, striking the bells in the appointed order.

Music may well have played a part in rituals for communicating with the supernatural, for the *taotie* typically appears on the front and back of each bell. The image is now much more intricate and stylized, partly in response to the refinement available with the **lost-wax casting** process (see "Lost-Wax Casting," page xxx), which had replaced the older piece-mold technique. On the coffin of the marquis are painted guardian warriors with half-human, half-animal attributes. The marquis, who died in 433 BCE, must have been a great lover of music, for among the more than 15,000 objects recovered from his tomb were many musical instruments.

10–6 | SET OF SIXTY-FIVE BELLS
Tomb of Marquis Yi of Zeng, Suixian, Hubei. Zhou dynasty, 433 BCE. Bronze, with bronze and timber frame, frame height 9′ (2.74 m), length 25′ (7.62 m). Hubei Provincial Museum, Wuhan.

Zeng was one of the smallest and shortest-lived states of the Eastern Zhou, but the contents of this tomb, in quantity and quality, attest to the high level of its culture.

THE CHINESE EMPIRE: QIN DYNASTY

Toward the middle of the third century BCE, the state of Qin launched military campaigns that led to its triumph over the other states by 221 BCE. For the first time in its history, China was united under a single ruler. This first emperor of Qin, Shihuangdi, a man of exceptional ability, power, and ruthlessness, was fearful of both assassination and rebellion. Throughout his life, he sought ways to attain immortality. Even before uniting China, he began his own **mausoleum** at Lintong, in Shaanxi province. This project continued throughout his life and after his death, until rebellion abruptly ended the dynasty in 206 BCE. Since that time, the mound over the mausoleum has always been visible, but not until an accidental discovery in 1974 was its army of terra-cotta soldiers and horses even imagined (SEE FIG. 10–1). Modeled from clay and then fired, the figures claim a prominent place in the great tradition of Chinese ceramic art. Individualized faces and meticulously rendered uniforms and armor demonstrate the sculptors' skill. Literary sources suggest that the tomb itself, which has not yet been opened, reproduces the world as it was known to the Qin, with stars overhead and rivers and mountains below. Thus did the tomb's architects try literally to ensure that the underworld—the world of souls and spirits—would match the human world.

Qin rule was harsh and repressive. Laws were based on a totalitarian philosophy called legalism, and all other philosophies were banned, their scholars executed, and their books burned. Yet the Qin also established the mechanisms of centralized bureaucracy that molded China both politically and culturally into a single entity. Under the Qin, the country was divided into provinces and prefectures, the writing system and coinage were standardized, roads were built to link different parts of the country with the capital, and battlements on the northern frontier were connected to form the Great Wall. China's rulers to the present day have followed the administrative framework first laid down by the Qin.

HAN DYNASTY

The commander who overthrew the Qin became the next emperor and founded the Han dynasty (206 BCE–220 CE). During this period the Chinese enjoyed a peaceful, prosperous, and stable life. Borders were extended and secured, and Chinese control over strategic stretches of Central Asia led to the opening of the Silk Road, a land route that linked China by trade all the way to Rome. One of the precious goods traded, along with spices, was silk, which had been cultivated and woven in China since at least the third millennium BCE. From as early as the third century BCE, Chinese silk cloth was treasured in Greece and Rome (for more on this topic, see "The Silk Road during the Tang Period," page 350).

PAINTED BANNER FROM CHANGSHA. The early Han dynasty marks the twilight of China's so-called mythocentric age, when people believed in a close relationship between the human and supernatural worlds. The most elaborate and most intact painting that survives from this time is a T-shaped silk

THE ⊙BJECT SPEAKS

THE SILK ROAD DURING THE TANG PERIOD

Under a series of ambitious and forceful Tang emperors, Chinese control once again extended over Central Asia. Goods, ideas, and influence flowed across the Silk Road. In the South China Sea, Arab and Persian ships carried on a lively trade with coastal cities. Chinese cultural influence in East Asia was so important that Japan and Korea sent thousands of students to study Chinese civilization.

Cosmopolitan and tolerant, Tang China was confident and curious about the world. Many foreigners came to the splendid new capital Chang'an (present-day Xi'an), and they are often depicted in the art of the period. A ceramic statue of a camel carrying a troupe of musicians reflects the Tang fascination with the "exotic" Turkic cultures of Central Asia. The three bearded musicians (one with his back to us) are Central Asian, while the two smooth-shaven ones are Han Chinese. Bactrian, or two-humped camels, themselves exotic Central Asian "visitors," were beasts of burden in the caravans that traversed the Silk Road. The stringed lute (which the Chinese called the *pipa*) came from Central Asia to become a lasting part of Chinese music.

Stylistically, the statue reveals a new interest in **naturalism**, an important trend in both painting and sculpture. Compared with the rigid, staring ceramic soldiers of the first emperor of Qin, this Tang band is alive with gesture and expression. The majestic camel throws its head back; the musicians are vividly captured in mid-performance. Ceramic figurines such as this, produced by the thousands for Tang tombs, offer glimpses into the gorgeous variety of Tang life. The statue's three-color **glaze** technique was a specialty of Tang ceramicists. The glazes—usually chosen from a restricted palette of amber, yellow, green, and white—were splashed freely and allowed to run over the surface during firing to convey a feeling of spontaneity. The technique is emblematic of Tang culture itself in its robust, colorful, and cosmopolitan expressiveness.

The Silk Road had first flourished in the second century CE. A 5,000-mile network of caravan routes from the Han capital near present-day Luoyang, Henan, on the Yellow River to Rome, it brought Chinese luxury goods to Western markets.

The journey began at the Jade Gate (Yumen), at the westernmost end of the Great Wall, where Chinese merchants turned their goods over to Central Asian traders. Goods would change hands many more times before reaching the Mediterranean. Caravans headed first for the nearby desert oasis of Dunhuang. Here northern and southern routes diverged to skirt the vast Taklamakan Desert. At Khotan, in western China, farther west than the area shown in map 10–1, travelers on the southern route could turn off toward a mountain pass into Kashmir, in northern India. Or they could continue on, meeting up with the northern route at Kashgar, on the western border of the Taklamakan, before proceeding over the Pamir Mountains into present-day Afghanistan. There, travelers could turn off into present-day Pakistan and India, or travel west through present-day Uzbekistan, Iran, and Iraq, arriving finally at Antioch, in Syria, on the coast of the Mediterranean. From there, land and sea routes led on to Rome.

CAMEL CARRYING A GROUP OF MUSICIANS
Tomb near Xi'an, Shanxi. Tang dynasty, c. mid-8th century CE. Earthenware with three-color glaze, height 26⅛" (66.5 cm). National Museum, Beijing.

banner, which summarizes this early worldview (FIG. 10–7). Found in the tomb of a noblewoman on the outskirts of present-day Changsha, the banner dates from the second century BCE and is painted with scenes representing three levels of the universe: heaven, earth, and underworld.

The heavenly realm is shown at the top, in the crossbar of the T. In the upper-right corner is the sun, inhabited by a mythical crow; in the upper left, a mythical toad stands on a crescent moon. Between them is a primordial deity shown as a man with a long serpent's tail—a Han image of the Great Ancestor. Dragons and other celestial creatures swarm below.

A gate guarded by two seated figures stands where the horizontal of heaven meets the banner's long, vertical stem.

10–7 | PAINTED BANNER
Tomb of the Marquess of Dai, Mawangdui, Changsha, Hunan. Han dynasty, c. 160 BCE. Colors on silk, height 6'8½" (2.05 m). National Museum, Beijing.

Two intertwined dragons loop through a circular jade piece known as a **bi**, itself usually a symbol of heaven, dividing this vertical segment into two areas. The portion above the *bi* represents the earthly realm. Here, the deceased woman and her three attendants stand on a platform while two kneeling figures offer gifts. The portion beneath the *bi* represents the underworld. Silk draperies and a stone chime hanging from the *bi* form a canopy for the platform below. Like the bronze bells we saw earlier, stone chimes were ceremonial instruments dating from Zhou times. On the platform, ritual bronze vessels contain food and wine for the deceased, just as they did in Shang tombs. The squat, muscular man holding up the platform stands in turn on a pair of fish whose bodies form another *bi*. The fish and the other strange creatures in this section are inhabitants of the underworld.

Philosophy and Art

While marking the end of the mythocentric age, the Han dynasty also marked the beginning of a new age. During this dynasty, the philosophical ideals of Daoism and Confucianism, formulated during the troubled times of the Eastern Zhou, became central to Chinese thought. Their influence since then has been continuous and fundamental.

DAOISM AND NATURE. Daoism emphasizes the close relationship between humans and nature. It is concerned with bringing the individual life into harmony with the *Dao*, or the Way, of the universe (see "Daoism," page 352). For some a secular, philosophical path, Daoism on a popular level developed into an organized religion, absorbing many traditional folk practices and the search for immortality.

Immortality was as intriguing to Han rulers as it had been to the first emperor of Qin. Daoist adepts experimented endlessly with diet, physical exercise, and other techniques in the belief that immortal life could be achieved on earth. A popular Daoist legend told of the Isles of the Immortals in

Myth and Religion
DAOISM

Daoism is an outlook on life that brings together many ancient ideas regarding humankind and the universe. Its primary text, a slim volume called the *Daodejing*, or *The Way and Its Power*, is ascribed to the Chinese philosopher Laozi, who is said to have been a contemporary of Confucius (551–479 BCE). Later, a philosopher named Zhuangzi (369–286 BCE) took up many of the same ideas in a book that is known simply by his name, *Zhuangzi*. Together the two texts formed a body of ideas that crystallized into a school of thought during the Han period.

A *dao* is a way or path. The *Dao* is the Ultimate Way, the Way of the universe. The Way cannot be named or described, but it can be hinted at. It is like water. Nothing is more flexible and yielding, yet water can wear down the hardest stone. Water flows downward, seeking the lowest ground. Similarly, a Daoist sage seeks a quiet life, humble and hidden, unconcerned with worldly success. The Way is great precisely because it is small. The Way may be nothing, yet nothing turns out to be essential.

To recover the Way, we must unlearn. We must return to a state of nature. To follow the Way, we must practice *wu wei*, or nondoing. "Strive for nonstriving," advises the *Daodejing*.

All our attempts at asserting ourselves, at making things happen, are like swimming against a current and thus ultimately futile, even harmful. If we let the current carry us, however, we will travel far. Similarly, a life that follows the Way will be a life of pure effectiveness, accomplishing much with little effort.

It is often said that the Chinese are Confucians in public and Daoists in private, and the two approaches do seem to balance each other. Confucianism is a rational political philosophy that emphasizes propriety, deference, duty, and self-discipline. Daoism is an intuitive philosophy that emphasizes individualism, nonconformity, and a return to nature. If a Confucian education molded scholars outwardly into responsible, ethical officials, Daoism provided some breathing room for the artist and poet inside.

10–8 | INCENSE BURNER
Tomb of Prince Liu Sheng, Mancheng, Hebei. Han dynasty, 113 BCE. Bronze with gold inlay, height 10½" (26 cm). Hebei Provincial Museum, Shijiazhuang.

the Eastern Sea, depicted on a bronze incense burner from the tomb of Prince Liu Sheng, who died in 113 BCE (FIG. 10–8). Around the bowl, gold inlay outlines the stylized waves of the sea. Above them rises the mountainous island, busy with birds, animals, and people who had discovered the secret of immortality. Technically, this exquisite piece represents the ultimate development of the long tradition of bronze casting in China.

CONFUCIANISM AND THE STATE. In contrast to the metaphysical focus of Daoism, Confucianism is concerned with the human world, and its goal is the attainment of equity. To this end, it proposes a system of ethics based on reverence for ancestors and the correct relationships among people. Beginning with self-discipline in the individual, Confucianism teaches to rectify relationships within the family, and then, in ever-widening circles, with friends and others, all the way up to the level of the emperor and the state (see "Confucius and Confucianism," page 355).

10–9 | **DETAIL FROM A RUBBING OF A STONE RELIEF IN THE WU FAMILY SHRINE (WULIANGCI)**
Jiaxiang, Shandong. Han dynasty, 151 CE, 27½ × 66½″ (70 × 169 cm).

Emphasis on social order and respect for authority made Confucianism especially attractive to Han rulers, who were eager to distance themselves from the disastrous legalism of the Qin. The Han emperor Wudi (ruled 141–87 BCE) made Confucianism the official imperial philosophy, and it remained the state ideology of China for more than 2,000 years, until the end of imperial rule in the twentieth century. Once institutionalized, Confucianism took on so many rituals that it too eventually assumed the form and force of a religion. Han philosophers contributed to this process by infusing Confucianism with traditional Chinese cosmology. They emphasized the Zhou idea, taken up by Confucius, that the emperor ruled by the mandate of Heaven. Heaven itself was reconceived more abstractly as the moral force underlying the universe. Thus the moral system of Confucian society became a reflection of the universal order (see "Confucius and Confucianism," page 355).

Confucian subjects turn up frequently in Han art. Among the most famous examples are the reliefs from the Wu family shrines built in 151 CE in Jiaxiang. Carved and engraved in low relief on stone slabs, the scenes were meant to teach Confucian themes such as respect for the emperor, filial piety, and wifely devotion. Daoist motifs also appear, as do figures from traditional myths and legends. Such mixed **iconography** is characteristic of Han art.

One relief shows a two-story building, with women in the upper floor and men in the lower (FIG. 10–9). The central figures in both floors are receiving visitors, some of whom bear gifts. The scene seems to depict homage to the first emperor of the Han dynasty, indicated by his larger size. The birds and small figures on the roof may represent mythical creatures and immortals, while to the left the legendary archer Yi shoots at one of the sun-crows. (Myths tell how Yi shot all but one of the ten crows of the ten suns so that the earth would not dry out.) Across the lower register, a procession brings more dignitaries to the reception.

When compared with the Han dynasty banner (SEE FIG. 10–7), this late Han relief clearly shows the change that took place in the Chinese worldview in the span of 300 years. The banner places equal emphasis on heaven, earth, and the underworld; human beings are dwarfed by a great swarming of supernatural creatures and divine beings. In the relief of the Wu shrine, the focus is clearly on the human realm (FIG. 10–9). The composition conveys the importance of the emperor as the holder of the mandate of Heaven and illustrates the fundamental Confucian themes of social order and decorum.

Architecture

Contemporary literary sources are eloquent on the wonders of the Han capital. Unfortunately, nothing of Han architecture remains except ceramic models. One model of a house found in a tomb, where it was provided for the dead to use in the afterlife, represents a typical Han dwelling (FIG. 10–10). Its four stories are crowned with a watchtower and face a small walled courtyard. Pigs and oxen probably occupied the ground floor, while the family lived in the upper stories.

Aside from the multilevel construction, the most interesting feature of the house is the **bracketing** system supporting the rather broad eaves of its tiled roofs. Bracketing

IO–IO │ TOMB MODEL OF A HOUSE
Eastern Han dynasty, 1st–mid-2nd century CE. Painted
earthenware, 52 × 33½ × 27″ (132.1 × 85.1 × 68.6 cm).
The Nelson-Atkins Museum of Art, Kansas City, Missouri.
Purchase, Nelson Trust (33-521)

became a standard element of East Asian architecture, not
only in private homes but more typically in palaces and tem-
ples (SEE, FOR EXAMPLE, FIG. 10–16). Another interesting
aspect of the model is the elaborate painting on the exterior
walls. Much of the painting is purely decorative, though
some of it illustrates structural features such as posts and lin-
tels. Still other images evoke the world outdoors: Notice the
trees flanking the gateway with crows perched in their
branches. Literary sources describe the walls of Han palaces
as decorated with paint and lacquer and also inlaid with pre-
cious metals and stones.

SIX DYNASTIES

With the fall of the Han dynasty in 220 CE, China splintered
into three warring kingdoms. In 280 CE the empire was
briefly reunited, but invasions by nomadic peoples from Cen-
tral Asia, a source of disruption throughout Chinese history,
soon forced the court to flee south. For the next three cen-
turies, northern and southern China developed separately. In
the north, sixteen kingdoms carved out by invaders rose and
fell before giving way to a succession of largely foreign
dynasties. Warfare was commonplace. Tens of thousands of
Chinese fled south, where six short-lived dynasties succeeded

each other in an age of almost constant turmoil broadly
known as the Six Dynasties period or the period of the
Southern and Northern dynasties (265–589 CE).

In such chaos, the Confucian system lost much influ-
ence. In the south especially, many intellectuals—the creators
and custodians of China's high culture—turned to Daoism,
which contained a strong escapist element. Educated to serve
the government, they increasingly withdrew from public life.
They wandered the landscape, drank, wrote poems, practiced
calligraphy, and expressed their disdain for the world through
willfully eccentric behavior.

The rarefied intellectual escape route of Daoism was
available only to the educated elite. Far more people sought
answers in the magic and superstitions of Daoism in its reli-
gious form. Though weak and disorganized, the southern
courts continued to patronize traditional Chinese culture,
and Confucianism remained the official doctrine. Yet ulti-
mately it was a new influence—Buddhism—that brought the
greatest comfort to the troubled China of the Six Dynasties.

Painting

Although few paintings survive from the Six Dynasties, abun-
dant descriptions in literary sources make clear that the
period was an important one for painting. Landscape, later a
major theme of Chinese art, first appeared as a subject during
this era. For Daoists, wandering through China's countryside
was a source of spiritual refreshment. Painters and scholars of
the Six Dynasties found that wandering in the mind's eye
through a painted landscape could serve the same purpose.
This new emphasis on the spiritual value of painting con-
trasted with the Confucian view, which had emphasized art's
moral and didactic uses.

Reflections on the tradition of painting also inspired
the first works on theory and aesthetics. Some of the earli-
est and most succinct formulations of the ideals of Chinese
painting are the six principles set out by the scholar Xie He
(fl.c. 500–535). The first two principles in particular offer
valuable insight into the spirit in which China's painters
worked.

The first principle announces that "spirit consonance"
imbues a painting with "life's movement." This "spirit" is the
Daoist *qi*, the breath that animates all creation, the energy
that flows through all things. When a painting has *qi*, it will
be alive with inner essence, not merely outward resem-
blance. Artists must cultivate their own spirit so that this uni-
versal energy flows through them and infuses their work.
The second principle recognizes that brushstrokes are the
"bones" of a picture, its primary structural element. The
Chinese judge a painting above all by the quality of its
brushwork. Each brushstroke is a vehicle of expression; it is
through the vitality of a painter's brushwork that "spirit con-
sonance" makes itself felt. We can sense this attitude already

Art and Its Context

CONFUCIUS AND CONFUCIANISM

Confucius was born in 551 BCE in the state of Lu, roughly present-day Shandong province, into a declining aristocratic family. While still in his teens he set his heart on becoming a scholar; by his early twenties he had begun to teach.

By Confucius's lifetime, warfare for supremacy among the various states of China had begun, and the traditional social fabric seemed to be breaking down. Looking back to the early Zhou dynasty as a sort of golden age, Confucius thought about how a just and harmonious society could again emerge. For many years he sought a ruler who would put his ideas into effect, but to no avail. Frustrated, he spent his final years teaching. After his death in 479 BCE, his conversations with his students were collected by his disciples and their followers into a book known in English as the *Analects*, which is the only record of his words.

At the heart of Confucian thought is the concept of *ren*, or human-heartedness. *Ren* emphasizes morality and empathy as the basic standards for all human interaction. The virtue of *ren* is most fully realized in the Confucian ideal of the *junzi*, or gen-

tleman. Originally indicating noble birth, the term was redirected to mean one who through education and self-cultivation had become a superior person, right-thinking and right-acting in all situations. A *junzi* is the opposite of a petty or small-minded person. His characteristics include moderation, integrity, self-control, loyalty, reciprocity, and altruism. His primary concern is justice.

Together with human-heartedness and justice, Confucius emphasized *li*, or etiquette. *Li* includes everyday manners as well as ritual, ceremony, and protocol—the formalities of all social conduct and interaction. Such forms, Confucius felt, choreographed life so that an entire society moved in harmony. *Ren* and *li* operate in the realm of the Five Constant Relationships that define Confucian society: parent and child, husband and wife, elder sibling and younger sibling, elder friend and younger friend, ruler and subject. Deference to age is clearly built into this view, as is the deference to authority that made Confucianism attractive to emperors. Yet responsibilities flow the other way as well: The duty of a ruler is to earn the loyalty of subjects, of a husband to earn the respect of his wife, of age to guide youth wisely.

in the rapid, confident brushstrokes that outline the figures of the Han banner (SEE FIG. 10–7) and again in the more controlled, rhythmical lines of one of the most important of the very few works surviving from this period, a painted scroll known as *Admonitions of the Imperial Instructress to Court Ladies.* Attributed to the painter Gu Kaizhi (344–407 CE), it alternates illustrations and text to relate seven Confucian stories of wifely virtue from Chinese history.

The first illustration depicts the courage of Lady Feng (FIG. 10–11). An escaped circus bear rushes toward her husband, a Han emperor, who is filled with fear. Behind his throne, two female servants have turned to run away. Before him, two male attendants, themselves on the verge of panic, try to fend off the bear with spears. Only Lady Feng is calm as she rushes forward to place herself between the beast and the emperor.

10–11 | Attributed to Gu Kaizhi **DETAIL OF ADMONITIONS OF THE IMPERIAL INSTRUCTRESS TO COURT LADIES**
Six Dynasties period. Handscroll, ink and colors on silk, 9¾" × 11'6" (24.8 cm × 3.5 cm).
The British Museum, London.

The style of the painting is typical of the fourth century. The figures are drawn with a brush in a thin, even-width line, and a few outlined areas are filled with color. Facial features, especially those of the men, are quite well depicted. Movement and emotion are shown through conventions such as the bands flowing from Lady Feng's dress, indicating that she is rushing forward, and the upturned strings on both sides of the emperor's head, suggesting his fear. There is no hint of a setting; instead, the artist relies on careful placement of the figures to create a sense of depth.

The painting is on silk, which was typically woven in bands about 12 inches wide and up to 20 or 30 feet long. Early Chinese painters thus developed the format used here, the **handscroll**—a long, narrow, horizontal composition, compact enough to be held in the hand when rolled up. Handscrolls are intimate works, meant to be viewed by only two or three people at a time. They were not displayed completely unrolled as we commonly see them today in museums. Rather, viewers would open a scroll and savor it slowly from right to left, displaying only a foot or two at a time.

Calligraphy

The emphasis on the expressive quality and structural importance of brushstrokes finds its purest embodiment in **calligraphy**. The same brushes are used for both painting and calligraphy, and a relationship between them was recognized as early as Han times. In his teachings, Confucius had extolled the importance of the pursuit of knowledge and the arts. Among the visual arts, painting was felt to reflect moral concerns, while calligraphy was believed to reveal the style and character of the writer.

Calligraphy is regarded as one of the highest forms of expression in China. For more than 2,000 years, China's "literati," Confucian scholars and literary men who also served the government as officials, have enjoyed being connoisseurs and practitioners of this abstract art. During the fourth century, calligraphy came to full maturity. The most important practitioner of the day was Wang Xizhi (c. 307–365 CE), whose works have served as models of excellence for all subsequent generations. The example here comes from a letter, now somewhat damaged and mounted as part of an album, known as **FENG JU** (FIG. 10–12).

Feng Ju is an example of "walking" or semi-cursive style, which is neither too formal nor too free but is done in a relaxed, easygoing manner. Brushstrokes vary in width and length, creating rhythmic vitality. Individual characters remain distinct, yet within each character the strokes are run together and simplified as the brush moves from one to the other without lifting off the page. The effect is fluid and graceful, yet still strong and dynamic. The walking style as developed by Wang Xizhi came to be officially accepted and learned along with other script styles.

10–12 | **WANG XIZHI PORTION OF A LETTER FROM THE FENG JU ALBUM**
Six Dynasties period, mid-4th century CE. Ink on paper, 9¾ × 18½" (24.7 × 46.8 cm). National Palace Museum, Taipei, Taiwan, Republic of China.

The stamped characters that appear on Chinese artworks are seals—personal emblems. The use of seals dates from the Zhou dynasty, and to this day seals traditionally employ the archaic characters, known appropriately as "seal script," of the Zhou or Qin. Cut in stone, a seal may state a formal, given name, or it may state any of the numerous personal names that China's painters and writers adopted throughout their lives. A treasured work of art often bears not only the seal of its maker, but also those of collectors and admirers through the centuries. In the Chinese view, these do not disfigure the work but add another layer of interest. This sample of Wang Xizhi's calligraphy, for example, bears the seals of two Song-dynasty emperors, a Song official, a famous collector of the sixteenth century, and two Qing-dynasty emperors of the eighteenth and nineteenth centuries.

Buddhist Art and Architecture

Buddhism originated in India during the fifth century BCE (Chapter 9), then gradually spread north into Central Asia. With the opening of the Silk Road during the Han dynasty, its influence reached China. To the Chinese of the Six Dynasties, beset by constant warfare and social devastation, Buddhism offered consolation in life and the promise of salvation after death. The faith spread throughout the country to all social levels, first in the north, where many of the invaders promoted it as the official religion, then slightly later in the south, where it found its first great patron in the emperor Liang Wu Di (ruled 502–549 CE). Thousands of temples and monasteries were built, and many people became monks and nuns.

Almost nothing remains in China of the Buddhist architecture of the Six Dynasties, but we can see what it must have looked like in the Japanese temple Horyu-ji (SEE FIG. 11–6),

which was based on Chinese models of this period. The slender forms and linear grace of Horyu-ji have much in common with the figures in Gu Kaizhi's handscroll, and they indicate the delicate, almost weightless style cultivated in southern China.

ROCK-CUT CAVES OF THE SILK ROAD. The most impressive works of Buddhist art surviving from the Six Dynasties are the hundreds of northern rock-cut caves along the trade routes between Xinjiang in Central Asia and the Yellow River Valley. Both the caves and the sculptures that fill them were carved from the solid rock of the cliffs. Small caves high above the ground were retreats for monks and pilgrims, while larger caves at the base of the cliffs were wayside shrines and temples.

The caves at Yungang, in Shanxi province in central China, contain many examples of the earliest phase of Buddhist sculpture in China, including the monumental **SEATED BUDDHA** in Cave 20 (FIG. 10–13). The figure was carved in the latter part of the fifth century by the imperial decree of a ruler of the Northern Wei dynasty (386–534 CE), the longest-lived and most stable of the northern kingdoms. Most Wei rulers were avid patrons of Buddhism, and under their rule the religion made its greatest advances in the north.

The front part of the cave has crumbled away, and the 45-foot statue, now exposed to the open air, is clearly visible from a distance. The elongated ears, protuberance on the head (*ushnisha*), and monk's robe are traditional attributes of the Buddha. The masklike face, full torso, massive shoulders, and shallow, stylized drapery indicate strong Central Asian influence. The overall effect of this colossus is remote and austere, less human than the more sensuous expression of the early Buddhist traditions in India.

SUI AND TANG DYNASTIES

In 581 CE, a general from the last of the northern dynasties replaced a child emperor and established a dynasty of his own, the Sui. Defeating all opposition, he molded China into a centralized empire as it had been in Han times. The short-lived Sui dynasty fell in 618 CE, but in reunifying the empire it paved the way for one of the greatest dynasties in Chinese history, the Tang (618–907 CE). Even today many Chinese living abroad still call themselves "Tang people." To them, Tang implies that part of the Chinese character that is strong and vigorous (especially in military power), noble and idealistic, but also realistic and pragmatic.

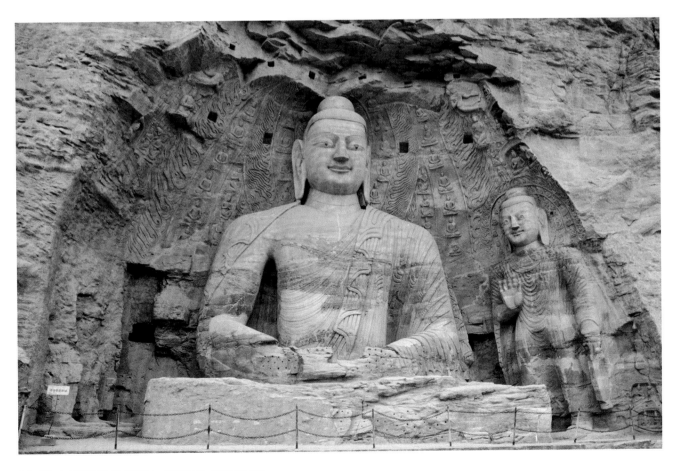

10–13 | **SEATED BUDDHA, CAVE 20, YUNGANG**
Datong, Shanxi. Northern Wei dynasty, c. 460 CE. Stone, height 45′ (13.7 m).

Buddhist Art and Architecture

The new Sui emperor was a devout Buddhist, and his reunification of China coincided with a fusion of the several styles of Buddhist sculpture that had developed. This new style is seen in a bronze altar to Amitabha Buddha (FIG. 10–14), one of the many *buddhas* of Mahayana Buddhism. Amitabha dwelled in the Western Pure Land, a paradise into which his faithful followers were promised rebirth. With its comparatively simple message of salvation, the Pure Land sect eventually became the most popular form of Buddhism in China and one of the most popular in Japan (see Chapter 11).

The altar depicts Amitabha in his paradise, seated on a lotus throne beneath a canopy of trees. Each leaf cluster is set with jewels. Seven celestial nymphs sit on the topmost clusters, and ropes of "pearls" hang from the tree trunks. Behind Amitabha's head is a halo of flames. To his left, the *bodhisattva* Guanyin holds a pomegranate; to his right, another *bodhisattva* clasps his hands in prayer. Behind are four disciples who first preached the teachings of the Buddha. On the lower level, an incense burner is flanked by seated lions and two smaller *bodhisattvas*. Focusing on Amitabha's benign

10–14 | **ALTAR TO AMITABHA BUDDHA**
Sui dynasty, 593 CE. Bronze, height 30⅛" (76.5 cm).
Museum of Fine Arts, Boston.
Gift of Mrs. W. Scott Fitz (22.407) and Gift of Edward Holmes Jackson in memory of his mother, Mrs. W. Scott Fitz (47.1407-1412)

expression and filled with objects symbolizing his power, the altar combines the sensuality of Indian styles, the schematic abstraction of Central Asian art, and the Chinese emphasis on linear grace and rhythm into a harmonious new style.

Buddhism reached its greatest development in China during the subsequent Tang dynasty, which for nearly three centuries ruled China and controlled much of Central Asia. From emperors and empresses to common peasants, virtually the entire country adopted the Buddhist faith. A Tang vision of the most popular sect, Pure Land, was expressed in a wall painting from a cave in Dunhuang (FIG. 10–15). A major stop along the Silk Road, Dunhuang has nearly 500 caves carved out of its sandy cliffs, all filled with painted clay sculpture and decorated with wall paintings from floor to ceiling. The site was worked on continuously from the fourth to the fourteenth century, a period of almost a thousand years. Rarely in art's history do we have the opportunity to study such an extended period of stylistic and iconographic evolution in one place.

In the detail shown here, Amitabha Buddha is seated in the center, surrounded by four *bodhisattvas*, who serve as his messengers to the world. Two other groups of *bodhisattvas* are clustered at the right and left. In the foreground, musicians and dancers create a heavenly atmosphere. In the background, great halls and towers rise. The artist has imagined the Western Paradise in terms of the grandeur of Tang palaces. Indeed, the lavish entertainment depicted could just as easily be taking place at the imperial court. This worldly vision of paradise, recorded with great attention to naturalism in the architectural setting, gives us our best visualization of the splendor of Tang civilization at a time when Chang'an (present-day Xi'an) was probably the greatest city in the world.

The early Tang emperors proclaimed a policy of religious tolerance, but during the ninth century a conservative reaction set in. Confucianism was reasserted and Buddhism was briefly persecuted as a "foreign" religion. Thousands of temples, shrines, and monasteries were destroyed and innumerable bronze statues melted down. Nevertheless, several Buddhist structures survive from the Tang dynasty. One of them, the Nanchan Temple, is the earliest important example of surviving Chinese architecture.

NANCHAN TEMPLE. Of the few structures earlier than 1400 CE to have survived, the Nanchan Temple is the most significant, for it shows characteristics of both temples and palaces of the Tang dynasty (FIG. 10–16). Located on Mount Wutai in the eastern part of Shanxi province, this small hall was constructed in 782 CE. The tiled roof, first seen in the Han tomb model (SEE FIG. 10–10), has taken on a curved silhouette. Quite subtle here, this curve became increasingly pronounced in later centuries. The very broad overhanging eaves are supported by a correspondingly elaborate bracketing system.

Also typical is the **bay** system of construction, in which a cubic unit of space, a bay, is formed by four posts

IO–I5 THE WESTERN PARADISE OF AMITABHA BUDDHA
Detail of a wall painting in Cave 217, Dunhuang, Gansu. Tang dynasty, c. 750 CE. 10′2″ × 16′ (3.1 × 4.86 m).

and their lintels. The bay functioned in Chinese architecture as a **module**, a basic unit of construction. To create larger structures, an architect multiplied the number of bays. Thus the Nanchan Temple—modest in scope with three bays—gives an idea of the vast, multistoried palaces of

the Tang depicted in such paintings as the one from Dunhuang (SEE FIG. 10–15).

GREAT WILD GOOSE PAGODA. Another important monument of Tang architecture is the Great Wild Goose Pagoda at the

IO–I6 NANCHAN TEMPLE, WUTAISHAN
Shanxi. Tang dynasty, 782 CE.

Ci'en Temple in Chang'an, the Tang capital (FIG. 10–17). The temple was constructed in 645 CE for the famous monk Xuanzang (600–664 CE) on his return from a sixteen-year pilgrimage to India. At Ci'en Temple, Xuanzang taught and translated the materials he had brought back with him.

The **pagoda**, a typical East Asian Buddhist structure, originated in the Indian Buddhist **stupa**, the elaborate burial mound that housed relics of the Buddha (see "Pagodas," page 361). In India the stupa had developed a multistoried form in the Gandhara region under the Kushan dynasty (c. 50–250 CE). In China this form blended with a traditional Han watchtower to produce the pagoda. Built entirely in masonry, the Great Wild Goose Pagoda nevertheless imitates the wooden architecture of the time. The walls are decorated in low relief to resemble bays, and bracket systems are reproduced under the projecting roofs of each story. Although modified and repaired in later times (its seven stories were originally five, and a new **finial** has been added), the pagoda still preserves the essence of Tang architecture in its simplicity, symmetry, proportions, and grace.

10–17 | **GREAT WILD GOOSE PAGODA AT CI'EN TEMPLE, CHANG'AN**
Shanxi. Tang dynasty, first erected 645 CE; rebuilt mid-8th century CE.

10–18 | Attributed to Emperor Huizong **DETAIL OF LADIES PREPARING NEWLY WOVEN SILK**
Copy after a lost Tang dynasty painting by Zhang Xuan. Northern Song dynasty, early 12th century CE. Handscroll, ink and colors on silk, 14½ × 57½" (36 × 145.3 cm). Museum of Fine Arts, Boston.
Chinese and Japanese Special Fund (12.886)

Confucius said of himself, "I merely transmit, I do not create; I love and revere the ancients." In this spirit, Chinese painters regularly copied paintings of earlier masters. Painters made copies both to absorb the lessons of their great predecessors and to perpetuate the achievements of the past. In later centuries, painters took up the practice of regularly executing a work "in the manner of" some particularly revered ancient master. This was at once an act of homage, a declaration of artistic allegiance, and a way of reinforcing a personal connection with the past.

Figure Painting

Later artists looking back on their heritage recognized the Tang dynasty as China's great age of figure painting. Unfortunately, very few scroll paintings that can be definitely identified as Tang still exist. We can get some idea of the character of Tang figure painting from the wall paintings of Dunhuang (SEE FIG. 10–15). Another way to savor the particular flavor of Tang painting is to look at copies made by later, Song-dynasty artists, which are far better preserved. An outstanding example of this can be seen in LADIES PREPARING NEWLY WOVEN SILK, attributed to Huizong (ruled 1101–1126 CE), the last emperor of the Northern Song dynasty (FIG. 10–18). A long handscroll in several sections, it depicts the activities of court women as they weave and iron silk. An inscription on the scroll informs us that the painting is a copy of a famous work by Zhang Xuan, an eighth-century painter known for his depictions of women at the Tang court. The original no longer exists, so we cannot know how faithful the copy is. Still, its refined lines and bright colors seem to share the grace and dignity of Tang sculpture and architecture.

SONG DYNASTY

A brief period of disintegration followed the fall of the Tang dynasty before China was again united, this time under the Song dynasty (960–1279 CE), which established a new capital at Bianjing (present-day Kaifeng), near the Yellow River. In contrast to the outgoing confidence of the Tang, the mood during the Song was more introspective, a reflection of China's weakened military situation. In 1126 the Jurchen tribes of Manchuria invaded China, sacked the capital, and took possession of much of the northern part of the country. Song forces withdrew south and established a new capital at Hangzhou. From this point on, the dynasty is known as the Southern Song (1127–1279 CE), with the first portion called in retrospect the Northern Song (960–1126 CE).

Although China's territory had diminished, its wealth had increased because of advances in agriculture, commerce, and technology begun under the Tang. Patronage was plentiful, and the arts flourished.

SEATED GUANYIN BODHISATTVA. In spite of changing political fortunes in the eleventh and twelfth centuries, artists continued to create splendid works. No hint of political disruption or religious questioning intrudes on the sublime grace and beauty of the SEATED GUANYIN BODHISATTVA (FIG. 10–19). *Bodhisattvas*, beings who are close to enlightenment but who voluntarily remain on earth to help others achieve enlightenment, are represented as young princes wearing royal garments and jewelry, their finery indicative of their worldly but virtuous lives. Guanyin is the *Bodhisattva* of Infinite Compassion, who appears in many guises, in this case as the Water and Moon Guanyin. He sits on rocks by the sea, in

Elements of Architecture
PAGODAS

Pagodas developed from Indian **stupas** as Buddhism spread northeastward along the Silk Road. Stupas merged with the watchtowers of Han dynasty China in multistoried stone or wood structures with projecting tiled roofs. This transformation culminated in wooden pagodas with upward-curving roofs supported by elaborate **bracketing** in China, Korea, and Japan. Buddhist pagodas retain the *axis mundi* masts of stupas. Like their South Asian prototypes, early East Asian pagodas were symbolic rather than enclosing structures; they were solid, with small devotional spaces hollowed out. Later examples often provided access to the ground floor and sometimes to upper levels.

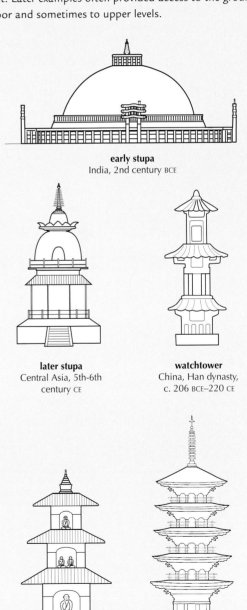

early stupa
India, 2nd century BCE

later stupa
Central Asia, 5th-6th century CE

watchtower
China, Han dynasty,
c. 206 BCE–220 CE

stone pagoda
northwestern China,
c. 5th century CE

wooden pagoda
Japan, 7th century CE

Drawings are not to scale

IO–I9 ⋮ **SEATED GUANYIN BODHISATTVA**
Liao dynasty, 10th–12th century CE. Wood with paint and gold, 95 × 65″ (241.3 × 165.1 cm). The Nelson-Atkins Museum of Art, Kansas City, Missouri.
Purchase, Nelson Trust (34-10)

the position known as royal ease. His right arm rests on his raised and bent right knee and his left arm and foot extended down, the foot touching a lotus blossom. The wooden figure was carved in the eleventh or twelfth century in a territory on the northern border of Song-dynasty China, a region ruled by the Liao dynasty (907–1125); the painting and gilding are sixteenth century.

Song culture is noted for its refined taste and intellectual grandeur. Where the Tang had reveled in exoticism, eagerly absorbing influences from Persia, India, and Central Asia, Song culture was more self-consciously Chinese. Philosophy experienced its most creative era since the "one hundred schools" of the Zhou. Song scholarship was brilliant, especially in history, and its poetry is noted for its depth. But the finest expressions of the Song are in art, especially painting and ceramics.

Philosophy: Neo-Confucianism

Song philosophers continued the process, begun during the Tang, of restoring Confucianism to dominance. In strengthening Confucian thought, philosophers drew on Daoist and especially Buddhist ideas, even as they openly rejected Buddhism itself as foreign. These innovations provided Confucianism with a metaphysical aspect it had previously lacked, allowing it to propose a more satisfying, all-embracing explanation of the universe. This new synthesis of China's three main paths of thought is called Neo-Confucianism.

Neo-Confucianism teaches that the universe consists of two interacting forces known as *li* (principle or idea) and *qi* (matter). All pine trees, for example, consist of an underlying *li* we might call "Pine Tree Idea" brought into the material world through *qi*. All the *li* of the universe, including humans, are but aspects of an eternal first principle known as the Great Ultimate, which is completely present in every object. Our task as human beings is to rid our *qi* of impurities through education and self-cultivation so that our *li* may realize its oneness with the Great Ultimate. This lifelong process resembles the striving to attain buddhahood, and if we persist in our attempts, one day we will be enlightened—the term itself comes directly from Buddhism.

Northern Song Painting

The Neo-Confucian ideas found visual expression in art, especially in landscape, which became the most highly esteemed subject for painting. Northern Song artists studied nature closely to master its many appearances—the way each species of tree grew, the distinctive character of each rock formation, the changes of the seasons, the myriad birds, blossoms, and insects. This passion for realistic detail was the artist's form of self-cultivation: Mastering outward forms showed an understanding of the principles behind them.

Yet despite the convincing accumulation of detail, the paintings do not record a specific site. The artist's goal was to paint the eternal essence of "mountain-ness," for example, not to reproduce the appearance of a particular mountain. Painting a landscape required an artist to orchestrate his cumulative understanding of *li* in all its aspects—mountains and rocks, streams and waterfalls, trees and grasses, clouds and mist. A landscape painting thus expressed the desire for the spiritual communion with nature that was the key to enlightenment. As the tradition progressed, landscape also became a vehicle for conveying human emotions, even for speaking indirectly of one's own deepest feelings.

In the earliest times, art reflected the mythocentric worldview of the ancient Chinese. Later, as religion came to dominate people's lives, the focus of art shifted and religious images and human actions became important subjects. Subsequently, during the Song dynasty, artists developed landscape as the chief means of expression, preferring to avoid direct depiction of the human condition and to show ideals in a symbolic manner. The major form of Chinese artistic expression thus moved from the mythical, through the religious and ethical, and finally to the philosophical and aesthetic.

FAN KUAN. One of the first great masters of Song landscape was the eleventh-century painter Fan Kuan (active c. 990–1030 CE), whose surviving major work, **TRAVELERS AMONG MOUNTAINS AND STREAMS**, is regarded as one of the great monuments of Chinese art (FIG. 10–20). The work is physically large—almost 7 feet high—but the sense of monumentality also radiates from the composition itself, which makes its impression even when much reduced.

The composition unfolds in three stages, comparable to three acts of a drama. At the bottom a large, low-lying group of rocks, taking up about one-eighth of the picture surface, establishes the extreme foreground. The rest of the landscape pushes back from this point. In anticipating the shape and substance of the mountains to come, the rocks introduce the main theme of the work, much as the first act of a drama introduces the principal characters. In the middle ground, travelers and their mules are coming from the right. They are somewhat startling, for we suddenly realize our human scale—how small we are, how vast nature is. This middle ground takes up twice as much picture surface as the foreground, and, like the second act of a play, shows variation and development. Instead of a solid mass, the rocks here are separated into two groups by a waterfall that is spanned by a bridge. In the hills to the right, the rooftops of a temple stand out above the trees.

Mist veils the transition to the background, with the result that the mountain looms suddenly. This background area, almost twice as large as the foreground and middle ground combined, is the climactic third act of the drama. As our eyes begin their ascent, the mountain solidifies. Its ponderous weight increases as it billows upward, finally bursting into the sprays of energetic brushstrokes that describe the scrubby growth on top. To the right, a slender waterfall plummets, not to balance the powerful upward thrust of the mountain but simply to enhance it by contrast. The whole painting, then, conveys the feeling of climbing a high mountain, leaving the human world behind to come face to face with the Great Ultimate in a spiritual communion.

All the elements are depicted with precise detail and in proper scale. Jagged brushstrokes describe the contours of rocks and trees and express their rugged character. Layers of short, staccato strokes (translated as "raindrop texture" from the Chinese) accurately mimic the texture of the rock surface. Spatial recession from foreground through middle ground to background is logically and convincingly handled, if not quite continuous.

Although it contains realistic details, the landscape represents no specific place. In its forms, the artist expresses the ideal forms behind appearances; in the rational, ordered composition, he expresses the intelligence of the universe. The arrangement of the mountains, with the central peak flanked by lesser peaks on each side, seems to reflect both the ancient Confucian notion of social hierarchy, with the emperor

10–20 | Fan Kuan **TRAVELERS AMONG MOUNTAINS AND STREAMS**
Northern Song dynasty, early 11th century CE. Hanging scroll, ink and colors on silk, height 6′ 9½″ (2.06 m). National Palace Museum, Taipei, Taiwan, Republic of China.

flanked by his ministers, and the Buddhist motif of the Buddha with *bodhisattvas* at his side. The landscape, a view of nature uncorrupted by human habitation, expresses a kind of Daoist ideal. Thus we find the three strains of Chinese thought united, much as they are in Neo-Confucianism itself.

The ability of Chinese landscape painters to take us out of ourselves and to let us wander freely through their sites is closely linked to the avoidance of perspective as it is understood in the West. Fifteenth-century European painters, searching for fidelity to appearances, developed a "scientific"

10–21 Xu Daoning **SECTION OF** FISHING IN A MOUNTAIN STREAM

Northern Song dynasty, mid-11th century CE. Handscroll, ink on silk, 19″ × 6′10″ (48.9 cm × 2.09 m).
The Nelson-Atkins Museum of Art, Kansas City, Missouri.

Purchase, Nelson Trust (33-1559)

10–22 Zhang Zeduan **SECTION OF** SPRING FESTIVAL ON THE RIVER

Northern Song dynasty, early 12th century CE. Handscroll, ink and colors on silk, 9½″ × 7′4″ (24.8 × 2.28 m).
The Palace Museum, Beijing.

system for recording exactly the view that could be seen from a single, fixed vantage point. The goal of Chinese painting is precisely to avoid such limits and show a totality beyond what we are normally given to see. If the ideal for centuries of Western painters was to render what can be seen from a fixed viewpoint, that of Chinese artists was to reveal nature through a distant, all-seeing, and mobile viewpoint.

XU DAONING. The sense of shifting perspective is clearest in the handscroll, where our vantage point changes constantly as we move through the painting. One of the finest handscrolls to survive from the Northern Song is **FISHING IN A MOUNTAIN STREAM (FIG. 10–21)**, a painting executed in the middle of the

eleventh century by Xu Daoning (c. 970–c. 1052 CE). Starting from a thatched hut in the right foreground, we follow a path that leads to a broad, open view of a deep vista dissolving into distant mists and mountain peaks. (Remember that viewers observed only a small section of the scroll at a time. To mimic this effect, use two pieces of paper to frame a small viewing area, then move them slowly leftward.) Crossing over a small footbridge, we are brought back to the foreground with the beginning of a central group of high mountains that show extraordinary shapes. Again our path winds back along the bank, and we have a spectacular view of the highest peaks from another small footbridge the artist has placed for us. At the far side of the bridge, we find ourselves looking up into a

10–23 Xia Gui TWELVE VIEWS FROM A THATCHED HUT

Southern Song dynasty, early 13th century CE. Handscroll, ink on silk, height 11″ (28 cm); length of extant portion
7′7½″ (2.31 m). The Nelson-Atkins Museum of Art, Kansas City, Missouri.

Purchase, Nelson Trust (32-159/2)

deep valley, where a stream lures our eyes far into the distance. We can imagine ourselves resting for a moment in the small pavilion halfway up the valley on the right. Or perhaps we may spend some time with the fishers in their boats as the valley gives way to a second, smaller group of mountains, serving both as an echo of the spectacular central group and as a transition to the painting's finale, a broad, open vista. As we cross the bridge here, we meet travelers coming toward us who will have our experience in reverse. Gazing out into the distance and reflecting on our journey, we again feel that sense of communion with nature that is the goal of Chinese artistic expression.

Such handscrolls have no counterpart in the Western visual arts and are often compared instead to the tradition of Western music, especially symphonic compositions. Both are generated from opening motifs that are developed and varied, both are revealed over time, and in both our sense of the overall structure relies on memory, for we do not see the scroll or hear the composition all at once.

ZHANG ZEDUAN. The Northern Song fascination with precision extended to details within landscape. The emperor Huizong, whose copy of *Ladies Preparing Newly Woven Silk* was seen in figure 10–18, gathered around himself a group of court painters who shared his passion for quiet, exquisitely detailed, delicately colored paintings of birds and flowers. Other painters specialized in domestic and wild animals, still others in palaces and buildings. One of the most spectacular products of this passion for observation is **SPRING FESTIVAL ON THE RIVER**, a long handscroll painted in the first quarter of the twelfth century by Zhang Zeduan, an artist connected to the emperor's court (FIG. 10–22). Beyond its considerable visual delights, the painting is also an invaluable record of daily life in the Song capital.

The painting depicts a festival day when local inhabitants and visitors from the countryside thronged the streets. One high point is the scene reproduced here, which takes place at the Rainbow Bridge. The large boat to the right is probably bringing goods from the southern part of China up the Grand Canal that ran through the city at that time. The sailors are preparing to pass beneath the bridge by lowering the sail and taking down the mast. Excited figures on ship and shore gesture wildly, shouting orders and advice, while a noisy crowd gathers at the bridge railing to watch. Stalls on the bridge are selling food and other merchandise; wine shops and eating places line the banks of the canal. Everyone is on the move. Some people are busy carrying goods, some are shopping, some are simply enjoying themselves. Each figure is splendidly animated and full of purpose; the buildings and boats are perfect in every detail—the artist's knowledge of this bustling world was indeed encyclopedic.

Little is known about the painter Zhang Zeduan other than that he was a member of the scholar-official class, the highly educated elite of imperial China. Interestingly, some of Zhang Zeduan's peers were already beginning to cultivate quite a different attitude toward painting as a form of artistic expression, one that placed overt display of technical skill at the lowest end of the scale of values. This emerging scholarly aesthetic, developed by China's literati, later came to dominate Chinese thinking about art, with the result that only in the twentieth century did *Spring Festival* again find an audience willing to hold it in the highest esteem.

Southern Song Painting and Ceramics

Landscape painting took a very different course after the fall of the north to the Jurchen in 1126, and the removal of the court to its new capital in the south, Hangzhou.

XIA GUI. This new sensibility is reflected in the extant portion of **TWELVE VIEWS FROM A THATCHED HUT** (FIG. 10–23) by Xia Gui (fl.c. 1195–1235 CE), a member of the newly established Academy of Painters. In general, academy members continued to favor such subjects as birds and flowers in the highly refined, elegantly colored court style patronized earlier by Huizong (SEE FIG. 10–18). Xia Gui, however, was interested in landscape and cultivated his own style. Only the last four of the twelve views that originally made up this long handscroll have survived, but they are enough to illustrate the unique quality of his approach.

10–24 GUAN WARE VASE
Southern Song dynasty, 13th century CE. Gray stoneware with crackled grayish blue glaze, height 6⅝" (16.8 cm). Percival David Foundation of Chinese Art, London.

In contrast to the majestic, austere landscapes of the Northern Song painters, Xia Gui presents an intimate and lyrical view of nature. Subtly modulated, perfectly controlled ink washes evoke a landscape veiled in mist, while a few deft brushstrokes suffice to indicate the details showing through the mist—the grasses growing by the bank, the fishers at their work, the trees laden with moisture, the two bent-backed figures carrying their heavy load along the path that skirts the hill. Simplified forms, stark contrasts of light and dark, asymmetrical composition, and great expanses of blank space suggest a fleeting world that can be captured only in glimpses. The intangible is somehow more real than the tangible. By limiting himself to a few essential details, the painter evokes a deep feeling for what lies beyond.

This development in Song painting from the rational and intellectual to the emotional and intuitive, from the tangible to the intangible, had a parallel in philosophy. During the late twelfth century a new school of Neo-Confucianism

called School of the Mind insisted that self-cultivation could be achieved through contemplation, which might lead to sudden enlightenment. The idea of sudden enlightenment may have come from Chan Buddhism, better known in the West by its Japanese name, Zen. Chan Buddhists rejected formal paths to enlightenment such as scripture, knowledge, and ritual, in favor of meditation and techniques designed to "short-circuit" the rational mind. Xia Gui's painting seems also to suggest this intuitive approach.

The subtle and sophisticated paintings of the Song were created for a highly cultivated audience who were equally discerning in other arts such as ceramics. Building on the considerable accomplishments of the Tang, Song potters achieved a technical and aesthetic perfection that has made their wares models of excellence throughout the world. Like their painter contemporaries, Song potters turned away from the exuberance of Tang styles to create more quietly beautiful pieces.

GUAN WARE. Most highly prized of the many types of Song ceramics is Guan ware, made mainly for imperial use (FIG. 10–24). The everted lip, high neck, and rounded body of this simple vase show a strong sense of harmony. Enhanced by a lustrous grayish blue glaze, the form flows without break from base to lip. The piece has an introspective quality as eloquent as the blank spaces in Xia Gui's painting. The aesthetic of the Song is most evident in the crackle pattern on the glazed surface. The crackle technique was probably discovered accidentally, but came to be used deliberately in some of the most refined Song wares. In the play of irregular, spontaneous crackles over a perfectly regular, perfectly planned form we can sense the same spirit that hovers behind the self-effacing virtuosity and freely intuitive insights of Xia Gui's landscape.

In 1279 the Southern Song dynasty fell to the conquering forces of the Mongol leader Kublai Khan (1215–1294). China was subsumed into the vast Mongol Empire. Mongol rulers founded the Yuan dynasty (1279–1368 CE), setting up their capital in the northeast in what is now Beijing. Yet the cultural center of China remained in the south, in the cities that rose to prominence during the Song, such as Bianjing (Kaifeng) and Hangzhou. This separation of political and cultural centers, coupled with a lasting resentment toward "barbarian" rule, created the climate for later developments in the arts.

THE ARTS OF KOREA

Set between China and Japan, Korea occupies a peninsula in northeast Asia. Inhabited for millennia, the peninsula gave rise to a distinctively Korean culture during the Three Kingdoms period.

The Three Kingdoms Period

Traditionally dated 57 BCE to 668 CE, the Three Kingdoms period saw the establishment of three independent nation-states:

10–25 | **CROWN**
Korean. Three Kingdoms period, Silla kingdom, probably 6th century. From the Gold Crown Tomb, Gyeongju, North Gyeongsang province. Gold with jadeite ornaments, height 17½" (44.5 cm). National Museum of Korea, Seoul, Republic of Korea.

Silla in the southeast, Baekje in the southwest, and Goguryeo in the north. Large tomb mounds built during the fifth and sixth centuries are enduring monuments of this period.

A GOLD HEADDRESS. The most spectacular items recovered from these tombs are trappings of royal authority (FIG. 10–25). Made expressly for burial, this elaborate crown was assembled from cut pieces of thin gold sheet, held together by gold wire. Spangles of gold embellish the crown, as do comma-shaped ornaments of green and white jadeite—a form of jade mineralogically distinct from the nephrite prized by the early Chinese. The tall, branching forms rising from the crown's periphery resemble trees and antlers. Within the crown is a conical cap woven of narrow strips of sheet gold and ornamented with appendages that suggest wings or feathers.

HIGH-FIRED CERAMICS. These tombs have also yielded ceramics in abundance. Most are containers for offerings of food placed in the tomb to nourish the spirit of the deceased. These items generally are of unglazed **stoneware**, a high-fired ceramic ware that is impervious to liquids, even without glaze.

The most imposing ceramic shapes are the tall stands that were used to support round-bottomed jars (FIG. 10–26).

10–26 | **CEREMONIAL STAND WITH SNAKE, ABSTRACT, AND OPENWORK DECORATION**
Korean. Three Kingdoms period, Silla kingdom, 5th–6th century. Gray stoneware with combed, stamped, applied, and openwork decoration and with traces of natural ash glaze, height 23⅛" (58.7 cm). Reportedly recovered in Andong, North Gyeongsang province. Arthur M. Sackler Museum, Harvard University, Cambridge, Massachusetts.
Partial gift of Maria C. Henderson and partial purchase through the Ernest B. and Helen Pratt Dane Fund for the Acquisition of Oriental Art [1991.501]

10–27 | **BODHISATTVA SEATED IN MEDITATION**
Korean. Three Kingdoms period, probably Silla kingdom, early 7th century. Gilt bronze, height 35⅞" (91 cm). National Museum of Korea, Seoul, Republic of Korea (formerly in the collection of the Toksu Palace Museum of Fine Arts, Seoul).

Such stands typically have a long, cylindrical shaft set on a bulbous base. Cut into the moist clay before firing, their openwork apertures lighten what otherwise would be rather ponderous forms. Although few examples of Three Kingdoms ceramics exhibit surface ornamentation, other than an occasional combed wave pattern or an incised configuration of circles and chevrons, here snakes inch their way up the shaft of the stand.

A BODHISATTVA SEATED IN MEDITATION. Buddhism was introduced into the Goguryeo kingdom from China in 372 and into Baekje by 384. Although it probably reached Silla in the second half of the fifth century, Buddhism gained recognition as the official religion of the Silla state only in 527.

At first, Buddhist art in Korea was a mere imitation of Chinese art. However, by the late sixth century, Korean sculptors had created a style of their own, as illustrated by a magnificent gilt bronze image of a bodhisattva (probably the Bodhisattva Maitreya) seated in meditation that likely dates to the early seventh century (**FIG. 10–27**). Although the pose links it to Chinese sculpture of the late sixth century, the slender body, elliptical face, elegant drapery folds, and trilobed crown distinguish it as Korean.

Buddhism was introduced to Japan from Korea—from the Baekje kingdom, according to literary accounts. In fact, historical sources indicate that numerous Korean sculptors were active in Japan in the sixth and seventh centuries; several early masterpieces of Buddhist art in Japan show pronounced Korean influence (SEE FIG. 11–8).

The Unified Silla Period

In 660, the Silla kingdom conquered Baekje, and, in 668, through an alliance with Tang-dynasty China, it vanquished Goguryeo, uniting the peninsula under the rule of the Unified Silla dynasty, which lasted until 935. Buddhism prospered under Unified Silla, and many large, important temples were erected in and around Gyeongju, the Silla capital.

SEOKGURAM. The greatest monument of the Unified Silla period is Seokguram, an artificial cave temple constructed under royal patronage atop Mt. Toham, near Gyeongju (**FIG. 10–28**). The temple is modeled after Chinese cave temples of the fifth, sixth, and seventh centuries, which were in turn inspired by the Buddhist cave temples of India.

Built in the mid-eighth century of cut blocks of granite, Seokguram consists of a small rectangular antechamber joined by a narrow vestibule to a circular main hall with a domed ceiling. More than 11 feet in height, the huge seated Buddha dominates the main hall. Seated on a lotus pedestal, the image represents the historical Buddha Shakyamuni at the moment of his enlightenment, as indicated by his earth-touching gesture, or *bhumisparsha-mudra*. The full, taut forms, diaphanous drapery, and anatomical details of his chest relate this image to eighth-century Chinese sculptures. Exquisitely carved low-relief images of bodhisattvas and lesser deities grace the walls of the antechamber, vestibule, and main hall.

Goryeo Dynasty

Established in 918, the Goryeo dynasty eliminated the last vestiges of Unified Silla rule in 935; it would continue until 1392, ruling from its capital at Gaeseong—to the northwest of present-day Seoul and now in North Korea. A period of courtly refinement, the Goryeo dynasty is best known for its celadon-glazed ceramics.

CELADON-GLAZED CERAMICS. The term **celadon** refers to a high-fired, transparent glaze of pale bluish-green hue, typically applied over a pale gray stoneware body. Chinese potters invented celadon glazes and had initiated the continuous

10–28 | SEATED SHAKYAMUNI BUDDHA
With hands in *Bhumisparsha mudra* (the Earth-Touching Gesture Symbolizing His Enlightenment), Seokguram Grotto, main Buddha. Korean. Unified Silla period, c. 751. Near Gyeongju, North Gyeongsang province. Granite, height of Buddha only 11′ 2½″ (342 cm).

10–29 | MAEBYEONG BOTTLE WITH DECORATION OF BAM-BOO AND BLOSSOMING PLUM TREE.
Korean. Goryeo dynasty, late 12th–early 13th century. Inlaid celadon ware: light gray stoneware with decoration inlaid with black and white slips under celadon glaze, height 13¼″ (33.7 cm). Tokyo National Museum, Tokyo, Japan.
[TG-2171]

production of celadon-glazed wares as early as the first century CE. Korean potters began to experiment with such glazes in the eighth and ninth centuries; their earliest celadons reflect the strong imprint of Chinese ware. Soon, the finest Goryeo celadons rivaled the best Chinese court ceramics. These wares were used by people of various socioeconomic classes during the Goryeo dynasty, with the finest examples going to the palace, nobles, or the powerful Buddhist clergy.

Prized for their classic simplicity, Korean celadons of the eleventh century often have little decoration, while those of the twelfth century frequently sport incised, carved, or molded decoration, thus generally mimicking the style and ornamentation of contemporaneous Chinese ceramics. By the mid-twelfth century, Korean potters began to explore new styles and techniques of decoration. Most notable among their inventions was inlaid decoration, in which black and white slips, or finely ground clays, were inlaid into the intaglio lines of decorative elements incised or stamped in the body, creating underglaze designs in contrasting colors. This bottle displays three different pictorial scenes inlaid in black and white slips (FIG. 10–29). The scene featured here depicts

10–30 | **SEATED WILLOW-BRANCH GWANSE'EUM BOSAL (THE BODHISATTVA AVALOKITESHVARA)**
Korean. Goryeo dynasty, late 14th century. Hanging scroll; ink, colors, and gold pigment on silk, height 62½" (159.6 cm). Arthur M. Sackler Museum, Harvard University, Cambridge, Massachusetts.

Bequest of Grenville L. Winthrop [1943.57.12]

a clump of bamboo growing at the edge of a lake, the stalks intertwined with the branches of a blossoming plum tree (which flowers in late winter, before donning its leaves). Geese swim in the lake and butterflies flutter above, linking the several scenes around the bottle. Called *maebyeong,* which means "plum bottle," such broad-shouldered vessels were used as storage jars for wine, vinegar, and other liquids. A small, bell-shaped cover originally capped the bottle, protecting its contents and complementing its curves.

BUDDHIST PAINTING. Buddhism, the state religion of Goryeo, enjoyed royal patronage; many temples were thus able to commission the very finest architects, sculptors, and painters. The most sumptuous Buddhist works produced during the Goryeo period were paintings. Wrought in ink and colors on silk, the fourteenth-century hanging scroll illustrated here depicts Gwanse'eum Bosal (whom the Chinese called Guanyin), the Bodhisattva of Compassion (FIG. 10–30). The flesh tones used for the bodhisattva's face and hands, along with the rich colors and gold pigment used for the deity's clothing, reflect the luxurious taste of the period. Numerous paintings of this type were exported to Japan, where they influenced the course of Buddhist painting.

IN PERSPECTIVE

Chinese civilization arose several millennia ago, distinctive for its early advancement in ceramics and metalwork, as well as for the elaborate working of jade. Early use of the potter's wheel, mastery of reduction firing, and the early invention of high-fired stoneware and porcelain distinguish the technological advancement of Chinese ceramics. Highly imaginative bronze castings and remarkably proficient techniques of mold making characterize early Chinese metalworking. Characters inscribed on these ancient bronzes are prototypes of written Chinese. Early China's attainments in so resistant a material as jade reflect not merely a technological competence with rotary tools and abrasive techniques, but moreover a profound passion for refinement and for the subtleties of shape, proportion, and surface texture. The Chinese artistic legacy to the world lies especially in these effects, with its ceramic glazes and monochrome ink paintings standing at the highest level of aesthetic refinement.

Chinese art also explored human relationships and heroic ideals, exemplifying Confucian values and teaching the standards of conduct that underlie social order. Later, China also came to embrace the Buddhist tradition from India, which was in turn transmitted to Korea and Japan, along with other aspects of Chinese culture. In princely representations of Buddhist divinities and in sublime and powerful, but often meditative, figures of the Buddha, China's artists presented the divine potential of the human condition.

Perhaps the most distinguished Chinese tradition, however, is the presentation of philosophical ideals through the theme of landscape. Paintings simply in black ink, depictions of mountains and water, became the ultimate artistic medium for expressing the vastness, abundance, and endurance of the universe.

Chinese civilization radiated its influence throughout East Asia. Chinese learning repeatedly stimulated the growth of culture in Korea, which in turn transmitted influence to Japan.

IMAGE OF A DEITY
BEFORE 3000 BCE

FANG DING
C. 12TH CENTURY BCE

TOMB MODEL OF A HOUSE
1ST–MID–2ND CENTURY CE

**BODHISATTVA SEATED
IN MEDITATION**
EARLY 7TH CENTURY CE

**ATTRIBUTED TO EMPEROR
HUIZONG OF LADIES PREPARING
NEWLY WOVEN SILK,** DETAIL
EARLY 12TH CENTURY CE

MAEBYEONG BOTTLE
LATE 12TH–
EARLY 13TH CENTURY CE

5000
BCE

2000

1000

I
CE

500

1000

1500

CHINESE AND KOREAN ART BEFORE 1279

◀ **Neolithic** c. 5000–2000 BCE

◀ **Liangzhu Culture Emerged**
c. 3300 BCE

◀ **Bronze Age** c. 1700–211 BCE
◀ **Shang Dynasty** c. 1700–1100 BCE

◀ **Zhou Dynasty** 1100–211 BCE

◀ **Warring States Period** c. 481–220 BCE
◀ **Qin Dynasty** 221–206 BCE
◀ **Han Dynasty** 206 BCE–220 CE
◀ **Three Kingdoms Period (Korea)**
c. 57 BCE–668 CE

◀ **Six Dynasties Period** c. 265–587 CE

◀ **Sui Dynasty** 581–618 CE
◀ **Tang Dynasty** 618–907 CE
◀ **Unified Silla** 668–935 CE
◀ **Song Dynasty** 960–1279 CE
◀ **Goryeo Dynasty** 918–1392 CE

◀ **Yuan Dynasty** 1279–1368 CE

II—I | **ALBUM LEAF FROM THE** *ISHIYAMA-GIRE* Heian period, early 12th century CE. Ink with gold and silver on decorated and collaged paper, 52 × 17⅓″ (131.8 × 44 cm). Freer Gallery of Art, Smithsonian Institution, Washington, D.C. (F1969.4)

JAPANESE ART BEFORE 1392

Buddhism pervaded the Heian era (794–1185), and yet a refined secular culture also arose at court. Gradually, over the course of these four centuries, the pervasive influence of Chinese culture gave rise to new, uniquely Japanese developments. Although court nobles continued to write many poems in Chinese, both men and women wrote in the new *kana* script of their native language (see "Writing, Language, and Culture," page 376). With its simple, flowing symbols interspersed with more complex Chinese characters, the new writing system allowed Japanese poets to create an asymmetrical calligraphy quite unlike that of China.

Refinement was greatly valued among the Heian-period aristocracy. A woman would be admired merely for the way she arranged the twelve layers of her robes by color, or a man for knowing which kind of incense was being burned. Much of court life was preoccupied by the poetical expression of human love written in five-line verses called *tanka*. A courtier leaving his beloved at dawn would send her a poem wrapped around a single flower still wet with dew. If his words or his calligraphy were less than stylish, however, he would not be welcome to visit her again. In turn, if she could not reply with equal elegance, he might not wish to repeat their amorous interlude. Society was ruled by taste, and pity any man or woman at court who was not accomplished in several forms of art.

During the later Heian period, the finest *tanka* were gathered in anthologies. The poems in one famous early anthology, the *Thirty-Six Immortal Poets*, are still known to educated Japanese today. This anthology was produced in sets of albums called the *Ishiyama-gire*. These albums consist of *tanka* written elegantly on high-quality papers decorated with painting, block printing, scattered gold and silver, and sometimes paper collage. Sometimes, as in FIG. 11–1, the irregular pattern of torn paper edges adds a serendipitous element. The page shown here reproduces two *tanka* by the courtier Ki no Tsurayuki. Both poems express sadness. Here is one of them:

> Until yesterday
> I could meet her,
> But today she is gone—
> Like clouds over the mountain
> She has been wafted away.

The spiky, flowing calligraphy and the patterning of the papers, the rich use of gold, and the suggestions of natural imagery match the elegance of the poetry, epitomizing courtly Japanese taste.

PREHISTORIC JAPAN

The earliest traces of human habitation in Japan are at least 30,000 years old. At that time the four islands that compose the country today were still linked to the East Asian landmass, forming a ring from Siberia to Korea around the present-day Sea of Japan, which was then a lake. With the end of the last Ice Age, some 15,000 years ago, melting glaciers caused the sea level to rise, gradually submerging the lowland links and creating the islands as we know them today (MAP 11–1). Sometime thereafter, Paleolithic peoples gave way to Neolithic hunter-gatherers, who gradually developed the ability to make and use ceramics. Recent scientific dating methods have shown some works of Japanese pottery to date earlier than 10,000 BCE, making them the oldest now known.

Jomon Period

The Jomon period (c. 11,000–400 BCE) is named for the patterns on much of the pottery produced during this time, which were made by pressing cord onto damp clay (*jomon* means "cord markings"). Jomon people were able to develop a sophisticated hunting-gathering culture, unusual for its early production of ceramics, in part because their island setting protected them from large-scale invasions and also because of their abundant food supply. Around 5000 BCE agriculture emerged with the planting and harvesting of beans and gourds. Some 4,500 years later, the Jomon remained primarily a hunting-gathering society that used stone tools and weapons. People lived in small communities, usually with fewer than ten or twelve dwellings, and seem to have enjoyed a peaceful life, giving them the opportunity to develop their artistry for even such practical endeavors as ceramics.

JOMON POTTERY. Jomon ceramics may have begun in imitation of reed baskets, as many early examples suggest. Other early Jomon pots have pointed bottoms. Judging from burn marks along the sides, they must have been planted firmly into the ground, then used for cooking. Applying fire to the sides rather than the bottom allowed the vessels to heat more fully and evenly. Still other early vessels were crafted with straight sides and flat bottoms, a shape that was useful for storage as well as cooking and which eventually became the norm. Jomon potters usually crafted their vessels by building them up with coils of clay, then firing them in bonfires at relatively low temperatures. Researchers think that Jomon pottery was made by women, as was the practice in most early societies, especially before the use of the potter's wheel.

During the middle Jomon period (2500–1500 BCE), pottery reached a high degree of creativity. By this time communities were somewhat larger, and each family may have wanted its ceramic vessels to have a unique design. The basic form remained straight-sided, but the rim now took on spectacular, flamboyant shapes (FIG. 11–2). Middle Jomon potters made full use of the malleable quality of clay, bending and twisting it as well as **incising** and applying designs. They

II–2 | **"FLAME WARE" (*KAEN-DOKI*) VESSEL**
Niigata Prefecture. Middle Jomon phase (c. 2500–1500 BCE), c. 2500–2400 BCE. Earthenware, height 12⅛" (30.8 cm). Kokubunji, Kokununji City, Tokyo.

MAP II–I | JAPAN

Melting glaciers at the end of the Ice Age in Japan 15,000 years ago raised the sea level and formed the four main islands of Japan: Hokkaido, Honshu, Shikoku, and Kyushu.

favored asymmetrical shapes, although certain elements in the geometric patterns are repeated. Some designs may have had specific meanings, but the vessels also display an abundantly playful artistic spirit.

Dogu. The people of the middle and late Jomon periods also used clay to fashion small humanoid figures. These figures were never fully realistic but rather were distorted into fascinating shapes. Called **dogu,** they tend to have large faces, small arms and hands, and compact bodies. Some of the later *dogu* seem to be wearing round goggles over their eyes. Others have heart-shaped faces. One of the finest, from Kurokoma, has a face remarkably like a cat's (FIG. II–3). The slit eyes and mouth have a haunting quality, as does the gesture of one hand touching the chest. The marks on the face, neck, and shoulders suggest tattooing and were probably incised with a bamboo stick. The raised area behind the face may indicate a Jomon hairstyle.

The purpose of Jomon *dogu* remains unknown, but most scholars believe that they were effigies, figures representing the owner or someone else, and that they manifested a kind

II–3 | **DOGU**
Kurokoma, Yamanashi Prefecture. Jomon period, c. 2500–1500 BCE. Earthenware, height 10″ (25.2 cm).
Tokyo National Museum.

Art and Its Context
WRITING, LANGUAGE, AND CULTURE

Chinese culture enjoyed great prestige in East Asia. Written Chinese served as an international language of scholarship and cultivation, much as Latin did in medieval Europe. Educated Koreans, for example, wrote almost exclusively in Chinese until the fifteenth century CE. In Japan, Chinese continued to be used for certain kinds of writing, such as philosophical and legal texts, into the nineteenth century.

When it came to writing their own language, the Japanese initially borrowed Chinese characters, or *kanji*. Differences between the Chinese and Japanese languages made this system extremely unwieldy, so during the ninth century CE two syllabaries, or *kana*, were developed from simplified Chinese characters. (A *syllabary* is a system of lettering in which each symbol stands for a syllable.) *Katakana*, now generally used for foreign words, consists of mostly angular symbols, while the more frequently used *hiragana* has graceful, cursive symbols.

Japanese written in *kana* was known as "women's hand," possibly because prestigious scholarly writing still emphasized Chinese, which women were rarely taught. Yet Japan had an ancient and highly valued poetic tradition of its own, and women as well as men were praised as poets from earliest times. So while women rarely became scholars, they were often authors. During the Heian period *kana* were used to create a large body of literature, written either by women or sometimes for women by men.

A charming poem originated in Heian times to teach the new writing system. In two stanzas of four lines each, it uses almost all of the syllable sounds of spoken Japanese and thus almost every *kana* symbol. It was memorized as we would recite our ABCs. The first stanza translates as:

> Although flowers glow with color
> They are quickly fallen,
> And who in this world of ours
> Is free from change?

(Translation by Earl Miner)

Like Chinese, Japanese is written in columns from top to bottom and across the page from right to left. (Following this logic, Chinese and Japanese narrative paintings also read from right to left.) Below is the stanza written three ways. At the right, it appears in *katakana* glossed with the original phonetic value of each symbol. (Modern pronunciation has shifted slightly.) In the center, the stanza appears in flowing *hiragana*. To the left is the mixture of *kanji* and *kana* that eventually became standard. This alternating rhythm of simple kana symbols and more complex Chinese characters gives a special flavor to Japanese calligraphy.

kanji and kana hiragana katakana

of sympathetic magic. Jomon people may have believed, for example, that they could transfer an illness or other unhappy experience to a *dogu*, then break it to destroy the misfortune. So many of these figures were deliberately broken and discarded that this theory has gained acceptance, but *dogu* may have had different functions at different times. Regardless of their purpose, the images still retain a powerful sense of magic thousands of years after their creation.

Yayoi and Kofun Periods

During the Yayoi (c. 400 BCE–300 CE) and Kofun (c. 300–552 CE) eras several features of Japanese culture became firmly established. Most important of these was the transformation of Japan into an agricultural nation, with rice cultivation becoming widespread. This momentous change was stimulated by the arrival of immigrants from Korea, who brought with them more complex forms of society and government.

YAYOI. As it did elsewhere in the world, the shift from hunting and gathering to agriculture brought profound social changes, including larger permanent settlements, the division of labor into agricultural and nonagricultural tasks, more hierarchical forms of social organization, and a more centralized government. The emergence of a class structure can be dated to the Yayoi period, as can the development of metal technology. Bronze was used to create weapons as well as ceremonial objects such as bells. Iron metallurgy developed later in this period, eventually replacing stone tools in everyday life.

Yayoi people lived in thatched houses with sunken floors and stored their food in raised granaries. Drawings of their granaries are to be found on bronze artifacts of this period, and these drawings bear a striking resemblance to the architectural design of shrines in later centuries (SEE FIG. 11–5). The sensitive use of wood and thatch in these shrines suggests an early origin of the Japanese appreciation of natural materials noted in later periods and up to the present.

KOFUN. The trend toward centralized government became more pronounced during the ensuing Kofun, or "old tombs," period, named for the large royal tombs that were built then. With the emergence of a more complex social order, the veneration of leaders grew into the beginnings of an imperial system. Still in existence today in Japan, this system eventually equated the emperor (or, very rarely, empress) with deities such as the sun goddess. When an emperor died, chamber tombs were constructed following Korean examples. Various grave goods were placed inside the tomb chambers, including large amounts of pottery, presumably to pacify the spirits of the dead and to serve them in their next life. As a part of a general cultural transfer from China through Korea, fifth-century potters in Japan gained knowledge of finishing techniques and improved kilns and began to produce a high-fired ceramic ware. Stoneware technology was thus added to the repertory of Japanese ceramic techniques developed in the **earthenware** of previous periods.

The Japanese government has never allowed the major sacred tombs to be excavated, but much is known about the mortuary practices of Kofun-era Japan. Some of the huge tombs of the fifth and sixth centuries CE were constructed in a shape resembling a large keyhole and surrounded by **moats** dug to protect the sacred precincts. Tomb sites might extend over more than 400 acres, with artificial hills built over the tombs themselves. On the top of the hills were placed ceramic works of sculpture called **haniwa.**

HANIWA. The first *haniwa* were simple cylinders that may have held jars with ceremonial offerings. By the fifth century CE, these cylinders came to be made in the shapes of ceremonial objects, houses, and boats. Gradually, living creatures were added to the repertoire of *haniwa* subjects, including birds, deer, dogs, monkeys, cows, and horses. By the sixth century,

11–4 | HANIWA
Kyoto. Kofun period, 6th century CE. Earthenware, height 27″ (68.5 cm). Collection of the Tokyo National Museum.

There have been many theories as to the function of *haniwa*. The figures seem to have served as some kind of link between the world of the dead, over which they were placed, and the world of the living, from which they could be viewed. This figure has been identified as a seated female shaman, wearing a robe, belt, and necklace and carrying a mirror at her waist. In early Japan, shamans acted as agents between the natural and the supernatural worlds, just as *haniwa* figures were links between the living and the dead.

haniwa in human shapes were crafted, including males and females of various types, professions, and classes (FIG. 11–4).

Haniwa illustrate several enduring characteristics of Japanese aesthetic taste. Unlike Chinese tomb ceramics, which were often beautifully glazed, *haniwa* were left unglazed to reveal their clay bodies. Nor do *haniwa* show a preoccupation with technical skill seen in Chinese ceramics. Instead, their makers explored the expressive potentials of simple and bold form. *Haniwa* are never perfectly symmetrical; their slightly off-center eye slits, irregular cylindrical bodies, and unequal arms impart the idiosyncrasy of life and individuality.

SHINTO. Shinto is considered to be the indigenous religion of Japan, but it is most accurately understood as the various ways that different communities of Japanese, from the

11–5 | **MAIN HALL, INNER SHRINE, ISE**
Mie Prefecture. Last rebuilt 1993.

imperial household to remote villages, have interacted with deities *(kami).* These *kami* were thought to inhabit awesome things in the ordinary world, including particularly hoary and magnificent trees, rocks, waterfalls, and living creatures such as deer. Shinto also emphasizes ritual purification of the ordinary world. The term *Shinto* was not coined until after the arrival of Buddhism in the sixth century CE, and as *kami* worship was influenced by and incorporated into Buddhism it became more systematized, with shrines, a hierarchy of deities, and more strictly regulated ceremonies.

THE ISE SHRINE. One of the great Shinto monuments is the shrine at Ise, on the coast southwest of Tokyo **(FIG. 11–5),** dedicated to the sun goddess Amaterasu-o-mi-kami, the legendary progenitor of Japan's imperial family. For nearly 2,000 years, the shrine has been ritually rebuilt, alternately on two adjoining sites at twenty-year intervals (most recently in 1993), by carpenters who train for the task from childhood. After the *kami* is ceremonially escorted to the freshly copied shrine, the old shrine is dismantled. It is believed that the temple accurately preserves features of Yayoi-era granaries, which were its original prototype. Thus—like Japanese culture itself—this exquisite shrine is both ancient and constantly renewed.

The Ise shrine has many aspects that are typical of Shinto architecture, including wooden piles raising the building off the ground, a thatched roof held in place by horizontal logs, the use of unpainted cypress wood, and the overall feeling of natural simplicity rather than overwhelming size or elaborate decoration. Although Ise is visited by millions of pilgrims each year, only members of the imperial family and a few Shinto priests are allowed within the fourfold enclosure that surrounds the sacred shrine. The shrine itself stores the three sacred symbols of Shinto—a sword, a mirror, and a jewel.

ASUKA PERIOD

Japan has experienced several periods of intense cultural transformation. Perhaps the greatest time of change was the Asuka period (552–645 CE). During a single century, new forms of philosophy, medicine, music, foods, clothing, agricultural methods, city planning, and arts and architecture were introduced into Japan from Korea and China. The three most significant introductions, however, were Buddhism, a centralized governmental structure, and a system of writing. Each was adopted and gradually modified to suit Japanese conditions, and each has had an enduring legacy.

Buddhism reached Japan in Mahayana form, with its many *buddhas* and *bodhisattvas* (see "Buddhism," page 317). After being accepted by the imperial family, it was soon adopted as a state religion. Buddhism represented not only different gods from Shinto but an entirely new concept of religion itself. Where Shinto had found deities in beautiful and imposing natural areas, Buddhist worship was focused in temples. At first this change must have seemed strange, for the Chinese-influenced architecture and elaborate iconography introduced by Buddhism (see "Buddhist Symbols," page 381) contrasted sharply with the simple and natural aesthetics of earlier Japan. Yet Buddhism offered a rich cosmology with profound teachings of meditation and enlightenment. Moreover, the new religion was accompanied by many highly developed aspects of continental Asian culture, including new methods of painting and sculpture.

Horyu-ji

The most significant surviving early Japanese temple is Horyu-ji, located on Japan's central plains not far from Nara. The temple was founded in 607 CE by Prince Shotoku (574–622 CE), who ruled Japan as a regent and became the most influential early proponent of Buddhism. Rebuilt after a fire in 670, Horyu-ji is the oldest wooden temple in the world. It is so famous that visitors are often surprised at its modest size. Yet its just proportions and human scale, together with the artistic treasures it contains, make Horyu-ji an enduringly beautiful monument to the early Buddhist faith of Japan.

The main compound of Horyu-ji consists of a rectangular courtyard surrounded by covered corridors, one of which contains a gateway. Within the compound are only two buildings, the **kondo,** or golden hall, and a five-story **pagoda.** The

Sequencing Events
HISTORIC PERIODS IN JAPANESE ART TO 1392

c. 11,000–400 BCE	Jomon Period
c. 400 BCE–300 CE	Yayoi Period
c. 300–552 CE	Kofun Period
552–645 CE	Asuka Period
645–794 CE	Nara Period
794–1185 CE	Heian Period
1185–1392 CE	Kamakura Period

simple layout of the compound is asymmetrical, yet the large *kondo* is perfectly balanced by the tall, slender pagoda (FIG. 11–6). The *kondo* is filled with Buddhist images and is used for worship and ceremonies. The pagoda serves as a reliquary and is not entered. Other monastery buildings lie outside the main compound, including an outer gate, a lecture hall, a repository for sacred texts, a belfry, and dormitories for monks.

Among the many treasures still preserved in Horyu-ji is a shrine decorated with paintings in lacquer. It is known as the Tamamushi Shrine after the *tamamushi* beetle, whose iridescent wings were originally affixed to the shrine to make it glitter, much like mother-of-pearl. There has been some debate whether the shrine was made in Korea, in Japan, or perhaps by Korean artisans in Japan. The question of whether it is, in fact, a "Japanese" work of art misses the point that

11–6 AERIAL VIEW OF HORYU-JI COMPOUND
Pagoda to the west, Golden Hall *(Kondo)* to the east, Nara Prefecture. Asuka period, 7th century CE.
Photo: Orion Press, Tokyo

Buddhism was so international at that time that matters of nationality were irrelevant.

HUNGRY TIGRESS JATAKA. The Tamamushi Shrine is a replica of an even more ancient palace-form building, and its architectural details preserve a tradition predating Horyu-ji itself. Its paintings are among the few two-dimensional works of art to survive from the Asuka period. Most celebrated among them are two that illustrate **jataka tales,** stories about former lives of the Buddha. One depicts the future Buddha nobly sacrificing his life in order to feed his body to a starving tigress and her cubs (**FIG. 11–7**). The tigers are at first too weak to eat him, so he must jump off a cliff to break open his flesh. The anonymous artist has created a full narrative within a single frame. The graceful form of the Buddha appears three times, harmonized by the curves of the rocky cliff and tall sprigs of bamboo. First, he hangs his shirt on a tree, then he dives downward onto the rocks, and finally he is devoured by the starving animals. The elegantly slender renditions of the figure and the somewhat abstract treatment of the cliff, trees, and bamboo represent an international Buddhist style largely shared during this time by China, Korea, and Japan. These illustrations for the *jataka* tales helped spread Buddhism in Japan.

SHAKA TRIAD. Another example of the international style of early Buddhist art at Horyu-ji is the sculpture called the **SHAKA TRIAD,** by Tori Busshi (**FIG. 11–8**). (**SHAKA** is the Japanese name for Shakyamuni, the historical Buddha.) Tori Busshi was a third-generation Japanese, whose grandfather had emigrated to Japan from the continent as part of an influx of Buddhists and artisans from China and Korea. The *Shaka Triad* reflects the strong influence of Chinese art of the Northern Wei dynasty (**SEE FIG. 10–13**). The frontal pose, the outsized face and hands, and the linear treatment of the drapery all suggest that Tori Busshi was well aware of earlier continental

11–7 | HUNGRY TIGRESS JATAKA
Panel of the Tamamushi Shrine, Horyu-ji. Asuka period, c. 650 CE. Lacquer on wood, height of shrine 7' 7½" (2.33 m). Horyu-ji Treasure House.

11–8 | Tori Busshi SHAKA TRIAD IN THE KONDO
Horyu-ji. Asuka period, c. 623 CE. Gilt bronze, height of seated figure 34½" (87.5 cm).

Myth and Religion
BUDDHIST SYMBOLS

A few of the most important Buddhist symbols, which have myriad variations, are described here in their most generalized forms.

Lotus flower: Usually shown as a white water lily, the lotus (Sanskrit, *padma*) symbolizes spiritual purity, the wholeness of creation, and cosmic harmony. The flower's stem is an **axis mundi** ("axis of the world").

Lotus throne: Buddhas are frequently shown seated on an open lotus, either single or double, a representation of *nirvana*.

Chakra: An ancient sun symbol, the wheel (*chakra*) symbolizes both the various states of existence (the Wheel of Life) and the Buddhist doctrine (the Wheel of the Law). A *chakra*'s exact meaning depends on how many spokes it has.

Marks of a buddha: A *buddha* is distinguished by thirty-two physical attributes (*lakshana*). Among them are a bulge on top of the head (*ushnisha*), a tuft of hair between the eyebrows (*urna*), elongated earlobes, and thousand-spoked *chakras* on the soles of the feet.

Mandala: *Mandalas* are diagrams of cosmic realms, representing order and meaning within the spiritual universe. They may be simple or complex, three- or two-dimensional, in a wide array of forms—such as an Indian stupa (SEE FIG. 9–8) or a Womb World *mandala* (SEE FIG. 11-10), an early Japanese type.

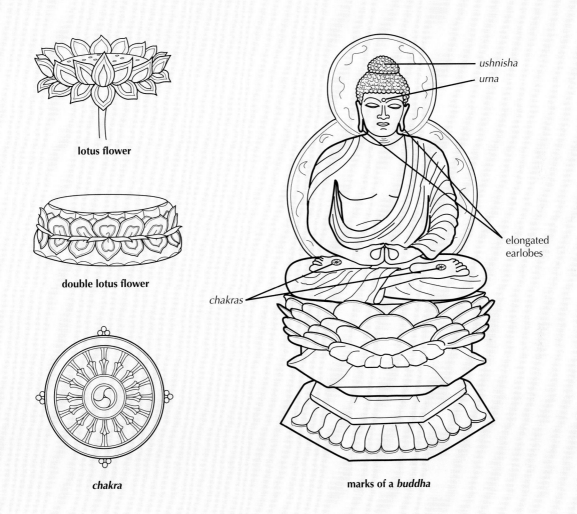

lotus flower

double lotus flower

chakra

ushnisha
urna
elongated earlobes
chakras

marks of a buddha

models, while the fine bronze casting of the figures shows his advanced technical skill. The *Shaka Triad* and the Tamamushi Shrine reveal how quickly Buddhist art became an important feature of Japanese culture.

NARA PERIOD

The Nara period (645–794 CE) is named for Japan's first permanent imperial capital. Previously, when an emperor died, his capital was considered tainted, and for reasons of purification (and perhaps also of politics) his successor usually selected a new site. With the emergence of a complex, Chinese-style government, however, this custom was no longer practical. By establishing a permanent capital in Nara, the Japanese were able to enter a new era of growth and consolidation. Nara swelled to a population of perhaps 200,000 people. During this period the imperial system solidified into an effective government that could withstand the powerful aristocratic families that had traditionally dominated the political world.

One result of strong central authority was the construction in Nara of magnificent Buddhist temples and monasteries that dwarfed those built previously. Even today a large area of Nara is a park where numerous temples preserve magnificent Nara-period art and architecture. The grandest of these temples, Todai-ji, is so large that the area surrounding only one of its pagodas could accommodate the entire main compound of Horyu-ji. When it was built, and for a thousand years thereafter, Todai-ji was the largest wooden structure in the world. Not all the monuments of Nara are Buddhist. There also are several Shinto shrines, and deer wander freely, reflecting Japan's Shinto heritage.

Buddhism and Shinto have coexisted quite comfortably in Japan over the ages. One seeks enlightenment, the other purification, and since these ideals did not clash, neither did the two forms of religion. Although there were occasional attempts to promote one over the other, more often they were seen as complementary, and to this day most Japanese see nothing inconsistent about having Shinto weddings and Buddhist funerals.

While Shinto became more formalized during the Nara period, Buddhism advanced to become the single most significant element in Japanese culture. One important method for transmitting Buddhism in Japan was through the copying of Buddhist sacred texts, the *sutras*. They were believed to be so beneficial and magical that occasionally a single word would be cut out from a *sutra* and worn as an amulet. Someone with hearing problems, for example, might use the word for "ear."

Copying the words of the Buddha was considered an effective act of worship by the nobility; it also enabled Japanese courtiers as well as clerics to become familiar with the Chinese system of writing—with both secular and religious results. During this period, the first histories of Japan were written, strongly modeled upon Chinese precedents, and the

first collection of Japanese poetry, the *Manyoshu*, was compiled. The *Manyoshu* includes Buddhist verse, but the majority of the poems are secular, including many love songs in the five-line *tanka* form, such as this example by the late seventh-century courtier Hitomaro (all translations from Japanese are by Stephen Addiss unless otherwise noted):

> Did those
> who lived in past ages
> lie sleepless
> as I do tonight
> longing for my beloved?

Unlike the poetry, most other art of the Nara period is sacred, with a robust splendor that testifies to the fervent belief and great energy of early Japanese Buddhists. Some of the finest Buddhist paintings of the late seventh century were preserved in Japan on the walls of the golden hall of Horyu-ji until a fire in 1949 defaced and partially destroyed them. Fortunately, they had been thoroughly documented before the fire in a series of color photographs. These murals represent what many scholars believe to be the golden age of Buddhist painting, an era that embraces the Tang dynasty in China (618–907 CE), the Unified Silla period in Korea (668–935 CE), and the Nara period in Japan.

One of the finest of the Horyu-ji murals is thought to represent Amida, the Buddha of the Western Paradise

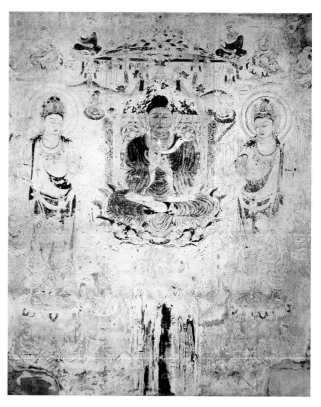

II–9 | AMIDA BUDDHA
Wall painting in the *kondo*, Horyu-ji. Nara period, c. 710 CE. Ink and colors (now severely damaged), 10′3″ × 8′6″ (3.13 × 2.6 m).

(FIG. 11–9). Delineated in the thin, even brushstrokes known as *iron-wire lines*, Amida's body is rounded, his face is fully fleshed and serene, and his hands form the **dharmachakra** ("revealing the Buddhist law") *mudra* (see "*Mudras*," page 325). Instead of the somewhat abstract style of the Asuka period, there is now a greater emphasis on realistic detail and body weight in the figure. The parallel folds of drapery show the enduring influence of the Gandhara style current in India 500 years earlier (SEE FIG. 9–13), but the face is fully East Asian in contour and spirit.

The Nara period was an age of faith, and Buddhism permeated the upper levels of society. Indeed, one of the few empresses in Japanese history wanted to cede her throne to a Buddhist monk. Her advisers and other influential courtiers became extremely worried at this, and they finally decided to move the capital away from Nara, where they felt Buddhist influence had become overpowering. The move of the capital to Kyoto marked the end of the Nara period.

HEIAN PERIOD

The Japanese fully absorbed and transformed the influences from China and Korea during the Heian period (794–1185 CE). Generally peaceful conditions contributed to a new air of self-reliance on the part of the Japanese. The imperial government severed ties to China in the ninth century and was sustained by support from aristocratic families. An efficient method of writing the Japanese language was developed, and the rise of vernacular literature generated such masterpieces as the world's first novel, Lady Murasaki's *The Tale of Genji*. During these four centuries of splendor and refinement, two major religious sects emerged—first, Esoteric Buddhism and, later, Pure Land Buddhism.

Esoteric Buddhist Art

With the removal of the capital to Kyoto, the older Nara temples lost their influence. Soon two new Esoteric sects of Buddhism, named Tendai and Shingon, grew to dominate Japanese religious life. Strongly influenced by polytheistic religions such as Hinduism, Esoteric Buddhism included a daunting number of deities, each with magical powers. The historical Buddha was no longer very important. Instead, the universal Buddha, called Dainichi in Japanese, meaning "Great Sun," was believed to preside over the universe. He was accompanied by *buddhas* and *bodhisattvas*, as well as guardian deities who formed fierce counterparts to the more benign gods.

Esoteric Buddhism is hierarchical, and its deities have complex relationships to one another. Learning all the different gods and their interrelationships was assisted greatly by works of art, especially **mandalas,** cosmic diagrams of the universe that portray the deities in schematic order. The Womb World *mandala* from To-ji, for example, is entirely

11–10 | **WOMB WORLD MANDALA**
To-ji, Kyoto. Heian period, late 9th century CE. Hanging scroll, colors on silk, 6′ × 5′1½″ (1.83 × 1.54 m).

Mandalas are used not only in teaching, but also as vehicles for practice. A monk, initiated into secret teachings, may meditate upon and assume the gestures of each deity depicted in the *mandala*, gradually working out from the center, so that he absorbs some of each deity's powers. The monk may also recite magical phrases called *mantras* as an aid to meditation. The goal is to achieve enlightenment through the powers of the different forms of the Buddha. *Mandalas* are created in sculptural and architectural forms as well as in paintings. Their integration of the two most basic shapes, the circle and the square, is an expression of the principles of ancient *geomancy* (divining by means of lines and figures) as well as Buddhist cosmology.

filled with depictions of gods. Dainichi is at the center, surrounded by *buddhas* of the four directions (FIG. 11–10). Other deities, including some with multiple heads and limbs, branch out in diagrammatical order, each with a specific symbol of power. To believers, the *mandala* represents an ultimate reality beyond the visible world.

Perhaps the most striking attribute of many Esoteric Buddhist images is their sense of spiritual force and potency, especially in depictions of the wrathful deities, which are often surrounded by flames, like those visible in the *Womb World Mandala* just below the main circle of Buddhas. Esoteric Buddhism, with its intricate theology and complex doctrines, was a religion for the educated aristocracy, not for the masses. Its intricate network of deities, hierarchy, and ritual found a parallel in the elaborate social divisions of the Heian court.

Pure Land Buddhist Art

During the latter half of the Heian period, a rising military class threatened the peace and tranquility of court life. The beginning of the eleventh century was also the time for which the decline of Buddhism (*Mappo*) had been prophesied. In these uncertain years, many Japanese were ready for another form of Buddhism that would offer a more direct means of salvation than the elaborate rituals of the Esoteric sects.

Pure Land Buddhism, although it had existed in Japan earlier, now came to prominence. It taught that the Western Paradise (the Pure Land) of the Amida Buddha could be reached through nothing more than faith. In its ultimate form, Pure Land Buddhism held that the mere chanting of a *mantra*—the phrase *Namu Amida Butsu* ("Hail to Amida Buddha")—would lead to rebirth in Amida's paradise. This doctrine soon swept throughout Japan. Spread by traveling monks who took the chant to all parts of the country (SEE FIG. 11–17), it appealed to people of all levels

11–11 | **PHOENIX HALL, BYODO-IN, UJI**
Kyoto Prefecture. Heian period, c. 1053 CE.

of education and sophistication. Pure Land Buddhism has remained the most popular form of Buddhism in Japan ever since.

BYODO-IN. One of the most beautiful temples of Pure Land Buddhism is the Byodo-in, located in the Uji Mountains not far from Kyoto (FIG. 11–11). The temple itself was originally a secular palace created to suggest the palace of Amida in the Western Paradise. It was built for a member of the powerful Fujiwara family who served as the leading counselor to the emperor. After the counselor's death in the year 1052, the palace was converted into a temple. The Byodo-in is often called Phoenix Hall, not only for the pair of phoenix images on its roof, but also because the shape of the building itself suggests the mythical bird. Its thin columns give the Byodo-in a sense of airiness, as though the entire temple could easily rise up through the sky to Amida's Western Paradise. The hall rests gently in front of an artificial pond created in the shape of the Sanskrit letter A, the sacred symbol for Amida.

II–I2 | Jocho **AMIDA BUDDHA**
Phoenix Hall, Byodo-in. Heian period, c. 1053 CE. Gold leaf and lacquer on wood, height 9'8″ (2.95 m).

The Byodo-in's central image of Amida, carved by the master sculptor Jocho (d. 1057), exemplifies the serenity and compassion of the Buddha, who welcomes the souls of all believers to his paradise (FIG. II–I2). When reflected in the water of the pond before it, the Amida image seems to shimmer in its private mountain retreat. The figure was not carved from a single block of wood like earlier sculpture, but from several blocks in Jocho's new **joined-wood** method of construction (see "Joined-Wood Sculpture," page 387). This technique allowed sculptors to create larger but lighter portrayals of *buddhas* and *bodhisattvas* for the many temples constructed and dedicated to the Pure Land faith. It also reflects the Japanese love of wood, which during the Heian period became the major medium for sculpture.

Surrounding the Amida on the walls of the Byodo-in are smaller wooden figures of *bodhisattvas* and angels, some playing musical instruments. Everything about the Byodo-in was designed to suggest the paradise that awaits the believer after death. Its remarkable state of preservation after more than 900 years allows visitors to experience the late Heian-period religious ideal at its most splendid.

Calligraphy and Painting

One prominent style of Japanese calligraphy that emerged at this period, such as that seen in the *Ishiyama-gire* (SEE FIG. 11–1), was considered "women's hand." Actually, it is not known how much of the calligraphy of the time was written by women or how widespread the term was in actual use. It is certain, however, that women were a vital force in Heian society. Although the place of women in Japanese society was to decline in later periods, they contributed greatly to the art at the Heian court.

Women were noted for both their poetry and their prose, including diaries, mythical tales, and courtly romances. Lady Murasaki transposed the lifestyle of the Heian court into fiction in the first known novel, *The Tale of Genji*, at the beginning of the eleventh century. She wrote in Japanese at a time when men still wrote prose primarily in Chinese, and her work remains one of Japan's—and the world's—great novels. Underlying the story of the love affairs of Prince Genji and his companions is the Japanese conception of fleeting pleasures and ultimate sadness in life, an echo of the Buddhist view of the vanity of earthly pleasures.

"WOMEN'S HAND" STYLE. One of the earliest extant secular paintings from Japan is a series of scenes from *The Tale of Genji*, painted in the twelfth century by unknown artists in "women's hand" painting style. This style was characterized by delicate lines, strong (but sometimes muted) colors, and asymmetrical compositions usually viewed from above through invisible, "blown-away" roofs. The *Genji* paintings have a refined, subtle emotional impact. They generally show court figures in architectural settings, with the frequent addition of natural elements, such as sections of gardens, that help to represent the mood of the scene. Thus a blossoming cherry tree appears in a scene of happiness, while unkempt weeds appear in a depiction of loneliness. Such correspondence between nature and human emotion is an enduring feature of Japanese poetry and art.

The figures in *The Tale of Genji* paintings do not show their emotions directly on their faces, which are rendered with a few simple lines. Instead, their feelings are conveyed by colors, poses, and the total composition of the scenes. One scene evokes the seemingly happy Prince Genji holding a baby boy borne by his wife, Nyosan. In fact, the baby was fathered by another court noble. Since Genji himself has not been faithful to Nyosan, who appears in profile below him, he cannot complain; meanwhile the true father of the child has died, unable to acknowledge his only son (FIG. 11–13). Thus, what should be a joyful scene has undercurrents of irony and sorrow. The irony is even greater because Genji himself is the illegitimate son of an emperor.

One might expect a painting of such an emotional scene to focus on the people involved. Instead, they are rendered in rather small size, and the scene is dominated by a screen that effectively

Technique
JOINED-WOOD SCULPTURE

Wood is a temperamental material because fluctuations in moisture content cause it to swell and shrink. Cut from a living, sap-filled tree, wood takes many years to dry to a state of stability. While the outside of a piece of wood dries fairly rapidly, the inside yields its moisture only gradually, causing a difference in the rates of shrinkage between the inside and the outside, which induces the wood to crack. Natural irregularities in wood, such as knots, further accentuate this problem. Thus, wood with a thinner cross-section and fewer irregularities is less susceptible to cracking because it can dry more evenly. (This is the logic behind sawing logs into boards before drying.) On the other hand, a large statue carved from a single log must inevitably crack as it ages.

An advanced strategy adopted by Japanese sculptors to reduce such cracking in large statues was the **joined-wood** technique. Here the design for a statue was divided into sections, each of which was carved from a separate block. These sections were then hollowed out and assembled. By using multiple blocks, sculptors could produce larger images than they could from any single block. Moreover, statue sections could be created by teams of carvers, some of whom became specialists in certain parts, such as hands or crossed legs or lotus thrones. Through this cooperative approach, large statues (see, for example, FIG. 11-12) could be produced with great efficiency to meet a growing demand.

squeezes Genji and his wife into a corner. This composition deliberately represents how their positions in courtly society have forced them into this unfortunate situation. In typical Heian style, Genji expresses his emotion by murmuring a poem:

> How will he respond,
> The pine growing on the mountain peak,
> When he is asked who planted the seed?

"MEN'S HAND" STYLE. While *The Tale of Genji* scroll represents courtly life as interpreted through the "women's hand" style of painting, Heian painters also cultivated a contrasting

"men's hand" style. Characterized by strong ink play and lively brushwork, it most often depicts subjects outside the court. One of the masterpieces of this style is *Frolicking Animals*, a set of scrolls satirizing the life of many different levels of society. Painted entirely in ink, the scrolls are attributed to Toba Sojo, the abbot of a Buddhist temple, and they represent the humor of Japanese art to the full.

In one scene, a frog is seated as a *buddha* upon an altar while a monkey dressed as a monk prays proudly to him; in other scenes frogs, donkeys, foxes, and rabbits are shown playing, swimming, and wrestling, with one frog boasting of

11–13 | **SCENE FROM *THE TALE OF GENJI***
Heian period, 12th century CE. Handscroll, ink and colors on paper, 8⅝ × 18⅞" (21.9 × 47.9 cm).
Tokugawa Art Museum, Nagoya.

Twenty chapters from *The Tale of Genji* have come down to us in illustrated scrolls such as this one. Scholars assume, however, that the entire novel of fifty-four chapters must have been written out and illustrated—a truly monumental project. Each scroll seems to have been produced by a team of artists. One was the calligrapher, most likely a member of the nobility. Another was the master painter, who outlined two or three illustrations per chapter in fine brushstrokes and indicated the color scheme. Next, colorists went to work, applying layer after layer of color to build up patterns and textures. After they had finished, the master painter returned to reinforce outlines and apply the finishing touches, among them the details of the faces.

11–14 ┆ Attributed to Toba Sojo, **DETAIL OF FROLICKING ANIMALS** Heian period, 12th century CE. Handscroll, ink on paper, height 12″ (30.5 cm). Kozan-ji, Kyoto.

his prowess when he flings a rabbit to the ground (FIG. 11–14). Playful and irreverent though it may be, the quality of the painting is remarkable. Each line is brisk and lively, and there are no strokes of the brush other than those needed to depict each scene. Unlike the *Genji* scroll, there is no text to *Frolicking Animals*, and we must make our own interpretations of the people and events being satirized. Nevertheless, the visual humor is so lively and succinct that we can recognize not only the Japanese of the twelfth century, but perhaps also ourselves.

KAMAKURA PERIOD

The courtiers of the Heian era became so engrossed in their own refinement that they neglected their responsibilities for governing the country. Clans of warriors—samurai—from outside the capital grew increasingly strong. Drawn into the factional conflicts of the imperial court, samurai leaders soon became the real powers in Japan.

A BATTLE HANDSCROLL. The two most powerful warrior clans were the Minamoto and the Taira, whose battles for domination became famous not only in medieval Japanese history but also in literature and art. One of the great painted handscrolls depicting these battles is **NIGHT ATTACK ON THE SANJO PALACE** (FIGS. 11–15, 11–16). Painted perhaps 100 years after the actual event, the scroll conveys a sense of eyewitness reporting even though the anonymous artist had to imagine the scene from verbal (and at best semifactual) descriptions. The style of the painting includes some of the brisk and lively linework of *Frolicking Animals* and also traces of the more refined brushwork, use of color, and bird's-eye viewpoint of *The Tale of Genji* scroll. The main element, however, is the savage depiction of warfare (see "Arms and Armor," page 389). Unlike the *Genji* scroll, *Night Attack* is full of action: Flames engulf the palace, horses charge, warriors behead their enemies, court ladies try to hide, and a sense of energy and violence is conveyed with great sweep and power. The era of

11–15 ┆ **SECTION OF NIGHT ATTACK ON THE SANJO PALACE**
Kamakura period, late 13th century CE. Handscroll, ink and colors on paper, 16¼ × 275½″ (41.3 × 699.7 cm). Museum of Fine Arts, Boston. Fenollosa-Weld Collection (11.4000)

The battles between the Minamoto and Taira clans were fought primarily by mounted and armored warriors, who used both bows and arrows and the finest swords. In the year 1160, some 500 Minamoto rebels opposed to the retired emperor Go-Shirakawa carried out a daring raid on the Sanjo Palace. In a surprise attack in the middle of the night, they abducted the emperor. The scene was one of great carnage, much of it caused by the burning of the wooden palace. Despite the drama of the scene, this was not the decisive moment in the war. The Minamoto rebels would eventually lose more important battles to their Taira enemies. Yet Minamoto forces, heirs to those who carried out this raid, would eventually prove victorious, destroying the Taira clan in 1185.

11–16 DETAIL OF NIGHT ATTACK ON THE SANJO PALACE

poetic refinement was now over in Japan, and the new world of the samurai began to dominate the secular arts.

The Kamakura era (1185–1333 CE) began when Minamoto Yoritomo (1147–99) defeated his Taira rivals and assumed power as shogun (general-in-chief). To resist the softening effects of courtly life in Kyoto, he established his military capital in Kamakura. While paying respect to the emperor, Yoritomo kept both military and political power for himself. He thus began a tradition of rule by shogun that lasted in various forms until 1868.

Pure Land Buddhist Art

Rising militarism, political turbulence, and the excesses of the imperial court marked the beginning of the eleventh century in Japan. To many Japanese of the late Heian and Kamakura eras, the unsettled times seemed to confirm the coming of *Mappo*, a long-prophesied dark age of spiritual degeneration. Japanese of all classes reacted by increasingly turning to the promise of simple salvation extended by Pure Land Buddhism, which had spread from China by way of Korea. The religion held that merely by chanting *Namu Amida Butsu*, hailing the Buddha Amida (the Japanese version of Amitabha Buddha), the faithful would be reborn into the Western (Pure Land) Paradise over which he presided.

A PORTRAIT SCULPTURE. The practice of chanting had been spread throughout Japan by traveling monks such as the charismatic Kuya (903–72 CE), who encouraged people to chant by going through the countryside singing. Believers would have immediately recognized Kuya in this thirteenth-century portrait statue by Kosho (FIG. 11–17): the traveling clothes, the small gong, the staff topped by deer horns (symbolic of his slaying a deer, whose death converted him to Buddhism), clearly identify the monk, whose sweetly intense expression gives this sculpture a radiant sense of faith. As for

ARMS AND ARMOR

Battles such as the one depicted in *Night Attack on the Sanjo Palace* (SEE FIGS. 11-15, 11-16) were fought largely by archers on horseback. Samurai archers charged the enemy at full gallop and loosed their arrows just before they wheeled away. The scroll clearly shows their distinctive bow, with its asymmetrically placed handgrip. The lower portion of the bow is shorter than the upper so it can clear the horse's neck. The samurai wear a long, curved sword at the waist.

By the tenth century, Japanese swordsmiths had perfected techniques for crafting their legendarily sharp swords. Swordmakers face a fundamental difficulty: Steel hard enough to hold a razor-sharp edge is brittle and breaks easily, but steel resilient enough to withstand rough use is too soft to hold a keen edge. The Japanese ingeniously forged a blade which laminated a hard cutting edge within less brittle support layers.

Samurai armor, illustrated here, was made of overlapping iron and lacquered leather scales, punched with holes and laced together with leather thongs and brightly colored silk braids. The principal piece wrapped around the chest, left side, and back. Padded shoulder straps hooked it together back to front. A separate piece of armor was tied to the body to protect the right side. The upper legs were protected by a skirt of four panels attached to the body armor, while two large rectangular panels tied on with cords guarded the arms. The helmet was made of iron plates riveted together. From it hung a neckguard flared sharply outward to protect the face from arrows shot at close range as the samurai wheeled away from an attack.

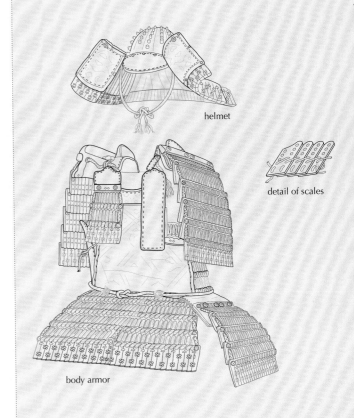

helmet

detail of scales

body armor

389

THE ⬤BJECT SPEAKS

MONK SEWING

In the early thirteenth century CE, a statue such as Kosho's *Kuya Preaching* (SEE FIG. 11–17) epitomized the faith expressed in Pure Land Buddhist art. At the very same time, Zen Buddhism was being introduced into Japan from China, and within a century its art communicated a far different message. Whereas Kuya had wandered the countryside, inviting the faithful to chant the name of Amida Buddha and relying on the generosity of believers to support him, Zen monks lived settled lives in monasteries—usually up in the mountains. They had no need of contributions from the court or from believers.

Then, as today, Japanese Zen monks grew and cooked their own food, cleaned their temples, and were as responsible for their daily lives as for their own enlightenment. In addition to formal meditation, they practiced *genjo koan*, taking an ordinary circumstance in their immediate world, such as mending a garment, as an object of meditation. Thus, a painting such as **MONK SEWING**, which bears the seals of the Buddhist priest-painter Kao Ninga (active mid-fourteenth century), would have spoken clearly to viewers of a commitment to a life of simplicity and responsibility for oneself. It was and is still so effective because it has the blunt style, strong sense of focus, and visual intensity of the finest Zen paintings. The almost humorous compression of the monk's face, coupled with the position of the darker robe, focuses our attention on his eyes, which then lead us out to his hand pulling the needle. We are drawn into the activity of the painting rather than merely sitting back and enjoying it as a work of art. This sense of intense activity within daily life, involving us directly with the painter and the subject, is, together with the bold ink brushwork, a feature of the best Zen figure paintings.

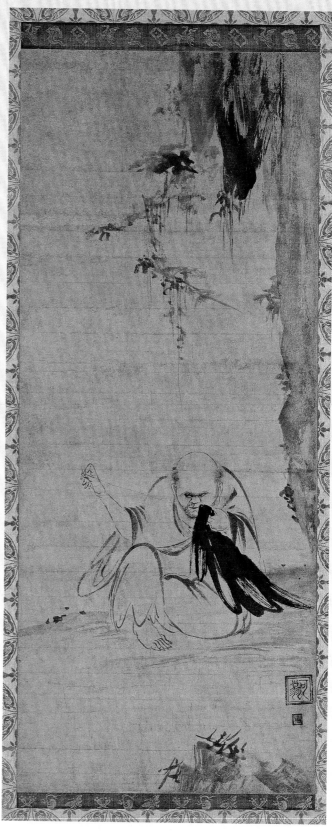

Attributed to Kao Ninga, MONK SEWING
Kamakura period, early 14th century. Ink on paper, 31⅞ × 13½"
(83.5 × 35.4 cm). The Cleveland Museum of Art.
John L. Severance Fund (62.163)

11-17 Kosho, **KUYA PREACHING**
Kamakura period, before 1207. Painted wood with inlaid eyes, height 46½" (117.5 cm). Rokuhara Mitsu-ji, Kyoto.

Kuya's chant, Kosho's solution to the challenge of putting words into sculptural form was simple but brilliant: He carved six small *buddhas* emerging from Kuya's mouth, one for each of the six syllables of *Na-mu-A-mi-da-Buts(u)* (the final *u* is not articulated). Believers would have understood that these six small *buddhas* embodied the Pure Land chant.

During the early Kamakura period, Pure Land Buddhism remained the most influential form of religion and was expressed in the new naturalistic style of sculpture as seen in *Kuya* by Kosho. Just as the *Night Attack* revealed the political turbulence of the period through its vivid colors and forceful style, Kamakura-era portraiture saw a new emphasis on realism, including the use of crystal eyes in sculpture for the first time. Perhaps the warriors had a taste for realism, for many sculptors and painters of the Kamakura period became expert in depicting faces, forms, and drapery with great attention to naturalistic detail. As we have seen, Kosho took on the more

difficult task of representing in three dimensions not only the person of the famous monk Kuya but also his chant.

RAIGO PAINTINGS. Pure Land Buddhism taught that even one sincere invocation of the sacred chant could lead the most wicked sinner to the Western Paradise. Paintings called **raigo** (literally "welcoming approach") were created depicting the Amida Buddha, accompanied by *bodhisattvas*, coming down to earth to welcome the soul of the dying believer. Golden cords were often attached to these paintings, which were taken to the homes of the dying. A person near death held on to these cords, hoping that Amida would escort the soul directly to paradise.

Raigo paintings are quite different in style from the complex *mandalas* and fierce guardian deities of Esoteric Buddhism. Like Jocho's sculpture of Amida at the Byodo-in (FIG. 11–12), they radiate warmth and compassion. One magnificent *raigo*, a portrayal of Amida Buddha and twenty-five *bodhisattvas* swiftly descending over mountains, employs gold paint and slivers of gold leaf cut in elaborate patterning to suggest the radiance of their draperies (FIG. 11–18). The sparkle of the gold over the figures is heightened by the darkening of the silk behind them, so that the deities seem to come forth from the surface of the painting. In the flickering light of oil lamps and torches, *raigo* paintings would have glistened and gleamed in magical splendor in a temple or a dying person's home.

In every form of Buddhism, paintings and sculpture became vitally important elements in religious teaching and belief. In their own time they were not considered works of art but rather visible manifestations of faith.

Zen Buddhist Art

Toward the latter part of the Kamakura period, Zen Buddhism, the last major form to reach Japan, appeared. Zen was already highly developed in China, where it was known as Chan, but it had been slow to reach Japan because of the interruption of relations between the two countries during the Heian period. But during the Kamakura era, both visiting Chinese and returning Japanese monks brought Zen to Japan. It would have a lasting impact on Japanese arts.

In some ways, Zen resembles the original teachings of the historical Buddha. It differed from both Esoteric and Pure Land

11–18 DESCENT OF AMIDA AND THE TWENTY-FIVE BODHISATTVAS
Kamakura period, 13th century. Colors and gold on silk, 57¼ × 61½″ (145 × 155.5 cm). Chion-in, Kyoto.

Buddhism in emphasizing that individuals must reach their own enlightenment through meditation, without the help of deities or magical chants. It especially appealed to the self-disciplined spirit of samurai warriors, who were not satisfied with the older forms of Buddhism connected with the Japanese court.

Zen temples were usually built in the mountains rather than in large cities. An abbot named Kao Ninga at an early Zen temple was a pioneer in the kind of rough and simple ink painting that so directly expresses the Zen spirit. We can see this style in a remarkable ink portrait of a monk sewing his robe (see "*Monk Sewing,*" page 390). Buddhist prelates of other sects undoubtedly had assistants to take care of such mundane tasks as repairing a robe, but in Zen Buddhism each monk, no matter how advanced, is expected to do all tasks for himself. Toward the end of the fourteenth century, Zen's spirit of self-reliance began to dominate many aspects of Japanese culture.

As the Kamakura era ended, the seeds of the future were planted: Control of rule by the warrior class and Zen values had become established as the leading forces in Japanese life and art.

IN PERSPECTIVE

The history of Japanese art illuminates an intriguing interplay between native traditions and transmitted culture. In the Japanese archipelago, the Jomon culture produced the world's first ceramics, their early technology developing into a distinctive and long-lived pottery style. Jomon eventually gave way to a new culture, that of the Yayoi, apparently brought by immigrants from the Asian continent. Yayoi and the subsequent Kofun period saw technological developments, includ-

ing new ceramic techniques and the casting of bronze. With the Kofun period, mounded tombs appeared, with *haniwa* figures to guard them. Wooden architecture emerged, with elements that today we think of as distinctively Japanese.

During the Asuka and Nara periods, cultural transmission from China via Korea accelerated bringing a system of writing, the Buddhist religion, and a new tile-roofed architecture. A permanent capital city was established, built on a Chinese model, and Chinese-style government was developed. Magnificent temples were constructed in this city, called Nara, and some of those still stand today.

During the Heian period, the Japanese built upon recent trends in Buddhism imported from the continent, and developed sects of Esoteric Buddhism and Pure Land Buddhism. The artistic legacy of these sects is seen today in mandalas and *raigo* paintings as well as in portrait sculpture. During this period, a distinctly Japanese writing system and calligraphy were created, with a syllabary of *kana* to supplement the *kanji* of Chinese origin. With the use of *kana*, calligraphic compositions diverged from the regulated Chinese forms into more spontaneous and asymmetrical compositions. Painting too embraced asymmetry and spontaneity, often combining these with gold decoration.

A warrior culture emerged at the end of the Heian period, and with the Kamakura period a long period of rule by military *shoguns* ensued. The *shogun* and *samurai* retainers adopted a new form of Buddhism from China, Chan or Zen, in which they found a self-reliant discipline. Ink painting, also from China, reflected both the restraint and the spontaneity of Zen, and became a highly developed and distinctly Japanese tradition.

DOGU
C. 2500–1500 BCE

HANIWA
6TH CENTURY CE

TORI BUSSHI
C. 623 CE

BYODO-IN
C. 1053 CE

**ATTRIBUTED TO
KAO NINGA, MONK SEWING**
EARLY 14TH CENTURY

JAPANESE ART BEFORE 1392

12,000 BCE

300

300 CE

500

700

900

1100

1200

1400 CE

◄ **Jomon**
c. 11,000–400 BCE

◄ **Yayoi**
c. 400 BCE–300 CE

◄ **Kofun**
c. 300–552 CE

◄ **Asuka** 552–646 CE

◄ **Nara** 646–794 CE

◄ **Heian** 794–1185 CE

◄ **Kamakura** 1185–1333 CE

◄ **Nambokucho (Period of Rival Northern and Southern)**
1336–1392 CE

12–1 **SUN DAGGER SOLAR MARKER AT EQUINOX** Fajada Butte, Chaco Canyon, New Mexico. 850–1250 CE.

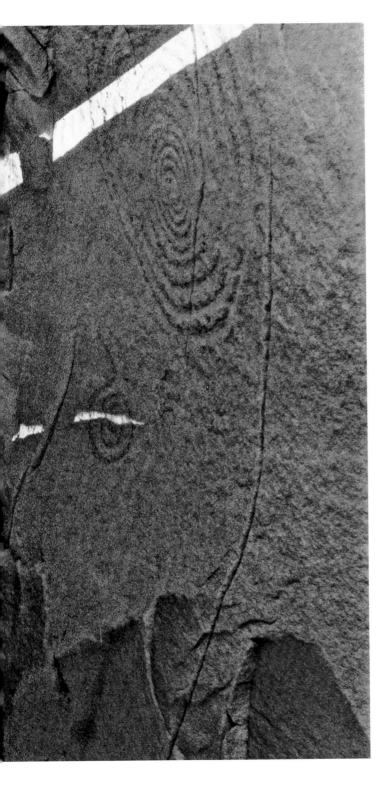

CHAPTER TWELVE

ART
OF THE AMERICAS
BEFORE 1300

12

On the morning of the summer solstice a streak of light strikes a high cliff in Chaco Canyon. Slowly this "Sun Dagger" descends, and by noontime it pierces the heart of a large spiral engraved into the rock (FIG. 12–1). The Ancestral Puebloans (formerly called Anasazi) of Chaco Canyon pecked out this spiral, along with a smaller one, on the face of the bluff. The shaft of light forming the Dagger is created by openings between huge slabs of rock, which admit streaks of light that project on the wall. The light moves with the seasonal motion of the sun. Only at the summer solstice in June does the great Dagger appear. At the winter solstice two streaks frame the spiral petroglyph, and at both spring and fall equinoxes a small spike of light hits the center of the small spiral and a large shaft cuts through the large spiral but misses its center. "Sun Watchers" may have monitored these events and reported to the community when the time had come to begin special ceremonies or to plant the life-sustaining corn. The rock formation that, together with the moving sun, creates the daggers of light is natural, but the two spirals were located thoughtfully. Nature and art combine, as they do in the work of a modern environmental artist.

Among Ancestral Puebloans spirals were signs for journeys, as well as for wind and water, serpents and snails. The later Zuni call the spiral a "journey in search of the Center."

The clocklike workings of the spiral petroglyphs, together with their location on a high point distant from living areas in the canyon, have led to the speculation that the Sun Marker was once a shrine.

The architectural and monumental center of Chaco Canyon is **PUEBLO BONITO** (SEE FIG. 12–25). A complex of rooms and corridors begun in the tenth century CE and enlarged regularly, Pueblo Bonito stood at the hub of a network of wide, straight roads that radiated out to some seventy other communities. Almost invisible today, the roads were discovered through aerial photography. The roads make no detour to avoid topographic obstacles; when they encounter cliffs, they become stairs. Their undeviating course suggests that the roads were more than practical thoroughfares; they may have served as processional ways. Was Pueblo Bonito a gathering place for people in the entire region at specific times of year? Did they assemble there when called by the Sun Watchers?

When the Puebloans of Chaco Canyon were watching for their Sun Dagger, men and women in Europe were also using light, to honor and communicate with God in churches with huge stained glass-windows. Pueblo Bonito is contemporary with the great ceremonial centers like the Abbey of Saint-Denis (FIGS. 16–1 TO 16–3) and the Cathedral of Chartres (FIGS. 16–11 TO 16–14) in Western Europe. In Chaco Canyon, without written texts and without a living tradition, we can speculate but we can never know how Pueblo Bonito and the Chaco Sun Dagger were used. For answers we turn not to texts, but to art and architecture.

THE NEW WORLD

In recent years the question of the original settlement of the Americas has become an area of scholarly debate. The traditional view has been that human beings arrived in North and South America from Asia during the last Ice Age, when glaciers trapped enough of the world's water to lower the level of the oceans and expose a land bridge across the Bering Strait. Although most of present-day Alaska and Canada was covered by glaciers at that time, an ice-free corridor along the Pacific coast would have provided access from Asia to the south and east. Thus, this theory holds that sometime before 12,000 years ago, perhaps as early as 20,000 to 30,000 years ago, Paleolithic hunter-gatherers emerged through this corridor and began to spread out into two vast, uninhabited continents. This view is now challenged by the early dates of some new archaeological finds and by evidence suggesting the possibility of early connections with Europe as well, perhaps along the Arctic coast of the North Atlantic. In any event, between 10,000 and 12,000 years ago, bands of hunters roamed throughout the Americas; and after the ice had retreated, the peoples of the Western Hemisphere were essentially cut off from the rest of the world until they were overrun by European invaders beginning at the end of the fifteenth century CE.

In this isolation the peoples of the Americas experienced cultural transformations similar to those seen elsewhere around the world following the end of the Paleolithic era. In most regions they developed an agricultural way of life. A trio of native plants—corn, beans, and squash—was especially important, but people also cultivated potatoes, tobacco, cacao, tomatoes, and avocados. New World peoples also domesticated many animals: dogs, turkeys, guinea pigs, llamas, and their camelid cousins—the alpacas, guanacos, and vicuñas.

As elsewhere, the shift to agriculture in the Americas was accompanied by population growth and, in some places, the rise of hierarchical societies, the appearance of ceremonial centers and towns with monumental architecture, and the development of sculpture, ceramics, and other arts. The peo-

MAP 12–1 | **THE AMERICAS**

Paleo-Indians moved across North America, then southward through Central America until they reached the Tierra del Fuego region of South America.

ple of Mesoamerica—the region that extends from central Mexico well into Central America—developed writing, astronomy, a complex and accurate calendar, and a sophisticated system of mathematics. Central and South American peoples had an advanced metallurgy and produced exquisite gold, silver, and copper pieces. The metalworkers of the Andes, the mountain range along the western coast of South America, began to produce metal weapons and agricultural implements in the first millennium CE, and people elsewhere in the Americas made tools and weapons from other materials such as bone, ivory, stone, wood, and, where it was available, obsidian, a volcanic glass capable of a cutting edge five hundred times finer than surgical steel. Basketry and weaving became major art forms (see "Andean Textiles," page 409).

In the American Southwest, Native American people built multistoried, apartmentlike village and cliff dwellings, as well as elaborate irrigation systems with canals. Evidence of weaving in the American Southwest dates to about 7400 BCE. Clearly many extraordinary artistic traditions flourished in many regions in the Americas before 1300 CE. This chap-

ter explores the accomplishments of some of the cultures in five of those regions—Mesoamerica, Central America, the central Andes of South America, the southeastern woodlands and great river valleys of North America, and the North American Southwest.

MESOAMERICA

Ancient Mesoamerica encompasses the area from north of the Valley of Mexico (the location of Mexico City) to present-day Belize, Honduras, and western Nicaragua in Central America (SEE MAP 12–1). The region is one of great contrasts, ranging from tropical rain forest to semiarid mountains. The civilizations that arose in Mesoamerica varied, but they were linked by cultural similarities and trade. Among the shared features of the civilizations that arose in Mesoamerica were a ritual ball game with religious and political significance, aspects of monumental ceremonial building construction, and a complex system of multiple calendars including a 260-day ritual cycle and a 365-day agricultural cycle.

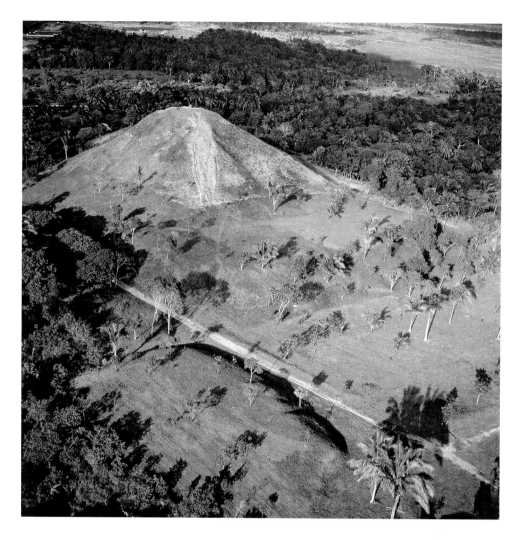

I2–2 | **GREAT PYRAMID AND BALL COURT, LA VENTA**
Mexico. Olmec culture, c. 1000–600 BCE. Pyramid height approx. 100′ (30 m).

Mesoamerican society was sharply divided into elite and commoner classes.

The transition to farming began in Mesoamerica between 7000 and 6000 BCE, and by 3000 to 2000 BCE settled villages were widespread. Customarily the region's subsequent history is divided into three broad periods: Formative or Preclassic (1500 BCE–250 CE), Classic (250–900 CE), and Postclassic (900–1521 CE). This chronology derives primarily from the archaeology of the Maya—the people of Guatemala and the Yucatan peninsula—with the Classic period bracketing the era during which the Maya erected dated stone monuments. The term reflects the view of early scholars that the Classic period was a kind of golden age. Although this view is no longer current—and the periods are only roughly applicable to other cultures of Mesoamerica—the terminology has endured.

The Olmecs

The first major Mesoamerican art style, that of the Olmecs, emerged during the Formative/Preclassic period. In the swampy coastal areas of the present-day Mexican states of Veracruz and Tabasco, the Olmecs cleared farmland, drained fields, and raised earth mounds on which they constructed ceremonial centers. These centers probably housed an elite group of ruler-priests supported by a larger population of farmers who lived in villages of pole-and-thatch houses. The presence at Olmec sites of goods such as obsidian, iron ore, and jade that are not found in the Gulf of Mexico region but come from throughout Mesoamerica indicates that the Olmecs participated in extensive long-distance trade. They went to great lengths to acquire jade, which they used for ceremonial objects and prized more than gold.

The earliest Olmec ceremonial center, at San Lorenzo, (c. 1200 to 900 BCE, abandoned by 400 BCE), included a possible ball court, an architectural feature of other major Olmec sites and large sculptures. Another center, at La Venta thriving from about 1000 to 400 BCE, was built on high ground between rivers. Its most prominent feature, an earth mound known as the Great Pyramid, still rises to a height of about 100 feet (FIG. I2–2). The Great Pyramid stands at the south end of a large, open court, possibly used as a playing field, arranged on a north-south axis and defined by long, low earth mounds. Many of the physical features of La Venta—including the symmetrical arrangement of earth mounds, platforms, and central open spaces along an axis that was probably determined by astronomical observations—are characteristic of later monumental and ceremonial architecture throughout Mesoamerica.

Although the Olmec developed no form of written language, their highly descriptive art gives us an idea of their

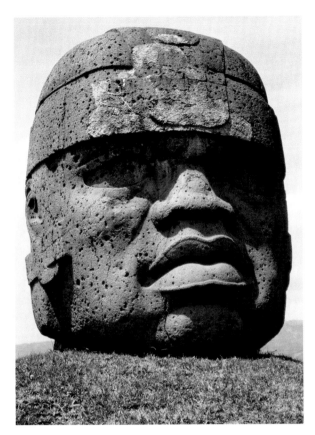

12–3 | **COLOSSAL HEAD, LA VENTA**
Mexico. Olmec culture, c. 900–400 BCE. Basalt, height 7′5″
(2.26 m).

beliefs. The Olmec universe had three levels: sky, earth surface, and underworld. A bird monster ruled the sky. The earth surface itself was a female deity—apparently La Venta's principal deity—the repository of wisdom and overseer of surface water as well as land. The underworld—ruled by a fish monster—was a cosmic sea on which the earth surface, including its plants, floated. A vertical axis joining the three levels made a fourth element.

At the beginning, religion seems to have centered on shamanistic practices in which a shaman (a priest or healer) traveled in a trance state through the cosmos with the help of animal spirits, usually jaguars but also frogs and birds. Olmec sculpture and ceramics depict humans in the process of taking animal form. As society changed from a hunting base to an agricultural one and natural forces like the sun and rain took on greater importance, a new priest class formed, in addition to the shamans, and they created rituals to try to control these natural forces.

The Olmecs produced an abundance of monumental basalt sculpture, including colossal heads (FIG. 12–3), altars, and seated figures. The huge basalt blocks for the large works of sculpture were quarried at distant sites and transported to San Lorenzo, La Venta, and other centers. Colossal heads ranged in height from 5 to 12 feet and weighed from 5 to more than 20 tons. The heads are adult males wearing close-

fitting caps with chin straps and large, round earspools (cylindrical earrings that pierce the earlobe). The fleshy faces have almond-shaped eyes, flat broad noses, thick protruding lips, and downturned mouths. Each face is different, suggesting that they may represent specific individuals. Twelve heads were found at San Lorenzo. All had been mutilated and buried about 900 BCE, about the time the site went into decline. At La Venta, 102 basalt monuments have been found.

The colossal heads and the subjects depicted on other monumental sculpture suggest that the Olmec elite were preoccupied with the commemoration of rulers and historic events. This preoccupation was probably an important factor in the development of calendrical systems, which first appeared around 600 to 500 BCE in areas with strong Olmec influence.

By 200 CE, forests and swamps began to reclaim Olmec sites, but Olmec civilization had spread widely throughout Mesoamerica and was to have an enduring influence on its successors. As the Olmec centers of the Gulf Coast faded, the great Classic-period centers in the Maya region and Teotihuacan area in the Basin of Mexico were beginning their ascendancy.

Teotihuacan

Located some thirty miles northeast of present-day Mexico City, Teotihuacan experienced a period of rapid growth early in the first millennium CE. The city's farmers terraced hillsides and drained swamps, and on fertile, reclaimed land they grew the common Mesoamerican staple foods, including corn, squash, and beans. From the fruit of the spiky-leafed maguey plant they fermented pulque, a mildly alcoholic brew still consumed today. By 200 CE Teotihuacan had emerged as a significant center of commerce and manufacturing, the first large city-state in the Americas. At its height, between 350 and 650 CE, Teotihuacan covered nearly nine square miles and had a population of about 200,000, making it the largest city in the Americas and one of the largest in the world at that time (FIG. 12–4). One reason for its wealth was its control of a source of high-quality obsidian. Goods made at Teotihuacan, including obsidian tools and pottery, were distributed widely throughout Mesoamerica in exchange for luxury items such as the brilliant green feathers of the quetzal bird, used for priestly headdresses, and the spotted fur of the jaguar, used for ceremonial garments.

Teotihuacan's principal monuments include the Pyramid of the Sun and the Pyramid of the Moon. A broad thoroughfare laid out on a north-south axis, extending for more than three miles and in places as much as 150 feet wide, bisects the city (FIG. 12–5). Much of the ceremonial center, in a pattern typical of Mesoamerica, is characterized by the symmetrical arrangement of structures around open courts or plazas. The Pyramid of the Sun is east of the main corridor.

The largest of Teotihuacan's architectural monuments, the Pyramid of the Sun is slightly over 200 feet high and measures about 720 feet on each side at its base, similar in size

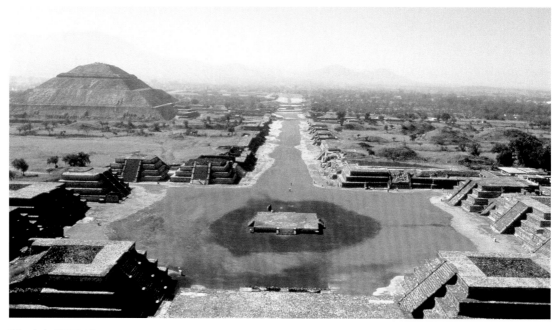

12–4 | **CEREMONIAL CENTER OF THE CITY OF TEOTIHUACAN**
Mexico. Teotihuacan culture, 350-650 CE.

View from the Pyramid of the Moon down the Avenue of the Dead toward the Ciudadela and the Temple of the Feathered Serpent. The Pyramid of the Sun is on the middle left. The avenue is over a mile long.

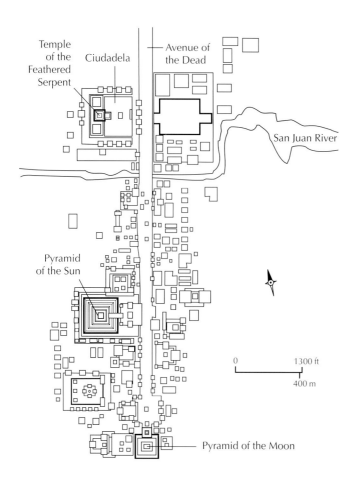

12–5 | **PLAN OF THE CEREMONIAL CENTER OF TEOTIHUACAN**
Positioned to match photograph of the site shown in FIGURE 12-4, with south at top.

but not as tall as the largest Egyptian pyramid at Giza. It is built over a four-chambered cave with a spring that may have been the original focus of worship at the site and its source of prestige. The pyramid rises in a series of sloping steps to a flat platform, where a two-room temple once stood. A monumental stone stairway led from level to level up the side of the pyramid to the temple platform. The exterior was faced with stone and stucco and was painted. The Pyramid of the Moon, not quite as large as the Pyramid of the Sun, stands at the north end of the main avenue, facing a large plaza flanked by smaller, symmetrically placed platforms.

At the southern end of the ceremonial center, and at the heart of the city, is the Ciudadela (Spanish for a fortified city center), a vast sunken plaza surrounded by temple platforms. The city's principal religious and political center, the plaza could accommodate an assembly of more than 60,000 people. Its focal point was the **TEMPLE OF THE FEATHERED SERPENT** (FIG. 12–6). This seven-tiered structure exhibits the talud-tablero (slope-and-panel) construction that is a hallmark of the Teotihuacan architectural style. The sloping base, or talud, of each platform supports a tablero, or entablature, that rises vertically, and is surrounded by a frame, often filled with sculptural decoration. The Temple of the Feathered Serpent was enlarged several times—as was typical of Mesoamerican pyramids—and each enlargement completely enclosed the previous structure like the layers of an onion.

Archaeological excavations of the temple's early-phase tableros and a stairway balustrade have revealed painted heads of the Feathered Serpent, the goggle-eyed Rain or Storm God

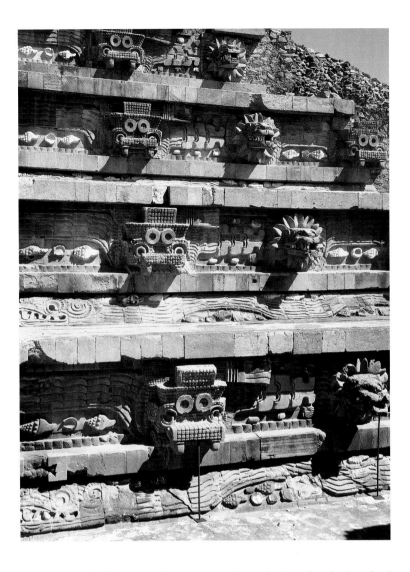

12–6 | TEMPLE OF THE FEATHERED SERPENT
The Ciudadela, Teotihuacan, Mexico. Teotihuacan culture, after 350 CE.

(or Fire God, according to some), and reliefs of aquatic shells and snails. Their flat, angular, abstract style, typical of Teotihuacan art, is in marked contrast to the curvilinear Olmec art. The Rain God has a squarish, stylized head or headdress with protruding upper jaw and huge, round eyes originally inlaid with obsidian, and it is surrounded by once-colored circles, and large, circular earspools. The fanged serpent heads, perhaps composites of snakes and other creatures, emerge from an aureole of stylized feathers. The Storm God and the Feathered Serpent may be symbols of regeneration and cyclical renewal, perhaps representing alternating wet and dry seasons.

The residential sections of Teotihuacan fanned out from the city's center. The large palaces of the elite, with as many as forty-five rooms and seven patios, stood nearest the ceremonial center. Artisans, foreign traders, and peasants lived farther away, in simpler compounds. The palaces and more humble homes alike were rectangular one-story structures with high walls, thatched roofs, and suites of rooms arranged symmetrically around open courts. Walls were plastered and, in the homes of the elite, were covered with paintings.

Teotihuacan's artists worked in a **fresco** technique, applying pigments directly on damp lime plaster. Paint was applied in layers, each layer polished before the next was applied. The style, like the sculpture, was flat, angular, and abstract. Their use

of color is complex—one work may include five shades of red with touches of ocher, green, and blue. A detached fragment of a wall painting, now in the Cleveland Museum of Art, depicts a bloodletting ritual in which an elaborately dressed man enriches and revitalizes the earth (the Great Goddess) with his own blood (FIG. 12–7). The man's Feathered Serpent headdress, decorated with precious quetzal feathers, indicates his high rank. He stands between rectangular plots of earth planted with bloody maguey spines, and he scatters seeds or drops of blood from his right hand, as indicated by the panel with conventionalized symbols for blood, seeds, and flowers. The speech scroll emerging from his open mouth symbolizes his ritual chant. The visual weight accorded the headdress and the speech scroll suggests that the man's priestly office and chanted words are essential elements of the ceremony. Such bloodletting rituals were widespread in Mesoamerica.

Sometime in the middle of the seventh century disaster struck Teotihuacan. The ceremonial center burned, and the city went into a permanent decline. Nevertheless, its influence continued as other centers throughout Mesoamerica and as far south as the highlands of Guatemala borrowed and transformed its imagery over the next several centuries. The site was never entirely abandoned, however, because it remained a legendary pilgrimage center. The much later

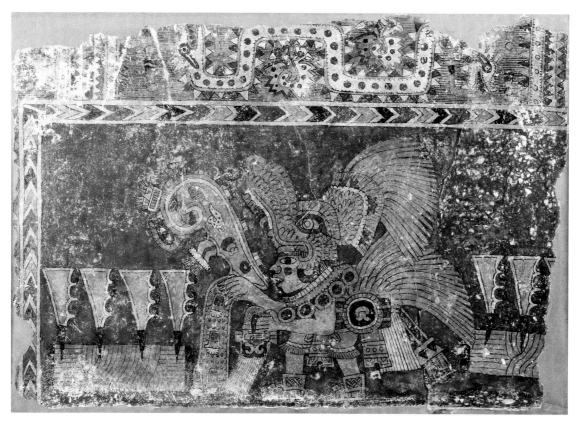

12–7 | **BLOODLETTING RITUAL**
Fragment of a fresco from Teotihuacan, Mexico. Teotihuacan culture, 600–750 CE. Pigment on lime plaster,
32¼ × 45¼" (82 × 116.1 cm). The Cleveland Museum of Art.
Purchase from the J. H. Wade Fund (63.252)

The maguey plant supplied the people of Teotihuacan with food; fiber for making clothing, rope, and paper; and the
precious drink pulque. As this painting indicates, priestly officials used its spikes in rituals to draw their own blood as a
sacrifice to the Great Goddess.

Aztec people (c. 1300–1525 CE) revered the site, believing it to be the place where the gods created the sun and the moon. In fact, the name Teotihuacan is actually an Aztec word meaning "Gathering Place of the Gods."

The Maya

The ancient Maya are noted for a number of achievements, including the production of high agricultural yields in the seemingly inhospitable tropical rain forest of the Yucatan. In densely populated cities they built imposing pyramids, temples, palaces, and administrative structures. They developed the most advanced hieroglyphic writing in Mesoamerica and perfected a sophisticated version of the Mesoamerican calendrical system (see "Maya Record Keeping," page 403). Using these, they recorded the accomplishments of their rulers on ceramic vessels, wall paintings, and in books. They studied astronomy and the natural cycles of plants and animals and used sophisticated mathematical concepts such as zero and place value.

An increasingly detailed picture of the Maya has been emerging from recent archaeological research and from advances in deciphering their writing. That picture shows a

society divided into competing centers, each with a hereditary ruler and an elite class of nobles and priests supported by a large group of farmer-commoners. Rulers established their legitimacy, maintained links with their divine ancestors, and sustained the gods through elaborate rituals, including ball games, bloodletting ceremonies, and human sacrifice. Rulers commemorated such events and their military exploits on carved steles. A complex pantheon of deities, many with several manifestations, presided over the Maya universe.

Olmec influence was widespread around 1000–300 BCE in what would come to be the Maya area. Maya civilization emerged during the late Preclassic period (250 BCE– 250 CE), reached its peak in the southern lowlands of Guatemala during the Classic period (250–900 CE), and shifted to the northern Yucatan peninsula during the Postclassic period (900–1521 CE).

TIKAL. The monumental buildings of Maya cities were masterly examples of the use of architecture for public display and propaganda. Seen from outside and afar, they would have impressed the common people with the power and authority

MAYA RECORD KEEPING

Since the rediscovery of Mayan sites of the Classic period in the nineteenth century, scholars have puzzled over the meaning of the hieroglyphic writing. They soon realized that many of the glyphs were numbers in a complex calendrical system. In 1894, a German librarian, Ernst Forstermann, deciphered the numbering systems, and by the early twentieth century, the Maya calendar had been correlated with the European calendar. The Maya calendar counts time from a starting date now securely established as August 13, 3114 BCE.

Since the late 1950s, scholars have made enormous progress in deciphering Maya writing. Previously, many prominent Mayanists argued that the inscriptions dealt with astronomical and astrological observations, not historical events. This interpretation accorded with the view that the Maya were a peaceful people ruled by a theocracy of learned priests. But further research suggests that such theories are incorrect. In fact, the inscriptions on Maya architecture and steles appear almost entirely devoted to historical events. They record the dates of royal marriages, births of heirs, alliances between cities, and great military victories, and they tie events to astronomical events and propitious periods in the Maya calendar.

Maya writing, like the Maya calendar, is the most advanced in ancient Mesoamerica. The system combines logographs—symbols representing entire words—and symbols representing syllables in the Maya language.

of the elite class and the gods they served. Tikal (in present-day Guatemala) was the largest Maya city, with a population of as many as 70,000 at its height (FIG. 12–8). Like other Maya cities—yet unlike Teotihuacan, with its grid plan—Tikal conformed to the uneven terrain of the rain forest. Plazas, pyramid-temples, ball courts, and other structures stood on high ground connected by elevated roads, or causeways. One major causeway, 80 feet wide, led from the center of the city to outlying residential areas.

In the ceremonial core of Tikal, the structure whose base is visible on the left in FIGURE 12–8, known as the North Acropolis, dates to the early Classic period. It contained many royal tombs and covers earlier structures that date to the origin of the city, about 500 BCE. The tall pyramid in the center, known as Temple I, faces a companion pyramid, Temple II, across a large plaza. Temple I covers the tomb of Ruler A (formerly called Ah Hasaw, 682–c. 727 CE), who initiated an ambitious expansion of Tikal. Under Ruler A and his successors, Tikal's influence grew, with evidence of contacts that extended from highland Mexico to Costa Rica.

Containing Ruler A's tomb in its limestone bedrock, Temple I rises above the forest canopy to a height of more than 140 feet. Its base has nine layers, probably reflecting the belief that the underworld had nine levels. Priests climbed the steep stone staircase on the exterior to the temple on top, which consists of two long, parallel rooms covered with a steep roof supported by corbel vaults. It is typical of Maya enclosed stone structures, which resemble the kind of pole-and-thatch houses the Maya still build in parts of the Yucatan today. The only entrance to the temple was on the long side, facing the plaza and the commemorative stele erected there. The crest that rises over the roof of the temple, known as a roof comb, was originally covered with brightly painted sculpture. Recent archaeological analysis suggests the possibil-

ity that the narrow platforms of the pyramids served as shallow stages for ritual reenactments of mythological narratives.

PALENQUE. Palenque (in the present-day Mexican state of Chiapas) rose to prominence later than Tikal, in the Classic period. Hieroglyphic inscriptions record the beginning of its royal dynasty in 431 CE, but the city had only limited regional importance until the ascension of a powerful ruler, Lord Pakal (Mayan for "shield"), who ruled from 615 to 683 CE. He and his son, who succeeded him, commissioned most of the structures visible at Palenque today. As at Tikal, major buildings are grouped on high ground. A northern complex has five temples, two nearby adjacent temples, and a ball

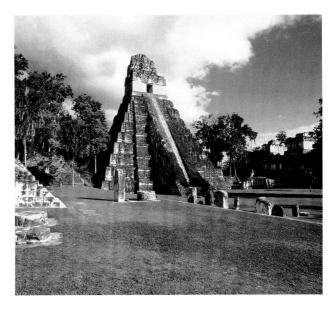

12–8 **BASE OF NORTH ACROPOLIS (LEFT) AND TEMPLE I**
Tomb of Ruler A, Tikal, Guatemala. Maya culture. North Acropolis, 5th century CE; Temple I, c. 700 CE.

court. A central group includes the so-called **PALACE**, the **TEMPLE OF THE INSCRIPTIONS**, and two other temples (FIG. 12–9). A third group of temples lies to the southeast.

The palace in the central group—a series of buildings on two levels around three open courts, all on a raised terrace—may have been an administrative rather than a residential complex. The Temple of the Inscriptions next to it is a pyramid that rises about 75 feet. Like Temple I at Tikal, it has nine levels. The shrine on the summit consisted of a portico with five entrances and a three-part, vaulted inner chamber surmounted by a tall roof comb. Its façade still retains much of its stucco sculpture. The inscriptions that give the building its name consist of three large panels of text that line the back wall of the outer chamber at the top of the temple.

In 1948 an archaeologist studying the structure of the Temple of the Inscriptions cleared the rear chamber and entered a corbel-vaulted stairway beneath the summit shrine. This stairway zigzagged down 80 feet to a small subterranean chamber that contained the undisturbed tomb of Lord Pakal, which was finally revealed in 1952 after four years of clearing the stairwell.

SCULPTURE. Lord Pakal lay in a monolithic carved sarcophagus that represented him balanced between the underworld and the earth. His ancestors, carved on the side of his sarcophagus, witness his death and apotheosis. Among them are the Lord's parents, Lady White Quetzal and Lord Yellow Jaguar-Parrot, supporting the contention of some scholars that both maternal and paternal lines transmitted royal power among the Maya.

The stucco **PORTRAIT OF LORD PAKAL** found with his sarcophagus shows him as a young man wearing a diadem of jade and flowers (FIG. 12–10). His features—sloping forehead and elongated skull (babies' heads were bound to produce this shape), large curved nose (enhanced by an ornamental bridge, perhaps of latex), full lips, and open mouth—are characteristic of the Maya ideal of beauty. His long narrow face and jaw are individual characteristics. Traces of pigment indicate that this portrait, like much Maya sculpture, was colorfully painted.

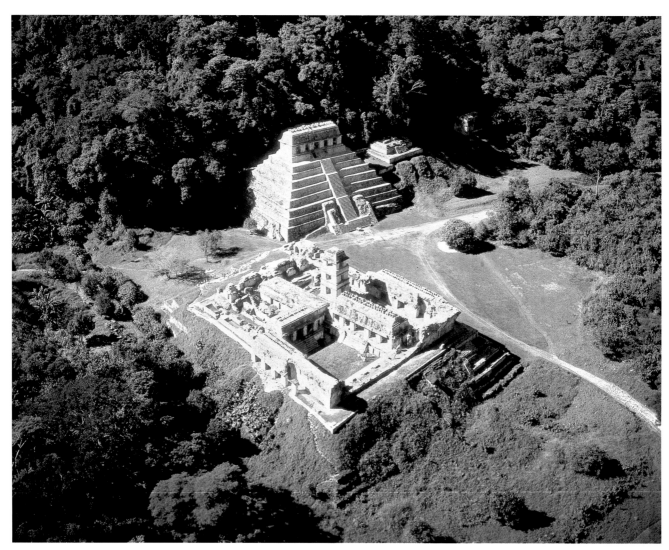

12–9 | **PALACE (FOREGROUND) AND TEMPLE OF THE INSCRIPTIONS (TOMB-PYRAMID OF LORD PAKAL), PALENQUE**
Mexico. Maya culture, late 7th century CE.

Art and Its Context
THE COSMIC BALL GAME

The ritual ball game was one of the defining characteristics of Mesoamerican society. The ball game was generally played on a long, rectangular court with a large, solid, heavy rubber ball. Using their elbows, knees, or hips—but not their hands—heavily padded players directed the ball toward a goal or marker. The rules, size and shape of the court, the number of players on a team, and the nature of the goal varied. The largest surviving ball court at Chichen Itza was about the size of modern football field. Large stone rings set in the walls of the court about 25 feet above the field served as goals.

The game was a common subject in Mesoamerican art. Players, complete with equipment, appear as ceramic figurines and on stone votive sculptures, and the game and its attendant rituals were represented in relief sculpture. The game may have had religious and political significance: The movement of the ball represented celestial bodies—the sun, moon, or stars—held aloft and directed by the skill of the players. The ball game was sometimes associated with warfare. Captive warriors might have been made to play the game, and players might have been sacrificed when the stakes were high.

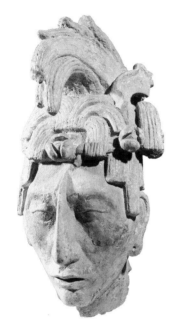

12–10 | **PORTRAIT OF LORD PAKAL**
Found in his tomb, Temple of the Inscriptions, Palenque, Mexico. Maya culture, mid-7th century CE. Stucco and red paint, height 16⅞″ (43 cm). Museo Nacional de Antropología, Mexico City.

SCULPTURE FOR LADY XOK. Elite men and women, rather than gods, were the usual subjects of Maya sculpture, and most show rulers dressed as warriors performing religious rituals in elaborate costumes and headdresses. Although they excelled at three-dimensional clay and stucco sculpture (SEE FIG. 12–10), the Maya favored low-relief for carving steles and buildings. Three carved lintels of a palace in Yaxchilan are among the masterpieces of Maya art. They formed the lintels of doors in a temple (known as structure 23) dedicated in 726 to Lady Xok, the principal wife and queen of the ruler, Shield Jaguar the Great. The first lintel illustrates a bloodletting ritual in which the queen runs a spiked rope through her tongue and catches the blood on papers in a basket. In the second, pictured here, she conjures up a serpent that spews forth a warrior who aims

his spear at the kneeling queen (FIG. 12–11). In the third, she holds Shield Jaguar's helmet and shield as he arms himself. Although the reliefs seem to tell a story, the events they depict actually happened at different times between 681 and 724. Lady Xok's vision of the monster snake actually took place when Shield Jaguar became the ruler of Yaxchilan in 681. The relief is unusually high, giving the sculptor ample opportunity to display a virtuoso carving technique, for example, in Lady Xok's garments and jewelry. The calm idealized face of the queen recalls the *Portrait of Lord Pakal*. That the queen was

12–11 | **LADY XOK'S VISION OF A GIANT SNAKE (ACCESSION CEREMONY)**
Lintel 25 of a temple (structure 23). Yaxchilan, Chiapas, Mexico. Dedicated in 723 CE and 726 CE. Limestone, 46½ × 29⅛″ (118 × 74 cm). British Museum. Acquired by the British Museum in 1883.

depicted on a lintel in a temple is an indication of her importance at court, and the role of elite Maya women generally.

PAINTING. Artists had high status in Maya society, reflecting the importance attached to record keeping among the Maya; they chronicled their history in carved and painted inscriptions on stele, ceramic vessels, and walls. And they recorded with hieroglyphic writing and illustrations in codices—books of folded paper made from the maguey plant. Vase painters and scribes were often members of the ruling elite and perhaps included members of the royal family not in the direct line of succession.

Maya painting survives on ceramics and a few large murals; most of the illustrated books have perished, except for a few late examples on astronomical and divinatory subjects. The influence of the books is reflected, however, in vases painted in the so-called codex style, which often show a fluid line and elegance similar to that of the manuscripts.

The codex-style painting on a Late Classic cylindrical vase (**FIG. 12–12**) may illustrate an episode from a Maya sacred text, *Popol Vuh*, about the creation of the world and the first people. The protagonists, the mythical Hero Twins, overcome death by defeating the lords of Xibalba, the Maya underworld. The vessel shows one of the lords of Xibalba, an aged-looking being known to archaeologists as God L, sitting inside a temple on a raised platform. Five female deities attend him. The god ties a wrist cuff on the attendant kneeling before him. Another attendant, seated outside the temple, looks over her shoulder at a scene in which two men sacrifice a bound victim. A rabbit in the foreground writes in a manuscript. The two men may be the Hero Twins and the bound

victim a bystander they sacrifice and then revive to gain the confidence of the Xibalban lords. The inscriptions on the vessel have not been entirely translated. They include a calendar reference to the Death God and to the evening star, which the Maya associated with war and sacrifice.

POSTCLASSIC PERIOD. A northern Maya group called the Itza rose to prominence in the Postclassic period. Their principal center, Chichen Itza, which means "at the mouth of the well of the Itza," grew from a village located near a sacred well. The city flourished from the ninth to the thirteenth century CE, and at its height covered about six square miles.

One of Chichen Itza's most conspicuous structures is a massive nine-level pyramid in the center of a large plaza (**FIG. 12–13**). There is a stairway on each side of the pyramid leading to a square temple on the pyramid's summit. At the spring and fall equinoxes, the setting sun casts undulating shadows on the stairways, forming bodies for the serpent heads carved at the bases of the balustrades. Many prominent features

12–12 **CYLINDRICAL VESSEL**
(Composite photograph in the form of a roll-out.) Maya culture, 600–900 CE. Painted ceramic, diameter 6½" (16.6 cm); height 8⅜" (21.5 cm). The Art Museum, Princeton University, Princeton, New Jersey.

The clay vessel was first covered by a creamy white slip and then painted in light brown washes and dark brown or black lines. The painter may have used turkey feathers to apply the pigments.

12–13 | **PYRAMID ("EL CASTILLO")
WITH CHACMOOL IN FOREGROUND,
CHICHEN ITZA**
Yucatan, Mexico. Itza (northern Maya)
culture, 9th–13th century CE; Chacmool,
800–1000 CE.
Library, Getty Research Institute, Los Angeles. Wim Swaan
Photograph Collection (96, p.21)

of Chichen Itza are markedly different from earlier sites. The pyramid, for example, is lower and broader than the stepped pyramids of Tikal and Palenque, and Chichen Itza's buildings have wider rooms. Another feature not found at earlier sites is the use of pillars and columns. Chichen Itza has broad, open galleries surrounding courtyards and inventive columns in the form of inverted, descending serpents. Brilliantly colored relief sculpture covered the buildings of Chichen Itza, and paintings of feathered serpents, jaguars, coyotes, eagles, and composite mythological creatures adorned its interior rooms. The surviving works show narrative scenes that emphasize the prowess of warriors and the skill of ritual ballplayers.

Sculpture at Chichen Itza, including the serpent columns and balustrades and the half-reclining figures known as Chacmools, has the sturdy forms, proportions, and angularity of architecture, rather than the curving subtlety of Classic Maya sculpture. The Chacmools probably represent fallen warriors and were used to receive sacrificial offerings.

After Chichen Itza's decline, Mayapan, on the north coast of the Yucatan, became the principal Maya center. But by the time the Spanish arrived in the early sixteenth century, Mayapan, too, had declined (destroyed in the mid-1400s CE). The Maya people and much of their culture would survive the conquest despite the imposition of Hispanic customs and beliefs. The Maya continue to speak their own languages, to venerate traditional sacred places, and to follow traditional ways.

CENTRAL AMERICA

Unlike their neighbors in Mesoamerica, who lived in complex hierarchical societies, the people of Central America lived in extended family groups in towns led by chiefs. A notable example of these small chiefdoms was the Diquis culture (located in present-day Costa Rica), which lasted from about 700 to 1500 CE. The Diquis occupied fortified villages

12–14 | **SHAMAN WITH DRUM AND SNAKE**
Costa Rica. Diquis culture, c. 13–16th century CE. Gold,
4¼ × 3¼" (10.8 × 8.2 cm). Museos del Banco Central de
Costa Rica, San José, Costa Rica.

and seem to have engaged in constant warfare with one another. Although they did not produce monumental architecture or sculpture, they created fine featherwork, ceramics, textiles, and objects of gold and jade.

Metallurgy and the use of gold and copper-gold alloys were widespread in Central America. The technique of lost-wax casting probably first appeared in present-day Colombia between 500 and 300 BCE. From there it spread north to the Diquis. A small, exquisite pendant (**FIG. 12–14**)

illustrates the style and technique of Diquis goldwork. The pendant depicts a male figure wearing bracelets, anklets, and a belt with a snake-headed penis sheath. He plays a drum while holding the tail of a snake in his teeth and its head in his left hand. The wavy forms with serpent heads emerging from his scalp suggest an elaborate headdress, and the creatures emerging from his legs suggest some kind of reptile costume. The inverted triangles on the headdress probably represent birds' tails.

In Diquis mythology, serpents and crocodiles inhabited a lower world, humans and birds a higher one. Their art depicts animals and insects as fierce and dangerous. Perhaps the man in the pendant is a shaman transforming himself into a composite serpent-bird or performing a ritual snake dance surrounded by serpents or crocodiles. The scrolls on the sides of his head may represent the shaman's power to hear and understand the speech of animals. Whatever its specific meaning, the pendant evokes a ritual of mediation between earthly and cosmic powers involving music, dance, and costume.

Whether gold figures of this kind were protective amulets or signs of high status, they were certainly more than personal adornment. Shamans and warriors wore gold to inspire fear, perhaps because gold was thought to capture the energy and power of the sun. This energy was also thought to allow shamans to leave their bodies and travel into cosmic realms.

SOUTH AMERICA: THE CENTRAL ANDES

Like Mesoamerica, the central Andes of South America—primarily present-day Peru and Bolivia—saw the development of complex hierarchical societies with rich and varied artistic traditions. The area is one of dramatic contrasts. The narrow coastal plain, bordered by the Pacific Ocean on the west and the abruptly soaring Andes on the east, is one of the driest deserts in the world. Life here depends on the rich marine resources of the Pacific Ocean and the rivers that descend from the Andes, forming a series of valley oases. The Andes themselves are a region of lofty snowcapped peaks, high grasslands, steep slopes, and deep, fertile river valleys. The high grasslands are home to the Andean camelids—llamas, alpacas, vicuñas, and guanacos—that have served for thousands of years as beasts of burden and a source of wool and meat. The lush eastern slopes of the Andes descend to the tropical rain forest of the Amazon basin.

The earliest evidence of monumental building in Peru dates to the third millennium BCE. (With no dated monuments, all dates are approximate.) On the coast, sites with ceremonial mounds and plazas were located near the sea. Coastal inhabitants depended on marine and agricultural resources,

farming the flood-plains of nearby coastal rivers. Their chief crops were cotton, used to make fishing nets, and gourds, used for floats. In the highlands, early centers consisted of multi-roomed stone-walled structures with sunken central fire pits for burning ritual offerings.

In the second millennium BCE, herding and agriculture became prevalent in the highlands. On the coast, people became increasingly dependent on agriculture. They began to build canal irrigation systems, greatly expanding their food supply. Settlements were moved inland, and large, U-shaped ceremonial complexes with circular sunken plazas were built. These complexes were oriented toward the mountains, the direction of the rising sun and the source of the water that nourished their crops. The shift to irrigation agriculture coincided with the spread of pottery and ceramic technology in Peru.

Between about 1000 and 200 BCE an art style associated with the northern highland site of Chavin de Huantar spread through much of the Andes. In Andean chronology, this era is known as the Early Horizon, the first of three so-called horizon periods. The political and social forces behind the spread of the Chavin style are not known; many archaeologists suspect that they involved an influential religious cult. The period was one of artistic and technical innovation in ceramics, metallurgy, and textiles. Ceramics, metalware, and textiles have been found in burial sites,

12–15 RAIMONDI STONE, CHAVIN DE HUANTAR
Peru, 1000–600 BCE. Height, 6'6" (2 m). Diorite. Museo Nacional de Antropología y Arqueología, Lima, Peru.

Technique
ANDEAN TEXTILES

Andean textiles played an important role in both private and public events. Specialized fabrics were developed for everything from ritual burial shrouds and shamans' costumes to rope bridges and knotted cords for record keeping. Clothing indicated ethnic group and social status and was customized for certain functions, the most rarefied being royal ceremonial garments made for specific occasions and worn only once. The creation of textiles, among the most technically complex cloths ever made, consumed a major portion of ancient Andean societies' resources. Weavers and embroiderers used nearly every textile technique known today, some of them the unique inventions of these cultures. Dyeing technology, too, was an advanced art form in the ancient Andes, with some textiles containing dozens of colors.

Cotton was grown in Peru by 3500 BCE and was the most widely used plant fiber. From about 400 BCE on, animal fibers—superior in warmth and dye absorption—largely replaced cotton in the Andes. The earliest Peruvian textiles were made by twining, knotting, wrapping, braiding, and looping fibers. Those techniques continued to be used even after the invention of weaving looms in the early second millennium BCE.

Early Andean peoples developed a simple, portable back-strap loom for weaving in which the undyed cotton warp (the lengthwise threads) was looped and stretched between two poles. One pole was tied to a stationary object and the other strapped to the waist of the weaver. The weaver controlled the tension of the warp threads by leaning back and forth while threading a bobbin, or shuttle, from side to side to create the weft (crosswise threads) that completely covered the warp.

Tapestry weaving appeared in Peru around 900 BCE. In tapestry, a technique especially suited to representational textiles, the weft does not run the full width of the fabric; each colored section is woven as an independent unit. Tapestry was followed by the introduction of embroidery in camelid fibers on cotton. (Camelid fiber—llama, guanaco, alpaca, or vicuña hair—is the Andean equivalent of wool.) As even more complex techniques developed, the production of a single textile might involve a dozen processes requiring highly skilled workers. Some of the most elaborate textiles were woven, unwoven, and rewoven to achieve special effects that were prized for their labor-intensiveness and difficulty of manufacture as well as their beauty. The finest woven pieces contain an amazing 200 weft threads per square inch (fine European work uses 60–80 threads per square inch).

Because of their complexity, deciphering how these textiles were made can be a challenge, and scholars rely on contemporary Andean weavers—inheritors of this tradition—for guidance. Then, as now, fiber and textile arts were primarily in the hands of women.

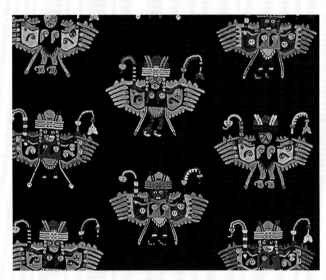

MANTLE WITH BIRD IMPERSONATORS DETAIL
From the Paracas peninsula, Peru. Paracas culture, c. 200 BCE–200 CE. Camelid fiber, plain weave with stem-stitch embroidery. Museum of Fine Arts, Boston.
Denman Waldo Ross Collection (16.34a).

reflecting the importance to the Chavin people of burial and the afterlife.

Chavin de Huantar was located on a trade route between the coast and the Amazon basin, and Chavin art features images of tropical forest animals. The relief sculpture on the **RAIMONDI STONE** (named for its discoverer) defies easy interpretation (FIG. 12–15). Found in a ceremonial complex, the huge slab of diorite was carved in low relief with a figure whose headdress completely fills the rectangular surface. Absolutely frontal and symmetrical, the figure grasps a complex staff in each paw. Easily identifiable are the snakes in the creature's hair filling the top half of the relief and the claws and fangs of a jaguar. The large head resting directly on the shoulders is topped by an extraordinary head/headdress that has three more heads. Compact frontality, flat relief, curvilinear design, and the combination of human, animal, bird, and reptile parts characterize this early art.

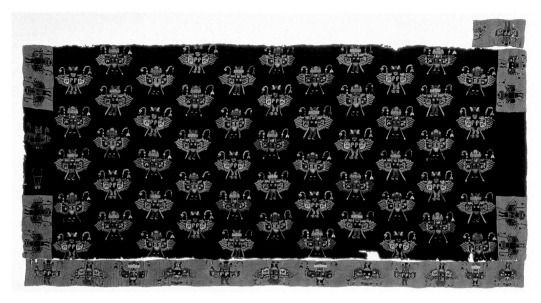

12–16 MANTLE WITH BIRD IMPERSONATORS
Paracas peninsula, Peru. Paracas culture, c. 200 BCE–200 CE. Camelid fiber, plain weave with stem-stitch embroidery, approx. 40″ × 7′11″ (1.01 × 2.41 m). Museum of Fine Arts, Boston.
Denman Waldo Ross Collection (16.34a).

The Paracas and Nazca Cultures

Chavin figures can be seen in the textiles of the Paracas culture on the south coast of Peru, in the art of the Nazca culture there, and in the ceramics and metalwork of the Moche culture on the north coast.

PARACAS. The Paracas culture of the Peruvian south coast flourished from about 1000 BCE to 200 CE, overlapping the Chavin period. It is best known for its stunning textiles, which were found in cemeteries as wrappings in many layers around bodies of the dead. Some bodies were wrapped in as many as 200 pieces of cloth.

Weaving is of great antiquity in the central Andes and continues to be among the most prized arts in the region (see "Andean Textiles," page 409, with detail of FIG. 12–16). Fine textiles were a source of prestige and wealth, and the production of textiles was an important factor in the domestication of both plants (cotton) and animals (llamas). The designs on Paracas textiles include repeated embroidered figures of warriors, dancers, and composite creatures such as bird-people (FIG. 12–16). Embroiderers used tiny overlapping stitches to create colorful, curvilinear patterns, sometimes using as many as twenty-two different colors within a single figure, but only one simple stitch. The effect of the clashing and contrasting colors and tumbling figures is dazzling.

NAZCA. The Nazca culture, which dominated the south coast of Peru from about 200 BCE to 600 CE, overlapped the Paracas culture. Nazca artisans wove fine fabrics, but they also produced multicolored pottery with painted and modeled images reminiscent of those on Paracas textiles.

12–17 EARTH DRAWING (GEOGLYPH) OF A HUMMINGBIRD, NAZCA PLAIN
Southwest Peru. Nazca culture, c. 100 BCE–700 CE. Length approx. 450′ (137 m); wingspan approx. 220′ (60.9 m).

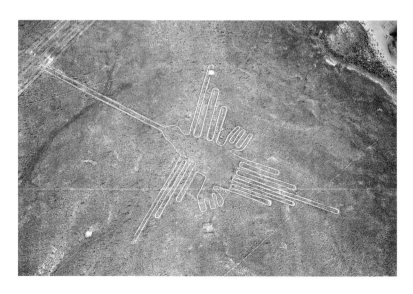

The Nazca are best known for their colossal earthworks, or geoglyphs, which dwarf even the most ambitious twentieth-century environmental sculpture. On great stretches of desert they literally drew in the earth. By removing dark, oxidized stones, they exposed the light underlying stones, then edged the resulting lines with more stones. In this way they created gigantic images—including a hummingbird, with a beak 120 feet long (FIG. 12–17), a killer whale, a monkey, a spider, a duck, and other birds—similar to those with which they decorated their pottery. They also made abstract patterns and groups of straight, parallel lines that extend for up to 12 miles. Each geoglyph was evidently maintained by a clan. At regular intervals the clans gathered on the plateau in a sort of fair where they traded goods and looked for marriage partners. The purpose and meaning of the glyphs remain a mystery, but the "lines" of stone are wide enough to have been ceremonial pathways.

The Moche Culture

The Moche culture dominated the north coast of Peru from the Piura Valley to the Huarmey Valley—a distance of some 370 miles—between about 200 BCE and 600 CE. Moche lords ruled each valley in this region from a ceremonial-administrative center. The largest of these, in the Moche Valley (from which the culture takes its name), contained the so-called Pyramids of the Sun and the Moon, both built of adobe brick. The Pyramid of the Sun, the largest ancient structure in South America, was originally a cross-shaped structure 1,122 feet long by 522 feet wide that rose in a series of terraces to a height of 59 feet. This site had been thought to be the capital of the entire Moche realm, but evidence is accumulating that indicates that the Moche maintained a decentralized social network.

The Moche were exceptional potters and metalsmiths. Vessels were made in the shape of naturalistically modeled human beings, animals, and architectural structures. They developed ceramic molds, which allowed them to mass-produce some forms. They also created realistic portrait vessels and recorded mythological narratives and ritual scenes in intricate fine-line painting. Similar scenes were painted on the walls of temples and administrative buildings. Moche metalsmiths, the most sophisticated in the central Andes, developed several innovative metal alloys.

A ceramic vessel (FIG. 12–18) shows a Moche lord sitting in a thronelike structure associated with high office. He wears an elaborate headdress and large earspools and strokes a cat or perhaps a jaguar cub. Vessels of this kind, used in Moche rituals, were also treasured as special luxury items and were buried in large quantities with individuals of high status.

THE TOMB OF THE WARRIOR PRIEST. A central theme in Moche iconography is the sacrifice ceremony, in which prisoners captured in battle are sacrificed and several elaborately dressed figures then drink their blood. Archaeologists have

12–18 | MOCHE LORD WITH A FELINE
Moche Valley, Peru. Moche culture, c. 100 BCE–500 CE. Painted ceramic, height 7½" (19 cm). Art Institute of Chicago. Buckingham Fund, 1955-2281

Behind the figure is the distinctive stirrup-shaped handle and spout.

labeled the principal figure in the ceremony as the Warrior Priest and other important figures as the Bird Priest and the Priestess. The recent discovery of a number of spectacularly rich Moche tombs indicates that the sacrifice ceremony was an actual Moche ritual and that Moche lords assumed the roles of the principal figures. The occupant of a tomb at Sipan, on the northwest coast, was buried with the regalia of the Warrior Priest. In a tomb at the site of San José de Moro, just south of Sipan, an occupant was buried with the regalia of the Priestess.

Among the riches accompanying the Warrior Priest at Sipan was a pair of exquisite gold-and-turquoise earspools,

12–19 | **EARSPOOL**
Sipan, Peru. Moche culture, 2nd–5th century CE. Gold, turquoise, quartz, and shell; diameter approx. 5″ (12.7 cm). Bruning Archaeological Museum, Lambayeque, Peru.

each of which depicts three Moche warriors (FIG. 12–19). The central figure is made of beaten gold and turquoise. He and his companions are adorned with tiny gold-and-turquoise earspools. They wear gold-and-turquoise head-dresses topped with delicate sheets of gold that resemble the crescent-shaped knives used in sacrifices. The central figure has a crescent-shaped nose ornament and carries a gold club and shield. A necklace of owl's-head beads strung with gold thread hangs around his shoulders. Many of his anatomical features have been rendered in painstaking detail.

NORTH AMERICA

Compared with the densely inhabited agricultural regions of Mesoamerica and South America, most of North America remained sparsely populated. Early people lived primarily by hunting, fishing, and gathering edible plants. Agriculture was developed on a limited scale, with evidence of squash cultivation in present-day Illinois dating from around 5000 BCE and maize cultivation in the Southwest around 1000 BCE. In the East and in the lands drained by the Mississippi and Missouri river system, a more settled way of life began to emerge, and by around 1000 BCE—in Louisiana as early as 2800 BCE—nomadic hunting and gathering had given way to more settled communities. People cultivated squash, sunflowers, and other plants to supplement their diet of game, fish, and berries. People across the American Southwest began to adopt a sedentary, agricultural life toward the end of the first millennium BCE.

The East

The culture of eastern North America is only beginning to be understood. Archaeologists have shown that people lived in communities that included both burial and ceremonial earthworks—mounds of earth-formed platforms that probably supported a chief's house, and served as the shrines of ancestors and places for a sacred fire, tended by special guardians. One of the largest, though not the earliest of the ceremonial centers (this distinction goes to Watson Brake, Louisiana, dating to 3400–3000 BCE), is Poverty Point, Louisiana. Between 1800–500 BCE people constructed huge earthen circles three quarters of a mile wide and seven miles long. Scholars have noted that these earthworks are contemporary with Stonehenge in England (SEE FIG. 1–17) and with the Olmec constructions in Mexico.

The Woodland Period

The Woodland period (300 BCE–1000 CE) saw the creation of impressive earthworks along the great river valleys of the Ohio and Mississippi. People built monumental mounds, and buried their leaders with valuable grave goods. Objects discovered in these burials indicate that the people of the Mississippi, Illinois, and Ohio river valleys traded widely with other regions of North and Central America. For example, the burial sites of the Adena (c. 1100 BCE–200 CE) and the Hopewell (c. 100 BCE–550 CE) cultures contained jewelry made with copper from present-day Michigan's Upper Peninsula and silhouettes cut in sheets of mica from the Appalachian Mountains. The pipes the Hopewell people created from fine-grained pipestone have been found from Lake Superior to the Gulf of Mexico. Among the items the Hopewell received in exchange for their pipestone and a flintlike stone used for toolmaking were turtle shells and sharks' teeth from Florida.

The Hopewell carved their pipes with representations of forest animals and birds, sometimes with inlaid eyes and teeth of freshwater pearls and bone. Combining realism and stylized simplification, a beaver crouching on a platform forms the bowl of a pipe found in present-day Illinois (FIG. 12–20). As in a modern pipe, the bowl—a hole in the beaver's back—could be filled with dried leaves (the Hopewell may not have grown tobacco), the leaves lighted, and smoke drawn through the hole in the stem. A second way that these pipes were used was to blow smoke inhaled from another vessel through the pipe to envelop the animal carved on it. The shining pearl eyes suggest an association with the spirit world. Native Americans of the Eastern Woodlands associated white, shiny materials with spirituality well into the post-contact period.

The Mississippian Period

The Mississippian period (c. 700–1550 CE) is characterized by the widespread distribution of complex chiefdoms, both large

12–20 | BEAVER EFFIGY PLATFORM PIPE
Bedford Mound, Pike County, Illinois. Hopewell culture, c. 100-200 CE. Pipestone, river pearls, and bone, length 4⁹⁄₁₆ × 1⅞ × 2″. Gilcrease Museum, Tulsa, Oklahoma.

and small, that proliferated throughout the region. The people of the Mississippian culture continued the mound-building tradition begun by the Adena, Hopewell, and others.

THE GREAT SERPENT MOUND. One of the most impressive Mississippian period earthworks is the Great Serpent Mound in present-day Adams County, Ohio (FIG. 12–21). Researchers, using carbon-14 radiometric dating, have recently dated the mound at about 1070 CE. There have been many interpretations of the twisting snake form, especially the "head" at the highest point, an oval enclosure that some see as opening its jaws to swallow a huge egg formed by a heap of stones. Perhaps the people who built it, like those who made the petroglyphs and Sun Dagger in Chaco Canyon (SEE FIGURE 12–1), were responding to the spectacular astronomical display of Halley's Comet in 1066. The Bayeaux Tapestry (page 506) shows one European reaction to the comet.

CAHOKIA. The Mississippian people built a major urban center known as Cahokia, near the juncture of the Illinois, Missouri, and Mississippi rivers (now East St. Louis, Illinois). Although the site may have been inhabited as early as c. 3000 BCE, Cahokia, as we know it, was begun about 900 CE, and

most construction took place between about 800 and 1500. At its height the city had a population of about 20,000 people, with another 10,000 in the surrounding countryside (FIGS. 12–22 and 12–23).

The most prominent feature of Cahokia is an enormous earth mound called Monk's Mound, covering 15 acres and originally 1200 feet high. A small, conical platform on its summit originally supported a wooden fence and a rectangular building. The mound is aligned with the sun at the equinox and may have had a special use during planting or harvest festivals. Smaller rectangular and conical mounds in front of the principal mound surrounded a large, roughly rectangular plaza. The city's entire ceremonial center was protected by a stockade, or fence, of upright wooden posts—whether to ward off external threats or due to social unrest among the different Mississippian classes is not certain. In all, the walled enclosure contained more than 500 mounds, platforms, wooden enclosures, and houses. The various earthworks functioned as tombs and bases for palaces and temples, and also served to make astronomical observations. One conical burial mound was located next to a platform that may have been used for sacrifices.

12–21 | GREAT SERPENT MOUND
Adams County, Ohio. c. 1070 CE. Length approx. 1,254′ (328.2 m).

THE OBJECT SPEAKS

ROCK ART

Rock art consists of pictographs, which are painted, and petroglyphs, which are pecked or engraved. While occurring in numerous distinctive styles, rock art images include humans, animals, and geometric figures, represented singly and in multifigured murals. In the Great Gallery of Horseshoe Canyon, Utah, the painted human figures have long decorated rectangular bodies and knoblike heads. One large, wide-eyed figure (popularly known as the "Holy Ghost") is nearly 8 feet tall. Previously, archaeologists dated these paintings as early as 1900 BCE and as recently as 300 CE, but some now claim that these paintings may be dated as early as 5400 or even 7500 BCE. The study of the early art of the Americas is filled with debates.

Petroglyphs are often found in places where the dark brown bacterial growths and staining known as "desert varnish" streaks down canyon walls (SEE FIG. 12–26). To create an image, the artist scrapes or pecks through the layer of varnish, exposing the lighter sandstone beneath.

In Nine Mile Canyon in central Utah, a large human hunter draws his bow and arrow on a flock of bighorn sheep. Other hunters and a large, rectangular armless figure wearing a horned headdress—perhaps a shaman—mingle with the animals. The scene gives rise to the same questions and arguments we have noted with regard to the prehistoric art discussed in Chapter 1: Is this a record of a successful hunt or is it part of some ritual activity to assure success? The petroglyphs are attributed to the Fremont people (800–1300 CE), who were agriculturists as well as hunters.

VISITING PICTOGRAPHS AND PETROGLYPHS

Petroglyphs are found from Kansas and Iowa to California and from Canada to Mexico, but they are concentrated in the Southwest in the Four Corners states (Colorado, Utah, New Mexico, and Arizona). Although many sites are easily visited, to see some of the finest petroglyphs requires arduous hiking and climbing. When you visit a rock site, certain rules must be observed:

1. Get the owner's permission if you venture onto private property.
2. Show respect. Remember that rock art has religious associations, especially for Native Americans.
3. Do not walk upon or touch rock art. You could permanently damage it, or leave traces of substances that could affect attempts to date the petroglyphs.
4. Leave the site as you found it. Do not pull up plants or move rocks.

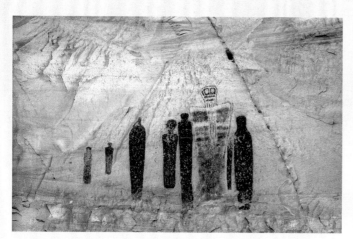

ANTHROPOMORPHS, THE GREAT GALLERY, HORSESHOE (BARRIER) CANYON
Utah. Variously dated. Largest figure about 8′ (2.44 m) tall.

The figures may represent shamans and are often associated with snakes, dogs, and other small energetic creatures. Big-eyed anthropomorphs may be rain gods. Painters used their fingers and yucca-fiber brushes to apply the reddish pigment made from hematite (iron oxide).

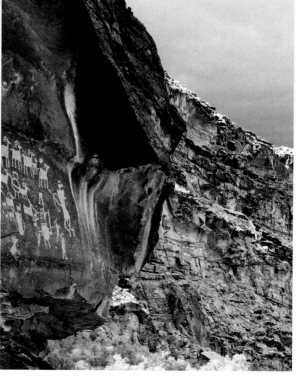

HUNTER'S MURAL
Nine Mile Canyon, Utah, Fremont People, 800–1300 CE.

Postholes indicate that wooden henges (circular areas) were a feature of Cahokia. The largest, with a diameter of about 420 feet (seen to the extreme left in FIGURE 12–23), had forty-eight posts and was oriented to the cardinal points. Sight lines between a forty-ninth post set east of the center of the enclosure and points on the perimeter enabled native astronomers to determine solstices and equinoxes.

FLORIDA GLADES CULTURE. In 1895, excavators working in submerged mud and shell mounds off Key Marco on the west coast of Florida made a remarkable discovery. Posts carved with birds and animals were found preserved in the swamps. The large mound called Fort Center, in Glades Country, Florida, gives the culture its name: Florida Glades.

In Key Marco painted wooden animal and bird heads, a human mask, and the figure of a kneeling cat-human were found in circumstances that suggested a ruined shrine. Recently carbon-14 dating of these items has confirmed a date of about 1000 CE. Although the heads are simplified, the artists show a remarkable power of observation in

12–22 | **RECONSTRUCTION OF CENTRAL CAHOKIA, AS IT WOULD HAVE APPEARED ABOUT 1150 CE**
East St. Louis, Illinois. Mississippian Culture. East-west length approx. 3 miles (4.5 km), north-south length approx. 2¼ miles (3.6 km); base of great mound, 1,037 × 790' (316 × 241 m), height approx. 100' (30 m). Painting by William R. Iseminger
Courtesy of Cahokia Mounds Historic site

12–23 | **CAHOKIA**
East St. Louis, Illinois. Mississippian Culture, c. 900-1500 CE.

reproducing the creatures they saw around them, such as the pelican (FIG. 12–24). The surviving head, neck, and breast of the pelican are made of carved wood painted black, white, and gray (other images also had traces of pink and blue paint). The bird's outstretched wings were found nearby, but the wood shrank and disintegrated as it dried. Carved wooden wolf and deer heads were also found. Archaeologists think the heads might have been attached to ceremonial furniture or posts. Such images suggest the existence of a bird and animal cult or perhaps the use of birds and animals as clan symbols.

In 1539–43 Hernando De Soto explored the region and encountered Mississippian societies. However, contact between native North American people and Europeans resulted in unforeseen catastrophe. The Europeans introduced the germs of diseases, especially smallpox, to which native populations had had no previous exposure and hence no immunity. In short order, 80 percent of the native population perished, an extraordinary disruption of society, far worse than the Black Death in fourteenth-century Europe.

The North American Southwest

Farming cultures were slower to arise in the arid American Southwest, which became home to three major early cultures. The Mimbres/Mogollon culture, located in the mountains of west-central New Mexico and east-central Arizona, flourished from c. 200 to about 1250 CE. The Hohokam culture, centered in the central and southern parts of present-day Arizona, emerged around 200 BCE and endured until sometime after 1200 CE. The Hohokam built large-scale irrigation systems; they constructed deep and narrow canals to reduce evaporation and lined the canals with clay to reduce seepage. Around 900 CE, they began building elaborate, multistoried structures with many rooms

12–24 | PELICAN FIGUREHEAD
Florida Glades culture, Key Marco, c. 1000 CE. Wood and paint, 4⅜ × 2⅜ × 3⅛" (11.2 × 6 × 8 cm). The University Museum of Archaeology and Anthropology, Philadelphia. (T4.303)

for specialized purposes, including communal food storage and rituals. The Spaniards called these communities "pueblos," or towns.

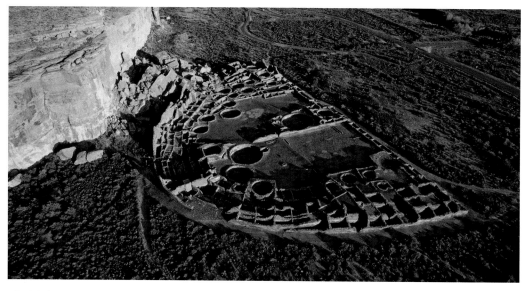

12–25 | PUEBLO BONITO
Chaco Canyon. New Mexico, 830–1250 CE.

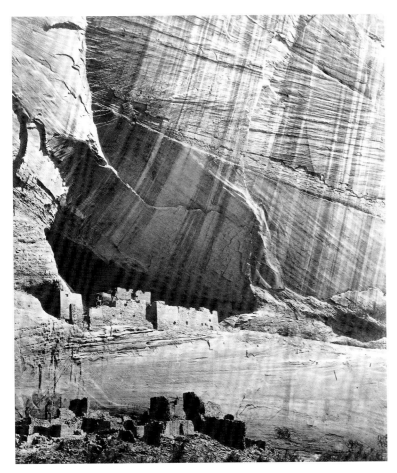

12–26 | Timothy O'Sullivan
ANCIENT RUINS IN THE CANON DE CHELLEY
Arizona, 1873. Albumen print.
National Archives, Washington, D.C.

Timothy O'Sullivan (1840-82) accompanied a geological survey expedition in the western United States. While ostensibly a documentary photograph, his depiction of "The White House," built by 12th century Ancestral Puebloans, is both a valuable document for the study of architecture and an evocative photograph, filled with the Romantic sense of sublime melancholy.

The third southwestern culture, the Ancestral Puebloans emerged around 550 CE in the Four Corners region, where present-day Colorado, Utah, Arizona, and New Mexico meet. The Puebloans adopted the irrigation technology of the Hohokam and began building elaborate, multistoried, apartmentlike "great houses" with many rooms for specialized purposes, including communal food storage. The largest known "great house" is Pueblo Bonito in Chaco Canyon, a New Mexico canyon of about 30 square miles with nine great houses, or pueblos. Interestingly, Pueblo Bonito remained the largest "apartment building" in North America until New York City surpassed it in the nineteenth century. (Calloway, 2004.)

PUEBLO BONITO. The most extensive great house in Chaco Canyon, Pueblo Bonito (FIG. 12–25, ALSO SEE FIG. 12–1), was built in stages between the tenth and mid-thirteenth centuries CE. Eventually it comprised over 800 rooms in four or five stories, arranged in a D-shape. Because so many rooms were not needed to house a resident population of the size that the land could support, perhaps the pueblo provided temporary shelter for people assembling there on ritual occasions. Within the crescent part of the D-shape, thirty-two kivas recall the round semisubmerged pit houses of the Ancestral Puebloans. Here men performed religious rituals

and instructed youths in their responsibilities. The top of the kivas formed the floor of the communal plaza. Interlocking pine logs formed a shallow, domelike roof with a hole in the center through which the men entered by climbing down a ladder. Inside the kiva, in the floor directly under the entrance, a square pit—the "navel of the earth"—symbolized the place where the Ancestral Pueblo ancestors had emerged from the earth in the mythic "first times."

About 1150 the pueblo dwellers began to move to more secure places (FIG. 12–26). They built their apartmentlike dwellings on ledges under sheltering cliffs. Difficult as it must have been to live high on canyon walls and farm the valley below, the cliff communities had the advantage of being relatively secure. The rock shelters in the cliffs also acted as insulation, protecting the dwellings from extremes of heat and cold. Like a modern apartment complex, the many rooms housed an entire community comfortably. Communal solidarity and responsibility became part of the heritage of the Pueblo peoples.

Pueblo people found aesthetic expression in their pottery, an old craft perfected over generations and still alive today. Women were the potters in Pueblo society. In the eleventh century they perfected a functional, aesthetically pleasing, coil-built earthenware, or low-fired ceramic. This ceramic tradition continues today among the Pueblo

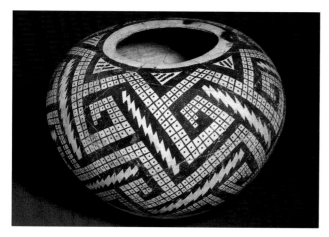

12–27 | SEED JAR

Pueblo culture, c. 1150 CE. Earthenware and black-and-white pigment, diameter 14½″ (36.9 cm). The St. Louis Art Museum, St. Louis, Missouri.

Purchase: Funds given by the Children's Art Bazaar, St. Louis

peoples of the Southwest. One type of vessel, a wide-mouthed seed jar with a globular body and holes near the rim (FIG. 12–27), would have been suspended from roof poles by thongs attached to the jar's holes, out of reach of voracious rodents. The example shown here is decorated with black-and-white dotted squares and zigzag patterns. The patterns conform to the body of the jar, and in spite of their angularity, they enhance its curved shape. The intricate play of dark and light suggests lightning flashing over a grid of irrigated fields.

Though no one knows for certain why the people of Chaco Canyon abandoned the site, the population declined during a severe drought in the twelfth century, and building at Pueblo Bonito ceased around 1250. The Pueblo population of Chaco Canyon may have moved to the Rio Grande and Mogollon River Valleys. Some scholars believe a new religion, based on controlling the rain (the "Katsina phenomenon"), drew the Ancestral Pueblo people to the new population centers. Even today, katsinas remain central to the Pueblo religion.

Throughout the Americas for the next several hundred years, artistic traditions would continue to emerge, develop, and be transformed as the indigenous peoples of various regions interacted. The sudden incursions of Europeans, beginning in the late fifteenth century, would have a dramatic and lasting impact on these civilizations and their art.

IN PERSPECTIVE

Much of American indigenous art has been lost to time and to the disruption of European conquest. Fortunately, during the past century, art history, anthropology, and archaeology have helped to recover at least some understanding of American art before Columbus. Far from being the vacant wilderness described by some European newcomers, the Americas had been home to a wide variety of peoples since the Ice Age, with cultural traditions dating back at least to the times of Classical Greece. Although art was central to their lives, the indigenous peoples of the Americas designated no special objects as "works of art." Some pieces were essentially utilitarian and others had ritual uses and symbolic associations, but people drew no distinction between art and other aspects of material culture or between the fine arts and the decorative arts. Native Americans, like all people, valued the visual pleasure afforded by objects made with skill and intelligence, and Native artists have always applied a variety of criteria in determining aesthetic value.

Throughout the Americas, some cultures were able to complete monumental undertakings, including vast earthworks, irrigation projects, road systems, and monumental public architecture. Large cities arose at ceremonial centers such as Teotihuacan in Mexico and Cahokia in Illinois. In the rain forests around Tikal in Guatemala and Palenque in Mexico, elaborate stone structures dominated the landscape. Remarkably, these monumental sites were built of quarried stone, cut timber, and transported materials—often from distant locations—without the benefit of wheeled vehicles or metal tools.

Following centuries of neglect, much of what remains of early American art is being preserved and studied. In Mesoamerica, monumental stone sculpture covered buildings and, in the form of gods and goddesses, loomed over the devotees. In the river valleys of North America, people heaped mounds of earth to shape huge serpents, bears, and eagles. On the Nazca Plain in Peru, people scraped away rocks to delineate enormous outlines of birds and insects on the surface of the earth. On the other hand, some of what remains is exquisite and fragile. The masterful textiles of the Paracas culture have been preserved in the desert climate, while in North America delicate Hopewell effigy pipes have survived. Likewise, ceramic vessels in the shape of strikingly realistic portrait heads were made by the Moche of Peru, while equally striking abstraction can be seen in pottery from the Pueblo people of the North American Southwest. Having survived first as "curiosities," then as tourist souvenirs, the arts of the indigenous peoples of the Americas are at last recognized for their own qualities.

Knowledge of indigenous peoples in the Americas constantly requires reevaluation in light of ongoing research. For instance, recent breakthroughs in deciphering inscriptions have led to wholesale revisions in ancient Maya history. Even the origins of indigenous Americans remain a matter of lively debate.

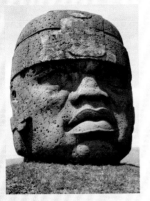

COLOSSAL OLMEC HEAD
C. 900–400 BCE

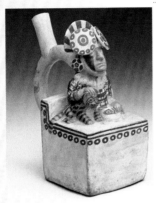

**MOCHE LORD WITH A
FELINE**
C. 100 BCE–500 CE

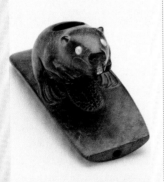

**HOPEWELL BEAVER EFFIGY
PLATFORM PIPE**
100–200 CE

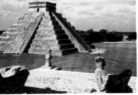

PYRAMID WITH CHACMOOL
CHICHEN ITZA
C. 800–1000 CE

PUEBLO SEED JAR
C. 1150 CE

1500
BCE

1000

I
CE

1000

1500

ART OF THE AMERICAS BEFORE 1300

◀ **Formative/Preclassic**
c. 1500 BCE –250 CE

◀ **Olmec** c. 1200–400 BCE

◀ **Chavin** c. 1000–200 BCE
◀ **Paracas** c. 1000 BCE–200 CE

◀ **Maya** c. 350 BCE–1521 CE
◀ **Nazca** c. 200 BCE–600 CE
◀ **Moche** c. 200 BCE–600 CE
◀ **Hohokam** c. 200 BCE–1200 CE
◀ **Hopewell** c. 100 BCE–550 CE

◀ **Teothucan** c. 1–750 CE

◀ **Mimbres/Mogollon** c. 200–1250 CE
◀ **Classic** c. 250–900 CE
◀ **Ancient Puebloan** c. 550–1250 CE

◀ **Diquis** c. 700–1500 CE
◀ **Itza** c. 800–1200 CE

◀ **Postclassic** c. 900–1521 CE

I3–I ❘ **RITUAL VESSEL** from Ife. Yoruba. 13–14th century. Terra cotta, height 9¹³⁄₁₆″ (24.9 cm).
University Art Museum, Obafemi, Awolowo University, Ife, Nigeria.

ART OF ANCIENT AFRICA

13

The Yoruba people of southwestern Nigeria have traditionally regarded the city of Ife (also known as Ile-Ife) as the "navel of the world," the site of creation, the place where kingship originated when Ife's first ruler—the *oni* Oduduwa—came down from heaven to create earth and then to populate it. By the eleventh century CE, Ife was a lively metropolis and cultural center; today, every one of the many Yoruba cities claims "descent" from Ife.

Ancient Ife was essentially circular in plan, with the *oni*'s palace at the center. Ringed by protective stone walls and moats, Ife was connected to other Yoruba cities by roads that radiated from the center, passing through the city walls at fortified gateways decorated with mosaics created from stones and pottery shards. From these elaborately patterned pavement mosaics, which covered much of Ife's open spaces, comes the name for Ife's most artistically cohesive historical period (c. 1000–1400 CE), the Pavement period.

Just as the *oni*'s palace was located in a large courtyard in the center of Ife, so too were ritual spaces elsewhere in Ife located in paved courtyards with altars. In the center of such a sacred courtyard, outlined by rings of pavement mosaic, archaeologists excavated an exceptional terra-cotta vessel (FIG. 13–1). The jar's bottom had been ritually broken before it was buried, so that liquid offerings (libations) poured into the neck opening would flow into the earth. The objects so elegantly depicted in relief on the surface of the vessel include what looks like an altar platform with three heads under it, the outer two quite abstract and the middle one almost **naturalistic** in the tradition of freestanding Yoruba portrait heads (SEE FIG. 13–7). The abstraction of the two outside heads may well have been a way of honoring or blessing the central portrait, a practice that survives today among Yoruba royalty.

THE LURE OF ANCIENT AFRICA

"I descended [the Nile] with three hundred asses laden with incense, ebony, grain, panthers, ivory, and every good product." Thus the Egyptian envoy Harkhuf described his return from Nubia, the African land to the south of Egypt, in 2300 BCE. The riches of Africa attracted merchants and envoys in ancient times, and trade brought the continent in contact with the rest of the world. Egyptian relations with the rest of the African continent continued through the Hellenistic era and beyond. Phoenicians and Greeks founded dozens of settlements along the Mediterranean coast of North Africa between 1000 and 300 BCE to extend trade routes across the Sahara to the peoples of Lake Chad and the bend of the Niger River (MAP 13–1). When the Romans took control of North Africa, they continued this lucrative trans-Saharan trade. In the seventh and eighth centuries CE, the expanding empire of Islam swept across North Africa, and thereafter Islamic merchants were regular visitors to Bilad al-Sudan, the Land of the Blacks (sub-Saharan Africa). Islamic scholars chronicled the great West African empires of Ghana, Mali, and Songhay, and West African gold financed the flowering of Islamic culture.

East Africa, meanwhile, had been drawn since at least the beginning of the Common Era into the maritime trade that ringed the Indian Ocean and extended east to Indonesia and the South China Sea. Arab, Indian, and Persian ships plied the coastline. A new language, Swahili, evolved from centuries of contact between Arabic-speaking merchants and Bantu-speaking Africans, and great port cities such as Kilwa, Mombasa, and Mogadishu arose.

In the fifteenth century, Europeans ventured by ship into the Atlantic Ocean and down the coast of Africa. Finally rediscovering the continent firsthand, they were often astonished by what they found (see "The Myth of 'Primitive' Art," page 424). "Dear King My Brother," wrote a fifteenth-century Portuguese king to his new trading partner, the king of Benin in West Africa. The Portuguese king's respect was well founded—Benin was vastly more powerful and wealthier than the small European country that had just stumbled upon it.

As we saw in Chapter 3, Africa was home to one of the world's earliest great civilizations, that of ancient Egypt, and

as we saw in Chapter 8, Egypt and the rest of North Africa contributed prominently to the development of Islamic art and culture. This chapter examines the artistic legacy of the rest of ancient Africa.

AFRICA—THE CRADLE OF ART AND CIVILIZATION

During the twentieth century, the sculpture of traditional African societies—wood carvings of astonishing formal inventiveness and power—found admirers the world over. While avidly collected, these works were much misunderstood. For the past seventy-five years, art historians and cultural anthropologists have studied African art firsthand, which has added to our overall understanding of art-making in many African cultures. However, except for a few isolated examples (such as in Nigeria and Mali), the historical depth of our understanding is still limited by the continuing lack of systematic archaeological research. Our understanding of traditions that are more than one hundred years old is especially hampered by the fact that most African art was made from wood, which decays rapidly in sub-Saharan Africa. Consequently, few examples of African masks and sculpture remain from before the nineteenth century, and scholars for the most part must rely on contemporary traditions and oral histories to help extrapolate backwards in time to determine what may have been the types, styles, and meaning of art made in the past. Nevertheless, the few ancient African artworks we have in such durable materials as terra cotta, stone, and bronze bear eloquent witness to the skill of ancient African artists and the splendor of the civilizations in which they worked.

Twentieth-century archaeology has made it popular to speak of Africa as the cradle of human civilization. Certainly the earliest evidence for our human ancestors comes from southern Africa. Now evidence of the initial stirrings of artistic activity comes from the southern tip of Africa as well. Recently, quantities of ocher pigment thought to have been used for ceremonial or decorative purposes and perforated shells thought to have been fashioned into beads and worn as personal adornment have been found in Blombos Cave on the Indian Ocean coast of South Africa dating to approximately 70,000 years ago. Also dis-

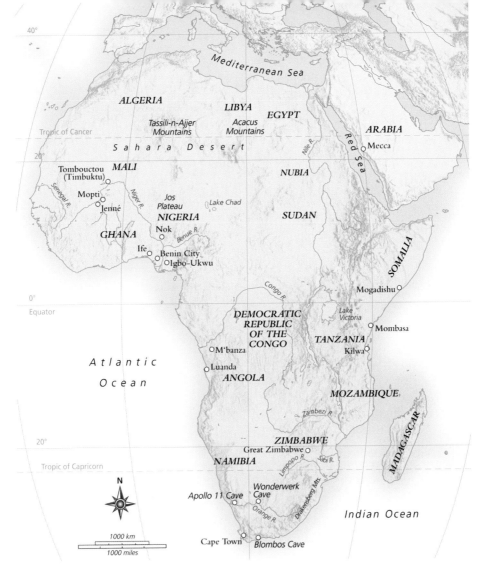

MAP 13–1 | ANCIENT AFRICA

Nearly 5,000 miles from north to south, Africa is the second-largest continent and was the home of some of the earliest and most advanced cultures of the ancient world.

covered together with these were two small ocher blocks that had been smoothed and then decorated with geometric arrays of carved lines (FIG. 13–2). These incised abstract patterns predate any other findings of ancient art by more than 30,000 years, and they suggest a far earlier development of modern human behavior than had been previously recognized.

The earliest known figurative art from the African continent are animal figures dating to c. 25,000 BCE painted in red and black pigment on flat stones found in a cave designated as

13–2 | INCISED OCHER PLAQUE
Blombos Cave, South Africa.
c. 70,000 BCE. Iron ore ocher stone, length 3″ (7.6 cm). Iziko South African Museum, Cape Town, South Africa.

OF "PRIMITIVE" ART

The word *primitive* was once used by Western art historians to categorize the art of Africa, the art of the Pacific islands, and the indigenous art of the Americas. The term itself means "early" or "first of its kind," but its use was meant to imply that these cultures were crude, simple, backward, and stuck in an early stage of development.

This attitude was accepted by Christian missionaries and explorers, who often described the peoples among whom they worked as "heathen," "barbaric," "ignorant," "tribal," "primitive," and other terms rooted in racism and colonialism. Such usages were extended to these peoples' creations, and "primitive art" became the conventional label for their cultural products.

Criteria that have been used to label a people "primitive" include the use of so-called Stone Age technology, the absence of written histories, and the failure to build great cities. Based on these criteria, however, the accomplishments of the peoples of Africa, to take just one example, contradict such prejudiced condescension: Africans south of the Sahara have smelted and forged iron since at least 500 BCE. Africans in many areas made and used high-quality steel for weapons and tools. Many African peoples have recorded their histories in Arabic since at least the tenth century CE. The first European visitors to Africa admired the style and sophistication of urban centers such as Benin and Luanda, to name only two of the continent's great cities. Clearly, neither the cultures of ancient Africa nor the artworks they produced were "primitive" at all.

Until quite recently, Westerners tended to see Africa as a single country and not as an immense continent of vastly diverse cultures. Moreover, they perceived artists working in Africa as craftsworkers bound to styles and images dictated by village elders and producing art that was anonymous and interchangeable. Over the past several decades, however, these misconceptions have crumbled. Art historians and anthropologists have now identified numerous African cultures and artists and compiled catalogs of their work. For example, the well-known Yoruba artist Olowe of Ise (see Chapter 28) was commissioned by rulers throughout the Yoruba region in the early twentieth century to create prestige objects such as palace veranda posts and palace doors or tour de force carvings such as magnificent lidded bowls supported by kneeling figures. Certainly we will never know the names of the vast majority of African artists of the past, just as we do not know the names of the sculptors responsible for the portrait busts of ancient Rome or the monumental reliefs of the Hindu temples of South Asia. But, as elsewhere, the greatest artists in Africa were famous and sought after, while innumerable others labored honorably and not at all anonymously.

figures are comparable to the better-known European cave drawings such as those from Chauvet Cave (c. 25,000–17,000 BCE) and Lascaux Cave (c. 15,000–13,000 BCE) (see Chapter 1).

AFRICAN ROCK ART

Like the Paleolithic inhabitants of Europe, early Africans painted and inscribed images on the walls of caves and rock shelters. Rock art is found throughout the African continent in places where the environment has been conducive to preservation—areas ranging from small, isolated shelters to great cavernous formations. Distinct geographic zones of rock art can be identified broadly encompassing the northern, central, southern, and eastern regions of the continent. These rock paintings and engravings range in form from highly abstract geometric designs to abstract and naturalistic representations of human and animal forms, including hunting scenes, scenes of domestic life, and costumed figures that appear to be dancing.

Saharan Rock Art

The mountains of the central Sahara—principally the Tassili-n-Ajjer range in the south of present-day Algeria and the Acacus Mountains in present-day Libya—contain images that span a period of thousands of years. They record not only the artistic and cultural development of the peoples who lived in the region, but also the transformation of the Sahara from a fertile grassland to the vast desert we know today.

The earliest images of Saharan rock art are thought to date from at least 8000 BCE, during the transition into a geological period known as the Makalian Wet Phase. At that time the Sahara was a grassy plain, perhaps much like the game-park reserves of modern East Africa. Vivid images of hippopotamus, elephant, giraffe, antelope, and other animals incised on rock surfaces attest to the abundant wildlife that roamed the region. Like the cave paintings in Altamira and Lascaux (Chapter 1), these images may have been intended to ensure plentiful game or a successful hunt, or they may have been symbolic of other life-enhancing activities, such as healing or rainmaking.

By 4000 BCE the climate had become more arid, and hunting had given way to herding as the primary life-sustaining activity of the Sahara's inhabitants. Among the most beautiful and complex examples of Saharan rock art created in this period are scenes of sheep, goats, and cattle and of the daily lives of the people who tended them. One such scene, **CATTLE BEING TENDED,** was found at Tassili-n-Ajjer and probably dates from late in the herding period, about 5000–2000 BCE (FIG. 13–3). Men and women are gathered in front of their round, thatched houses, the men tending cattle, the women preparing a meal and caring for children. A large herd of cattle, many of them tethered to a long rope, has been

driven in from pasture. The cattle shown are quite varied. Some are mottled, while others are white, red, or black. Some have short, thick horns, while others have graceful, lyre-shaped horns. The overlapping forms and the placement of near figures low and distant figures high in the picture plane create a sense of depth and distance.

By 2500–2000 BCE the Sahara was drying and the great game had disappeared, but other animals were introduced that appear in the rock art. The horse was brought from Egypt by about 1500 BCE and is seen regularly in rock art over the ensuing millennia. The fifth-century BCE Greek historian Herodotus described a chariot-driving people called the Garamante, whose kingdom corresponds roughly to present-day Libya. Rock-art images of horse-drawn chariots bear out his account. Around 600 BCE the camel was introduced into the region from the east, and images of camels were painted on and incised into the rock.

The drying of the Sahara coincided with the rise of Egyptian civilization along the Nile Valley to the east. Similarities can be noted between Egyptian and Saharan motifs, among them images of rams with what appear to be disks between their horns. These similarities have been interpreted as evidence of Egyptian influence on the less-developed regions of the Sahara. Yet in light of the great age of Saharan rock art, it seems just as plausible that the influence flowed the other way, carried by people who had migrated into the Nile Valley when the grasslands of the Sahara disappeared.

SUB-SAHARAN CIVILIZATIONS

Saharan peoples presumably migrated southward as well, into the Sudan, the broad belt of grassland that stretches across Africa south of the Sahara Desert. They brought with them knowledge of settled agriculture and animal husbandry. The earliest evidence of settled agriculture in the Sudan dates from about 3000 BCE. Toward the middle of the first millennium BCE, at the same time that iron technology was being developed elsewhere in Africa, knowledge of ironworking spread across the Sudan as well, enabling its inhabitants to create more effective weapons and farming tools. In the wake of these developments, larger and more complex societies emerged, especially in the fertile basins of Lake Chad in the central Sudan and the Niger and Senegal rivers to the west.

Nok

Some of the earliest evidence of iron technology in sub-Saharan Africa comes from the so-called Nok culture, which arose in the western Sudan, in present-day Nigeria, as early as

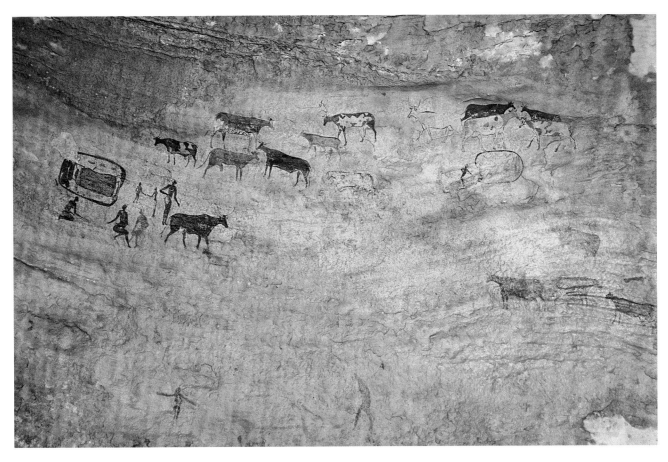

13–3 | **CATTLE BEING TENDED**
Section of rock-wall painting, Tassili-n-Ajjer, Algeria. c. 5000–2000 BCE.

Rock painting and engraving from sites in southern Africa differ in terms of style and age from those discussed for the Sahara region. Some examples of artworks predate those found in the Sahara, while other found works continued to be produced into the modern era. These works include an engraved fragment found in dateable debris in Wonderwerk Cave, South Africa, which dates back to 10,000 years ago. Painted stone flakes found at a site in Zimbabwe suggest dates between 13,000 and 8000 BCE.

Numerous examples of rock painting are also found in South Africa in the region of the Drakensberg Mountains. Almost 600 sites have been located in rock shelters and caves, with approximately 35,000 individual images catalogued. It is believed the paintings were produced, beginning approximately 2,400 years ago, by the predecessors of San peoples who still reside in the region. Ethnographic research among the San and related peoples in the area suggest possible interpretations for some of the paintings. For example, rock paintings depicting groups of dancing figures may relate to certain forms of San rituals that are still performed today to heal individuals or to cleanse communities. These may have been created by San ritual specialists or shamans to record their curing dances or trance experiences of the spirit world. San rock artists continued to create rock paintings into the late nineteenth century. These latter works depict the arrival of Afrikaner pioneers to the region as well as British soldiers brandishing guns used to hunt elands.

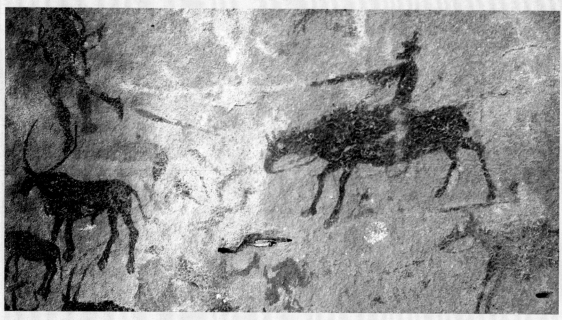

SECTION OF SAN ROCK-WALL PAINTING
San peoples. n.d. Drakensberg Mountains, South Africa. Pigment and eland blood on rock.

500 BCE. The Nok people were farmers who grew grain and oil-bearing seeds, but they were also smelters with the technology for refining ore. Slag and the remains of furnaces have been discovered, along with clay nozzles from the bellows used to fan the fires. The Nok people created the earliest known sculpture of sub-Saharan Africa, producing accomplished terra-cotta figures of human and animal subjects between about 500 BCE and 200 CE.

Nok sculpture was discovered in modern times by tin miners digging in alluvial deposits on the Jos plateau north of the confluence of the Niger and Benue rivers. Presumably, floods from centuries past had removed the sculptures from their original contexts, dragged and rolled them along, and then deposited them, scratched and broken, often leaving only the heads from what must have been complete human figures. Following archaeological convention, scholars gave the name of a nearby village, Nok, to the culture that created these works. Nok-style works of sculpture have since been found in numerous sites over a wide area.

The Nok head shown (FIG. 13–4), slightly larger than life-size, probably formed part of a complete figure. The triangular or D-shaped eyes are characteristic of Nok style and appear also on sculpture of animals. Holes in the pupils, nostrils, and mouth allowed air to pass freely as the figure was fired. Each of the large buns of its elaborate hairstyle is pierced with a hole that may have held ornamental feathers. Other Nok figures were created displaying beaded necklaces, armlets, bracelets, anklets, and other prestige ornaments. Nok sculpture may represent ordinary people dressed for special occasions or it may portray people of high status, thus reflecting social stratification

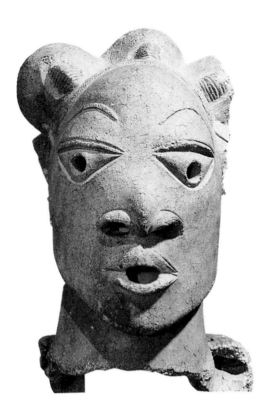

13–4 | **HEAD**
Nok, c. 500 BCE–200 CE. Terra cotta, height 14³⁄₁₆" (36 cm).
National Museum, Lagos, Nigeria.

in this early farming culture. In either case, the sculpture provides evidence of considerable technical accomplishment, which has led scholars to speculate that Nok culture was built on the achievements of an earlier culture still to be discovered.

Igbo-Ukwu

A number of significant sites have been excavated in Nigeria in the mid-twentieth century that increase our understanding of the development of art and culture in West Africa. This includes the archaeological site of Igbo-Ukwu in eastern Nigeria where Igbo peoples reside, one of Nigeria's numerically largest and most politically important populations. The earliest known evidence for copper alloy or bronze casting in sub-Saharan Africa is found at Igbo-Ukwu. This evidence dates to the ninth and tenth century CE. Igbo-Ukwu is also the earliest known site containing an elite burial and shrine complex yet found in sub-Saharan Africa. Three distinct archaeological sites have been excavated at Igbo-Ukwu—one containing a burial chamber, another resembling a shrine or storehouse containing ceremonial objects, and the third an ancient pit containing ceremonial and prestige objects.

The burial chamber contained an individual dressed in elaborate regalia, placed in a seated position, and surrounded by emblems of his power and authority. These included three ivory tusks, thousands of imported beads that originally

formed part of an elaborate necklace, other adornments, and a cast bronze representation of a leopard skull (FIG. 13–5). Elephants and leopards are still symbols of temporal and spiritual leadership in Africa today. Ethnographic research among the Nri, an Igbo-related people currently residing in the region, suggests that the burial site is that of an important Nri king or ritual leader called an *eze*.

The second excavation uncovered a shrine or storehouse complex containing ceremonial and prestige objects. These copper alloy castings were made by the **lost-wax technique** (see "Lost-Wax Casting," page xxix) in the form of elaborately decorated small bowls, fly-whisk handles, altar stands, staff finials, and ornaments. Igbo-Ukwu's unique style consists of the representation in bronze of natural objects such as gourd bowls and snail shells whose entire outer surface is covered with elaborate raised and banded decorations. These decorations include linear, spiral, circular, and granular designs, sometimes with the addition of small animals or insects such as snakes, frogs, crickets, or flies applied to the decorated surface. Some castings are further enlivened with the addition of brightly colored beads.

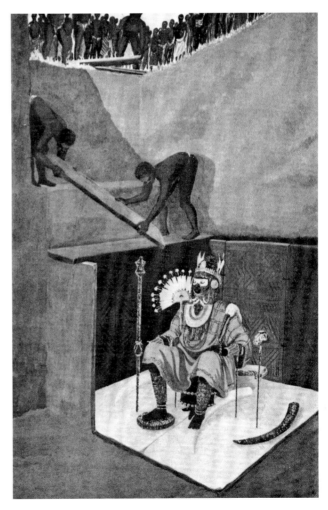

13–5 | **BURIAL CHAMBER**
Igbo-Ukwu, showing the placement of the ruler and artifacts in the chamber in the 10th century. Reconstruction painting by Caroline Sassoon.

THE ⊙BJECT SPEAKS

A WARRIOR CHIEF PLEDGING LOYALTY

Hundreds of brass plaques, each averaging about 16 to 18 inches in height, once decorated the walls and pillars of the royal palace of the kingdom of Benin. Produced during the sixteenth and seventeenth centuries, the plaques, numbering approximately 900 examples, were found located in a storehouse by the British during the 1897 Punitive Expedition. Like the brass memorial heads and figure sculpture, the plaques were made following the lost-wax casting process. They illustrate a variety of subjects including ceremonial scenes at court, showing the *oba*, other court functionaries, and (at times) Portuguese soldiers.

Modeled in relief, the plaques depict one or more figures, with precise details of costume and regalia. Some figures are modeled in such high relief that they appear almost freestanding as they emerge from a textured surface background that often includes foliate patterning representing the leaves employed in certain healing rituals.

This plaque features a warrior chief in ceremonial attire. His rank is indicated by a necklace of leopard's teeth, and coral-decorated cap and collar. He also wears an elaborately decorated skirt with a leopard mask on his hip. The chief is depicted holding a spear in one hand and

an *eben* sword held above his head in the other hand.

The warrior chief is flanked by two warriors holding shields and spears, and two smaller figures representing court attendants. One attendant is depicted playing a side-blown horn that announces the warrior chief's presence, while the other attendant carries a ceremonial box for conveying gifts. The scene recounts a ceremony of obeisance to the *oba*. The warrior chief's gesture of raising the *eben* sword is still performed at annual ceremonies in which chiefs declare their allegiance and loyalty to the *oba* by raising the sword and spinning it in the air.

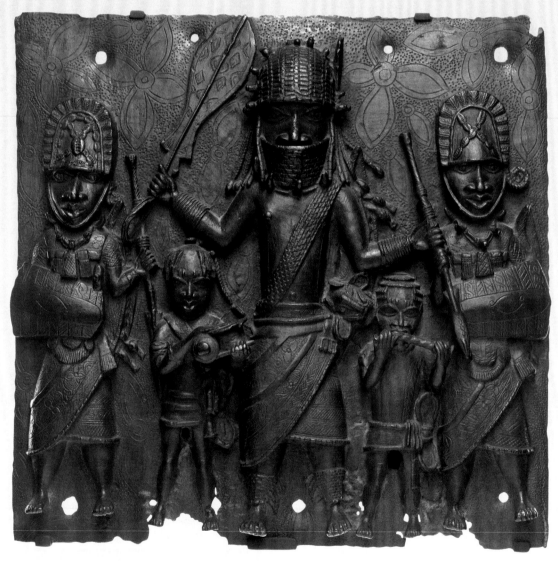

PLAQUE: WARRIOR CHIEF FLANKED BY WARRIORS AND ATTENDANTS
Benin, Nigeria. Middle Period, c. 1550–1650 CE. Brass, height 14¾″ × 15½″ (37.5 × 39.4 cm). The Nelson-Atkins Museum of Art, Kansas City, Missouri.
K [58-3]

ken, the knowledge of how these works were used has been lost. When archaeologists showed the ancient sculpture to members of the contemporary *oni*'s court, however, they recognized symbols of kingship that had been worn within living memory, indicating that the figures represent rulers.

A life-size head (FIG. 13–7) shows the extraordinary artistry of ancient Ife. The modeling of the flesh is remarkably sensitive, especially the subtle transitions around the nose and mouth. The lips are full and delicate, and the eyes are strikingly similar in shape to those of some modern Yoruba. The face is covered with thin, parallel **scarification** patterns (decorations made by scarring). The head was cast of zinc brass using the lost-wax method.

Holes along the scalp apparently permitted a crown or perhaps a beaded veil to be attached. Large holes around the base of the neck may have allowed the head itself to be attached to a wooden mannequin for display during

13–6 | **ROPED POT ON A STAND**
Igbo-Ukwu. 9th–10th century. Leaded bronze, height 12¹¹⁄₁₆″
(32.3 cm). National Museum, Lagos.

The artifacts include a cast fly-whisk handle topped with the representation of an equestrian figure whose face, like that of a pendant head also found during excavation, is represented scarified in a style similar to the patterning found on some of the terra-cotta and cast heads of rulers at Ife. These markings are similar to markings called *ichi,* which are still used by Igbo men as a symbol of high achievement.

Among the most complex castings found at Igbo-Ukwu is a representation of a water jar resting on a stand and encircled by elaborate rope decoration (FIG. 13–6). This object was cast in several parts, which were then assembled using sophisticated metalworking techniques.

Ife

The naturalistic works of sculpture created by the artists of the city of Ife, which arose in the southwestern forested part of Nigeria about 800 CE, are among the most remarkable in art history.

Ife was, and remains, the sacred city of the Yoruba people. A tradition of naturalistic sculpture began there about 1050 CE and flourished for some four centuries. Although the ancestral line of the current Ife king, or *oni*, continues unbro-

13–7 | **HEAD OF A KING**
Ife. Yoruba. c. 13th century CE. Zinc brass, height 11⁷⁄₁₆″
(29 cm). Museum of Ife Antiquities, Ife, Nigeria.

The naturalism of Ife sculpture contradicted everything Europeans thought they knew about African art. The German scholar who "discovered" Ife sculpture in 1910 suggested that it had been created not by Africans but by survivors from the legendary lost island of Atlantis. Later scholars speculated that influence from ancient Greece or Renaissance Europe must have reached Ife. Scientific dating methods, however, finally put such misleading comparisons and prejudices to rest.

13–8 | HEAD SAID TO REPRESENT THE USURPER LAJUWA
Ife. Yoruba. c. 1200–1300 CE. Terra cotta, height 12¹⁵⁄₁₆″
(32.8 cm). Museum of Ife Antiquities, Ife, Nigeria.

memorial services for a deceased *oni*. Mannequins with natu-
ralistic facial features have been documented at memorial
services for deceased individuals among contemporary
Yoruba peoples. The Ife mannequin was probably dressed in
the *oni's* robes; the head probably bore his crown. The head
could also have been used to display a crown during annual
purification and renewal rites.

The artists of ancient Ife also produced heads in terra
cotta. They were probably placed in shrines devoted to the
memory of each dead king. One of the most famous was not
found by archaeologists but had been preserved through the
centuries in the *oni's* palace. It is said to represent Lajuwa, a
court retainer who usurped the throne by intrigue and
impersonation (FIG. 13–8).

Scholars continue to debate whether the Ife heads are
true portraits. Their realism gives an impression that they
could be. The heads, however, all seem to represent men of
the same age and embody a similar concept of physical per-
fection, suggesting that they are **idealized** images. Idealized
images of titled individuals are a common feature of sub-
Saharan African sculpture, as they are for many other cultures
throughout the world.

Benin

Ife was probably the artistic parent of the great city-state of
Benin, which arose some 150 miles to the southeast. Accord-
ing to oral histories, the earliest kings of Benin belonged to

13–9 | MEMORIAL HEAD OF AN OBA
Benin, Early Period, c. 16th century. Brass, height 9″ (23 cm).
The Nelson-Atkins Museum of Art, Kansas City, Missouri.
Purchase: Nelson Trust through the generosity of Donald J. and Adele C. Hall,
Mr. and Mrs. Herman Robert Sutherland, an anonymous donor,
and the exchange of Nelson Gallery Foundation properties [87-7].

This head belongs to a small group of rare Early Period sculptures
called "rolled-collar" heads that are distinguished by the roll collar
that serves as a firm base for the exquisitely rendered head.

the Ogiso, or Skyking, dynasty. After a long period of misrule,
however, the people of Benin asked the *oni* of Ife for a new
ruler. The *oni* sent Prince Oranmiyan, who founded a new
dynasty in 1170 CE. Some two centuries later, the fourth
king, or *oba*, of Benin decided to start a tradition of memorial
sculpture like that of Ife, and he sent to Ife for a master metal
caster named Iguegha. The tradition of casting memorial
heads for the shrines of royal ancestors endures among the
successors of Oranmiyan to this day (FIG. 13–9).

Benin came into contact with Portugal in the late fif-
teenth century CE. The two kingdoms established cordial
relations in 1485 and carried on an active trade, at first in
ivory and forest products, but eventually in slaves. Benin
flourished until 1897, when, in reprisal for the massacre of a
party of trade negotiators, British troops sacked and burned
the royal palace, sending the *oba* into an exile from which he
did not return until 1914. The palace was later rebuilt, and the
present-day *oba* continues the dynasty started by Oranmiyan.

The British invaders discovered shrines to deceased *obas*
covered with brass heads, bells, and figures. They also found
wooden rattles and enormous ivory tusks carved with images
of kings, court attendants, and sixteenth-century Portuguese
soldiers. The British appropriated the treasure as war booty
making no effort to note which head came from which

shrine, thus destroying evidence that would have helped establish the relative age of the heads and determine a chronology for the evolution of Benin style. Nevertheless, scholars have managed to piece together a chronology from other evidence.

The Benin heads, together with other objects, were originally placed on a semicircular platform and surmounted by large elephant tusks, another symbol of power (FIG. 13–10). All of the heads include representations of coral-bead necklaces and headdresses, which still form part of the royal costume. Benin brass heads range from small, thinly cast, and naturalistic to large, thickly cast, and highly stylized. Many scholars have concluded that the smallest, most naturalistic heads with only a few strands of beads around the neck were created during a so-called Early Period (1400–1550 CE), when Benin artists were still heavily influenced by Ife. Heads grew heavier, increasingly stylized, and the strands of beads increased in number until they concealed the chin during the Middle Period (1550–1700 CE). Heads from the ensuing Late Period (1700–1897 CE) are very large and heavy, with angular, stylized features and an elaborate beaded crown. During the Late Period, the necklaces form a tall, cylindrical mass. In addition, broad, horizontal flanges, or projecting edges, bearing small images cast in low relief ring the base of the Late Period heads. The increase in size and weight of Benin memorial heads over time may reflect the growing power and wealth flowing to the *oba* from Benin's expanding trade with Europe.

At Benin, as in many other African cultures, the head is the symbolic center of a person's intelligence, wisdom, and ability to succeed in this world or to communicate with spiritual forces in the ancestral world. One of the honorifics used for the king is "Great Head": The head leads the body as the king leads the people. All of the memorial heads include representations of coral-beaded caps and necklaces and royal costume. Coral, enclosing the head and displayed on the body, is still the ultimate symbol of the *oba*'s power and authority.

The art of Benin is a royal art, for only the *oba* could commission works in brass. Artisans who served the court were organized into guilds and lived in a separate quarter of the city. *Obas* also commissioned important works in ivory.

13–10 | ALTAR
Edo Culture, Nigeria. c. 1959. Photo by Eliot Elisofon. The National Museum of African Art, Smithsonian Institution, Washington, D.C.
Eliot Elisofon Photographic Archives 7584

13–11 | HIP MASK

Representing an *iyoba* ("queen mother"). Benin, Middle Period, c. 1550 CE. Ivory, iron, and copper, height 9⅜" (23.4 cm). The Metropolitan Museum of Art, New York.

The Michael C. Rockefeller Memorial Collection, Gift of Nelson A. Rockefeller, 1972 (1978.412.323)

One example is a beautiful ornamental mask (FIG. 13–11). It represents an *iyoba*, or queen mother (the Oba's mother), the senior female member of the royal court. The mask was carved as a belt ornament and was worn at the *oba's* hip. Its pupils were originally inlaid with iron, as were the scarification patterns on the forehead. This particular belt ornament may represent Idia, who was the mother of Esigie, a powerful Oba who ruled from 1504 to 1550 CE. Idia is particularly remembered for raising an army and using magical powers to help her son defeat his enemies. Like Idia, the Portuguese helped Esigie expand his kingdom. The necklace represents heads of Portuguese soldiers with beards and flowing hair. In the crown, more Portuguese heads alternate with figures of mudfish, which symbolize Olokun, the Lord of the Great Waters. Mudfish live near riverbanks, mediating between water and land, just as the *oba*, who is viewed as semidivine, mediates between the human world and the supernatural world of Olokun.

OTHER URBAN CENTERS

Ife and Benin were but two of the many cities that arose in ancient Africa. The first European visitors to the West African coast at the end of the fifteenth century were impressed not only by Benin, but also by the city of Mbanza Kongo, south of the mouth of the Congo River. Along the East African coastline, Europeans also happened upon cosmopolitan cities that had been busily carrying on long-distance trade across the Indian Ocean and as far away as China and Indonesia for hundreds of years.

Important centers also existed in the interior, especially across the central and western Sudan. There, cities and the states that developed around them grew wealthy from the trans-Saharan trade that had linked West Africa to the Mediterranean from at least the first millennium BCE. Indeed, the routes across the desert were probably as old as the desert itself. Among the most significant goods exchanged in this trade were salt from the north and gold from West Africa. Such fabled cities as Mopti, Timbuktu, and **Jenné** arose in the vast area of grasslands along the Niger River in the region known as the Niger Bend (present-day Mali), a trading crossroads as early as the first century BCE. They were great centers of commerce, where merchants from all over West Africa met caravans arriving from the Mediterranean. Eventually the trading networks extended across Africa from the Sudan in the east to the Atlantic coast in the west. In the twelfth century CE a Mande-speaking people formed the kingdom of Mali (Manden). The rulers adopted Islam, and by the fourteenth century they controlled the oases on which the traders' caravans depended. Mali prospered, and wealthy cities like Timbuktu and Jenné became famed as centers of Islamic learning.

At a site near Jenné known as **Jenné-Jeno** or Old Jenné, excavations (by both archaeologists and looters) have uncovered hundreds of terra-cotta figures dating from the thirteenth to the sixteenth centuries. The figures were polished, covered with a red clay slip, and fired at a low temperature. A horseman, armed with quiver, arrows, and a dagger, is a good example of the technique (FIG. 13–12). Man and horse are formed of rolls of clay on which details of the face, clothing, and harness are carved, engraved, and painted. The rider has a long oval head and jutting chin, pointed oval eyes set in multiple framing lids, and a long straight nose. He wears short pants and a helmet with a chin strap, and his horse has an ornate bridle. Such elaborate trappings suggest that the horseman could be a guardian figure, hero, or even a deified ancestor. Similar figures have been found in sanctuaries. But, as urban life declined, so did the arts. The long tradition of ceramic sculpture came to an end in the fifteenth and sixteenth centuries, when rivals began to raid the Manden cities.

13–12 | **HORSEMAN**

Old Jenné, Mali. 13–15th century. Terra cotta, height 27¾"
(70.5 cm). The National Museum of African Art, Smithsonian
Institution, Washington, D.C.

Museum Purchase, (86-12-2)

Jenné

In 1655, the Islamic writer al-Sadi wrote this description of
Jenné:

> This city is large, flourishing, and prosperous; it is rich, blessed,
> and favoured by the Almighty. . . . Jenne [Jenné] is one of the
> great markets of the Muslim world. There one meets the salt
> merchants from the mines of Teghaza and merchants carrying
> gold from the mines of Bitou. . . . Because of this blessed city,
> caravans flock to Timbuktu from all points of the horizon. . . .
> The area around Jenne is fertile and well populated; with
> numerous markets held there on all the days of the week. It is
> certain that it contains 7,077 villages very near to one another.
>
> (Translated by Graham Connah in *Connah*, page 97)

By the time al-Sadi wrote his account, Jenné already had a
long history. Archaeologists have determined that the city was
established by the third century CE, and that by the middle of
the ninth century, it had become a major urban center. Also
by the ninth century, Islam was becoming an economic and
religious force in West Africa, North Africa, and the northern
terminals of the trans-Saharan trade routes that had already
been incorporated into the Islamic Empire.

When Koi Konboro, the twenty-sixth king of Jenné,
converted to Islam in the thirteenth century, he transformed
his palace into the first of three successive **mosques** in the
city. Like the two that followed, the first mosque was built of
adobe brick, a sun-dried mixture of clay and straw. With its
great surrounding wall and tall towers, it was said to have
been more beautiful and more lavishly decorated than the
Kaaba, the central shrine of Islam, at Mecca. The mosque
eventually attracted the attention of austere Muslim rulers
who objected to its sumptuous furnishings. Among these was
the early nineteenth-century ruler Sekou Amadou, who had
it razed and a far more humble structure erected on a new
site. This second mosque was in turn replaced by the current
grand mosque, constructed between 1906 and 1907 on the
ancient site in the style of the original. The reconstruction
was supervised by the architect Ismaila Traoré, the head of the
Jenné guild of masons.

The mosque's eastern, or "marketplace," façade boasts
three tall towers, the center of which contains the **mihrab**
(FIG. 13–13). The **finials,** or crowning ornaments, at the top
of each tower bear ostrich eggs, symbols of fertility and
purity. The façade and sides of the mosque are distinguished
by tall, narrow, engaged columns, which act as buttresses.
These columns are characteristic of West African mosque
architecture, and their cumulative rhythmic effect is one of
great verticality and grandeur. The most unusual features of
West African mosques are the **torons,** wooden beams project-
ing from the walls. *Torons* provide permanent supports for the
scaffolding erected each year so that the exterior of the
mosque can be replastered.

Traditional houses resemble the mosque on a small scale.
Adobe walls, reinforced by buttresses, rise above the roofline
in conical turrets, emphasizing the entrance. Rooms open
inward onto a courtyard. Extended upper walls mask a flat
roof terrace that gives more space for work and living.

Great Zimbabwe

Thousands of miles from Jenné, in southeastern Africa, an
extensive trade network developed along the Zambezi,
Limpopo, and Sabi rivers. Its purpose was to funnel gold,
ivory, and exotic skins to the coastal trading towns that had
been built by Arabs and Swahili-speaking Africans. There, the
gold and ivory were exchanged for prestige goods, including
porcelain, beads, and other manufactured items. Between
1000 and 1500 CE, this trade was largely controlled from a site
that was called Great Zimbabwe, home of the Shona people.

The word *zimbabwe* derives from the Shona term *dzimba
dza mabwe*, meaning "venerated houses" or "houses of stone."
Scholars agree that the stone buildings at Great Zimbabwe
were constructed by ancestors of the present-day people of

13–13 | **GREAT FRIDAY MOSQUE**
Jenné, Mali, showing the eastern and northern façades. Rebuilding of 1907, in the style of 13th-century original.

The plan of the mosque is not quite rectangular. Inside, nine rows of heavy adobe columns, 33 feet tall and linked by pointed arches, support a flat ceiling of palm logs. An open courtyard on the west side (not seen here) is enclosed by a great double wall only slightly lower than the walls of the mosque itself. The main entrances to the prayer hall are in the north wall (to the right in the photograph).

this region. The earliest construction at the site took advantage of the enormous boulders abundant in the vicinity. Masons incorporated the boulders and used the uniform granite blocks that split naturally from them to build a series of tall enclosing walls high on a hilltop. Each enclosure defined a family's living space and housed dwellings made of adobe with conical, thatched roofs.

The largest building complex at Great Zimbabwe is located in a broad valley below the hilltop enclosures. Known as Imba Huru, or the Great Enclosure, the complex is ringed by a masonry wall more than 800 feet long, up to 32 feet tall, and 17 feet thick at the base. Inside the great outer wall are numerous smaller stone enclosures and adobe platforms. The buildings at Great Zimbabwe were built without mortar; for stability the walls are *battered*, or built so that they slope inward toward the top. Although some of the enclosures at Great Zimbabwe were built on hilltops, there is no evidence that they were constructed as

fortresses. There are neither openings for weapons to be thrust through nor battlements for warriors to stand on. Instead, the walls and structures seem intended to reflect the wealth and power of the city's rulers. The Imba Huru was probably a royal residence, or palace complex, and other structures housed members of the ruler's family and court. The complex formed the nucleus of a city that radiated for almost a mile in all directions. Over the centuries, the builders grew more skillful, and the later additions are distinguished by **dressed stones**, or smoothly finished stones, laid in fine, even, level **courses**. One of these later additions is a fascinating structure known simply as the **CONICAL TOWER** (FIG. 13–14). Some 18 feet in diameter and 30 feet tall, the tower was originally capped with three courses of ornamental stonework. It may have represented the good harvest and prosperity believed to result from allegiance to the ruler of Great Zimbabwe, for it resembles a present-day Shona granary built large.

Among the many interesting finds at Great Zimbabwe is a series of carved soapstone birds (FIG. 13–15). The carvings, which originally crowned tall **monoliths** (single large stones), seem to depict birds of prey, perhaps eagles. They may, however, represent mythical creatures. Traditional Shona beliefs include an eagle called *shiri ye denga*, or "bird of heaven," who brings lightning, a metaphor for communication between the heavens and earth. These soapstone birds may have represented such messengers from the spirit world. Recently, the birds, and also the crocodiles found decorating such monoliths, have been identified as symbols of royalty,

expressing the king's power to mediate between his subjects and the supernatural world of spirits.

It is estimated that at the height of its power, in the four-teenth century CE, Great Zimbabwe and its surrounding city housed a population of more than 10,000 people. A large cache of goods containing items of such far-flung origin as Portuguese medallions, Persian pottery, and Chinese porcelain testify to the extent of its trade. Yet beginning in the mid-fifteenth century Great Zimbabwe was gradually abandoned as control of the lucrative southeast African trade network passed to the Mwene Mutapa and Kami empires a short distance away.

13–14 | **CONICAL TOWER**
Great Zimbabwe. c. 1200–1400 CE. Height of tower 30′ (9.1 m).

Kongo Kingdom

The Portuguese first encountered Kongo culture in 1482 at approximately the same time contact was made with the royal court of Benin in present-day western Nigeria. They visited the capital of Mbanza Kongo (present-day M'banza Congo) and met the *manikongo* ("king") who ruled over a kingdom that was remarkable in terms of its complex political organization and artistic sophistication. The kingdom, divided into six provinces, encompassed over 100,000 square miles of present-day northwestern Angola and the western part of the Democratic Republic of the Congo. In 1491, King Nzinga converted to Christianity, as did his successor Afonso I and, later, Afonso's son who was sent to Europe for education. The conversions helped to solidify trade relations with the Portuguese, as trade in copper, salt, ivory, cloth, and, later, slaves brought increased prosperity to the kingdom. Its influence expanded until the mid-seventeenth century when its trading routes were taken over by neighboring peoples including Lunda and Chokwe.

The increase in wealth brought a corresponding increase in the production of specialty textiles, baskets, and regalia for the nobility. Textiles in central Africa, as elsewhere in Africa, are of extreme importance in terms of their value as wealth. Textiles were used as forms of currency before European contact and figure prominently in funerary rituals even to the present day. Kongo-decorated textiles were lauded by the Portuguese from first contact and were accepted as gifts or collected and found their way into European museum collections (FIG. 13–16).

13–15 | **BIRD, TOP PART OF A MONOLITH**
Great Zimbabwe. c. 1200–1400 CE. Soapstone, height of bird 14½″ (36.8 cm); height of monolith 5′4½″ (1.64 m).
Great Zimbabwe Site Museum, Zimbabwe.

Following Portuguese contact in the fifteenth century, Kongolese art increasingly absorbed Western influences, as suggested in a staff finial (FIG. 13–17). While representations of the matrilineal ancestress were a common Kongolese motif symbolizing leadership, this finial also reflects European influences that followed the conversion of the king and the arrival of Catholic missionaries, who brought with them objects such as the monstrance (a highly decorated vessel used to display the consecrated bread or "body" of Christ) and the crucifix. Made in the Kongo, this cast brass female figure seated within an ornate frame with its foliated decoration seems European in style. Although the figure may appear to be praying, in Kongo iconography, as elsewhere in central Africa, the clapping of hands is a common gesture of respect for another person. As Chapter 28 will show, this complex synthesis of Western and traditional influences would hereafter continue to affect African art in both subtle and overt ways.

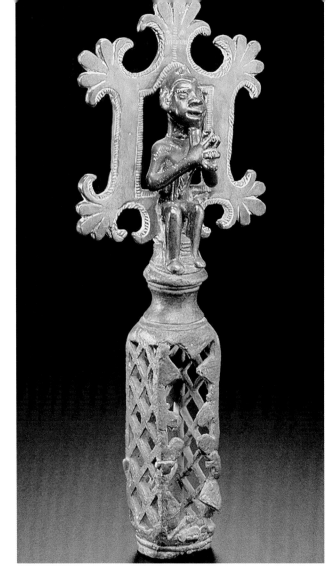

13–17 | **STAFF FINIAL**
Kongo peoples, possibly 17th century. Brass, height 11″
(28 cm). Musée Royal de l'Afrique Central, Tervuren, Belgium.
RG/Hist. 53.100.1.

Our picture of Africa's ancient history is remarkably incomplete. This is due to a relative absence of archaeological investigation and because much of ancient African art was made of materials that have perished over time. Nevertheless, a tantalizing impression of Africa's ancient past can still be gained from those few objects made of durable materials such as terra cotta, stone, and metal that have been brought to light, and from an extensive record in rock art that has been preserved in sheltered places.

The long record of rock art, extending for thousands of years in numerous places, charts dramatic environmental and social change in the deserts of Africa. Rock art depicting human subjects is also important evidence that the African artistic traditions of mask-making, performance, and body decoration spring from ancient African roots.

The discovery of significant figurative traditions in terra cotta and bronze affords at least a partial reconstruction of the rich cultural heritage in regions of Nigeria. These traditions, including the use of the complicated lost-wax casting technique, seem to have arisen fully realized without evidence of earlier artistic experimentation. They further demonstrate the perennial importance of body decoration and ornamentation as markers of individual status and achievement. The use of animal imagery to suggest the supernatural power of leaders is another enduring tradition seen in some of these artworks.

The pronounced naturalism seen in some Ife sculpture has always sparked avid speculation. While these artworks may be portraits representing distinct individuals, they may also have been intended as idealizations of physical beauty and moral character. Heightened feelings for both naturalism and abstraction have combined distinctively in the aesthetic traditions of Africa since ancient times.

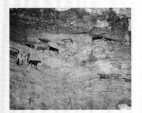
CATTLE BEING TENDED
C. 5000–2000 BCE

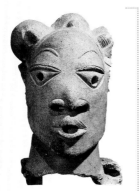
NOK HEAD
C.500 BCE–200 CE

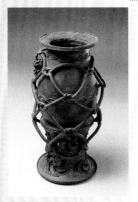
ROPED POT ON A STAND
C. 9TH–10TH CENTURY CE

GREAT ZIMBAWE TOWER
C. 1200–1400 CE

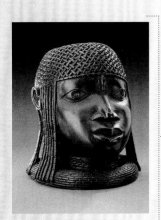
MEMORIAL HEAD OF AN OBA
C.16TH CENTURY CE

8000 BCE

500

200 CE

800

1000

1500 CE

ART OF ANCIENT AFRICA

◄ **Sahara Rock Art**
c. 8000–500 BCE

◄ **Nok**
c. 500 BCE–200 CE

◄ **Djenné** c. 200 CE–Present

◄ **Ghana Empire** 600–1100 CE

◄ **Islam introduced**
mid-Seventeenth century

◄ **Ife** c. 800 CE–Present

◄ **Igbo Ukwu** 9th–10th century

◄ **Great Zimbabwe** c. 1000–1500 CE

◄ **Benin** c. 1170 CE–Present

◄ **Mali Empire** 1250–1450 CE
◄ **Songhay Kingdom** 1465–1591 CE

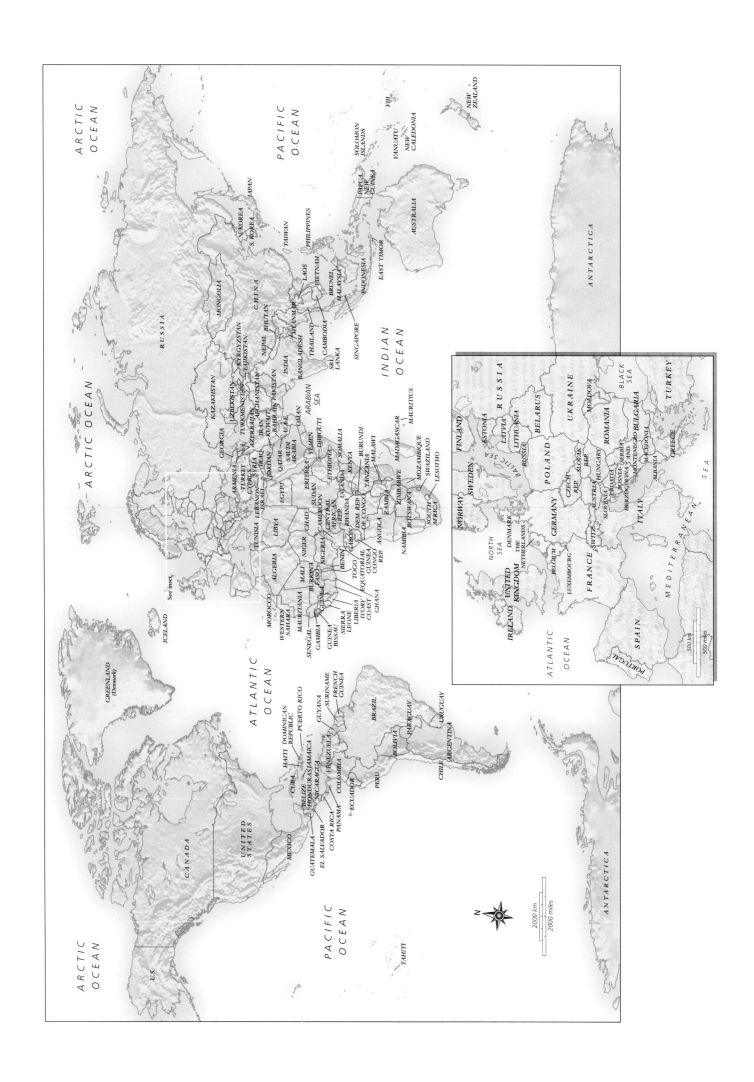

ARCTIC
OCEAN

PACIFIC
OCEAN

JAPAN
N.KOREA
S.KOREA
TAIWAN
PHILIPPINES
LAOS
VIETNAM
MYANMAR
BRUNEI
MALAYSIA
INDONESIA
EAST TIMOR
SINGAPORE
THAILAND
CAMBODIA
SRI
LANKA

FIJI
NEW
ZEALAND
VANUATU
NEW
CALEDONIA
SOLOMON
ISLANDS
PAPUA
NEW
GUINEA
AUSTRALIA

RUSSIA
MONGOLIA
CHINA
KAZAKHSTAN
KYRGYZSTAN
TAJIKISTAN
UZBEKISTAN
TURKMENISTAN
AZERBAIJAN
GEORGIA
ARMENIA
TURKEY
CYPRUS
SYRIA
IRAQ
IRAN
AFGHANISTAN
PAKISTAN
NEPAL BHUTAN
INDIA
BANGLADESH
KUWAIT
BAHRAIN
JORDAN
ISRAEL
LEBANON
QATAR
U.A.E.
SAUDI
ARABIA
OMAN
YEMEN
ARABIAN
SEA

INDIAN
OCEAN

ARCTIC OCEAN

ANTARCTICA

EGYPT
LIBYA
TUNISIA
ALGERIA
MOROCCO
WESTERN
SAHARA
MAURITANIA
MALI
NIGER
CHAD
SUDAN
ERITREA
DJIBOUTI
ETHIOPIA
SOMALIA
CENTRAL
AFRICAN
REP.
CAMEROON
NIGERIA
BENIN
TOGO
GHANA
IVORY
COAST
LIBERIA
SIERRA
LEONE
GUINEA
BISSAU
GUINEA
GAMBIA
SENEGAL
BURKINA
FASO
EQUATORIAL
GUINEA
CONGO
REP.
GABON
DEM. REP.
OF CONGO
RWANDA
BURUNDI
UGANDA
KENYA
TANZANIA
MALAWI
ANGOLA
ZAMBIA
NAMIBIA
BOTSWANA
ZIMBABWE
MOZAMBIQUE
MADAGASCAR
MAURITIUS
SWAZILAND
LESOTHO
SOUTH
AFRICA

GREENLAND
(Denmark)
ICELAND

ATLANTIC
OCEAN

CANADA
UNITED
STATES
U.S.

ARCTIC
OCEAN

PACIFIC
OCEAN

MEXICO
GUATEMALA
EL SALVADOR
COSTA RICA
PANAMA
NICARAGUA
HONDURAS
BELIZE
CUBA
HAITI
JAMAICA
DOMINICAN
REPUBLIC
PUERTO RICO
COLOMBIA
ECUADOR
VENEZUELA
GUYANA
SURINAME
FRENCH
GUIANA
PERU
BRAZIL
BOLIVIA
PARAGUAY
CHILE
ARGENTINA
URUGUAY

TAHITI

ANTARCTICA

See inset.

N

2000 km
2000 miles

Inset:

NORWAY
SWEDEN
FINLAND
RUSSIA
ESTONIA
LATVIA
LITHUANIA
BALTIC SEA
BELARUS
UKRAINE
MOLDOVA
POLAND
GERMANY
DENMARK
THE
NETHERLANDS
BELGIUM
LUXEMBOURG
UNITED
KINGDOM
IRELAND
NORTH
SEA
ATLANTIC
OCEAN
CZECH
REP.
SLOVAK
REP.
AUSTRIA
SWITZ.
SLOVENIA
HUNGARY
ROMANIA
CROATIA
BOSNIA-
HERZEGOVINA
SERBIA
AND
MONTENEGRO
BULGARIA
MACEDONIA
ALBANIA
GREECE
TURKEY
BLACK
SEA
ITALY
FRANCE
SPAIN
PORTUGAL
MEDITERRANEAN
SEA

500 km
500 miles

GLOSSARY

abacus The flat slab at the top of a **capital**, directly under the **entablature**.

absolute dating A method of assigning a precise historical date to periods and objects based on known and recorded events in the region as well as technically extracted physical evidence (such as carbon-14 disintegration). See also **radiometric dating, relative dating**.

abstract, abstraction Any art that does not represent observable aspects of nature or transforms visible forms into a stylized image. Also: the formal qualities of this process.

acropolis The **citadel** of an ancient Greek city, located at its highest point and housing temples, a treasury, and sometimes a royal palace. The most famous is the Acropolis in Athens.

acroterion (acroteria) An ornament at the corner or peak of a roof.

adobe Sun-baked blocks made of clay mixed with straw. Also: the buildings made with this material.

adyton The back room of a Greek temple. At Delphi, the place where the **oracles** were delivered. More generally, a very private space or room.

aedicula (aediculae) A decorative architectural frame, usually found around a niche, door, or window. An aedicula is made up of a **pediment** and **entablature** supported by **columns** or **pilasters**.

agora An open space in a Greek town used as a central gathering place or market. See also forum.

aisle Passage or open corridor of a church, hall, or other building that parallels the main space, usually on both sides, and is delineated by a row, or **arcade**, of **columns** or piers. Called side aisles when they flank the **nave** of a church.

album A book consisting of a series of painting or prints (album leaves) mounted into book form.

all'antica Meaning, "in the ancient manner."

allegory In a work of art, an image (or images) that symbolically illustrates an idea, concept, or principle, often moral or religious.

alloy A mixture of metals; different metals melted together.

amalaka In Hindu architecture, the circular or square-shaped element on top of a spire (*shikhara*), often crowned with a **finial**, symbolizing the cosmos.

ambulatory The passage (walkway) around the **apse** in a basilican church or around the **central space in a central-plan building**.

amphiprostyle Term describing a building, usually a temple, with **porticoes** at each end but without **columns** along the other two sides.

amphora An ancient Greek jar for storing oil or wine, with an egg-shaped body and two curved handles.

aniconic A symbolic representation without images of human figures, very often found in Islamic art.

animal interlace Decoration made of interwoven animals or serpents, often found in Celtic and early medieval Northern European art.

ankh A looped cross signifying life, used by ancient Egyptians.

appropriation Term used to describe an artist's practice of borrowing from another source for a new work of art. While in previous centuries artists often copied one another's figures, motifs, or compositions, in modern times the sources for appropriation extend from material culture to works of art.

apse, apsidal A large semicircular or polygonal (and usually vaulted) niche protruding from the end wall of a building. In the Christian church, it contains the altar. Apsidal is an adjective describing the condition of having such a space.

arabesque A type of linear surface decoration based on foliage and **calligraphic** forms, usually characterized by flowing lines and swirling shapes.

arcade A series of **arches**, carried by **columns** or **piers** and supporting a common wall or lintel. In a blind arcade, the arches and supports are engaged (attached to the wall) and have a decorative function.

arch In architecture, a curved structural element that spans an open space. Built from wedge-shaped stone blocks called **voussoirs**, which, when placed together and held at the top by a trapezoidal **keystone**, form an effective space-spanning and weight-bearing unit. Requires buttresses at each side to contain the outward thrust caused by the weight of the structure. **Corbel** arch: arch or **vault** formed by **courses** of stones, each of which projects beyond the lower course until the space is enclosed; usually finished with a **capstone**. Horseshoe arch: an arch of more than a half-circle; typical of western Islamic architecture. Ogival arch: a pointed arch created by S curves. Relieving arch: an arch built into a heavy wall just above a post-and-lintel structure (such as a gate, door, or window) to help support the wall above by transferring the load to the side walls.

archaic smile The curved lips of an ancient Greek statue, usually interpreted as an attempt to animate the features.

architrave The bottom element in an **entablature**, beneath the **frieze** and the **cornice**.

art brut French for "raw art." Term introduced by Jean Dubuffet to denote the often vividly **expressionistic** art of children and the insane, which he considered uncontaminated by culture.

articulated Joined; divided into units; in architecture, divided into parts to make spatial organization intelligible.

ashlar A highly finished, precisely cut block of stone. When laid in even **courses**, ashlar masonry creates a uniform face with fine joints. Often used as a facing on the visible exterior of a building, especially as a veneer for the **façade**. Also called **dressed stone**.

assemblage Artwork created by gathering and manipulating two and/or three-dimensional found objects.

astragal A thin convex decorative **molding**, often found on classical **entablatures**, and usually decorated with a continuous row of beadlike circles.

atelier The studio or workshop of a master artist or craftsperson, often including junior associates and apprentices.

atmospheric perspective See **perspective**.

atrial cross The cross placed in the atrium of a church. In Colonial America, used to mark a gathering and teaching place.

atrium An unroofed interior courtyard or room in a Roman house, sometimes having a pool or garden, sometimes surrounded by columns. Also: the open courtyard in front of a Christian church; or an entrance area in modern architecture.

automatism A technique whereby the usual intellectual control of the artist over his or her brush or pencil is foregone. The artist's aim is to allow the subconscious to create the artwork without rational interference.

avant-garde Term derived from the French military word meaning "before the group," or "vanguard." Avant-garde denotes those artists or concepts of a strikingly new, experimental, or radical nature for the time.

axis mundi A concept of an "axis of the world," which marks sacred sites and denotes a link between the human and celestial realms. For example, in Buddhist art, the axis mundi can be marked by monumental freestanding decorative pillars.

baldachin A canopy (whether suspended from the ceiling, projecting from a wall, or supported by columns) placed over an honorific or sacred space such as a throne or church altar.

bargeboards Boards covering the rafters at the gable end of a building; bargeboards are often carved or painted.

barrel vault See **vault**.

bar tracery See **tracery**.

bas-de-page French: bottom of the page; a term used in manuscript studies to indicate pictures below the text, literally at the bottom of the page.

base Any support. Also: masonry supporting a statue or the **shaft** of a **column**.

basilica A large rectangular building. Often built with a **clerestory**, side **aisles** separated from the center **nave** by **colonnades**, and an **apse** at one or both ends. Roman centers for administration, later adapted to Christian church use. Constantine's architects added a transverse aisle at the end of the nave called a **transept**.

bay A unit of space defined by architectural elements such as **columns**, **piers**, and walls.

beehive tomb A **corbel-vaulted** tomb, conical in shape like a beehive, and covered by an earthen mound.

Benday dots In modern printing and typesetting, the individual dots that, together with many others, make up lettering and images. Often machine- or computer-generated, the dots are very small and closely spaced to give the effect of density and richness of tone.

bestiary A book describing characteristics, uses, and meaning illustrated by moralizing tales about real and imaginary animals, especially popular during the Middle Ages in western Europe.

bi A jade disk with a hole in the center.

biomorphic Adjective used to describe forms that resemble or suggest shapes found in nature.

black-figure A style or technique of ancient Greek pottery in which black figures are painted on a red clay ground. See also **red-figure**.

bodhisattva In Buddhism, a being who has attained enlightenment but chooses to remain in this world in order to help others advance spiritually. Also defined as a potential Buddha.

boss A decorative knoblike element. Bosses can be found in many places, such as at the intersection of a Gothic vault rib. Also buttonlike projections in decorations and metalwork.

bracket, bracketing An architectural element that projects from a wall to support a horizontal part of a building, such as beams or the eaves of a roof.

brandea An object, such as a linen strip, having contact with a relic and taking on the power of the relic.

buon fresco *See* **fresco**.

cairn A pile of stones or earth and stones that served both as a prehistoric burial site and as a marker of underground tombs.

calligraphy Handwriting as an art form.

calyx krater *See* **krater**.

came (cames) A lead strip used in the making of leaded or **stained-glass** windows. Cames have an indented vertical groove on the sides into which the separate pieces of glass are fitted to hold the design together.

cameo Gemstone, clay, glass, or shell having layers of color, carved in **low relief** to create an image and ground of different colors.

camera obscura An early cameralike device used in the Renaissance and later for recording images of nature. Made from a dark box (or room) with a hole in one side (sometimes fitted with a lens), the camera obscura operates when bright light shines through the hole, casting an upside-down image of an object outside onto the inside wall of the box.

canon of proportions A set of ideal mathematical ratios in art based on measurements of the human body.

capital The sculpted block that tops a **column**. According to the conventions of the orders, capitals include different decorative elements. See **order**. Also: a historiated capital is one displaying a narrative.

capriccio A painting or print of a fantastic, imaginary landscape, usually with architecture.

capstone The final, topmost stone in a **corbel arch** or vault, which joins the sides and completes the structure.

cartoon A full-scale drawing used to transfer the outline of a design onto a surface (such as a wall, canvas, panel, or tapestry) to be painted, carved, or woven.

cartouche A frame for a **hieroglyphic** inscription formed by a rope design surrounding an oval space. Used to signify a sacred or honored name. Also: in architecture, a decorative device or plaque, usually with a plain center used for inscriptions or epitaphs.

caryatid A sculpture of a draped female figure acting as a column supporting an **entablature**.

catacomb A subterranean burial ground consisting of tunnels on different levels, having niches for urns and **sarcophagi** and often incorporating rooms (cubiculae).

celadon A high-fired, transparent **glaze** of pale bluish-green hue whose principal coloring agent is an oxide of iron. In China and Korea, such glazes typically were applied over a pale gray **stoneware** body, though Chinese potters some-

times applied them over **porcelain** bodies during the Ming (1368-1644) and Qing (1644-1911) dynasties. Chinese potters invented celadon glazes and initiated the continuous production of celadon-glazed wares as early as the third century CE.

cella The principal interior room at the center of a Greek or Roman temple within which the cult statue was usually housed. Also called the **naos**.

cenotaph A funerary monument commemorating an individual or group buried elsewhere.

centering A temporary structure that supports a masonry **arch** and **vault** or **dome** during construction until the mortar is fully dried and the masonry is self-sustaining.

centrally planned building Any structure designed with a primary central space surrounded by symmetrical areas on each side. For example, **Greek-cross plan** (equal-armed cross).

ceramics A general term covering all types of wares made from fired clay, including **porcelain** and **terra cotta**.

chaitya A type of Buddhist temple found in India. Built in the form of a hall or **basilica**, a chaitya hall is highly decorated with sculpture and usually is carved from a cave or natural rock location. It houses a sacred shrine or stupa for worship.

chamfer The slanted surface produced when an angle is trimmed or beveled, common in building and metalwork.

chasing Ornamentation made on metal by incising or hammering the surface.

chattri (chattris) A decorative pavilion with an umbrella-shaped **dome** in Indian architecture.

chevron A decorative or heraldic motif of repeated Vs; a zigzag pattern.

chiaroscuro An Italian word designating the contrast of dark and light in a painting, drawing, or print. Chiaroscuro creates spatial depth and volumetric forms through gradations in the intensity of light and shadow.

chiton A thin sleeveless garment, fastened at waist and shoulders, worn by men and women in ancient Greece.

citadel A fortress or defended city, if possible placed in a high, commanding location.

clapboard Horizontal overlapping planks used as protective siding for buildings, particularly houses in North America.

clerestory The topmost zone of a wall with windows in a **basilica** extending above the **aisle** roofs. Provides direct light into the central interior space (the **nave**).

cloisonné An enamel technique in which metal wire or strips are affixed to the surface to form the design. The resulting areas (cloisons) are filled with enamel (colored glass).

cloister An open space, part of a monastery, surrounded by an **arcaded** or **colonnaded** walkway, often having a fountain and garden, and dedicated to nonliturgical activities and the secular life of the religious. Members of a cloistered order do not leave the monastery or interact with outsiders.

codex (codices) A book, or a group of **manuscript** pages (folios), held together by stitching or other binding on one side.

coffer A recessed decorative panel that is used to reduce the weight of and to decorate ceilings or **vaults**. The use of coffers is called coffering.

colonnade A row of **columns**, supporting a straight lintel (as in a **porch** or **portico**) or a series of arches (an **arcade**).

colophon The data placed at the end of a book listing the book's author, publisher, illuminator, and other information related to its production. Also, in East Asian handscrolls, the inscriptions which follow the painting are called colophons.

column An architectural element used for support and/or decoration. Consists of a rounded or polygonal vertical **shaft** placed on a **base** and topped by a decorative **capital**. In classical architecture, built in accordance with the rules of one of the architectural **orders**. Columns can be freestanding or attached to a background wall (**engaged**).

complementary color The primary and secondary colors across from each other on the color wheel (red and green, blue and orange, yellow and purple). When juxtaposed, the intensity of both colors increases. When mixed together, they negate each other to make a neutral graybrown.

Composite order *See* **order**.

cong A square or octagonal jade tube with a cylindrical hole in the center. A symbol of the earth, it was used for ritual worship and astronomical observations in ancient China.

connoisseurship A term derived from the French word connoisseur, meaning "an expert," and signifying the study and evaluation of art based primarily on formal, visual, and stylistic analysis. A connoisseur studies the style and technique of an object to deduce its relative quality and possible maker. This is done through visual association with other, similar objects and styles. See also **contextualism**; **formalism**.

contextualism An interpretive approach in art history that focuses on the culture surrounding an art object. Unlike **connoisseurship**, contextualism utilizes the literature, history, economics, and social developments (among other things) of a period, as well as the object itself, to explain the meaning of an artwork. See *also* **connoisseurship**.

contrapposto An Italian term meaning "set against," used to describe the twisted pose resulting from parts of the body set in opposition to each other around a central axis.

corbel, corbeling An early roofing and **arching** technique in which each course of stone projects slightly beyond the previous layer (a corbel) until the uppermost corbels meet. Results in a high, almost pointed **arch** or **vault**. A corbel table is a ledge supported by corbels.

corbeled vault *See* **vault**.

Corinthian order *See* **order**.

cornice The uppermost section of a Classical **entablature**. More generally, a horizontally projecting element found at the top of a building wall or **pedestal**. A raking cornice is formed by the junction of two slanted cornices, most often found in **pediments**.

course A horizontal layer of stone used in building.

crenellation Alternating high and low sections of a wall, giving a notched appearance and creating permanent defensive shields in the walls of fortified buildings.

crockets A stylized leaf used as decoration along the outer angle of spins, pinnacles, gables, and around **capitals** in Gothic architecture.

cuneiform An early form of writing with wedge-shaped marks impressed into wet clay with a stylus, primarily used by ancient Mesopotamians.

curtain wall A wall in a building that does not support any of the weight of the structure. Also: the freestanding outer wall of a castle, usually encircling the inner bailey (yard) and keep (primary defensive tower).

cyclopean construction or **masonry** A method of building using huge blocks of rough-hewn stone. Any large-scale, monumental building project that impresses by sheer size. Named after the Cyclopes (sing. Cyclops) one-eyed giants of legendary strength in Greek myths.

cylinder seal A small cylindrical stone decorated with incised patterns. When rolled across soft clay or wax, the resulting raised pattern or design (**relief**) served in Mesopotamian and Indus Valley cultures as an identifying signature.

dado (dadoes) The lower part of a wall, differentiated in some way (by a **molding** or different coloring or paneling) from the upper section.

daguerreotype An early photographic process that makes a positive print on a light-sensitized copperplate; invented and marketed in 1839 by Louis-Jacques-Mandé Daguerre.

demotic writing The simplified form of ancient Egyptian hieratic writing, used primarily for administrative and private texts.

dharmachakra Sanskrit for "wheel" (*chakra*) and "law" or "doctrine" (*dharma*); often used in Buddhist iconography to signify the "wheel of the law."

diptych Two panels of equal size (usually decorated with paintings or reliefs) hinged together.

dogu Small human figurines made in Japan during the Jomon period. Shaped from clay, the figures have exaggerated expressions and are in contorted poses. They were probably used in religious rituals.

dolmen A prehistoric structure made up of two or more large upright stones supporting a large, flat, horizontal slab or slabs.

dome A round **vault**, usually over a circular space. Consists of a curved masonry vault of shapes and cross sections that can vary from hemispherical to bulbous to ovoidal. May use a supporting vertical wall (**drum**), from which the vault springs, and may be crowned by an open space (**oculus**) and/or an exterior **lantern**. When a dome is built over a square space, an intermediate element is required to make the transition to a circular drum. There are two types: A dome on **pendentives** (spherical triangles) incorporates **arched**, sloping intermediate sections of wall that carry the weight and thrust of the dome to heavily buttressed supporting **piers**. A dome on **squinches** uses an arch built into the wall (squinch) in the upper corners of the space to carry the weight of the dome across the corners of the square space below. A half-dome or conch may cover a semicircular space.

domino construction System of building construction introduced by the architect Le Corbusier in which reinforced concrete floor slabs are floated on six freestanding posts placed as if at the positions of the six dots on a domino playing piece.

Doric order See **order**.

dressed stone See **ashlar**.

drum The wall that supports a **dome**. Also: a segment of the circular **shaft** of a **column**.

drypoint An **intaglio** printmaking process by which a metal (usually copper) plate is directly inscribed with a pointed instrument (**stylus**). The resulting design of scratched lines is inked, wiped, and printed. Also: the print made by this process.

earthenware A low-fired, opaque **ceramic** ware that is fired in the range of 800 to 900 degrees Celsius. Earthenware employs humble clays that are naturally heat resistant; the finished wares remain porous after firing unless **glazed**. Earthenware occurs in a range of earth-toned colors, from white and tan to gray and black, with tan predominating.

echinus A cushionlike circular element found below the **abacus** of a Doric **capital**. Also: a similarly shaped **molding** (usually with egg-and-dart motifs) underneath the **volutes** of an Ionic **capital**.

electron spin resonance techniques Method that uses magnetic field and microwave irradiation to date material such as tooth enamel and its surrounding soil.

emblema (emblemata) In a mosaic, the elaborate central motif on a floor, usually a self-contained unit done in a more refined manner, with smaller **tesserae** of both marble and semiprecious stones.

encaustic A painting technique using pigments mixed with hot wax as a medium.

engaged column A **column** attached to a wall. See also column.

engraving An intaglio printmaking process of inscribing an image, design, or letters onto a metal or wood surface from which a print is made. An engraving is usually drawn with a sharp implement (burin) directly onto the surface of the plate. Also: the print made from this process.

entablature In the **Classical orders**, the horizontal elements above the **columns** and **capitals**. The entablature consists of, from bottom to top, an **architrave**, a **frieze**, and a **cornice**.

entasis A slight swelling of the **shaft** of a Greek column. The optical illusion of entasis makes the column appear from afar to be straight.

exedra (exedrae) In architecture, a semicircular niche. On a small scale, often used as decoration, whereas larger exedrae can form interior spaces (such as an **apse**).

expressionism, expressionistic Terms describing a work of art in which forms are created primarily to evoke subjective emotions rather than to portray objective reality.

façade The face or front wall of a building.

faience Type of **ceramic** covered with colorful, opaque glazes that form a smooth, impermeable surface. First developed in ancient Egypt.

fang ding A square or rectangular bronze vessel with four legs. The fang ding was used for ritual offerings in ancient China during the Shang dynasty.

fête galante A subject in painting depicting well-dressed people at leisure in a park or country setting. It is most often associated with eighteenth-century French Rococo painting.

filigree Delicate, lacelike ornamental work.

fillet The flat ridge between the carved out flutes of a **column shaft**. See also **fluting**.

finial A knoblike architectural decoration usually found at the top point of a spire, pinnacle, canopy, or gable. Also found on furniture; also the ornamental top of a staff.

fluting In architecture, evenly spaced, rounded parallel vertical grooves **incised** on **shafts** of **columns** or columnar elements (such as **pilasters**).

foreshortening The illusion created on a flat surface in which figures and objects appear to recede or project sharply into space. Accomplished according to the rules of **perspective**.

formal analysis See **formalism**.

formalism, formalist An approach to the understanding, appreciation, and valuation of art based almost solely on considerations of form. This approach tends to regard an artwork as independent of its time and place of making. See also **connoisseurship**.

four-iwan mosque See **iwan** and **mosque**.

fresco A painting technique in which waterbased pigments are applied to a surface of wet plaster (called **buon fresco**). The color is absorbed by the plaster, becoming a permanent part of the wall. **Fresco secco** is created by painting on dried plaster, and the color may flake off. Murals made by both these techniques are called frescoes.

fresco secco See **fresco**.

frieze The middle element of an **entablature**, between the **architrave** and the **cornice**. Usually decorated with sculpture, painting, or **moldings**. Also: any continuous flat band with **relief sculpture** or painted decorations.

frottage A design produced by laying a piece of paper over a textured surface and rubbing with charcoal or other soft medium.

fusuma Sliding doors covered with paper, used in traditional Japanese construction. Fusuma are often highly decorated with paintings and colored backgrounds.

galleria See **gallery**.

gallery In church architecture, the story found above the side **aisles** of a church, usually open to and overlooking the nave. Also: in secular architecture, a long room, usually above the ground floor in a private house or a public building used for entertaining, exhibiting pictures, or promenading. *Also*: a building or hall in which art is displayed or sold. Also: *galleria*.

garbhagriha From the Sanskrit word meaning "womb chamber," a small room or shrine in a Hindu temple containing a holy image.

genre A type or category of artistic form, subject, technique, style, or medium. See also genre painting.

gesso A ground made from glue, gypsum, and/or chalk forming the ground of a wood panel or the priming layer of a canvas. Provides a smooth surface for painting.

gilding The application of paper-thin **gold leaf** or gold pigment to an object made from another medium (for example, a sculpture or painting). Usually used as a decorative finishing detail.

giornata (giornate) Adopted from the Italian term meaning "a day's work," a giornata is the section of a **fresco** plastered and painted in a single day.

glaze See **glazing**.

glazing An outermost layer of vitreous liquid (**glaze**) that, upon firing, renders **ceramics** waterproof and forms a decorative surface. In painting, a technique particularly used with oil mediums in which a transparent layer of paint (**glaze**) is laid over another, usually lighter, painted or glazed area.

gloss A type of clay **slip** used in **ceramics** by ancient Greeks and Romans that, when fired, imparts a colorful sheen to the surface.

golf foil A thin sheet of gold.

gold leaf Paper-thin sheets of hammered gold that are used in **gilding**. In some cases (such as Byzantine **icons**), also used as a ground for paintings.

gopura The towering gateway to an Indian Hindu temple complex. A temple complex can have several different gopuras.

Grand Manner An elevated style of painting popular in the eighteenth century in which the artist looked to the ancients and to the Renaissance for inspiration; for portraits as well as history painting, the artist would adopt the poses, compositions, and attitudes of Renaissance and antique models.

Grand Tour Popular during the eighteenth and nineteenth centuries, an extended tour of cultural sites in southern Europe intended to finish the education of a young upper-class person from Britain or North America.

grattage A pattern created by scraping off layers of paint from a canvas laid over a textured surface. See also *frottage*.

Greek-cross plan See **centrally planned building**.

Greek-key pattern A continuous rectangular scroll often used as a decorative border. Also called a **meander pattern**.

grid A system of regularly spaced horizontally and vertically crossed lines that gives regularity to an architectural plan. Also: in painting, a grid enables designs to be enlarged or transferred easily.

grisaille A style of monochromatic painting in shades of gray. Also: a painting made in this style.

groin vault See **vault**.

guild An association of craftspeople. The medieval guild had great economic power, as it set standards and controlled the selling and marketing of its members' products, and as it provided economic protection, group solidarity, and training in the craft to its members.

hall church A church with a **nave** and **aisles** of the same height, giving the impression of a large, open hall.

handscroll A long, narrow, horizontal painting or text (or combination thereof) common in Chinese and Japanese art and of a size intended for individual use. A handscroll is stored wrapped tightly around a wooden pin and is unrolled for viewing or reading.

hanging scroll In Chinese and Japanese art, a vertical painting or text mounted within sections of silk. At the top is a semicircular rod; at the bottom is a round dowel. Hanging scrolls are kept rolled and tied except for special occasions, when they are hung for display, contemplation, or commemoration.

haniwa Pottery forms, including cylinders, buildings, and human figures, that were placed on top of Japanese tombs or burial mounds.

hemicycle A semicircular interior space or structure.

henge A circular area enclosed by stones or wood posts set up by Neolithic peoples. It is usually bounded by a ditch and raised embankment.

hieratic In painting and sculpture, a formalized style for representing rulers or sacred or priestly figures.

hieratic scale The use of different sizes for significant or holy figures and those of the everyday world to indicate importance. The larger the figure, the greater the importance.

high relief Relief sculpture in which the image projects strongly from the background. See also **relief sculpture**.

himation In ancient Greece, a long loose outer garment.

historicism The strong consciousness of and attention to the institutions, themes, styles, and forms of the past, made accessible by historical research, textual study, and archaeology.

history painting Paintings based on historical, mythological, or biblical narratives. Once considered the noblest form of art, history paintings generally convey a high moral or intellectual idea and are often painted in a grand pictorial style.

hollow-casting See **lost-wax casting**.

hypostyle hall A large interior room characterized by many closely spaced **columns** that support its roof.

icon An image in any material representing a sacred figure or event in the Byzantine, and later in the Orthodox, Church. Icons were venerated by the faithful, who believed them to have miraculous powers to transmit messages to God.

iconoclasm The banning or destruction of images, especially icons and religious art. Iconoclasm in eighth- and ninth-century Byzantium and sixteenth- and seventeenth-century Protestant territories arose from differing beliefs about the power, meaning, function, and purpose of imagery in religion.

iconographic See **iconography**.

iconography The study of the significance and interpretation of the subject matter of art.

iconostasis The partition screen in a Byzantine or Orthodox church between the **sanctuary** (where the Mass is performed) and the body of the church (where the congregation assembles). The iconostasis displays **icons**.

idealism *See* idealization.

idealization A process in art through which artists strive to make their forms and figures attain perfection, based on pervading cultural values and/or their own mental image of beauty.

ideograph A written character or symbol representing an idea or object. Many Chinese characters are ideographs.

ignudi Heroic figures of nude young men.

illumination A painting on paper or **parchment** used as illustration and/or decoration for **manuscripts** or **albums**. Usually done in rich colors, often supplemented by gold and other precious materials. The illustrators are referred to as illuminators. Also: the technique of decorating manuscripts with such paintings.

impasto Thick applications of pigment that give a painting a palpable surface texture.

impost, impost block A block, serving to concentrate the weight above, imposed between the **capital** of a **column** and the springing of an arch above.

in antis Term used to describe the position of columns set between two walls, as in a **portico** or a **cella**.

incising A technique in which a design or inscription is cut into a hard surface with a sharp instrument. Such a surface is said to be incised.

ink painting A monochromatic style of painting developed in China using black ink with gray **washes**.

inlay To set pieces of a material or materials into a surface to form a design. *Also:* material used in or decoration formed by this technique.

installation art Artworks created for a specific site, especially a gallery or outdoor area, that create a total environment.

intaglio Term used for a technique in which the design is carved out of the surface of an object, such as an engraved seal stone. In the graphic arts, intaglio includes **engraving**, etching, and **drypoint**—all processes in which ink transfers to paper from incised, ink-filled lines cut into a metal plate.

intarsia Decoration formed through wood inlay.

intuitive perspective See **perspective**.

Ionic order See **order**.

iwan A large, **vaulted** chamber in a **mosque** with a monumental arched opening on one side.

jamb In architecture, the vertical element found on both sides of an opening in a wall, and supporting an **arch** or lintel.

japonisme A style in French and American nineteenth-century art that was highly influenced by Japanese art, especially prints.

jasperware A fine-grained, unglazed, white **ceramic** developed by Josiah Wedgwood, often colored with metallic oxides with the raised designs ramaining white.

jataka **tales** In Buddhism, stories associated with the previous lives of Shakyamuni, the historical Buddha.

joined-wood sculpture A method of constructing large-scale wooden sculpture developed in Japan. The entire work is constructed from smaller hollow blocks, each individually carved, and assembled when complete. The joined-wood technique allowed the production of larger sculpture, as the multiple joints alleviate the problems of drying and cracking found with sculpture carved from a single block.

joggled voussoirs Interlocking voussoirs in an arch or lintel, often of contrasting materials for colorful effect.

kantharos A type of Greek vase or goblet with two large handles and a wide mouth.

key block A key block is the master block in the production of a colored **woodblock print**, which requires different blocks for each color. The key block is a flat piece of wood with the entire design carved or drawn on its surface. From this, other blocks with partial drawings are made for printing the areas of different colors.

keystone The topmost **voussoir** at the center of an **arch**, and the last block to be placed. The pressure of this block holds the arch together. Often of a larger size and/or decorated.

kiln An oven designed to produce enough heat for the baking, or firing, of clay.

kinetic art Artwork that contains parts that can be moved either by hand, air, or motor.

kondo The main hall inside a Japanese Buddhist temple where the images of Buddha are housed.

kore (korai) **An Archaic** Greek statue of a young woman.

kouros (kouroi) An Archaic Greek statue of a young man or boy.

krater An ancient Greek vessel for mixing wine and water, with many subtypes that each have a distinctive shape. **Calyx krater:** a bell-shaped vessel with handles near the base that resemble a flower calyx. Volute krater: a type of krater with handles shaped like scrolls.

kufic An ornamental, angular Arabic script.

kylix A shallow Greek vessel or cup, used for drinking, with a wide mouth and small handles near the rim.

lacquer A type of hard, glossy surface varnish used on objects in East Asian cultures, made from the sap of the Asian sumac or from shellac, a resinous secretion from the lac insect. Lacquer can be layered and manipulated or combined with pigments and other materials for various decorative effects.

lakshana Term used to designate the thirtytwo marks of the historical Buddha. The lakshana include, among others, the Buddha's golden body, his long arms, the wheel impressed on his palms and the soles of his feet, and his elongated earlobes.

lamassu Supernatural guardian-protector of ancient Near Eastern palaces and throne rooms, often represented sculpturally as a combination of the bearded head of a man, powerful body of a lion or bull, wings of an eagle, and the horned headdress of a god, and usually possessing five legs.

lancet A tall narrow window crowned by a sharply pointed **arch**, typically found in Gothic architecture.

lantern A turretlike structure situated on a roof, **vault**, or **dome**, with windows that allow light into the space below.

lekythos (lekythoi) A slim Greek oil vase with one handle and a narrow mouth.

limner An artist, particularly a portrait painter, in England during the sixteenth and seventeenth centuries and in New England during the seventeenth and eighteenth centuries.

lingam shrine A place of worship centered on an object or representation in the form of a phallus (the lingam), which symbolizes the power of the Hindu god Shiva.

literati The English word used for the Chinese wenren or the Japanese bunjin, referring to well-educated artists who enjoyed literature, **calligraphy**, and painting as a pastime. Their painting are termed **literati painting**.

literati painting A style of painting that reflects the taste of the educated class of East Asian intellectuals and scholars. Aspects include an appreciation for the antique, small scale, and an intimate connection between maker and audience.

lithograph See **lithography**.

lithography Process of making a print (**lithograph**) from a design drawn on a flat stone block with greasy crayon. Ink is applied to the wet stone and adheres only to the greasy areas of the design.

loggia Italian term for a covered open-air. **gallery**. Often used as a corridor between buildings or around a courtyard, loggias usually have **arcades** or **colonnades**.

lost-wax casting A method of casting metal, such as bronze, by a process in which a wax mold is covered with clay and plaster, then fired, melting the wax and leaving a hollow form. Molten metal is then poured into the hollow space and slowly cooled. When the hardened clay and plaster exterior shell is removed, a solid metal form remains to be smoothed and polished.

low relief Relief sculpture whose figures project slightly from the background. See also **relief sculpture**.

lunette A semicircular wall area, framed by an arch over a door or window. Can be either plain or decorated.

lusterware Ceramic pottery decorated with metallic **glazes**.

madrasa An Islamic institution of higher learning, where teaching is focused on theology and law.

maenad In ancient Greece, a female devotee of the wine god Dionysos who participated in orgiastic rituals. She is often depicted with swirling drapery to indicate wild movement or dance. (Also called a Bacchante, after Bacchus, the Roman name of Dionysos.)

majolica Pottery painted with a tin glaze that, when fired, gives a lustrous and colorful surface.

mandala An image of the cosmos represented by an arrangement of circles or concentric geometric shapes containing diagrams or images. Used for meditation and contemplation by Buddhists.

mandapa In a Hindu temple, an open hall dedicated to ritual worship.

mandorla Light encircling, or emanating from, the entire figure of a sacred person.

manuscript A handwritten book or document.

maqsura An enclosure in a Muslim mosque, near the mihrab, designated for dignitaries.

martyrium (martyria) In Christian architecture, a church, chapel, or shrine built over the grave of a martyr or the site of a great miracle.

mastaba A flat-topped, one-story structure with slanted walls over an ancient Egyptian underground tomb.

matte Term describing a smooth surface that is without shine or luster.

mausoleum A monumental building used as a tomb. Named after the tomb of Mausolos erected at Halikarnassos around 350 BCE.

meander See **Greek-key pattern**.

medallion Any round ornament or decoration. Also: a large medal.

megalith A large stone used in prehistoric building. Megalithic architecture employs such stones.

megaron The main hall of a Mycenaean palace or grand house, having a columnar **porch** and a room with a central fireplace surrounded by four **columns**.

memento mori From Latin for "remember that you must die." An object, such as a skull or extinguished candle, typically found in a *vanitas* image, symbolizing the transience of life.

memory image An image that relies on the generic shapes and relationships that readily spring to mind at the mention of an object.

menorah A Jewish lamp-stand with seven or nine branches; the nine-branched menorah is used during the celebration of Hanukkah. Representations of the seven-branched menorah, once used in the Temple of Jerusalem, became a symbol of Judaism.

metope The carved or painted rectangular panel between the **triglyphs** of a **Doric frieze**.

mihrab A recess or niche that distinguishes the wall oriented toward Mecca (*qibla*) in a **mosque**.

minaret A tall slender tower on the exterior of a mosque from which believers are called to prayer.

minbar A high platform or pulpit in a **mosque**.

miniature Anything small. In painting, miniatures may be illustrations within **albums** or **manuscripts** or intimate portraits.

mirador In Spanish and Islamic palace architecture, a very large window or room with windows, and sometimes balconies, providing views to interior courtyards or the exterior landscape.

mithuna The amorous male and female couples in Buddhist sculpture, usually found at the entrance to a sacred building. The mithuna symbolize the harmony and fertility of life.

moat A large ditch or canal dug around a castle or fortress for military defense. When filled with water, the moat protects the walls of the building from direct attack.

mobile A sculpture made with parts suspended in such a way that they move in a current of air.

modeling In painting, the process of creating the illusion of three-dimensionality on a two-dimensional surface by use of light and shade. In sculpture, the process of molding a three-dimensional form out of a malleable substance.

module A segment or portion of a repeated design. Also: a basic building block.

molding A shaped or sculpted strip with varying contours and patterns. Used as decoration on architecture, furniture, frames, and other objects.

monolith A single stone, often very large.

mortise-and-tenon joint A method of joining two elements. A projecting pin (tenon) on one element fits snugly into a hole designed for it (mortise) on the other. Such joints are very strong and flexible.

mosaic Images formed by small colored stone or glass pieces (tesserae), affixed to a hard, stable surface.

mosque An edifice used for communal Muslim worship.

mudra A symbolic hand gesture in Buddhist art that denotes certain behaviors, actions, or feelings.

mullion A slender vertical element or **colonnette** that divides a window into subsidiary sections.

muqarnas Small nichelike components stacked in tiers to fill the transition between differing vertical and horizontal planes.

naos The principal room in a temple or church. In ancient architecture, the **cella**. In a Byzantine church, the **nave** and **sanctuary**.

narthex The vestibule or entrance porch of a church.

naturalism, naturalistic A style of depiction that seeks to imitate the appearance of nature. A naturalistic work appears to record the visible world.

nave The central space of a **basilica**, two or three stories high and usually flanked by **aisles**.

necking The molding at the top of the **shaft** of the **column**.

necropolis A large cemetery or burial area; literally a "city of the dead."

nemes headdress The royal headdress of Egypt.

niello A metal technique in which a black sulfur alloy is rubbed into fine lines engraved into a metal (usually gold or silver). When heated, the alloy becomes fused with the surrounding metal and provides contrasting detail.

nishiki-e A multicolored and ornate Japanese print.

nocturne A night scene in painting, usually lit by artificial illumination.

nonrepresentational art An **abstract** art that does not attempt to reproduce the appearance of objects, figures, or scenes in the natural world. Also called nonobjective art.

oculus (oculi) In architecture, a circular opening. Oculi are usually found either as windows or at the apex of a **dome**. When at the top of a dome, an oculus is either open to the sky or covered by a decorative exterior lantern.

ogee An S-shaped curve. See **arch**.

olpe Any Greek vase or jug without a spout.

one-point perspective See **perspective**.

opithodomos In greek temples, the entrance porch or room at the back.

oracle A person, usually a priest or priestess, who acts as a conduit for divine information. Also: the information itself or the place at which this information is communicated.

orant The representation of a standing figure praying with outstretched and upraised arms.

orchestra The circular performance area of an ancient Greek theater. In later architecture, the section of seats nearest the stage or the entire main floor of the theater.

order A system of proportions in Classical architecture that includes every aspect of the building's plan, elevation, and decorative system. Composite: a combination of the Ionic and the Corinthian orders. The **capital** combines acanthus leaves with **volute** scrolls. **Corinthian:** the most ornate of the orders, the Corinthian includes a **base**, a fluted **column shaft** with a capital elaborately decorated with acanthus leaf carvings. Its **entablature** consists of an **architrave** decorated with **moldings**, a **frieze** often containing **sculptured reliefs**, and a **cornice** with dentils. Doric: the column shaft of the Doric order can be fluted or smooth-surfaced and has no base. The Doric capital consists of an undecorated **echinus** and **abacus**. The Doric entablature has a plain architrave, a frieze with **metopes** and **triglyphs**, and a simple cornice. Ionic: the column of the Ionic order has a base, a fluted shaft, and a capital decorated with volutes. The Ionic entablature consists of an architrave of three panels and moldings, a frieze usually containing sculpted relief ornament, and a cornice with dentils. **Tuscan:** a variation of Doric characterized by a smooth-surfaced column shaft with a base, a plain architrave, and an undecorated frieze. A colossal order is any of the above built on a large scale, rising through several stories in height and often raised from the ground by a **pedestal**.

orthogonal Any line running back into the represented space of a picture perpendicular to the imagined picture plane. In linear perspective, all orthogonals converge at a single **vanishing point** in the picture and are the basis for a **grid** that maps out the internal space of the image. An orthogonal plan is any plan for a building or city that is based exclusively on right angles, such as the grid plan of many modern cities.

pagoda An East Asian **reliquary** tower built with successively smaller, repeated stories. Each story is usually marked by an elaborate projecting roof.

palace complex A group of buildings used for living and governing by a ruler and his or her supporters, usually fortified.

palmette A fan-shaped ornament with radiating leaves.

parapet A low wall at the edge of a balcony, bridge, roof, or other place from which there is a steep drop, built for safety. A parapet walk is the passageway, usually open, immediately behind the uppermost exterior wall or battlement of a fortified building.

parchment A writing surface made from treated skins of animals. Very fine parchment is known as **vellum**.

parterre An ornamental, highly regimented flowerbed. An element of the ornate gardens of seventeenth-century palaces and châteaux.

pastel Dry pigment, chalk, and gum in stick or crayon form. Also: a work of art made with pastels.

pedestal A platform or **base** supporting a sculpture or other monument. Also: the block found below the base of a Classical **column** (or **colonnade**), serving to raise the entire element off the ground.

pediment A triangular gable found over major architectural elements such as Classical Greek **porticoes**, windows, or doors. Formed by an **entablature** and the ends of a sloping roof or a raking **cornice**. A similar architectural element is often used decoratively above a door or window, sometimes with a curved upper **molding**. A broken pediment is a variation on the traditional pediment, with an open space at the center of the topmost angle and/or the horizontal cornice.

pendentive The concave triangular section of a **vault** that forms the transition between a square or polygonal space and the circular base of a **dome**.

peplos A loose outer garment worn by women of ancient Greece. A cloth rectangle fastened on the shoulders and belted below the bust or at the waist.

peripteral A term used to describe any building (or room) that is surrounded by a single row of columns. When such **columns** are engaged instead of freestanding, called pseudo-peripteral.

peristyle A surrounding **colonnade** in Greek architecture. A peristyle building is surrounded on the exterior by a colonnade. Also: a peristyle court is an open colonnaded courtyard, often having a pool and garden.

perspective A system for representing three-dimensional space on a two-dimensional surface. **Atmospheric** perspective: A method of rendering the effect of spatial distance by subtle variations in color and clarity of representation. **Intuitive perspective:** A method of giving the impression of recession by visual instinct, not by the use of an overall system or program. Oblique perspective: An intuitive spatial system in which a building or room is placed with one corner in the picture plane, and the other parts of the structure recede to an imaginary vanishing point on its other side. Oblique perspective is not a comprehensive, mathematical system. **One-point** and multiple-point **perspective** (also called linear, scientific or mathematical perspective): A method of creating the illusion of three-dimensional space on a two-dimensional surface by delineating a horizon line and multiple orthogonal lines. These recede to meet at one or more points on the horizon (called **vanishing** points), giving the appearance of spatial depth. Called scientific or mathematical because its use requires some

knowledge of geometry and mathematics, as well as optics. **Reverse perspective:** A Byzantine perspective theory in which the orthogonals or rays of sight do not converge on a vanishing point in the picture, but are thought to originate in the viewer's eye in front of the picture. Thus, in reverse perspective the image is constructed with orthogonals that diverge, giving a slightly tipped aspect to objects.

photomontage A photographic work created from many smaller photographs arranged (and often overlapping) in a composition.

picture plane The theoretical spatial plane corresponding with the actual surface of a painting.

picture stone A medieval northern European memorial stone covered with figural decoration. See also **rune stone**.

picturesque A term describing the taste for the familiar, the pleasant, and the pretty, popular in the eighteenth and nineteenth centuries in Europe. When contrasted with the sublime, the picturesque stood for all that was ordinary but pleasant.

piece-mold casting A casting technique in which the mold consists of several sections that are connected during the pouring of molten metal, usually bronze. After the cast form has hardened, the pieces of the mold are disassembled, leaving the completed object.

pier A masonry support made up of many stones, or rubble and concrete (in contrast to a **column shaft** which is formed from a single stone or a series of **drums**), often square or rectangular in plan, and capable of carrying very heavy architectural loads.

pietra dura Italian for "hard stone." Semiprecious stones selected for color variation and cut in shapes to form ornamental designs such as flowers or fruit.

pietra serena A gray Tuscan limestone used in Florence.

pilaster An **engaged** columnar element that is rectangular in format and used for decoration in architecture.

pillar In architecture, any large, freestanding vertical element. Usually functions as an important weight-bearing unit in buildings.

plate tracery See **tracery**.

plinth The slablike **base** or **pedestal** of a **column**, statue, wall, building, or piece of furniture.

pluralism A social structure or goal that allows members of diverse ethnic, racial, or other groups to exist peacefully within the society while continuing to practice the customs of their own divergent cultures. Also: an adjective describing the state of having many valid contemporary styles available at the same time to artists.

podium A raised platform that acts as the foundation for a building, or as a platform for a speaker.

polychrome See **polychromy**.

polychromy The multicolored painted decoration applied to any part of a building, sculpture, or piece of furniture.

polyptych An altarpiece constructed from multiple panels, sometimes with hinges to allow for movable wings.

porcelain A high-fired, vitrified, translucent, white **ceramic** ware that employs two specific clays—kaolin and petuntse—and that is fired in the range of 1,300 to 1,400 degrees Celsius. The

relatively high proportion of silica in the body clays renders the finished porcelains translucent. Like **stonewares**, porcelains are glazed to enhance their aesthetic appeal and to aid in keeping them clean. By definition, porcelain is white, though it may be covered with a **glaze** of bright color or subtle hue. Chinese potters were the first in the world to produce porcelain, which they were able to make as early as the eighth century.

porch The covered entrance on the exterior of a building. With a row of **columns** or **colonnade**, also called a **portico**.

portal A grand entrance, door, or gate, usually to an important public building, and often decorated with sculpture.

portico In architecture, a projecting roof or porch supported by columns, often marking an entrance. See also porch.

post-and-lintel construction An architectural system of construction with two or more vertical elements (posts) supporting a horizontal element (lintel).

potassium-argon dating Technique used to measure the decay of a radioactive potassium isotope into a stable isotope of argon, an inert gas.

potsherd A broken piece of ceramic ware.

Praire Style A style of architecture initiated by the American Frank Lloyd Wright (1867-1959), in which he sought to integrate his structures in an "organic" way into the surrounding natural landscape, often having the lines of the building follow the horizontal contours of the land. Since Wright's early buildings were built in the Prairie States of the Midwest, this type of architecture became known as the Prairie Style.

primitivism The borrowing of subjects or forms usually from non-Western or prehistoric sources by Western artists. Originally practiced by Western artists as an attempt to infuse their work with the naturalistic and expressive qualities attributed to other cultures, especially colonized cultures, primitivism also borrowed from the art of children and the insane.

pronaos The enclosed vestibule of a Greek or Roman temple, found in front of the **cella** and marked by a row of **columns** at the entrance.

proscenium The stage of an ancient Greek or Roman theater. In modern theater, the area of the stage in front of the curtain. Also: the framing **arch** that separates a stage from the audience.

psalter In Jewish and Christian scripture, a book containing the psalms, or songs, attributed to King David.

punchwork Decorative designs that are stamped onto a surface, such as metal or leather, using a punch (a handheld metal implement).

putto (putti) A plump, naked little boy, often winged. In classical art, called a cupid; in Christian art, a cherub.

pylon A massive gateway formed by a pair of tapering walls of oblong shape. Erected by ancient Egyptians to mark the entrance to a temple complex.

qibla The mosque wall oriented toward Mecca indicated by the mihrab.

quatrefoil A four-lobed decorative pattern common in Gothic art and architecture.

quincunx A building in which five **domed** bays are arranged within a square, with a central unit and four corner units. (When the central unit has similar units extending from each side, the form becomes a **Greek cross**.)

quoin A stone, often extra large or decorated for emphasis, forming the corner of two walls. A vertical row of such stones is called quoining.

radiometric dating A method of dating prehistoric works of art made from organic materials, based on the rate of degeneration of radiocarbons in these materials. *See also* **relative dating, absolute dating**.

raigo A painted image that depicts the Amida Buddha and other Buddhist deities welcoming the soul of a dying worshiper to paradise.

raku A type of **ceramic** pottery made by hand, coated with a thick, dark **glaze**, and fired at a low heat. The resulting vessels are irregularly shaped and glazed, and are highly prized for use in the Japanese tea ceremony.

readymade An object from popular or material culture presented without further manipulation as an artwork by the artist.

realism In art, a term first used in Europe around 1850 to designate a kind of **naturalism** with a social or political message, which soon lost its didactic import and became synonymous with naturalism.

red-figure A style and technique of ancient Greek vase painting characterized by red clay-colored figures on a black background. (The figures are reversed against a painted ground and details are drawn, not engraved, as in black-figure style.) See also **black-figure**.

register A device used in systems of spatial definition. In painting, a register indicates the use of differing **groundlines** to differentiate layers of space within an image. In sculpture, the placement of self-contained bands of **reliefs** in a vertical arrangement. In printmaking, the marks at the edges used to align the print correctly on the page, especially in multiple-block color printing.

registration marks In Japanese **woodblock** printing, these were two marks carved on the blocks to indicate proper alignment of the paper during the printing process. In multicolor printing, which used a separate block for each color, these marks were essential for achieving the proper position or registration of the colors.

relative dating See also **radiometric dating**.

relief sculpture A three-dimensional image or design whose flat background surface is carved away to a certain depth, setting off the figure. Called high or **low (bas) relief** depending upon the extent of projection of the image from the background. Called **sunken relief** when the image is carved below the original surface of the background, which is not cut away.

reliquary A container, often made of precious materials, used as a repository to protect and display sacred relics.

repoussé A technique of hammering metal from the back to create a protruding image. Elaborate reliefs are created with wooden armatures against which the metal sheets are pressed and hammered.

reverse perspective See **perspective**.

rhyton A vessel in the shape of a figure or an animal, used for drinking or pouring liquids on special occasions.

rib vault See **vault**.

ridgepole A longitudinal timber at the apex of a roof that supports the upper ends of the rafters.

rosette A round or oval ornament resembling a rose.

rotunda Any building (or part thereof) constructed in a circular (or sometimes polygonal) shape, usually producing a large open space crowned by a **dome**.

round arch See **arch.**

roundel Any element with a circular format, often placed as a decoration on the exterior of architecture.

rune stone A stone used in early medieval northern Europe as a commemorative monument, which is carved or inscribed with runes, a writing system used by early Germanic peoples.

running spirals A decorative motif based on the shape formed by a line making a continuous spiral.

rustication In building, the rough, irregular, and unfinished effect deliberately given to the exterior facing of a stone edifice. Rusticated stones are often large and used for decorative emphasis around doors or windows, or across the entire lower floors of a building. Also, masonry construction with conspicuous, often beveled joints.

salon A large room for entertaining guests; a periodic social or intellectual gathering, often of prominent people; a hall or **gallery** for exhibiting works of art.

sanctuary A sacred or holy enclosure used for worship. In ancient Greece and Rome, consisted of one or more temples and an altar. In Christian architecture, the space around the altar in a church called the chancel or presbytery.

sarcophagus (sarcophagi) A stone coffin. Often rectangular and decorated with **relief sculpture**.

scarab In Egypt, a stylized dung beetle associated with the sun and the god Amun.

scarification Ornamental decoration applied to the surface of the body by cutting the skin for cultural and/or aesthetic reasons.

school of artists An art historical term describing a group of artists, usually working at the same time and sharing similar styles, influences, and ideals. The artists in a particular school may not necessarily be directly associated with one another, unlike those in a workshop or **atelier**.

scribe A writer; a person who copies texts.

scriptorium (scriptoria) A room in a monastery for writing or copying manuscripts.

scroll painting A painting executed on a rolled support. Rollers at each end permit the horizontal scroll to be unrolled as it is studied or the vertical scroll to be hung for contemplation or decoration.

seals Personal emblems usually carved of stone in **intaglio** or **relief** and used to stamp a name or legend onto paper or silk. They traditionally employ the archaic characters appropriately known as "seal script," of the Zhou or Qin. Cut in stone, a seal may state a formal givem name, or it may state any of the numerous personal names that China's painters and writers adopted throughout their lives. A treasured work of art often bears not only the seal of its maker but also those of collectors and admirers through the centuries. In the Chinese view, these do not disfigure the work but add another layer of interest.

seraph (seraphim) An angel of the highest rank in the Christian hierarchy.

serdab In Egyptian tombs, the small room in which the ka statue was placed.

sfumato Italian term meaning "smoky," soft, and mellow. In painting, the effect of haze in an image. Resembling the color of the atmosphere at dusk, sfumato gives a smoky effect.

sgraffito Decoration made by incising or cutting away a surface layer of material to reveal a different color beneath.

shaft The main vertical section of a column between the capital and the base, usually circular in cross section.

shaftgrave A deep pit used for burial.

shikhara In the architecture of northern India, a conical (or pyramidal) spire found atop a Hindu temple and often crowned with an *amalaka*.

shoji A standing Japanese screen covered in translucent rice paper and used in interiors.

sinopia The preparatory design or underdrawing of a **fresco**. Also: a reddish chalklike earth pigment.

site-specific sculpture A sculpture commissioned and/or designed for a particular spot.

slip A mixture of clay and water applied to a **ceramic** object as a final decorative coat. Also: a solution that binds different parts of a vessel together, such as the handle and the main body.

spandrel The area of wall adjoining the exterior curve of an arch between its **springing** and the **keystone**, or the area between two arches, as in an **arcade**.

springing The point at which the curve of an arch or vault meets with and rises from its support.

squinch An **arch** or lintel built across the upper corners of a square space, allowing a circular or polygonal **dome** to be more securely set above the walls.

stained glass Molten glass is given a color that becomes intrinsic to the material. Additional colors may be fused to the surface (flashing). Stained glass is most often used in windows, for which small pieces of differently colored glass are precisely cut and assembled into a design, held together by **cames**. Additional painted details may be added to create images.

stele (stelae) A stone slab placed vertically and decorated with inscriptions or reliefs. Used as a grave marker or memorial.

stereobate A foundation upon which a Classical temple stands.

still life A type of painting that has as its subject inanimate objects (such as food, dishes, fruit, or flowers).

stoa In Greek architecture, a long roofed walkway, usually having columns on one long side and a wall on the other.

stoneware A high-fired, vitrified, but opaque **ceramic** ware that is fired in the range of 1,100 to 1,200 degrees Celsius. At that temperature, particles of silica in the clay bodies fuse together so that the finished vessels are impervious to liquids, even without **glaze**. Stoneware pieces are glazed to enhance their aesthetic appeal and to aid in keeping them clean (since unglazed ceramics are easily soiled). Stoneware occurs in a range of earth-toned colors, from white and tan to gray and black, with light gray predominating. Chinese potters were the first in the world to produce stoneware, which they were able to make as early as the Shang dynasty.

stucco A mixture of lime, sand, and other ingredients into a material that can be easily molded or modeled. When dry, produces a very durable surface used for covering walls or for architectural sculpture and decoration.

stupa In Buddhist architecture, a bell-shaped or pyramidal religious monument, made of piled earth or stone, and containing sacred relics.

stylobate In Classical architecture, the stone foundation on which a temple **colonnade** stands.

stylus An instrument with a pointed end (used for writing and printmaking), which makes a delicate line or scratch. Also: a special writing tool for **cuneiform** writing with one pointed end and one triangular wedge end.

sublime Adjective describing a concept, thing, or state of high spiritual, moral, or intellectual value; or something awe-inspiring. The sublime was a goal to which many nineteenth-century artists aspired in their artworks.

sunken relief See **relief sculpture**.

syncretism In religion or philosophy, the union of different ideas or principles.

taotie A mask with a dragon or animal-like face common as a decorative motif in Chinese art.

tapestry Multicolored pictorial or decorative weaving meant to be hung on a wall or placed on furniture.

tatami Mats of woven straw used in Japanese houses as a floor covering.

tempera A painting medium made by blending egg yolks with water, pigments, and occasionally other materials, such as glue.

tenebrism The use of strong **chiaroscuro** and artificially illuminated areas to create a dramatic contrast of light and dark in a painting.

terra cotta A medium made from clay fired over a low heat and sometimes left unglazed. Also: the orange-brown color typical of this medium.

tessera (tesserae) The small piece of stone, glass, or other object that is pieced together with many others to create a mosaic.

tetrarchy Four-man rule, as in the late Roman Empire, when four emperors shared power.

thatch A roof made of plant materials.

thermo-luminescence dating A technique that measures the irradiation of the crystal structure of material such as flint or pottery and the soil in which it is found, determined by luminescence produced when a sample is heated.

tholos A small, round building. Sometimes built underground, as in a Mycenaean tomb.

thrust The outward pressure caused by the weight of a vault and supported by buttressing. *See* **arch**.

tierceron In **vault** construction, a secondary rib that arcs from a **springing** point to the rib that runs lengthwise through the vault, called the ridge rib.

tokonoma A niche for the display of an art object (such as a screen, scroll, or flower arrangement) in a Japanese hall or tearoom.

tondo A painting or **relief sculpture** of circular shape.

torana In Indian architecture, an ornamented gateway arch in a temple, usually leading to the stupa.

toron In West African **mosque** architecture, the wooden beams that project from the walls. Torons are used as support for the scaffolding erected annually for the replastering of the building.

tracery Stonework or woodwork applied to wall surfaces or filling the open space of windows. In **plate tracery**, opening are cut through the wall. In **bar tracery**, **mullions** divide the space into vertical segments and form decorative patterns at the top of the opening or panel.

transept The arm of a cruciform church, perpendicular to the **nave**. The point where the nave and transept cross is called the crossing. Beyond the crossing lies the **sanctuary**, whether **apse**, choir, or chevet.

travertine A mineral building material similar to limestone, typically found in central Italy.

trefoil An ornamental design made up of three rounded lobes placed adjacent to one another.

triglyph Rectangular block between the **metopes** of a **Doric frieze**. Identified by the three carved vertical grooves, which approximate the appearance of the end of a wooden beam.

triptych An artwork made up of three panels. The panels may be hinged together so the side segments (**wings**) fold over the central area.

trompe l'oeil A manner of representation in which the appearance of natural space and objects is re-created with the express intention of fooling the eye of the viewer, who may be convinced that the subject actually exists as three-dimensional reality.

trumeau A column, pier, or post found at the center of a large portal or doorway, supporting the lintel.

tugra A calligraphic imperial monogram used in Ottoman courts.

Tuscan order *See* **order**.

twisted perspective A convention in art in which every aspect of a body or object is represented from its most characteristic viewpoint.

ukiyo-e A Japanese term for a type of popular art that was favored from the sixteenth century, particularly in the form of color **woodblock prints**. Ukiyo-e prints often depicted the world of the common people in Japan, such as courtesans and actors, as well as landscapes and myths.

urna In Buddhist art, the curl of hair on the forehead that is a characteristic mark of a buddha. The urna is a symbol of divine wisdom.

ushnisha In Asian art, a round turban or tiara symbolizing royalty and, when worn by a buddha, enlightenment.

vanishing point In a **perspective** system, the point on the horizon line at which **orthogonals** meet. A complex system can have multiple vanishing points.

vanitas An image, especially popular in Europe during the seventeenth century, in which all the objects symbolize the transience of life. Vanitas paintings are usually of **still lifes** or **genre** subjects.

vault An **arched** masonry structure that spans an interior space. Barrel or tunnel vault: an elongated or continuous semicircular vault, shaped like a half-cylinder. **Corbeled** vault: a vault made by projecting courses of stone. **Groin** or cross vault: a vault created by the intersection of two barrel vaults of equal size which creates four side compartments of identical size and shape. Quadrant or half-barrel vault: as the name suggests, a half-barrel vault. Rib vault: ribs (extra masonry) demarcate the junctions of a groin vault. Ribs may function to reinforce the groins or may be purely decorative. See also **corbeling**.

veduta (vedute) Italian for "vista" or "view."

Paintings, drawings, or prints often of expansive city scenes or of harbors.

vellum A fine animal skin prepared for writing and painting. See also parchment.

veneer In architecture, the exterior facing of a building, often in decorative patterns of fine stone or brick. In decorative arts, a thin exterior layer of finer material (such as rare wood, ivory, metal, and semiprecious stones) laid over the form.

verism A style in which artists concern themselves with capturing the exterior likeness of an object or person, usually by rendering its visible details in a finely executed, meticulous manner.

vihara From the Sanskrit term meaning "for wanderers." A vihara is, in general, a Buddhist monastery in India. It also signifies monks' cells and gathering places in such a monastery.

vimana The main element of a Southern Indian Hindu temple, usually in the shape of a pyramidal or tapering tower raised on a **plinth**.

volute A spiral scroll, as seen on an Ionic **capital**.

votive figure An image created as a devotional offering to a god or other deity.

voussoirs The oblong, wedge-shaped stone blocks used to build an **arch**. The topmost voussoir is called a **keystone**.

warp The vertical threads in a weaver's loom. Warp threads make up a fixed framework that provides the structure for the entire piece of cloth, and are thus often thicker than **weft** threads. See also **weft**.

wash A diluted watercolor or ink. Often washes are applied to drawings or prints to add tone or touches of color.

wattle and daub A wall construction method combining upright branches, woven with twigs (wattles) and plastered or filled with clay or mud (daub).

weft The horizontal threads in a woven piece of cloth. Weft threads are woven at right angles to and through the **warp** threads to make up the bulk of the decorative pattern. In carpets, the weft is often completely covered or formed by the rows of trimmed knots that form the carpet's soft surface. See also **warp**.

white-ground A type of ancient Greek pottery in which the background color of the object is painted with a slip that turns white in the firing process. Figures and details were added by painting on or **incising** into this **slip**. White-ground wares were popular in the Classical period as funerary objects.

wing A side panel of a **triptych** or **polyptych** (usually found in pairs), which was hinged to fold over the central panel. Wings often held the depiction of the donors and/or subsidiary scenes relating to the central image.

woodblock print A print made from one or more carved wooden blocks. In Japan, woodblock prints were made using multiple blocks carved in relief, usually with a block for each color in the finished print. See also **woodcut**.

woodcut A type of print made by carving a design into a wooden block. The ink is applied to the block with a roller. As the ink remains only on the raised areas between the carvedaway lines, these carved-away areas and lines provide the white areas of the print. Also: the process by which the woodcut is made.

x-ray style In Aboriginal art, a manner of representation in which the artist depicts a figure or animal by illustrating its outline as well as essential internal organs and bones.

yaksha, yakshi The male (yaksha) and female (yakshi) nature spirits that act as agents of the Hindu gods. Their sculpted images are often found on Hindu temples and other sacred places, particularly at the entrances.

ziggurat In Mesopotamia, a tall stepped tower of earthen materials, often supporting a shrine.

BIBLIOGRAPHY

Susan V. Craig

This bibliography is composed of books in English that are appropriate "further reading" titles. Most items on this list are available in good libraries, whether college, university, or public institutions. I have emphasized recently published works so that the research information would be current. There are three classifications of listings: general surveys and art history reference tools, including journals and Internet directories; surveys of large periods that encompass multiple chapters (ancient art in the Western tradition, European medieval art, European Renaissance through eighteenth-century art, modern art in the West, Asian art, and African and Oceanic art and art of the Americas); and books for individual chapters 1 through 32.

General Art History Surveys and Reference Tools

Adams, Laurie Schneider. *Art across Time*. 2nd ed. New York: McGraw-Hill, 2002.

Barnet, Sylvan. *A Short Guide to Writing about Art*. 8th ed. New York: Pearson/Longman, 2005.

Boströöm, Antonia. *Encyclopedia of Sculpture*. 3 vols. New York: FitzroyDearborn, 2004.

Broude, Norma, and Garrard, Mary D., eds. *Feminism and Art History: Questioning the Litany*. Icon Editions. New York: Harper & Row, 1982.

Chadwick, Whitney. *Women, Art, and Society*. 3rd ed. New York: Thames and Hudson, 2002.

Chilvers, Ian, ed. The *Oxford Dictionary of Art*. 3rd ed. New York: Oxford Univ. Press, 2004.

Curl, James Stevens. *A Dictionary of Architecture and Landscape Architecture*. 2nd ed. Oxford: Oxford Univ. Press, 2006.

Davies, Penelope J.E., et al. *Janson's History of Art: The Western Tradition*. 7th ed. Upper Saddle River, NJ: Prentice Hall, 2006.

Dictionary of Art, The. 34 vols. New York: Grove's Dictionaries, 1996.

Encyclopedia of World Art. 16 vols. New York: McGraw-Hill, 1972–83.

Frank, Patrick, Duane Preble, and Sarah Preble. *Preble's Artforms*. 8th ed. Upper Saddle River, NJ: Prentice Hall, 2006.

Gardner, Helen. *Gardner's Art through the Ages*. 12th ed. Ed. Fred S. Kleiner & Christin J. Mamiya. Belmont, CA: Thomson/Wadsworth, 2005.

Gaze, Delia, ed. *Dictionary of Women Artists*. 2 vols. London: Fitzroy Dearborn Publishers, 1997.

Griffiths, Antony. *Prints and Printmaking: An Introduction to the History and Techniques*. 2nd ed. London: British Museum Press, 1996.

Hadden, Peggy. *The Quotable Artist*. New York: Allworth Press, 2002.

Hall, James. *Illustrated Dictionary of Symbols in Eastern and Western Art*. New York: Icon Editions, 1994.

Holt, Elizabeth Gilmore, ed. *A Documentary History of Art*. 3 vols. New Haven: Yale Univ. Press, 1986.

Honour, Hugh, and John Fleming. *The Visual Arts: A History*. 7th ed. Upper Saddle River, NJ: Prentice Hall, 2005.

Hults, Linda C. *The Print in the Western World: An Introductory History*. Madison: Univ. of Wisconsin Press, 1996.

Johnson, Paul. *Art: A New History*. New York: Harper-Collins, 2003.

Kaltenbach. G. E. *Pronunciation Dictionary of Artists' Names*. 3rd ed. Rev. Debra Edelstein. Boston: Little, Brown, and Co., 1993.

Kemp, Martin. *The Oxford History of Western Art*. Oxford: Oxford Univ. Press, 2000.

Kostof, Spiro. *A History of Architecture: Settings and Rituals*. 2nd ed. Rev. Greg Castillo. New York: Oxford Univ. Press, 1995.

Mackenzie, Lynn. *Non-Western Art: A Brief Guide*. 2nd ed. Upper Saddle River, NJ: Prentice Hall, 2001.

Marmor, Max, and Alex Ross, eds. *Guide to the Literature of Art History 2*. Chicago: American Library Association, 2005.

Onians, John, ed. *Atlas of World Art*. New York: Oxford Univ. Press, 2004.

Roberts, Helene, ed. *Encyclopedia of Comparative Iconography: Themes Depicted in Works of Art*. 2 vols. Chicago: Fitzroy Dearborn, 1998.

Rogers, Elizabeth Barlow. *Landscape Design: A Cultural and Architectural History*. New York: Harry N. Abrams, 2001.

Sayre, Henry M. *Writing about Art*. 5th ed. Upper Saddle River, NJ: Pearson/Prentice Hall, 2006.

Sed-Rajna, Gabrielle. *Jewish Art*. Trans. Sara Friedman and Mira Reich. New York: Abrams, 1997.

Slatkin, Wendy. *Women Artists in History: From Antiquity to the Present*. 4th ed. Upper Saddle River, NJ: Prentice Hall, 2000.

Sutton, Ian. *Western Architecture: From Ancient Greece to the Present*. World of Art. New York: Thames and Hudson, 1999.

Trachtenberg, Marvin, and Isabelle Hyman. *Architecture: From Prehistory to Postmodernity*. 2nd ed. Upper Saddle River, NJ: Prentice Hall, 2001.

Tufts, Eleanor. *Our Hidden Heritage: Five Centuries of Women Artists*. New York: Paddington Press, 1974.

West, Shearer. *Portraiture*. Oxford History of Art. Oxford: Oxford Univ. Press, 2004.

Wilkins, David G., Bernard Schultz, and Katheryn M. Linduff. *Art Past, Art Present*. 5th ed. Upper Saddle River, NJ: Prentice Hall, 2005.

Watkin, David. *A History of Western Architecture*. 4th ed. New York: Watson-Guptill Publications, 2005.

Art History Journals: A Select List of Current Titles

African Arts. Quarterly. Los Angeles: Univ. of California at Los Angeles, James S. Coleman African Studies Center, 1967–

American Art: The Journal of the Smithsonian American Art Museum. 3/year. Chicago: Univ. of Chicago Press, 1987–

American Indian Art Magazine, Quarterly. Scottsdale, AZ: American Indian Art Inc, 1975–

American Journal of Archaeology. Quarterly. Boston: Archaeological Institute of America, 1885–

Antiquity: A Periodical of Archaeology. Quarterly. Cambridge, UK: Antiquity Publications Ltd, 1927–

Apollo: The International Magazine of the Arts. Monthly. London: Apollo Magazine Ltd, 1925–

Architectural History. Annually. Farnham, UK: Society of Architectural Historians of Great Britain, 1958–

Archives of American Art Journal. Quarterly. Washington, D.C.: Archives of American Art, Smithsonian Institution, 1960–

Archives of Asian Art. Annually. New York: Asia Society, 1945–

Ars Orientalis: The Arts of Asia, Southeast Asia, and Islam. Annually. Ann Arbor: Univ. of Michigan Dept. of Art History, 1954–

Art Bulletin. Quarterly. New York: College Art Association, 1913–

Art History: Journal of the Association of Art Historians. 5/year. Oxford: Blackwell Publishing Ltd, 1978–

Art in America. Monthly. New York: Brant Publications Inc, 1913–

Art Journal. Quarterly. New York: College Art Association, 1960–

Art Nexus. Quarterly. Bogata, Colombia: Arte en Colombia Ltda, 1976–

Art Papers Magazine. Bi-monthly. Atlanta: Atlanta Art Papers Inc, 1976–

Artforum International. 10/year. New York: Artforum International Magazine Inc, 1962–

Artnews. 11/year. New York: Artnews LLC, 1902–

Bulletin of the Metropolitan Museum of Art. Quarterly. New York: Metropolitan Museum of Art, 1905-.

Burlington Magazine. Monthly. London: Burlington Magazine Publications Ltd, 1903–

Dumbarton Oaks Papers. Annually. Locust Valley, NY: J. J. Augustin Inc, 1940–

Flash Art International. Bimonthly. Trevi, Italy: Giancarlo Politi Editore, 1980–

Gesta. Semiannually. New York: International Center of Medieval Art, 1963–

History of Photography. Quarterly. Abingdon, UK: Taylor & Francis Ltd, 1976–

International Review of African American Art. Quarterly. Hampton, VA: International Review of African American Art, 1976–

Journal of Design History. Quarterly. Oxford: Oxford Univ. Press, 1988–

Journal of Egyptian Archaeology. Annually. London: Egypt Exploration Society, 1914–

Journal of Hellenic Studies. Annually. London: Society for the Promotion of Hellenic Studies, 1880–

Journal of Roman Archaeology. Annually. Portsmouth, RI: Journal of Roman Archaeology LLC, 1988–

Journal of the Society of Architectural Historians. Quarterly. Chicago: Society of Architectural Historians, 1940–

Journal of the Warburg and Courtauld Institutes. Annually. London: Warburg Institute, 1937–

Leonardo: Art, Science and Technology. 6/year. Cambridge, MA: MIT Press, 1968–

Marg. Quarterly. Mumbai, India: Scientific Publishers, 1946–

Master Drawings. Quarterly. New York: Master Drawings Association, 1963–

October. Cambridge, MA: MIT Press, 1976–

Oxford Art Journal. 3/year. Oxford: Oxford Univ. Press, 1978–

Parkett. 3/year. Züürich, Switzerland: Parkett Verlag AG, 1984–

Print Quarterly. Quarterly. London: Print Quarterly Publications, 1984–

Simiolus: Netherlands Quarterly for the History of Art. Quarterly. Apeldoorn, Netherlands: Stichting voor Nederlandse Kunsthistorische Publicaties, 1966–

Woman's Art Journal. Semiannually. Philadelphia: Old City Publishing Inc, 1980–

Internet Directories for Art History Information

ARCHITECTURE AND BUILDING

http://library.nevada.edu/arch/rsrce/webrsrce/contents.html

A directory of architecture websites collected by Jeanne Brown at the Univ. of Nevada at Las Vegas. Topical lists include architecture, building and construction, design, history, housing, planning, preservation, and landscape architecture. Most entries include a brief annotation and the last date the link was accessed by the compiler.

ART HISTORY RESOURCES ON THE WEB

http://witcombe.sbc.edu/ARTHLinks.html

Authored by Christopher L. C. E. Witcombe of Sweet Briar College in Virginia since 1995, the site includes an impressive number of links for various art historical eras as well as links to research resources, museums, and galleries. The content is frequently updated.

ART IN FLUX: A DIRECTORY OF RESOURCES FOR RESEARCH IN CONTEMPORARY ART

http://www.boisestate.edu/art/artinflux/intro.html

Cheryl K. Shutleff of Boise State Univ. in Idaho has authored this directory, which includes sites selected according to their relevance to the study of national or international contemporary art and artists. The subsections include artists, museums, theory, reference, and links.

ARTCYCLOPEDIA: THE FINE ARTS SEARCH ENGINE

With over 2,100 art sites and 75,000 links, this is one of the most comprehensive web directories for artists and art topics.

The primary searching is by artist's name but access is also available by artistic movement, nation, timeline and medium.

MOTHER OF ALL ART HISTORY LINKS PAGES

http://www.art-design.umich.edu/mother/

Maintained by the Dept. of the History of Art at the Univ. of Michigan, this directory covers art history departments, art museums, fine arts schools and departments as well as links to research resources. Each entry includes annotations.

VOICE OF THE SHUTTLE

http://vos.ucsb.edu

Sponsored by Univ. of California, Santa Barbara, this directory includes over 70 pages of links to humanities and

humanities-related resources on the Internet. The struc-
tured guide includes specific sub-sections on architecture,
on art (modern & contemporary), and on arthistory. Links
usually include a one sentence explanation and the
resource is frequently updated with new information.

YAHOO! ARTS>ART HISTORY

http://dir.yahoo.com/Arts/Art_History/

Another extensive directory of art links organized into
subdivisions with one of the most extensive being "Peri-
ods and Movements." Links include the name of the site
as well as a few words of explanation.

Asian Art, General

Addiss, Stephen, Gerald Groemer, and J. Thomas Rimer,
eds. *Traditional Japanese Arts and Culture: An Illustrated
Sourcebook*. Honolulu: Univ. of Hawai'i Press, 2006.

Barnhart, Richard M. Three *Thousand Years of Chinese
Painting*. New Haven: Yale Univ. Press, 1997.

Blunden, Caroline, and Mark Elvin. *Cultural Atlas of
China*. 2nd ed. New York: Checkmark Books, 1998.

Brown, Kerry, ed. *Sikh Art and Literature*. New York:
Routledge in collaboration with the Sikh Founda-
tion, 1999.

Bussagli, Mario. *Oriental Architecture*. History of World
Architecture. 2 vols. New York: Electa/Rizzoli,
1989.

Chang, Leon Long-Yien, and Peter Miller. *Four Thousand
Years of Chinese Calligraphy*. Chicago: Univ. of
Chicago Press, 1990.

Chung, Yang-mo. *Arts of Korea*. Ed. Judith G. Smith. New
York: Metropolitan Museum of Art, 1998.

Clark, John. *Modern Asian Art*. Honolulu: Univ. of Hawaii
Press, 1998.

Clunas, Craig. *Art in China*. Oxford History of Art.
Oxford: Oxford Univ. Press, 1997.

Collcutt, Martin, Marius Jansen, and Isao Kumakura.
Cultural Atlas of Japan. New York: Facts on File,
1988.

Craven, Roy C. *Indian Art: A Concise History*. Rev. ed.
World of Art. New York: Thames and Hudson, 1997.

Dehejia, Vidya. *Indian Art*. Art & Ideas. London: Phaidon
Press, 1997.

Fisher, Robert E. *Buddhist Art and Architecture*. World of
Art. New York: Thames and Hudson, 1993.

Fu, Xinian. *Chinese Architecture*. Ed. & exp. Nancy S.
Steinhardt. The Culture & Civilization of China.
New Haven: Yale Univ. Press, 2002.

Hearn, Maxwell K., and Judith G. Smith, eds. *Arts of the
Sung and Yüüan: Papers Prepared for an International
Symposium*. New York: Dept. of Asian Art, Metropoli-
tan Museum of Art, 1996.

Heibonsha Survey of Japanese Art. 31 vols. New York:
Weatherhill, 1972–80.

Hertz, Betti-Sue. *Past in Reverse: Contemporary Art of East
Asia*. San Diego: San Diego Museum of Art, 2004.

Japanese Arts Library. 15 vols. New York: Kodansha Inter-
national, 1977–87.

Kerlogue, Fiona. *Arts of Southeast Asia*. World of Art. New
York: Thames & Hudson, 2004.

Khanna, Balraj, and George Michell. *Human and Divine:
2000 Years of Indian Sculpture*. London: Hayward
Gallery Pub., 2000.

Lee, Sherman E. *A History of Far Eastern Art*. 5th ed. Ed.
Naomi Noble Richards. New York: Abrams, 1994.

———. *China, 5000 Years: Innovation and Transformation in
the Arts*. New York: Solomon R. Guggenheim
Museum, 1998.

Liu, Cary Y., and Dora C.Y. Ching, eds. *Arts of the Sung
and Yüüan: Ritual, Ethnicity, and Style in Painting*.
Princeton: Art Museum, Princeton Univ., 1999.

McArthur, Meher. *The Arts of Asia: Materials, Techniques,
Styles*. New York: Thames & Hudson, 2005.

———. *Reading Buddhist Art: An Illustrated Guide to Bud-
dhist Signs and Symbols*. New York: Thames & Hud-
son, 2002.

Mason, Penelope. *History of Japanese Art*. 2nd ed. Upper
Saddle River, NJ: Pearson Prentice Hall, 2005.

Michell, George. *Hindu Art and Architecture*. World of Art.
London: Thames & Hudson, 2000.

———. *The Penguin Guide to the Monuments of India*. 2
vols. New York: Viking, 1989.

Mitter, Partha. *Indian Art*. Oxford History of Art. Oxford:
Oxford Univ. Press, 2001.

Nickel, Lukas, ed. *Return of the Buddha: The Qingzhou
Discoveries*. London: Royal Academy of Arts, 2002.

Pak, Youngsook, and Roderick Whitfield. *Buddhist Sculp-
ture*. Handbook of Korean Art. London: Laurence
King, 2003.

Stanley-Baker, Joan. *Japanese Art*. Rev. & exp. ed. World
of Art. New York: Thames and Hudson, 2000.

Sullivan, Michael. *The Arts of China*. 4th ed., Exp. & rev.
Berkeley: Univ. of California Press, 1999.

Thorp, Robert L., and Richard Ellis Vinograd. *Chinese
Art & Culture*. New York: Abrams, 2001.

Topsfield, Andrew, ed. *In the Realm of Gods and Kings:
Arts of India*. London: Philip Wilson, 2004.

Tucker, Jonathan. *The Silk Road: Art and History*.
Chicago: Art Media Resources, 2003.

Tregear, Mary. *Chinese Art*. Rev. ed. World of Art. New
York: Thames and Hudson, 1997.

Vainker S. J. *Chinese Pottery and Porcelain: From Prehistory
to the Present*. London: British Museum, 1991.

Varley, H. Paul *Japanese Culture*. 4th ed., Updated & exp.
Honolulu: Univ. of Hawaii Press, 2000.

African and Oceanic Art and Art of
the Americas, General

Anderson, Richard L., and Karen L Field, eds. *Art in
Small-Scale Societies: Contemporary Readings*. Engle-
wood Cliffs, NJ: Prentice-Hall, 1993.

Bacquart, Jean-Baptiste. *The Tribal Arts of Africa*. New
York: Thames and Hudson, 1998.

Bassani, Ezio, ed. *Arts of Africa: 7000 Years of African Art*.
Milan: Skira, 2005.

Benson, Elizabeth P. *Retratos: 2,000 Years of Latin American
Portraits*. San Antonio: San Antonio Museum of Art,
2004.

Berlo, Janet Catherine, and Lee Ann Wilson. *Arts of
Africa, Oceania, and the Americas: Selected Readings*.
Upper Saddle River, NJ: Prentice Hall, 1993.

Calloway, Colin G.. *First Peoples: A Documentary Survey of
American Indian History*. Boston and New York: Bed-
ford/St. Martin's, 2004.

Coote, Jeremy, and Anthony Shelton, eds. *Anthropology,
Art, and Aesthetics*. New York: Oxford Univ. Press,
1992.

D'Azevedo, Warren L. *The Traditional Artist in African
Societies*. Bloomington: Indiana Univ. Press, 1989.

Drewal, Henry, and John Pemberton III. *Yoruba: Nine
Centuries of African Art and Thought*. New York: Center
for African Art, 1989.

Evans, Susan Toby. *Ancient Mexico & Central America:
Archaeology and Culture History*. New York: Thames &
Hudson, 2004.

———, and David L. Webster, eds. *Archaeology of Ancient
Mexico and Central America : An Encyclopedia*. New
York: Garland Pub., 2001.

———, and Joanne Pillsbury, eds. *Palaces of the Ancient
New World: A Symposium at Dumbarton Oaks, 10th and
11th October, 1998*. Washington, D.C.: Dumbarton
Oaks Research Library and Collection, 2004.

Geoffroy-Schneiter, Bérénice. *Tribal Arts*. New York:
Vendome Press, 2000.

Guidoni, Enrico. *Primitive Architecture*. Trans. Robert Eric
Wolf. History of World Architecture. New York: Riz-
zoli, 1987.

Hiller, Susan, ed. & comp. *The Myth of Primitivism:
Perspectives on Art*. London: Routledge, 1991.

Mack, John, ed. *Africa, Arts and Cultures*. London: British
Museum, 2000.

Mexico: Splendors of Thirty Centuries. New York: Metro-
politan Museum of Art, 1990.

Murray, Jocelyn, ed. *Cultural Atlas of Africa*. Rev. ed. New
York: Facts on File, 1998.

Nunley, John W., and Cara McCarty. *Masks: Faces of Cul-
ture*. New York: Abrams in assoc. with the Saint Louis
Art Museum, 1999.

Perani, Judith, and Fred T. Smith. *The Visual Arts of Africa:
Gender, Power, and Life Cycle Rituals*. Upper Saddle
River, NJ: Prentice Hall, 1998.

Phillips, Tom. *Africa: The Art of a Continent*. London: Pres-
tel, 1996.

Price, Sally. *Primitive Art in Civilized Places*. Chicago:
Univ. of Chicago Press, 1989.

Rabineau, Phyllis. *Feather Arts: Beauty, Wealth, and Spirit
from Five Continents*. Chicago: Field Museum of Nat-
ural History, 1979.

Schuster, Carl, and Edmund Carpenter. *Patterns that Con-
nect: Social Symbolism in Ancient & Tribal Art*. New
York: Abrams, 1996.

Scott, John F. *Latin American Art: Ancient to Modern*.
Gainesville: Univ. Press of Florida, 1999.

Stepan, Peter. *Africa*. Trans. John Gabriel & Elizabeth
Schwaiger. World of Art. London: Prestel, 2001.

Visonàà, Monica Blackmun, et al. *A History of Art in
Africa*. Upper Saddle River, NJ: Prentice Hall,
2000.

Chapter 8
Islamic Art

Al-Faruqi, Ismail R, and Lois Lamya'al Faruqi. *Cultural
Atlas of Islam*. New York: Macmillan, 1986.

Atasoy, Nurhan. *Splendors of the Ottoman Sultans*. Ed.
and Trans. Tulay Artan. Memphis, TN: Lithograph,
1992.

Atil, Esin. *The Age of Sultan Suleyman the Magnificent*.
Washington, D.C.: National Gallery of Art, 1987.

Baer, Eva. *Islamic Ornament*. New York: New York Univ.
Press, 1998.

Baker, Patricia L. *Islam and the Religious Arts*. New York:
Continuum, 2004.

Barry, Michael. *Figurative Art in Medieval Islam and the
Riddle of Bihzââd of Herâât (1465-1535)*. Paris:
Flammarion, 2004.

Blair, Sheila S., and Jonathan Bloom. *The Art and Architec-
ture of Islam 1250–1800*. Pelican History of Art. New
Haven: Yale Univ. Press, 1994.

Carboni, Stefano, and David Whitehouse. *Glass of the Sul-
tans*. New York: Metropolitan Museum of Art, 2001.

Denny, Walter B. *Iznik: The Artistry of Ottoman Ceramics*.
New York: Thames & Hudson, 2004.

Dodds, Jerrilynn D., ed. al-Andalus: The Art of Islamic
Spain. New York: Metropolitan Museum of Art, 1992.

Ecker, Heather. *Caliphs and Kings: The Art and Influence of
Islamic Spain*. Washington, D.C.: Arthur M. Sackler
Gallery, Smithsonian Institution, 2004.

Ettinghausen, Richard, Oleg Grabar, and Marilyn Jenk-
ins-Madina. *Islamic Art and Architecture, 650–1250*. 2nd
ed. Yale Univ. Press Pelican History of Art. New
Haven: Yale Univ. Press, 2001. Reissue ed. 2003.

Frishman, Martin, and Hasan-Uddin Khan. *The Mosque:
History, Architectural Development and Regional Diversity*.
London: Thames and Hudson, 1994.

Grabar, Oleg. *The Formation of Islamic Art*. Rev. ed. New
Haven: Yale Univ. Press, 1987.

———. *The Great Mosque of Isfahan*. New York: New York
Univ. Press, 1990.

———. *Mostly Miniatures: An Introduction to Persian Painting*.
Princeton: Princeton Univ. Press, 2000.

———, Mohammad al-Asad, Abeer Audeh, and Said
Nuseibeh. *The Shape of the Holy; Early Islamic
Jerusalem*. Princeton: Princeton Univ. Press, 1996.

Hillenbrand, Robert. *Islamic Art and Architecture*. World of
Art. London: Thames and Hudson, 1999.

Irwin, Robert. *The Alhambra*. Cambridge, MA: Harvard
Univ. Press, 2004.

Khatibi, Abdelkebir, and Mohammed Sijelmassi. *The
Splendour of Islamic Calligraphy*. Rev. & exp. ed. New
York: Thames and Hudson, 1996.

Komaroff, Linda, and Stefano Carboni, eds. *The Legacy of
Genghis Khan: Courtly Art and Culture in Western Asia,
1256- 1353*. New York: Metropolitan Museum of
Art, 2002.

Lentz, Thomas W., and Glenn D. Lowry. *Timur and the
Princely Vision: Persian Art and Culture in the Fifteenth
Century*. Los Angeles: Los Angeles County Museum
of Art, 1989.

Necipo lu, Güülru. *The Age of Sinan: Architectural Culture
in the Ottoman Empire*. Princeton: Princeton Univ.
Press, 2005.

Petruccioli, Attilio, and Khalil K. Pirani, eds. *Understanding
Islamic Architecture*. New York: Routledge Curzon, 2002.

Roxburgh, David J., ed. *Turks: A Journey of a Thousand Years,
600-1600*. London: Royal Academy of Arts, 2005.

Sims, Eleanor, Boris I. Marshak, and Ernest J. Grube.
Peerless Images: Persian Painting and Its Sources. New
Haven: Yale Univ. Press, 2002.

Stanley, Tim, Mariam Rosser-Owen, and Stephen
Vernoit. *Palace and Mosque: Islamic Art from the Middle
East*. London: V & A Publications, 2004.

Steele, James. *An Architecture for People: The Complete
Works of Hassan Fathy*. New York: Whitney Library of
Design, 1997.

Stierlin, Henri. *Islamic Art and Architecture: From Isfahan to
the Taj Mahal*. New York: Thames & Hudson, 2002.

Suhrawardy, Shahid. *The Art of the Mussulmans in Spain*.
New York: Oxford Univ. Press, 2005.

Tadgell, Christopher. *Four Caliphates: The Formation and
Development of the Islamic Tradition*. London: Ellipsis,
1998.

Ward, R. M. *Islamic Metalwork*. New York: Thames and
Hudson, 1993.

Watson, Oliver. *Ceramics from Islamic Lands*. New York:
Thames & Hudson in assoc. with the al-Sabah
Collection, Dar al-Athar al-Islamiyyah, Kuwait
National Museum, 2004.

CHAPTER 9
Art of South and Southeast Asia before 1200

Atherton, Cynthia Packert. *The Sculpture of Early Medieval Rajasthan*. Studies in Asian Art and Archaeology, v. 21. New York: Brill, 1997.

Behl, Benoy K. *The Ajanta Caves: Artistic Wonder of Ancient Buddhist India*. New York: Abrams, 1998.

Behrendt, Kurt A. *The Buddhist Architecture of Gandhara*. Handbook of Oriental Studies: Section Two: India, v. 17. Boston: Brill, 2004.

Berkson, Carmel. *Elephanta: The Cave of Shiva*. Princeton: Princeton Univ. Press, 1983.

Chakrabarti, Dilip K. *India, an Archaeological History: Palaeolithic Beginnings to Early Historic Foundations*. New York: Oxford Univ. Press, 1999.

Chandra, Pramod. *The Sculpture of India, 3000 B.C.–1300 A.D.* Washington, D.C.: National Gallery of Art, 1985.

Craven, Roy C. *Indian Art: A Concise History*. Rev. ed. World of Art. New York: Thames and Hudson, 1997.

Czuma, Stanislaw J. *Kushan Sculpture: Images from Early India*. Cleveland: Cleveland Museum of Art, 1985.

Dehejia, Vidya. *Art of the Imperial Cholas*. New York: Columbia Univ. Press, 1990.

———. *The Sensuous and the Sacred: Chola Bronzes from South India*. New York: American Federation of Arts, 2002.

Dessai, Vishakha N., and Darielle Mason, eds. *Gods, Guardians, and Lovers: Temple Sculptures from North India, A.D. 700–1200*. New York: Asia Society Galleries, 1993.

Dhavalikar, Madhukar Keshav. *Ellora*. New York: Oxford Univ. Press, 2003.

Girard-Geslan, Maud. *Art of Southeast Asia*. Trans. J.A. Underwood. New York: Harry N. Abrams, Inc., 1998.

Huntington, Susan L. *The Art of Ancient India: Buddhist, Hindu, Jain*. New York: Weatherhill, 1985.

———. *Leaves from the Bodhi Tree: The Art of Pala India (8th–12th Centuries) and Its International Legacy*. Dayton, OH: Dayton Art Institute, 1990.

Hutt, Michael. *Nepal: A Guide to the Art and Architecture of the Kathmandu Valley*. Boston: Shambala, 1995.

Knox, Robert. *Amaravati: Buddhist Sculpture from the Great Stupa*. London: British Museum, 1992.

Khanna, Sucharita. *Dancing Divinities in Indian Art: 8th–12th Century A.D.* Delhi: Sharada Pub. House, 1999.

Kramrisch, Stella. *The Art of Nepal*. New York: Abrams, 1964.

———. *Presence of Siva*. Princeton: Princeton Univ. Press, 1981.

Meister, Michael, ed. *Encyclopedia of Indian Temple Architecture*. 2 vols. in 7. Philadelphia: Univ. of Pennsylvania Press, 1983.

Michell, George. *Hindu Art and Architecture*. World of Art. London: Thames & Hudson, 2000.

Mitter, Partha. *Indian Art*. Oxford History of Art. Oxford: Oxford Univ. Press, 2001.

Neumayer, Erwin. *Lines on Stone: The Prehistoric Rock Art of India*. New Delhi: Manohar, 1993.

Pal, Pratapaditya, ed. *The Ideal Image: The Gupta Sculptural Tradition and Its Influence*. New York: Asia Society, 1978.

Poster, Amy G. *From Indian Earth: 4,000 Years of Terracotta Art*. Brooklyn: Brooklyn Museum, 1986.

Skelton, Robert, and Mark Francis. *Arts of Bengal: The Heritage of Bangladesh and Eastern India*. London: Whitechapel Gallery, 1979.

Stierlin, Henri. *Hindu India: From Khajuraho to the Temple City of Madurai*. New York: Taschen, 1998.

Tadgell, Christopher. *India and South-East Asia: The Buddhist and Hindu Tradition*. New York: Whitney Library of Design, 1998.

Williams, Joanna G. *Art of Gupta India, Empire and Province*. Princeton: Princeton Univ. Press, 1982.

CHAPTER 10
Chinese and Korean Art before 1279

Ciarla, Roberto, ed. *The Eternal Army: The Terracotta Soldiers of the First Chinese Emperor*. Vercelli: White Star, 2005.

Fong, Wen, ed. *Beyond Representation: Chinese Painting and Calligraphy, 8th–14th Century*. Princeton Monographs in Art and Archaeology. New York: Metropolitan Museum of Art, 1992.

Fraser, Sarah Elizabeth. *Performing the Visual: The Practice of Buddhist Wall Painting in China and Central Asia, 618-960*. Stanford, CA: Stanford Univ. Press, 2004.

James, Jean M. *A Guide to the Tomb and Shrine Art of the Han Dynasty 206 B.C.–A.D. 220*. Chinese Studies, 2. Lewiston, NY: Edwin Mellen Press, 1996.

Karetzky, Patricia Eichenbaum. *Court Art of the Tang*. Lanham, MD: Univ. Press of America, 1996.

Kim, Kumja Paik. *Goryeo Dynasty: Korea's Age of Enlightenment, 918-1392*. San Francisco: Asian Art Museum—Chong-Moon Lee Center for Asian Art and Culture in cooperation with the National Museum of Korea and the Nara National Museum, 2003.

Li, Jian, ed. *The Glory of the Silk Road: Art from Ancient China*. Dayton, OH: Dayton Art Institute, 2003.

Little, Stephen, and Shawn Eichman. *Taoism and the Arts of China*. Chicago: Art Institute of Chicago, 2000.

Liu, Cary Y., Dora C.Y. Ching, and Judith G. Smith. *Character & Context in Chinese Calligraphy*. Princeton: Art Museum, Princeton Univ., 1999.

Luo, Zhewen. *Ancient Pagodas in China*. Beijing, China: Foreign Languages Press, 1994.

Ma, Ch'eng-yuan. *Ancient Chinese Bronzes*. Ed. Hsio-Yen Shih. Hong Kong: Oxford Univ. Press, 1986.

Murck, Alfreda. *Poetry and Painting in Song China: The Subtle Art of Dissent*. Harvard-Yenching Institute Monograph Series, 50. Cambridge, MA: Harvard Univ. Asia Center for the Harvard-Yenching Institute, 2000.

Ortiz, Valéérie Malenfer. *Dreaming the Southern Song Landscape: The Power of Illusion in Chinese Painting*. Studies in Asian Art and Archaeology, v. 22. Boston: Brill, 1999.

Paludan, Ann. *Chinese Tomb Figurines*. Hong Kong: Oxford Univ. Press, 1994.

Portal, Jane. *Korea: Art and Archaeology*. New York: Thames & Hudson, 2000.

Rawson, Jessica. *Mysteries of Ancient China: New Discoveries from the Early Dynasties*. London: British Museum Press, 1996.

Rhie, Marylin M. *Early Buddhist Art of China and Central Asia*. 2 vols in 3. Handbuch der Orientalistik. Vierte Abteilung; China, 12. Leiden: Brill, 1999.

Scarpari, Maurizio. *Splendours of Ancient China*. London: Thames & Hudson, 2000.

So, Jenny F. ed. *Noble Riders from Pines and Deserts: The Artistic Legacy of the Qidan*. Hong Kong: Art Museum, the Chinese Univ. of Hong Kong, 2004.

Sturman, Peter Charles. *Mi Fu: Style and the Art of Calligraphy in Northern Song*. New Haven: Yale Univ. Press, 1997.

Wang, Eugene Y. *Shaping the Lotus Sutra: Buddhist Visual Culture in Medieval China*. Seattle: Univ. of Washington Press, 2005.

Watson, William. *The Arts of China to AD 900*. Pelican History of Art. New Haven: Yale Univ. Press, 1995.

———. *The Arts of China 900-1620*. Yale Univ. Press Pelican History of Art. New Haven: Yale Univ. Press, 2000. Reissue ed. 2003.

Watt, James C.Y. *China: Dawn of a Golden Age, 200-750 AD*. New York: Metropolitan Museum of Art, 2004.

Whitfield, Susan, and Ursula Sims-Williams, eds. *The Silk Road: Trade, Travel, War and Faith*. Chicago: Serindia Publications, 2004.

Wu Hung. *Monumentality in Early Chinese Art and Architecture*. Stanford: Stanford Univ. Press, 1995.

Yang, Xiaoneng, ed. *The Golden Age of Chinese Archaeology: Celebrated Discoveries from the People's Republic of China*. Washington D.C.: National Gallery of Art, 1999.

CHAPTER 11
Japanese Art before 1392

Cunningham, Michael R. *Buddhist Treasures from Nara*. Cleveland: Cleveland Museum of Art, 1998.

Fowler, Sherry D. *Muroji: Rearranging Art and History at the Japanese Buddhist Temple*. Honolulu: Univ. of Hawaii Press, 2005.

Harris, Victor, ed. *Shinto: The Sacred Art of Ancient Japan*. London: British Museum, 2001.

Izutsu, Shinry, and Shory œmori. *Sacred Treasures of Mount Kÿ_ya: The Art of Japanese Shingon Buddhism*. Honolulu: Koyasan Reihokan Museum, 2002.

Kenrick, Douglas Moore. *Jomon of Japan: The World's Oldest Pottery*. New York: Kegan Paul International, 1995.

Kurata, Bunsaku. *Horyu-ji, Temple of the Exalted Law: Early Buddhist Art from Japan*. New York: Japan Society, 1981.

LaMarre, Thomas. *Uncovering Heian Japan: An Archaeology of Sensation and Inscription*. Asia-Pacific. Durham, NC: Duke Univ. Press, 2000.

Miki, Fumio. *Haniwa*. Trans. and adapted by Gino Lee Barnes. Arts of Japan, 8. New York: Weatherhill, 1974.

Mino, Yutaka. *The Great Eastern Temple: Treasures of Japanese Buddhist Art from Todai-ji*. Chicago: Art Institute of Chicago, 1986.

Mizoguchi, Koji. *An Archaeological History of Japan: 30,000 B.C. to A.D. 700*. Philadelphia: Univ. of Pennsylvania Press, 2002.

Nishiwara, Kyotaro, and Emily J. Sano. *The Great Age of Japanese Buddhist Sculpture, A.D. 60–1300*. Fort Worth, TX: Kimbell Art Museum, 1982.

Pearson, Richard J. *Ancient Japan*. Washington, D.C.: Sackler Gallery, 1992.

Rosenfield, John M. *Japanese Arts of the Heian Period: 794–1185*. New York: Asia Society, 1967.

Soper, Alexander Coburn. *Evolution of Buddhist Architecture in Japan*. Princeton Monographs in Art and Archaeology, no. 22. New York: Hacker Art, 1978.

The Tale of Genji: Legends and Paintings. Intro. Miyeko Murase. New York: G. Braziller, 2001.

Washizuka, Hiromitsu, et al. *Transmitting the Forms of Divinity: Early Buddhist Art from Korea and Japan*. Ed. Naomi Noble Richard. New York: Japan Society, 2003.

Yiengpruksawan, Mimi Hall. *Hiraizumi: Buddhist Art and Regional Politics in Twelfth-Century Japan*. Harvard East Asian Monographs, 171. Cambridge, MA: Harvard Univ. Asia Center, 1998

CHAPTER 12
Art of the Americas before 1300

Baudez, Claude F., and Sydney Picasso. *Lost cities of the Maya*. Trans. Caroline Palmer. Discoveries. New York: Harry N. Abrams, 1992.

Benson, Elizabeth P., and Beatriz de la Fuente. *Olmec Art of Ancient Mexico*. Washington, D.C.: National Gallery of Art, 1996.

Berrin, Kathleen, ed. *Feathered Serpents and Flowering Trees: Reconstructing the Murals of Teotihuacan*. San Francisco: Fine Arts Museums of San Francisco, 1988.

Brody, J. J. *Anasazi and Pueblo Painting*. Albuquerque: Univ. of New Mexico Press, 1991.

———, Catherine J. Scott, and Steven A. LeBlanc. *Mimbres Pottery: Ancient Art of the American Southwest: Essays*. New York: Hudson Hills Press in assoc. with The American Federation of Arts, 1983.

Clark, John E., and Mary E. Pye, eds. *Olmec Art and Archaeology in Mesoamerica*. Studies in the History of Art, 58: Symposium Papers, 35. Washington, D.C.: National Gallery of Art, 2000.

Clayton, Lawrence A., editor. *The De Soto Chronicles: The Expedition of Hernando de Soto to North America, 1539-`1543*. Tuscaloosa: University of Alabama Press, 1995.

Coe, Michael D., and Rex Koontz. *Mexico: From the Olmecs to the Aztecs*. 5th ed. rev. & exp. New York: Thames & Hudson, 2002.

Fagan, Brian M. *Chaco Canyon: Archeologists Explore the Lives of an Ancient Society*. New York: Oxford Univ. Press, 2005.

Hall, Robert L. *An Archaeology of the Soul: North American Indian Belief and Ritual*. Urbana: Univ. of Illinois Press, 1997.

Herring, Adam. *Art and Writing in the Maya Cities, A.D. 600-800: A Poetics of Line*. Cambridge, U.K.: Cambridge Univ. Press, 2005.

Heyden, Doris, and Paul Gendrop. *Pre-Columbian Architecture of Mesoamerica*. Trans. Judith Stanton. History of World Architecture. New York: Electa/Rizzoli, 1988.

Korp, Maureen. *The Sacred Geography of the American Mound Builders*. Native American Studies. Lewiston, NY: Edwin Mellen, 1990.

Kubler, George. *The Art and Architecture of Ancient America: The Mexican, Maya, and Andean Peoples*. 3rd ed. Pelican History of Art. New Haven: Yale Univ. Press, 1990.

Labbéé, Armand J. *Shamans, Gods, and Mythic Beasts: Colombian Gold and Ceramics in Antiquity*. New York: American Federation of Arts, 1998.

Loendorf, Lawrence L., Christopher Chippindale, and David S. Whitley, eds. *Discovering North American Rock Art*. Tucson: Univ. of Arizona Press, 2005.

Martin, Simon, and Nikolai Grube. *Chronicle of the Maya Kings and Queens: Deciphering the Dynasties of the Ancient Maya*. New York: Thames & Hudson, 2000.

Miller, Mary Ellen. *The Art of Mesoamerica: from Olmec to Aztec*. 3rd ed. World of Art. London: Thames and Hudson, 2001.

———. *Maya Art and Architecture*. World of Art. London: Thames and Hudson, 1999.

Miller, Mary Ellen, and Simon Martin. *Courtly Art of the Ancient Maya*. San Francisco: Fine Arts Museums of San Francisco, 2004.

Milner, George R. *The Moundbuilders: Ancient Peoples of Eastern North America*. Ancient Peoples and Places. London: Thames & Hudson, 2004.

Noble, David Grant. *In Search of Chaco: New Approaches to an Archaeological Enigma*. Santa Fe, NM: School of American Research Press, 2004.

O'Connor, Mallory McCane. *Lost Cities of the Ancient Southeast*. Gainesville: Univ. Press of Florida, 1995.

Pasztory, Esther. *Pre-Columbian Art*. Cambridge, U.K.: Cambridge Univ. Press, 1998.

———. *Teotihuacan: An Experiment in Living*. Norman: Univ. of Oklahoma Press, 1997.

Pillsbury, Joanne, ed. *Moche Art and Archaeology in Ancient Peru*. Studies in the History of Art: Center for Advanced Study in the Visual Arts, 63: Symposium Papers, 40. Washington, D.C.: National Gallery of Art, 2001.

Power, Susan C. *Early Art of the Southeastern Indians: Feathered Serpents & Winged Beings*. Athens: Univ. of Georgia Press, 2004.

Rohn, Arthur H., and William M. Ferguson. *Puebloan Ruins of the Southwest*. Albuquerque: Univ. of New Mexico Press, 2006.

Schobinger, Juan. *The Ancient Americans: A Reference Guide to the Art, Culture, and History of Pre-Columbian North and South America*. Trans. Carys Evans Corrales. 2 vols. Armonk, NY: Sharp Reference, 2001.

Sharer, Robert J. and Loa P. Traxler. *The Ancient Maya*. 6th ed. Stanford, CA: Stanford Univ. Press, 2006.

Stierlin, Henri, and Anne Stierlin, *The Maya: Palaces and Pyramids of the Rainforest*. London: Taschen, 2001.

Stone-Miller, Rebecca. *Art of the Andes: From Chavin to Inca*. 2nd ed. World of Art. New York: Thames and Hudson, 2002.

Townsend, Richard F. and Robert V. Sharp, eds. *Hero, Hawk, and Open Hand: American Indian Art of the Ancient Midwest and South*. Chicago: Art Institute of Chicago, 2004.

Von Hagen, Adriana, and Craig Morris. *The Cities of the Ancient Andes*. New York: Thames and Hudson, 1998.

CHAPTER 13
Art of Ancient Africa

Ben-Amos, Paula. *The Art of Benin*. Rev. ed. Washington, D.C.: Smithsonian Institution Press, 1995.

Blier, Suzanne Preston. *The Royal Arts of Africa: The Majesty of Form*. New York: H.N. Abrams, 1998.

Cole, Herbert M. *Igbo Arts: Community and Cosmos*. Los Angeles: Fowler Museum of Cultural History, Univ. of California, 1984.

Connah, Graham. *African Civilizations: An Archaeological Perspective*. 2nd ed. Cambridge, U.K.: Cambridge Univ. Press, 2001.

———. *Forgotten Africa: An Introduction to Its Archaeology*. New York: Routledge, 2004.

Coulson, David, and Alec Campbell. *African Rock Art: Paintings and Engravings on Stone*. New York: Harry N. Abrams, Inc., 2001.

Darish, Patricia J. *"Memorial Head of an Oba: Ancestral Time in Benin Culture," in Tempus Fugit, Time Flies.* Ed. Jan Schall. Kansas City: The Nelson Atkins Museum of Art, 2000. Pgs. 290-97.

Eyo, Ekpo, and Frank Willett. *Treasures of Ancient Nigeria*. Ed. Rollyn O. Kirchbaum. New York: Knopf, 1980.

Ezra, Kate. *Royal Art of Benin: The Perls Collection in the Metropolitan Museum of Art*. New York: Metropolitan Museum of Art, 1992.

Garlake, Peter S. *Early Art and Architecture of Africa*. Oxford History of Art. Oxford: Oxford Univ. Press, 2002.

———. *The Hunter's Vision: The Prehistoric Art of Zimbabwe*. Seattle: Univ. of Washington Press, 1995.

Grunne, Bernard de. *The Birth of Art in Africa: Nok Statuary in Nigeria*. Paris: A. Biro, 1998.

Huffman, Thomas N. *Symbols in Stone: Unravelling the Mystery of Great Zimbabwe*. Johannesburg: Witwatersrand Univ. Press, 1987.

LaViolette, Adria Jean. *Ethno-Achaeology in Jennéé, Mali: Craft and Status among Smiths, Potters, and Masons*. Oxford: Archaeopress, 2000.

Le Quellec, Jean-Loïc. *Rock Art in Africa: Mythology and Legend*. Trans. Paul Bahn. Paris: Flammarion, 2004.

M'Bow, Babacar, and Osemwegie Ebohon. *Benin, a Kingdom in Bronze: The Royal Court Art*. Ft. Lauderdale, FL: African American Research Library and Cultural Center, Broward County Library, 2005.

Phillipson, D. W. *African Archaeology*. 3rd ed. New York: Cambridge Univ. Press, 2005.

Schäädler, Karl-Ferdinand. *Earth and Ore: 2500 Years of African Art in Terra-Cotta and Metal*. Trans. Geoffrey P. Burwell. Müünchen: Panterra, 1997.

CREDITS

INDEX

Italic page numbers refer to illustrations and maps.

Notes

Notes

Notes

Notes

Notes

Notes